# IMAGES
OF
# HAMPSTEAD

# IMAGES OF
# HAMPSTEAD

*Narrative*
## SIMON JENKINS

*Catalogue*
## JONATHAN DITCHBURN

*Gallery of Prints*
### HARRIET and PETER
### GEORGE

ACKERMANN
SAINT HELENA TERRACE
RICHMOND-UPON-THAMES
MCMLXXXII

This is Volume Three of *Images of London*, a series of books
describing, reproducing and cataloguing the prints of
the separate areas of Greater London. The catalogues are
being compiled under the editorial supervision of
Ralph Hyde
*Keeper of Prints and Maps at the
Guildhall Library, City of London*

Each volume of *Images of London* is published in two limited
and numbered editions: an edition of 50 copies hand-bound in
full morocco (numbered in Roman numerals I to L) and an edition
of 1000 copies in cloth (numbered 1 to 1000).

This copy is number    **332**    of *Images of Hampstead*.

Set in Monophoto Apollo and printed by
BAS Printers Limited, Over Wallop, Hampshire

Binding by Hunter & Foulis Ltd,
Bridgeside Works, McDonald Road, Edinburgh.

ISBN 0 946186 01 4 (copies numbered I to L)
ISBN 0 946186 02 2 (copies numbered 1 to 1000)

# The Subscribers

J. D. Abrahamson
Robert Adams
R. F. Allen
Professor and Mrs Michael
  Allingham
Irene Andreae
Margot and James O. Andrew
Marie and Angel Arando
Dr and Mrs Andrew Bamji
Peter and Christiane Barber
Miss E. Bartholomew
Martin H. Bayer
Karen and Derek Beasley
Charles Becker
Ann and Neil Benson
Stephen Benson
Warwick M. Bergin
Marcus Binney
Kaj and Sonia Birksted
Bishopsgate Institute
Charles J. Branchini
Alfred J. Brazier
Alfred and Irene Brendel
British Architectural Library
Margaret Brock
The Hon. Peter Brooke, M.P.
Colin and Helen Brough
Dr and Mrs M. Bryn-Jones
Burgh House
Annetta Bynum
Camden Public Libraries
John Carswell, C.B.
Michael Chambers
I. O. Chance
Frances W. Chase
Michael and Catherine Chelk
Lady Brenda Clarke, B.A.Phil.,
  B.A.Psychol.
Roger Cline, M.A., LL.B.
Frank Cole
Joseph Connolly
Anthony Cooper
Chris and Beta Copley
Mary Cosh
Hugh Ivri Courts
Anthony and Susan Cox
Kenneth and Sylvia Cox
Mr and Mrs Frank Cridlan

Walter and Doris Crowley
Helene and Hugh Curtis
B. B. Daly
John Dangerfield
Don and Mimi Daniels
J. Ewart and Eirlys Davies
Jeremy and Imogen Davies
Michael and Diane Dean
H. C. Delves, F.R.I.C.S., F.R.T.P.I.
Michael and Pauline Ditchburn
Mr and Mrs Robert Dougall
Fintan and Jean Earley
Roger H. Ellis, F.S.A.
Roberta M. Entwistle
John A. Etchells
Neal and Janet Etchells
John Farago
Alan Farmer
John and Mary Fasal
J. J. Fenton, F.C.A.
Gilbert Joseph Ferrier
Francoise and Paul Findlay
Mr and Mrs Jarlath Finney
Geoffrey Finsberg, M.B.E., J.P.,
  M.P.
Mr and Mrs Dudley Fishburn
David Ford
Patrick Frazer
Bamber and Christina
  Gascoigne
Brian and Laura Gascoigne
Ken Gay
Christina M. Gee
Ron and Vicky German
Jonathan Gestetner
Peter and Allyson Getsinger
R. W. S. Gibbs
Jacqueline and Lewis Golden
Ruth and Peter Gorb
Arthur N. Goss
John and Lisa Grant
Frederick A. Gray
Greater London Council History
  Library
Philip and Stella Greenall
Edward C. Greenway, R.I.B.A.
Trevor and Valerie Grove
Sophie Guest

Guildhall Library, City of
  London
A. E. Gunther, F.L.S., F.G.S.
Dennis W. Hackett
Susan M. Hale
Robert and Caroline Hamburger
Michael Hammerson, B.Sc.,
  M.Phil., A.R.I.C.S.
Hampton and Sons
Miles and Melissa Hardie
Harvard College Library
Alice Hemming, O.B.E.
Mr and Mrs Jack Henry
John and Katie Hillaby
Charles and Tess Hoffmann
J. Hogendonk
Ann and John Holness
Susan and Philip Hopkins
Mr I. O.Horvitch, F.R.I.B.A.
Michael and Monica Hughes
Huntington Library, Art
  Gallery and Botanical
  Gardens
C. W. Ikin
Institute of Historical Research,
  University of London
Gerry and Delphine Isaaman
The Iveagh Bequest, Kenwood,
  Greater London Council
Islington Libraries
Richard Jeffree
Alex and Roberta de Joia
Geraint and Winifred Jones
Jennifer and Humphrey Jones
Joan Kean
Diane and Peter King
Richard and Vivian King
Ronald and Valerie Knight
Jim and Jackie Lagden
Mr and Mrs Peter Lambert
Alice and Desmond Laurence
Marilyn and Joseph Lehrer
Leicester University Library
Mr and Mrs James J. Lenahan
Sir Godfray Le Quesne, Q.C.
Conrad Levy
Deborah Levy
Mr and Mrs Dennis Levy

E. T. Levy
W. Lewington
S. Licht
Mr and Mrs Ian S. Lockhart
London College of Printing
    Library
Elizabeth Longford
Ariel M. Los
Elizabeth and Bruce MacBeth
Sue MacGregor
Frederic Symonds and Michael
    MacKenzie
John and Pamela McKibbin
Annabel MacLeay of Linsaig
Patrick McNeil
Stella Mann
Dora and Bernard Marks
Stephen Marks, F.S.A.
Tom and Fay Maschler
Michael and Wendy Max
Peter and Dorothy Meade
Betty Menkes
Derek D. Merton
John R. Mitchell
Mr and Mrs Stephen Mitchell
M. D. T. Moore
Jack and Edith Morgan
Paul Morice
Dennis Mosselson, Dip. Iuris
    (Rand).
M. D. Moulder
The Princess Helena Moutafian,
    M.B.E.
Neil Munro
Museum of London
Frank and Constance
    Myerscough
V. M. Newall
William and Karmen Newman
Claudine E. Nicolson
J. A. Norrington
Vivien and Nicolas Norton
Raymond and Joyce Nottage
E. G. Nugee, T.D., Q.C.
Carol O'Brien
George Oppenheim
Max E. Ott
Robert Ottaway
Diana and Peter Phillips
Angela and Peter Phipps
M. W. Pinhard
Alan and Pauline Pleasance

Robert Powell
Michael Powers, R.I.B.A.
Jane and Allan Ramsay
Diana and Anthony Rau
Hymie and Zelda Ravid
Reading University Library
S. G. Relfe
John Richardson
Richmond-upon-Thames
    Libraries Department
Lee and June Robinson
S. N. Roditi
Nella K. Rodwell, O.B.E.
Frances Rollason
L. E. Room, O.B.E.
Tom and Ann Rosenthal
E. Leonard Ross
Victor Ross
Helmut and Annema
    Rothenberg
Breda and Gordon Rowlands
The Ryerson and Burnham
    Libraries of the Art Institute
    of Chicago
Mr and Mrs John Salter
Chris and Barbara Sanham
Mr and Mrs Mátyás Sárközi
E. E. and Y. Shane
Andrew Sharman
Frank Shelley
Henrietta Shire
Masayoshi and Kyoko Shirota
Horace V. Shooter
Rodney Silverman
Jacob Simon
Alasdair and Jane Simpson
Cicely and Norman Singleton
Mr and Mrs Malcolm Slowe
Robert J. Smith
John Robert Sperr
Anne Stacey
J. O. Stanley
Frances Stewart
Valerie Stitson
Ann and Frank Stockwell
Derek and Dawn Stollar
Carol Allen Storey
Mary and Ronald Strudwick
Dr and Mrs Christopher
    Sturridge
Andy and Layla Summers
Barbara and Cyril Sweett

G. I. M. Swyer, M.A., D.M., M.D.,
    D.Phil., F.R.C.P., F.R.C.O.G.
Michael and Kirsteen Tait
Tate Gallery Library
Andrea and Michael Taylor
Peter Templer
Roland Thorne
Rodney and Penelope Timson
Jocelyne and Julian Tobin
Harry and Diana Towb
T. Peter and Joanna Townsend
Renata Magdalena and Boris
    Trainin
Robert Turnbull
University of London Library
University of Toronto Library
David W. Vine
The Reverend Michael Vine
Mr and Mrs Christopher Wade
Ralph E. F. Wade, F.R.S.A.
Chris and Tony Craven Walker
Gordon and Cressida
    Wasserman
Heba and Steven Watson
Claude and Elinor Wedeles
Simon F. J. Westall
Westminster City Libraries
Robert Whitby
Mr and Mrs John Williams
W. Charles Williams, O.B.E., D.L.
John and Margaret Willmer
Christine and Bryan Wilmot
Alexander P. Wilson
Antony Wilson
Guy and Annabel Wilson
Lynne Wilson
Martha and Stephen Wilson
Sally Wilson
Terence Wincott
Bessie Winton
Cheryl Winton
Ed Wolf
Edmund and Rebecca Wolf
Tatiana A. Wolff
Bonny Wong
Mr and Mrs Malcolm Wroe
Victor and Marianne Wynn
Yale Center for British Art
Mr and Mrs Shohei Yamada
Alan and Sadie Yates
Dr P. M. E. Youngman

# CONTENTS

# ACKNOWLEDGEMENTS

The main collection of Hampstead prints is stored in the Swiss Cottage Library and consists of several collections acquired by Camden Borough Libraries over the years. Consequently without access to this collection it would have been impossible for our undertaking to get off the ground. For their permission to use this material and enthusiastic cooperation we are extremely grateful to Camden Borough Libraries. In particular we would like to thank Malcolm Holmes and his team of Bowen Pearse, Valerie Hart, Lesley Marshall and Mike Hinton at Swiss Cottage for all the assistance they have given us during the period in which we were compiling the book. This was generously provided and is perhaps best illustrated by Malcolm Holmes' enthusiasm in taking responsibility for the two maps in this book, by providing our mapmaker, W. F. N. Watson, with the locations of all the subjects appearing on the prints.

In addition we have reason to be grateful to the staffs of many other libraries and museums with whom we have come into contact while making the book: the Guildhall Library, the British Library, the Victoria and Albert Museum, the Print Room, the Members' Library and Survey of London Department of the Greater London Council, the Greater London Record Office, the Museum of London, the Ashmolean Museum and Bodleian Library at Oxford, and the Royal Library at Windsor. Particular assistance has been provided by Peter Charles of Cambridge University Library, Paul Quarrie of Eton College Library, Judith Knight of the Grange Museum, Betty Fathers of the Bodleian Library, John Phillips of the Greater London Council, Michael Snodin of the Victoria and Albert Museum, Paul Goldman, Martin Tillier and Andrew Clary of the Print Room of the British Museum. A number of prints emerged from private collections and galleries and to their owners we would like to extend our thanks. These include Peter Jackson, Jonathan Gestetner, Hugh Curtis, Nicholas Potter of the Burlington Art Gallery, Nigel Talbot and Wendy Chisold of Grosvenor Prints.

We describe in the Introduction the many local historians, past and present, to whom any book on Hampstead is indebted. More specifically, Simon Jenkins is grateful for the help and advice of Christopher and Diana Wade, David Sullivan, Christopher Ikin and Anthony Cooper, each of whom read the typescript in whole or part. They are in no way responsible for any historical or topographical errors. However any student of Hampstead history will know that few subjects are surrounded with more spirited controversy. Hampstead's past can be as unpredictable as its future. Thanks go also to Maggie Willmer of St John's Church, Christina Gee of Keats House and many others mentioned in the text. Nor should we forget those three citadels of local historical enlightenment, the ever-eccentric catalogue of Swiss Cottage Library, the masterful exhibitions staged at Burgh House and the splendidly committed High Hill Bookshop.

SIMON JENKINS & JONATHAN DITCHBURN

# INTRODUCTION

To one who has been long in city pent,
'Tis very sweet to look into the fair
And open face of heaven.

Keats' lines on visiting Hampstead well express the quality which for centuries has drawn Londoners to this steep hill north of the city, the quality of escape. Since the seventeenth century, it has been a retreat from the noise and dirt of the metropolis, a place within easy reach of London yet with the unmistakable aura of country. For millions, Hampstead has meant holiday, a resort of clear air, distant views and a brief respite from toil. For a few it has been home, either crammed into the lanes and alleyways of the hillside or spread across the gentler slopes of the valley beneath. And for fewer still – to whom this book is dedicated – it has been a source of artistic inspiration.

These different Hampsteads are here chronicled by London's most un-obtrusive observers, the producers of eighteenth- and nineteenth-century topographical prints. These men are forgotten artists, living and working often in total obscurity, uncatalogued and remembered only by a scratched signature or monogram at the foot of their plates. Yet from the start of the Georgian era until the coming of photography, they were the indispensable witnesses to London's changing appearance. They bring old maps to life and clothe old buildings with history.

Their Hampstead enthusiasm was, of course, shared by many of the more famous names in landscape art. The natural features of the Heath, its accessibility and above all its sweeping vista towards London (for John Constable 'a view unsurpassed in Europe') all recommended Hampstead to painters of the English landscape school. Richard Wilson was an early visitor. George Romney built himself a house on Holly Hill in the 1790s. John Linnell and William Collins rented property in North End in the 1820s. John Varley, George Morland and Samuel Palmer each acknowledged their debt to the Heath.

Constable came here first in 1819 and returned regularly for the rest of his life, marking his affection by being buried with his family in St John's churchyard. The Royal Academician, Clarkson Stanfield, moved to the town in 1847 and

became doyen of its cultural life. Yet with the exception of Constable, few of these men produced Hampstead landscapes, and of these only a handful were reproduced in print form.

The artists with whom we are dealing form a very different group. Most were the product of a demand for topographical prints which emerged in the second half of the eighteenth century, largely through the enterprise of the engraver-turned-publisher, John Boydell. (His partner and nephew, Josiah Boydell, was a prominent Hampstead resident.) This market was further exploited by Boydell's chief competitor, Rudolph Ackermann, a German immigrant who had premises in the Strand from 1795. The market reached its zenith in the fashion for the 'art of the picturesque' which flourished in the first quarter of the nineteenth century.

First – and foremost – on the Hampstead scene was the engraver Jean Baptiste Chatelain. He was the latest in a long line of continentals who had come to London to develop a talent for an art form, topography, which native painters considered beneath them. His series, *Prospects of Hampstead and Highgate*, was first published in 1745, with further editions in 1750 and 1752, priced at 5s. a set. We know of ten from the series, of which six are of Hampstead. They coincide with the second phase of the Wells' popularity. Their composition is strongly reminiscent of Chatelain's stylistic mentor, Gaspar Poussin. Hampstead is portrayed as an Arcadian resort in which fashionable visitors promenade in a landscape filled with happy shepherds and well-fed animals. The world is at peace in a Chatelain print.

*417 Hampstead and Highgate; copper-engraving after Chatelain, c. 1760.*

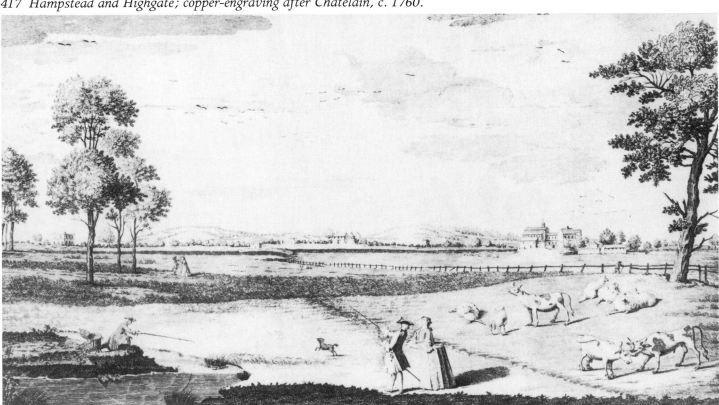

In 1750, Chatelain also produced a collection of engravings with the title, *Fifty Small, Original and Elegant Views of the most Splendid Churches, Villages, Rural Prospects and Masterly Places of Architecture adjacent to London*. This series included two prints of Hampstead, though they are not of the quality of his earlier work. Chatelain appears to have been unable to capitalise on his ability as artist and draughtsman. He was employed from time to time by John Boydell, but Samuel Redgrave says of him: 'He worked only when impelled by necessity, and it was his custom to hire himself by the hour, working as long as the fit lasted and bargaining for instant payment. . . . His great talents were obscured by his depraved manners and irregularities.' He died in poverty, but at least after eating a huge meal (his favourite indulgence).

The Regency saw another burst of activity in the print market. Topographical prints were bound into volumes with a written text added. Although interest tended to concentrate on the more dramatic foreign and provincial landscapes, Hampstead Heath was sufficiently picturesque, and sufficiently well known, to qualify for inclusion in a number of them.

Hampstead scenes appeared in such major topographical collections as Britton and Brayley's *Beauties of England and Wales* (1801–18), James Dugdale's *New British Traveller* (1819), Westall and Finden's *Great Britain Illustrated* (1830), and in a number of London works, such as those by Thomas Baynes, James Malcolm, W. E. Trotter and Thomas Stowers. Heath landscapes were also reproduced by many of the better-known engravers – Edward Hassell, Paul Gauci, Edward Finden, Nathaniel Green and that splendid chronicler of the early railway, J. C. Bourne. But two artists claim special mention by the sheer quantity of their Hampstead output, Thomas Hastings and George Childs.

Captain Thomas Hastings was by profession a collector of customs. As an amateur etcher, his work was limited in scope and, it must be admitted, in quality. He copied some paintings by Richard Wilson, for whom he had a great admiration, and published a set of etchings of Canterbury under the title, *Vestiges of Antiquity*. His collection of Hampstead etchings was executed and published over the years 1822–26, with more in 1831. That is all we know of him. Maurice Grant comments on his work, 'He rarely shows himself as a first rate etcher, many of his plates being scratched and indeterminate as if involving tasks too lengthy for care and concentration.' Yet what Hastings may have lacked in craftsmanship, he made up for in atmosphere. His Heath is unlike any other. It is a spare landscape, open to the horizon, a place in which people seem lost amid undulating contours. These are clearly the etchings of a sailor.

Hastings' work is all the more distinctive when set alongside that of George Childs. While the former worked with the economical line of the etching needle, Childs employed the softer, more luxuriant tone of lithography. His dates are

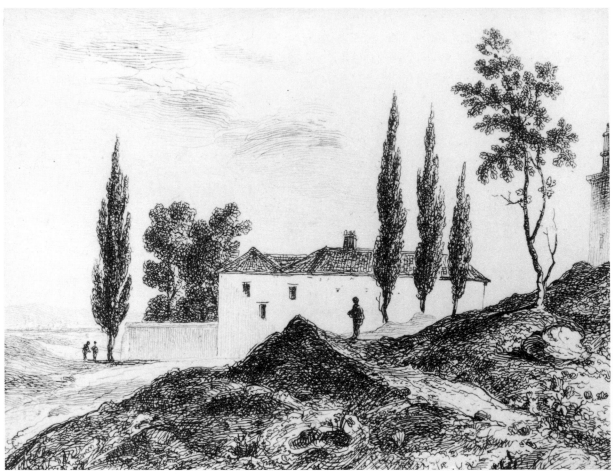

266 *Squire's Mount; etching by Hastings, 1826.*

57 *Near the Vale of Health; lithograph by Childs, c. 1840.*

unknown, though he was active between 1826 and 1873. We know he worked in Hampstead in the early 1840s, twenty years later than Hastings. As an artist he favoured landscape and had a particular affection for trees, publishing a volume entitled *English Landscape Scenery and Woodland Sketches*. For us his most important work was *Child's Advanced Drawing Book*, containing twenty-four magnificent lithographs of Hampstead.

The only available copy of this book is at the Yale Centre for British Art. Through it we have been able to reproduce all twenty-four prints for the first time and identify the location of most of them, though this has often been a challenging task. Childs' prints of Hampstead and its surroundings are the most characteristic of all images of Hampstead. They have about them none of Chatelain's contrivance. They show local people going about their daily affairs in quiet harmony with nature under the protective canopy of Childs' beloved trees. The contrast between Childs and Hastings could not be greater, and is well illustrated in their respective portrayals of the same cottages on Squire's Mount. Hastings is almost surreal in the comparison.

Contemporary with Childs was David Lucas, engraver to John Constable. Lucas, who lived from 1802–81, had the very different task of recreating Constable's early canvasses in mezzotint for his *English Landscape Scenery* (see Chapter Eight). Lucas' prints represent a complete change in key from the others in this book. Where Hastings is desolate and Childs sylvan, Lucas is tempestuous, bravely interpreting in black and white the tonal complexity of Constable's skies and storms and splashes of sunlight. Of his life we know little except that he died in Fulham poorhouse, like many of his calling a wholly unappreciated man.

These artists were the last to picture Hampstead as a separate community detached from London by open fields. The mid-Victorian era saw the expansion which had been satirised by George Cruikshank's 'March of Bricks and Mortar' *558, p. 21* (occasioned in 1829 by the building of Finchley Road) and which finally laid siege to the old hill town. Adelaide Road, Fleet Road and Fitzjohn's Avenue provided the supply lines to this siege. The booming Victorian housing market was its ammunition. But it was not wholly successful. In the Battle for the Heath, which lasted from the 1840s until the Heath purchase of 1871, it was repulsed. Suburban London finally turned to assault Hendon and Edgware instead. And the Hampstead which greeted the twentieth century was, in its topographical essentials, the Hampstead which we see today.

In the middle of the nineteenth century Hampstead prints change their character. Etchings and lithographs give way to wood engravings, suitable for mass reproduction without loss of definition. Their object is no longer to illustrate the picturesque or dramatic qualities of the Heath, but to show the institutions of a growing suburb. Our search is no longer in topographical collections but in the

pages of the *Illustrated London News*, the *Graphic* and the *Builder* as local churches, schools and charities seek to record their foundation and growth. Some of these prints are of limited artistic appeal, performing the function of a modern photograph. But many are remarkably fine and all were the work of men labouring over their wood blocks just as Chatelain and Lucas laboured over their metal plates.

Prints of Victorian Hampstead present us with a topographical problem. They are excellent records of its institutional evolution but less useful in charting the development of the town as a whole. Thus we have many portrayals of the churches of Belsize Park, but few of its houses. We have found no engraved record of the buildings of Fitzjohn's Avenue and little of the town centre, Heath Street and the High Street. Historians here must rely chiefly on watercolours and early photographs.

Yet the spirit of the printmaker was by no means killed by the advent of photography. Throughout the nineteenth century we find individual and collected views by artists who clearly derived pleasure and satisfaction from the medium of engraving and some are among the most vivid images in this book. Arthur Evershed (1836–1919) was a traditional landscape painter and etcher. He seems to have worked in much the same manner as Hastings and at one time was a resident of Primrose Hill. His art was, in Grant's words, 'of the most intimate and English kind . . . wherever old mills or barns or woody rivers called the artist to a halt'. Evershed's etchings, mostly dating from the 1860s, are the hardest of all Hampstead prints to identify. We have therefore collected most of his vague and often unfinished Heath sketches at the end of the Gallery section of this book.

Evershed was followed by the lithographer, Thomas Way (1862–1913), who was a collaborator and friend of James McNeill Whistler. Way produced a set of six Hampstead chromolithographs in the 1890s, and he drew most attractive brochure advertisements for the local property firm of Debenham and Tewson. William Monk (1863–1937) was a landscape painter and etcher whose seven prints of Hampstead were produced as a set in 1900, many unmistakably reflecting the serpentine lines of contemporary Art Nouveau. Finally we have the anonymous artist of the nine *Old Hampstead* prints, also of 1900, published to record the surviving traces of the eighteenth-century town centre.

In among these formal sets of prints are the individual curiosities: John Rathbone's autumnal aquatints of Childs Hill and Kilburn; Maria Prestel's 'Good Samaritan' of Montagu Grove; the Cruikshank family's many visits to Primrose Hill; the pompous lithographs of Victorian church architects, intended as much to impress the next client as the last; John Bourne at the opening of the Primrose Hill tunnel; the treescapes of Paul Gauci and Harriet Gouldsmith.

Much of the joy of studying the work of these artists is that their subject matter

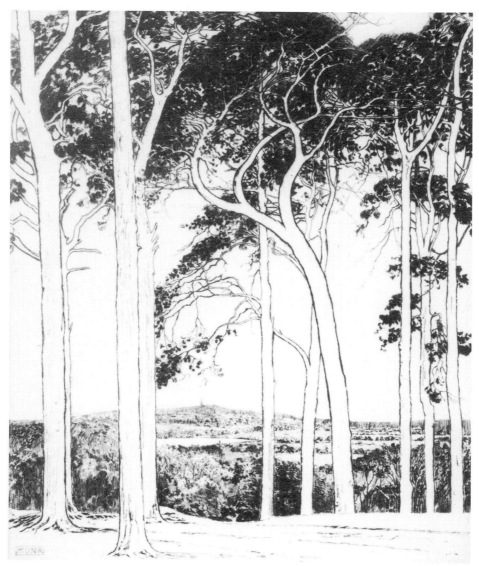

*154 The Firs at the Spaniards; etching by Monk, 1900.*

has to a remarkable extent survived. Perhaps more than any other early suburb of London, the printmaker's Hampstead is still our Hampstead. Most of the favourite scenes in this book can be appreciated today: St John's Church, Church Row, Pond Street, the town's larger houses, the curve of its best-known streets. Above all, Hampstead still has its Heath. This great open space is not another manicured municipal sward. It has remained a place of wildness since the Middle Ages, surviving invasions and desecrations which have done nothing to tame it. North End, the Vale of Health, the East Heath are all defined still by its boundaries. It is a magical landscape of oak and fir, bracken and gorse, sandy paths and hidden ponds, with above it Constable's great awning of sky. It was chiefly to convey this glory that the engravers of Hampstead toiled with burin and needle over their plates. The modern topographer should salute them.

On the right hand of the topographical artist sits the mapmaker. Hampstead, like most north London suburbs, appears on early Middlesex maps simply as a dot or series of dots. The first cartographer to give some idea of the street alignment of the village was John Rocque in a map covering a ten-mile radius of London in 1746. This was followed by another of Middlesex in 1757. Rocque's experience was as a garden designer – he is believed to have worked for a time at Hampton Court. His surveying is inexact and his roads are often woefully out of line. But his use of stippling and shading to express landscape features can convey almost as clear a sense of place as does a pictorial engraving. He may scatter buildings almost at random (and omit one as important as Foley House) but fields and slopes, groves and hedges are meticulously drawn. With Chatelain, Rocque is the indispensable companion on any tour of eighteenth-century Hampstead.

Subsequent maps are of too specialist an interest to be illustrated here (see *Camden History Review* No. 1 for a full list). Those mentioned in the text include J. and W. Newton's detailed diagram of the manor and parish which appeared in 1762 and was updated for Park in 1814. Cruchley's map of 1829, though later, is as graphic as Rocque's and considerably more accurate. Weller's map of 1862 shows the town on the brink of its period of greatest expansion. Specially drawn for this volume is a complete map of the area, in which we indicate, where possible, the location of the best-known print views.

Hampstead's history has been copiously researched, probably more so than that of any other London community. Charles Dickens indeed satirised its antiquarians as the embodiment of useless speculation in Mr Pickwick's scholastic masterpiece, 'On Tracing the Origins of the Mighty Ponds of Hampstead'. Thomas Park's *Topography and Natural History of Hampstead* appeared in 1814 and has been the point of departure for local historians ever since. But antiquarian enthusiasm was most pronounced at the end of the nineteenth century with the formation of the Hampstead Antiquarian and Historical Society in 1897. Its leading members, including E. E. Newton, G. W. Potter, Professor J. W. Hales and Thomas Barratt, produced work of considerable scholarship, published in the Society's transactions and in the more literary *Hampstead Annual*. Both had ceased publication by the time of World War I.

The greatest of the Hampstead history publications is Barratt's three-volume *Annals of Hampstead*, which appeared in 1912. This is so monumental a work that most successors have done no more than clamber over its surface. Barratt was clearly a remarkable man. A perfumier by trade, he married the daughter of the Pears soap empire and rose to become the company's chairman. It was he who commissioned the famous Millais painting of Bubbles as an advertisement for his product. He purchased and rebuilt as one house the four old buildings which comprised Bellmoor near Whitestone Pond (redeveloped again after his death as

*Hampstead as seen in the engraved map published by John Rocque in 1746.*

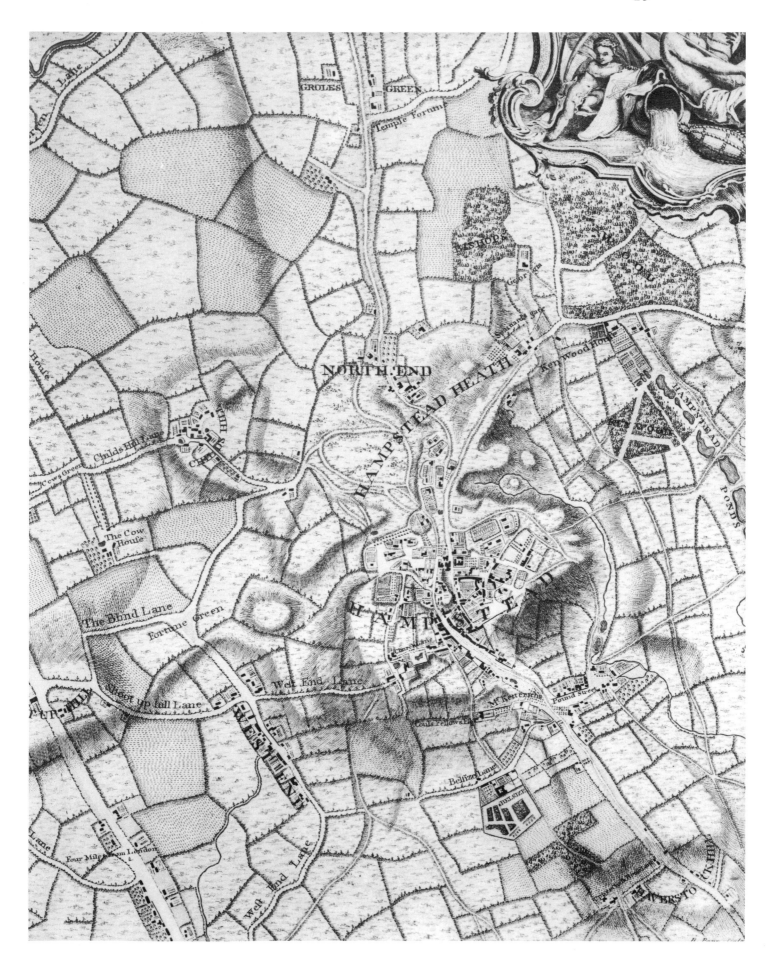

the present block of flats). Barratt was an ardent antiquarian and his collection of pictures and Hampsteadiana is now housed at Swiss Cottage Library.

Other Victorian histories, such as Kennedy's work on the church and Baines' *Records of Hampstead,* were superseded by Barratt and are listed in the bibliography. The contemporary reminiscences of Anna Maxwell and Caroline White are more entertaining than reliable. But Miss White deserves more than passing mention. She lived to be 102 and published her *Sweet Hampstead* at the age of ninety in 1901. Her zest for investigation and her colourful reconstruction of events make her work delightful if erratic. Her postman who 'remembered' Leigh Hunt's cottage has sabotaged a generation of historians and given rise to a strictly unofficial blue plaque in the Vale of Health.

The only work to do more than tinker with Barratt is the official history of the borough of Hampstead, produced in 1974 by Professor F. M. L. Thompson at the time of the borough's amalgamation into Camden. Thompson acknowledges his debt to Barratt by concentrating his attention on the late-nineteenth century, picking up the historical thread with the mid-Victorian development boom. Most of his book thus deals with a later period than ours, but it remains a useful corrective to the self-congratulatory tone of many local works. Indeed, in the case of the Heath preservation campaign, Thompson cannot contain his irritation at the odium heaped on the lord of the manor, Sir Thomas Maryon Wilson. Not surprisingly, the book is controversial among Heath enthusiasts (see Chapter Eight).

In the past quarter of a century, the embers of the old Antiquarian Society have been rekindled first by the New Hampstead Historical Society and more recently by the Camden History Society. The *Camden History Review* was launched in 1973 with Christopher Wade as editor. And the proprietor of the High Hill bookshop, Ian Norrie, published a series of historical booklets under the generic title of *The Streets of Hampstead,* again with Wade as editor. The *Streets* series now covers the town centre, Frognal, West Hampstead, Belsize and Primrose Hill and is a model of local research and teamwork. Long may Hampstead be so blessed.

Lastly, a note on the organisation of the succeeding chapters. Given the subject matter, I have chosen for the most part to make the prints rather than the geography the determining factor. Hampstead's early history is sparsely illustrated and is thus dealt with in the first two chapters. Then comes the Georgian town, including Victorian prints which portray pre-Victorian buildings. This is followed by an account of the ring of communities which immediately surround the town, such as Frognal, North End and South End. Then comes the central chapter, on the Heath itself.

Victorian Hampstead is treated separately, since it is mostly illustrated by wood engravings very different in character from the prints of the Georgian town.

Belsize and Haverstock Hill make a chapter on their own. Finally we reach neighbourhoods on Hampstead's perimeter: Primrose Hill, Childs Hill, West End and Kilburn. For the most part we have taken the boundary of the old borough as the limit. But where, as on Primrose Hill, the boundary cuts a sequence of prints in two we have allowed ourselves some latitude.

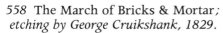

*558* The March of Bricks & Mortar;
*etching by George Cruikshank, 1829.*

The figures in the margin give the number in both Catalogue and Gallery of each print referred to, and will lead quickly to that print in the Gallery if it is not reproduced in the Text. If the print appears on the following spread of the text, a page reference is given.

# 1

# EARLY HAMPSTEAD

Pre-Georgian Hampstead is a composition scattered in broken fragments across a hillside. There is no great house or castle to give it focus. The main routes north and west out of the city went elsewhere, through Highgate and Edgware, avoiding the muddy track over the Heath to Hendon. In the Middle Ages, the history of its manor, owned by Westminster Abbey and partly alienated to such archaic institutions as the Knights Templars and the Hospitallers, is remarkable chiefly for its lack of incident. Local records are lost or imperfect. Whole centuries pass without a trace.

We know that there were small settlements at the manor farm beneath the site of the present church in Frognal and round the old 'king's well' where Heath Street now turns into the High Street. The bulk of the demesne lands of the manor lay on the well-watered sunnier side of the hill, looking south-west towards the present West End and Kilburn. They were arable and were farmed first by the Abbey through local bailiffs but later by a succession of tenants and sub-tenants. To the north-east, the sandy soil and woodland of the Heath itself would have been more appropriate for livestock and forestry, and it was here alongside the track to Hendon that the early squatters would have staked their claims and created the nucleus of a village. This distinction between the lord of the manor's demesne holdings, more fertile and therefore more resistant to encroachment, and the commons and 'heath waste' nearer the summit of the hill was typical of the bifocal character of many English villages. It determined the personality of Hampstead as a hillside town and laid the ground rules for many later battles.

After the dissolution of the monasteries, the manor of Hampstead passed briefly to the Bishop of Westminster, then to Sir Thomas Wroth and then in 1620 to Sir Baptist Hickes (later Lord Campden), a City merchant and alderman. His family retained it into the eighteenth century in the guise of the earls of Gainsborough before selling it to a distant ancestor of what became the Maryon Wilson family. They retained it into the twentieth century. Other manorial holdings in the area were fixed even earlier. In 1449, Eton College became wardens of Wyldes manor north of the Heath and of Chalcots, between Belsize and Primrose Hill, through Henry VI's grant to the college of land belonging to St James's leper hospital. In

1531 Eton was allowed to retain these holdings even after losing St James's to Henry VIII for his new palace. The Belsize estate enjoyed even longer continuity of tenure. It was the only part of the original Westminster Abbey lands in Hampstead not to be alienated at the Reformation, passing to the Dean and Chapter in 1542. Both Eton and the Church have retained responsibility for these estates, in whole or part, to the present day.

Most of this would have passed unnoticed by the early villagers. No lord of the manor of Hampstead has ever lived in the place. Even the nineteenth-century Maryon Wilsons preferred their seat at Charlton, near Greenwich. Norden's map of 1593 mentions only two 'gentlemen' as having houses there. At the close of the sixteenth century, the population is thought to have been no more than 300, mostly employed in farming or Heath forestry.

The one potentially significant incident in the settlement's early history was an act of Henry VIII in 1543 to improve the water supply of his capital by developing 'the dyvers great and plentyful sprynges at Hampstede Hethe'. Even this came to nothing at first. Although by 1600 some conduits are believed to have been laid and possibly some damming taken place, Hampstead's water supply was not organised, let alone exploited, until the 1690s. Then it was developed largely to cope with local needs. The springs did, however, attract an early colony of laundresses in the Tudor period, described by some enthusiasts as even working for the royal household.

No pictorial record survives from this early community, but we do have two later prints showing the two major institutions of the pre-Reformation parish, the church and Kilburn Priory. A 1785 engraving of the medieval church, dedicated *20* to the 'Blessed Mary', is the earliest of several produced after its demolition, the later ones all drawing on the same original source. It shows the building as it must have looked at the very end of its life. Georgian chest-tombs are already

*20 The medieval church; copper-engraving, 1785.*

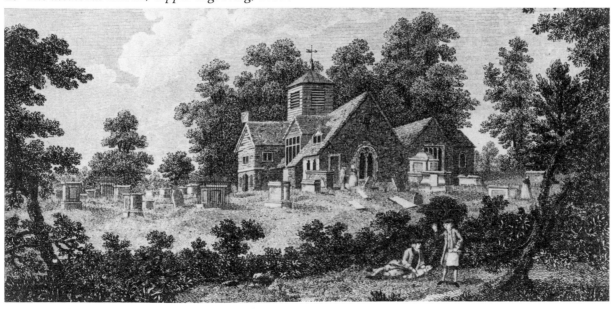

awaiting a grander setting and a number of these, including the large tomb
with a domed top, are identifiable today.

The church tower was at the west end and the altar at the east in the usual
fashion. The bellcote is timber, typical of many Middlesex churches in the late
Middle Ages. The nave was basically fourteenth century, but with a
Perpendicular north aisle and dormers in the roof. Only the east window is
remarkable. It seems to be Norman with two lights and an elaborately carved
tympanum. Since there is no record of a church on the site earlier than 1312, this
must be an artist's anachronism. Or is it our only trace of a much earlier
foundation?

The Priory of Kilburn to the west was founded in the twelfth century and
subsequently escaped tax in return for supplying hospitality to pilgrims on the
road to St Albans. The inventory drawn up at the time of the Dissolution suggests
it was a modest establishment, with twelve rooms in total. The Priory was never
occupied by more than a dozen nuns and it closed completely at the Reformation.
Its diminutive size is indicated by the one illustration we have of what may have
*509*  been the chapel: a drawing of 1722 engraved several times. The building
appears as a deserted ruin, alone in the fields rising towards Hampstead behind. It
vanished altogether in the eighteenth century but made a last brief appearance in
1850 during excavations for the London and North-Western Railway at Kilburn.
A number of medieval objects were recovered and some of these are at St Mary's
church, Kilburn. Kilburn Priory now lives only in local street names, that
enduring roll call of London archaeology.

Also vanished without trace is the subject of a third print of the 'pre-Wells'
period, and our only seventeenth-century Hampstead engraving, Hollar's
*1*  'Hollow Elm'. Wenceslaus Hollar was a Czech who had arrived in London in 1636
and made a living as both portrait engraver and topographical artist. He fled to
France after the Civil War but returned in straitened circumstances and
attempted, without great success, to take up his old career. He died in poverty,
with bailiffs waiting to seize his bed from under him.

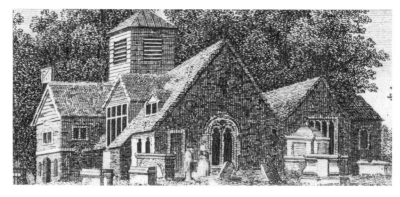

*20 (Detail) The medieval church;
copper-engraving, 1785.*

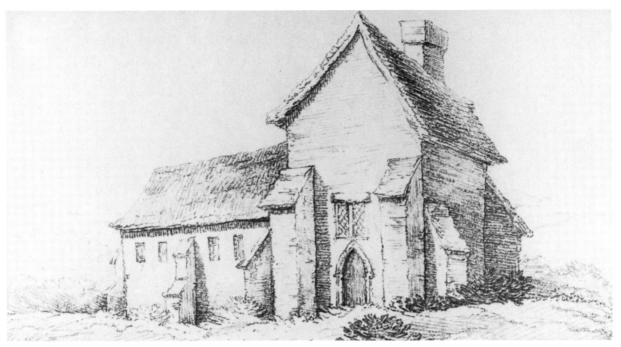

*509 Kilburn Priory; soft ground etching, 1813.*

*1 The Hollow Elm; copper-engraving by Hollar, 1653.*

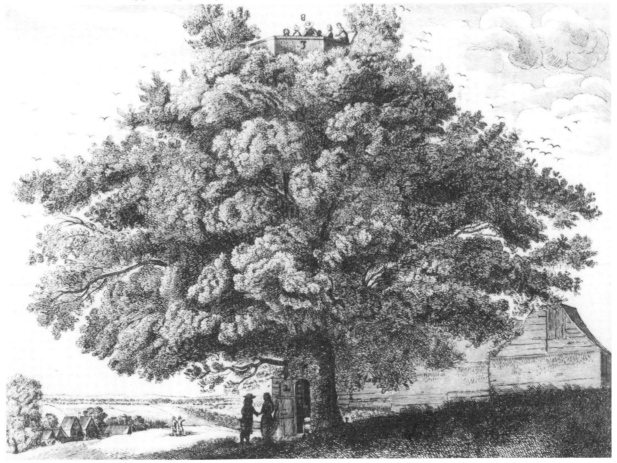

He must therefore have been glad of the commission offered shortly after his return in 1653 from a stationer named Michael Sparke. This was for a handbill for visitors to a large hollow tree situated on Hampstead Heath. The tree had an octagonal platform built on its crown, reached through a door in its trunk and a staircase of forty-two steps. Hollar's engraving shows a man and woman apparently shaking hands at its foot, with a large barn behind and cottages in the distance. Its precise location on the Heath is unknown (one version of the print places it misleadingly in Windsor Great Park).

The Hollow Elm was clearly a major attraction. The contemporary poet, Roger Codrington, composed lines in its honour, including the effusive: 'Six neighbouring countries do on tiptoe all/Gaze on thy mighty limbs, and seem to call/Unto thy patient greatness.' And Michael Sparke himself was caught up in the enthusiasm, celebrating a school which an enterprising tutor had established in the tree: 'Drive on to see the youngest branch so flourish,/That Air and Hill and Well and School may cherish.'

This couplet provides Thomas Barratt with the opportunity for a rare joke, that the tree was Hampstead's first attempt at 'higher education'. But it also serves a more significant use. It is evidence that by the mid-seventeenth century Hampstead was already famous not only for its 'Air' but for its 'Well'. Searching for clues to medicinal springs in Hampstead before their exploitation in 1700 is a cottage industry among local antiquarians. There is no shortage of material. In 1697, the ubiquitous Celia Fiennes could remark that the water at Barnet 'appears not to be a quick spring as at Tunbridg or the Spaw [Bath] or Hampsted waters'. Here is Hampstead spoken of in the same breath as Bath. And there are tokens in existence of 1669-70 marked as coming from the 'Well in Hampsteede', with a well and bucket on their reverse. All this certainly suggests a widely known watering place, if not a medicinal one.

It is probable that the 'waters' were at first a minor attraction of what was anyway becoming a place of residence and recreation within easy reach of the City. The 146 dwellings listed in a 1646 survey would have meant a population in excess of 600, or double that of half a century earlier (see Thompson). Barratt lists a number of prominent Roundheads who took up residence in Hampstead under the Commonwealth, as they also did in neighbouring Highgate. Captain Wilde had a house on the Heath. The regicide Colonel Downes was living at Belsize House in 1660 at the time of his arrest. The church was in strongly Puritan hands. Like many similar London communities, Hampstead may have been owned by Royalists but its sympathies were Parliamentarian.

Expansion continued after the Restoration. Hampstead began to be referred to for the first time as a 'towne' and individual houses are mentioned in records. These include the manor house at Frognal, the 'Chicken House' in Rosslyn Hill, the

Parsonage in the High Street and Belsize House. Pond Street emerges as a settlement in its own right, as does Wildwood Corner and Childs Hill on the north side of the Heath. Sir Henry Vane came to live, briefly, in a large house at the top of Rosslyn Hill, later called Vane House. The town developed a special appeal for lawyers (it already had one for civil servants) and two of Charles II's Attorneys-General had houses there. Pepys mentions a visit to one of them on office business: his other Hampstead excursion was strictly for pleasure, one of his secret amorous outings.

Hampstead still remains an elusive place to visualise, but by the end of the seventeenth century it was clearly a growing community attracting a distinctive group of residents. They were not the sort who were colonising the new West End suburbs of Covent Garden and St James's Square. They were wealthy rather than aristocratic and sought good air rather than high fashion. Like Joshua Gee, builder of Fenton House above Holly Bush Hill, many of these residents would have been Dissenters and City merchants and their houses would often have been for weekend and holiday occupation.

This suburban expansion is a continuing sub-plot to the more spectacular incidents in Hampstead's history. It is to the first of these that we now turn. Whether the exploitation of Hampstead Wells had any effect on the long-term growth of the town or was merely an extraneous event is a matter for debate. What is certain is that those who had chosen Hampstead for its qualities of peace and seclusion must have been appalled at the frenzy which seized it in the first two decades of the new century.

# 2

# THE WELLS PERIOD

In 1698, the Honourable Susannah Noel, mother and guardian of the thirteen-year-old lord of the manor of Hampstead, the Earl of Gainsborough, granted 'six acres of waste' on the lower Heath 'lying about and encompassing the Well of medicinal waters' for the 'sole use and benefit of the poor of the Parish'. Whatever may have prompted this act of charity – and we have seen it could not have been any recent discovery of the Wells themselves – it initiated a swift increase in their popularity.

A year later, the Wells Trustees were arranging for the spring water to be bottled in flasks and sold in Fleet Street by a Mr Phelps. Later an exclusive franchise was given to a Mr Adams and other outlets were also supplied. For a time, the local distribution appears to have been in the hands of Elizabeth Keys, for she had specifically to be excluded from dealings in the waters both in 1700 and 1701. By then, the Trustees had clearly decided the time had come to do more than merely subcontract the sale of spring water. They proceeded to develop the site as a fully fledged spa.

Accordingly a lease of twenty-one years at £50 a year was granted to John Duffield on condition that he spend £300 on building improvements to the Wells within three years. The only other restrictions were that the people of Hampstead were to be allowed free access to the Wells in the morning and 'Widow Keys' was banned from any involvement without permission of the Trustees.

Duffield began work at once. A pump room and assembly room were built on the south side of what is now Well Walk at the entrance to Gainsborough Gardens. A bowling green was laid out below it and trees were planted along the walk itself. To complete the attraction, a local doctor, Dr William Gibbons, obligingly pronounced the Wells 'as efficacious in all cases where ferruginous waters are advised as any chalybeate waters in England'. The hedonism and hypochondria of eighteenth-century London were thus equally accommodated.

Duffield was clearly a master impresario – predating by five years his more famous successor, Beau Nash of Bath. He understood the importance of combining the needs of health with a zest for pleasure, and he made strenuous efforts to maintain the 'quality' of his attractions. In addition to dinners and dancing, there

were concerts with ticket prices carefully graded to different markets at different times of day and week. On one occasion he was confident enough to charge 5s. admission to a concert, an astronomical sum for its day. To bring visitors out from town, regular coach services were provided from Holborn, Covent Garden and Tottenham Court Road.

The project was not without its enemies. The trouble with Widow Keys plainly reflected local opposition, not least from traders furious at Wells visitors being encouraged to go via Pond Street rather than past the shops and taverns of the town centre. This opposition even ran to a poet, who wrote: 'And when the gentry hither come/In coaches for to see't/They'll not come into Hampstead towne/But all go through – Pond Street!' One night it was found that all the new trees recently planted along Well Walk had been uprooted.

Nonetheless, from 1701 onwards the project prospered. Additional temporary buildings appear to have been constructed to cope with the crowds, including a tavern and, at a later date, a chapel for combined receptions and weddings. There were betting tents and 'raffling' stalls. The Wells' daily attractions were featured in the London press. The flask water was constantly pirated. Itinerant actors came to set up their stage in Hampstead Square. And the Wells began to be mentioned in popular plays and songs.

In 1705, at the apex of Duffield's success, a comedy entitled *Hampstead Heath* by Thomas Baker was staged at Drury Lane. It opened with the enticing pronouncement: 'We have court ladies that are all air and no dress; city ladies that are overdressed and no air; and country dames with broad brown faces like a Stepney bun; besides, an endless number of Fleet Street seamstresses that dance minuets in furbeloe scarfs, and their cloaths hang as loose about 'em as their morals.'

One of the ladies in the play, which presents much the most vivid picture of Hampstead at this time, is made to remark, 'Well, this Hampstead is a charming place, to dance all night at the Wells, and to be treated at Mother Huffs [a Heath tavern], to have presents made one at the raffling shops, and then take a walk in Cane Wood [Kenwood] with a man of Wit that's not too rude, but to be 5 or 6 miles from one's husband. Marriage were a happy state could one be always 5 or 6 miles from one's husband.' (Victorian historians quoting the play fastidiously omit the last two lines.)

Duffield's Wells enjoyed less than a decade and a half of good fortune. He was soon in default on his payments to the Trustees. And the proximity of the spa to London, the basis of its early popularity, now became a curse. Taking the waters was a steadily less important reason for trekking up the hill and Duffield found himself having to amuse a more vulgar clientele. Respectable residents became as resentful as the early traders had been. Petitions against drinking, gaming and

even acting crowded in on the magistrates. Hampstead also became dangerous. In 1718, the management were having to advertise in the London press assuring visitors that 'for the future at half past ten in the evening . . . there will be a sufficient guard, well-armed, sent by the inhabitants of the said Wells to attend the company thence to London'.

Duffield and his co-financier, a man named Luffingham, began subletting in a bid to ward off bankruptcy, but by the 1720s, with Belsize to the south enjoying the same sudden fame the Wells had seen twenty years earlier, the Wells' fate was sealed. The Long Room was closed and by 1725 it had been put to very different use, as a chapel of ease for the new inhabitants of the eastern part of the town, much to the glee of contemporary satirists.

No trace of this early Long Room remains, apart from a few nineteenth-century watercolours. Gainsborough Gardens covers its bowling green and the houses of Well Walk have taken the place of its raffling shops. Only two houses built at the time – doubtless in part from the Wells' profits – survive at either end of Well Walk. John Duffield is recorded as having built himself a substantial property in 1706 for £1,000. Although we have no evidence of its location, the Wells' historian, G. W. Potter, assumes it to be Foley House on East Heath Road. The house clearly dates from the beginning of the eighteenth century and is a likely place for the Wells' proprietor to live, at the Heath end of his new Walk. The name probably derives from Admiral Thomas Foley, who occupied the house from 1805. A glimpse of the house in the 1840s is shown in a Childs lithograph.

*59*

The doctor who gave the Wells its first testimonial appears to have fared better than Duffield. In 1720, Dr Gibbons bought the present Burgh House, which had been built at the height of the Wells' popularity in 1703 probably by the Quaker, Henry Sewell (*Camden History Review* No. 2). From here Gibbons would have overlooked both the Wells and his patients as they promenaded along Well Walk. After his death in 1725, the house suffered many vicissitudes. The name dates from its Regency owner, the Reverend Allatson Burgh, vicar of St Lawrence Jewry in the City. From 1858 to about 1881, it was the headquarters of the local Middlesex Militia, with a parade ground in front and additional buildings on either side. Our only prints of it are two chromolithographs by T. R. Way in 1906. Way goes to considerable lengths to avoid portraying the militia building on the west side of the house. This has since been demolished, the garden replanted, and the house is now a community centre and Hampstead Museum, open to the public.

*14, 15*

The first phase in the Wells' popularity did leave one glittering footnote in Hampstead history. The Upper Flask tavern at the top of Heath Street was the venue for meetings of the Whig Kit-Cat club. The name derived from a London tavern-keeper, Christopher Cat, whose pies had been saluted at an early gathering

*14  Gateway to Burgh
House; chromolithograph
by Way, 1906.*

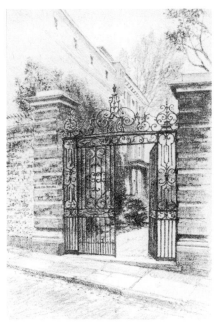

*15  Burgh House;
chromolithograph
by Way, 1906.*

of the club. The members, who have become a ritual roll call in all local histories, included Walpole, Marlborough, Congreve, Vanbrugh, Steele and Addison. Their evenings were dominated by the discussion and toasting of a new 'beauty'. On one occasion there the future Lady Mary Wortley Montagu received her first accolade at the age of seven. The club is best remembered for the portraits of its members painted by one of their number, Sir Godfrey Kneller. This array of early Georgian faces and fashions is one of the treasures of the National Portrait Gallery, though some now hang in the National Trust's Beningbrough Hall in Yorkshire.

The Upper Flask was considered the Wells' most sophisticated establishment. It was located some distance from the throng of Well Walk and from the more plebeian Lower Flask (which lives on today at the top of Flask Walk). Its gardens enjoyed magnificent views towards London. The tavern was converted in the mid-eighteenth century to a private house for the Shakespearian editor, George Steevens (see Chapter Four). The old building probably survived as the street façade of Steevens' house in the 1836 steel engraving of the top of Heath Street.     *227*

Hampstead's impresarios and their attendant physicians were not the sort to let their lucrative business vanish without a fight. Where Dr Gibbons had succeeded at the beginning of the century, Dr John Soames now stepped forward. In 1734 he dedicated a small book to the new proprietor of the Wells, John Mitchel, clearly aimed at reviving the prosperity of the spa. The British race, said Soames, was then in a state of advanced degeneration particularly as a result of the current craze of tea-drinking. A 'national tragedy' could only be averted by encouraging the taking of copious quantities of chalybeate water, followed by dancing,

smoking ('away from the ladies') and riding on the Heath.

It is hard to believe this tract can have had much effect. The chalybeate spring was becoming increasingly polluted and references to it die out in further accounts of visits to Hampstead. But the Wells in the 1730s did seem to experience a revival as a place of fashionable resort, and to have done so while ridding itself of the burden of less desirable visitors. Public 'assemblies' are recorded intermittently until the 1770s. Since the old Long Room was now a chapel, these took place in an existing building on the north side of Well Walk next to Burgh House. It is this new Long Room which appears in the only known print of it, made by Chatelain in 1745, with a later building situated to its right.

Chatelain's engravings (see the Introduction) present a very different Wells from the frenetic day-tripper resort of the earlier period. Mid-century Hampstead is now a classical landscape. The Heath is the major attraction, dotted with trees, amiable locals and their grazing animals. Among them fashionable ladies and gentlemen promenade as if in Hyde Park or at Bath. In the first print, the Long Room is viewed from the foot of the present Willow Road, and Burgh House can just be detected behind and to its left. The print was much distorted by later copyists: Jewitt adds a large barn to the right and Walford gives the adjacent building an extra storey.

A second Chatelain of 1745 shows a view of the Wells area 'from the corner of Mrs Holford's garden'. This print has caused some confusion to topographers. The garden was not that of the later Holford House farther up the hill but of Cannon Hall, which was occupied by Mrs Holford at this time. The view is looking south-west from the bottom of Cannon Lane across what is now Well Road and Christchurch Hill, with the town proper rising to the right (the church spire is incorrectly placed). The large building with dormer windows at the bottom of the field is the same as that to the right of the Long Room in Chatelain's first view from the south.

Some doubt surrounds the identity of this second building. One clue would appear to be in the 1748 edition of Defoe's *Tour through Great Britain* as amended by Samuel Richardson. Here Richardson, who knew Hampstead well, writes: '. . . besides the Long Room, an Assembly Room has been built by Mr Vipand in 1735. 2/6d. admits a gent and two ladies; 6d. each Sunday nights. Tea and coffee only.' In a paper delivered to the Hampstead Antiquarians in 1902, E. E. Newton suggested that this was the separate building later known as Lasted Lodge. This must almost certainly be the one shown by Chatelain. However, the Wells' historian, George Potter, writing in 1904, assumes that Vipand's Assembly Room was actually part of the Long Room structure and the second building was a separate ballroom. Since 'assemblies' were normally held in the Long Room, this seems a more plausible identification.

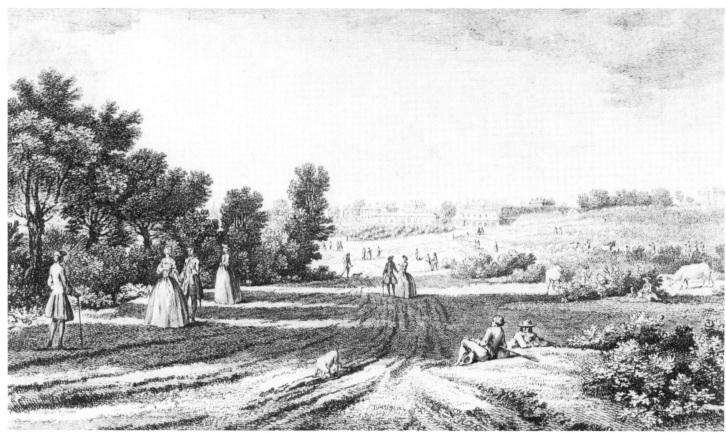

6 *The Long Room from Willow Road; copper-engraving after Chatelain, 1745.*

9 *The Wells area from Mrs Holford's garden; copper-engraving after Chatelain, 1745.*

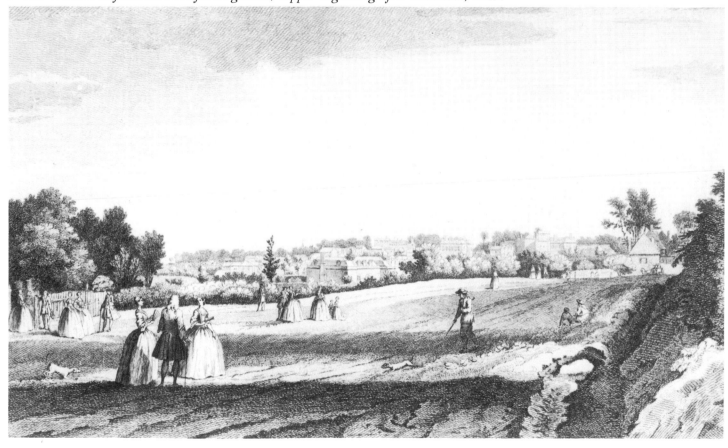

A less worrying confusion has been caused by the matter of Mr Osborne's fan. Thomas Osborne was a bookseller in mid-eighteenth century London, wealthy and eager for social advancement. It is one indication of the Wells' revival that he decided to rent a house in Hampstead and consult the then Master of Ceremonies, Captain Pratten, as to how to proceed. Pratten rose to the occasion and proposed that Osborne should invite the 'genteel families' of the neighbourhood to a large breakfast party and duck hunt on the Heath. This took place on 10 September 1754 and was going so well that Pratten advised Osborne to prolong the party into lunch and then again into the evening with dinner and dancing, all of which he would provide. According to a contemporary account, 'No sooner was this suggested than it was done . . . and the younger part of the company tripped the light fantastic toe until bedtime.' To crown everything, Osborne was persuaded to

*11,12*   have the event engraved onto fans to be presented to each of the ladies afterwards as a memento.

Two of these fans survive (one at the British Museum) and would be an invaluable guide to the topography and social behaviour of the Georgian Wells were the engravings reliable. They are almost certainly not. The scenes portrayed on front and back are highly specific, down to walls, hedges and gazebos. It can be assumed that the artist was portraying (or trying to recollect?) a view northwards from below Well Walk, the hedge along the bottom of both sides being

*11 Dancing at Mr Osborne's breakfast party; etching, 1754.*

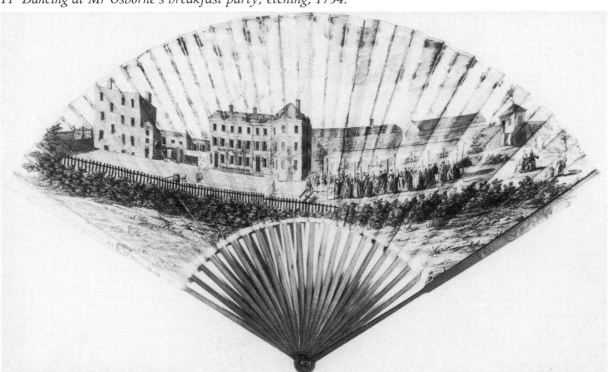

*12 Duck hunting at Mr Osborne's; etching, 1754.*

continuous. The left-hand building could be Burgh House, though with a very different window configuration, and the large house could be the ballroom shown in the Chatelains and probably available for instant rent by such as Mr Osborne. But it has one storey too many and there is no sign of the Long Room itself between it and Burgh House.

The only clue for this detective work is the gazebo at the top right-hand corner of the first print. This could be the same structure as appears in the corner of the Chatelain from the Holfords' garden. More to the point, it can still be seen today on Christchurch Hill, immediately below Acrise Cottage. Were this view of the fan correct, the guests would be passing from the garden of the ballroom into the fields above Well Walk for the duck shoot, with the Heath itself in the distance. But as Barratt implies, the fan was probably the product of considerable artistic licence.

At the start of the nineteenth century, Hampstead experienced one last undignified attempt to resurrect its past reputation as a health spa. In 1802 and 1803, two works were published extolling the virtues of its mineral waters by rival doctors named Bliss and Goodwin. The latter produced a medical treatise on the 'neutral saline' springs he claimed to have discovered in the region of Pond Street. These efforts were wholly unsuccessful as the waters were polluted and probably undrinkable by that time. But Hampstead could do without them. The

rowdies who had previously packed the Wells and Flask Walk now passed them by on their way to Jack Straw's Castle, the Spaniards and the Bull and Bush. Hampstead itself returned to the career it had only momentarily abandoned, that of a prosperious residential and holiday suburb of London.

There is no better illustration of this more settled Hampstead than the two *17, 19* delightful engravings of local scenes by Isaac Cruikshank, produced for Woodward's *Eccentric Excursions* in 1796. They show customers at an unspecified local tavern bowling, smoking, drinking punch and reading a newspaper. Bowling took place in most Hampstead taverns at this time, and there were certainly alleys at the Spaniards and Jack Straw's Castle. Even with a pint of 'small beer' inside them, the players presumably stood a little further from the pins than Cruikshank indicates.

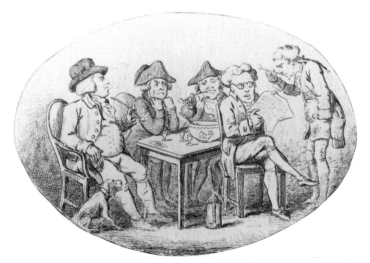

*17  Drinking at a local tavern; copper-engraving by Isaac Cruikshank, 1796.*

*19  A skittle ground; copper-engraving by Isaac Cruikshank, 1796.*

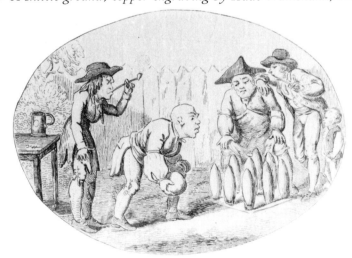

# 3

# THE GEORGIAN TOWN

The town which developed in the century following the exploitation of the Wells is easier to describe than to illustrate. The print-buying public would gladly see themselves promenading on the Heath, admiring its natural qualities and the distant views of London. But the workaday High Street and its surrounding lanes were of less appeal. We must therefore rely on views of the more prominent mansions on the outskirts, and on the Victorian artist-etchers' enthusiasm for capturing its more antiquated corners.

We start with the church. By 1745 it was clear that the medieval building could not accommodate the town's growing population and plans were laid for its reconstruction. The most distinguished local architect, Henry Flitcroft, appears to have risen to the occasion with a detailed model of a new tower and portico (now kept in the church). But the vestry wanted a competition and this Flitcroft felt to be beneath either his dignity or his price. The competition was won by another local man, John Sanderson, with a considerably less sophisticated proposal. Sanderson was an architect of limited talents – indeed this is one of his few unaided works – and his appeal to the vestry appears to have been economy rather than quality. The unusual placing of the new tower at the east end was not out of deference to Church Row but, Sanderson explained, 'to produce a considerable saving in expense' through less elaborate piling. The new building was financed largely from the sale of pew rents at £50 each for life.

The new church was consecrated in 1747 and dedicated to St John – though which John is not known. The entrance to the churchyard from Church Row was graced with railings and gates purchased at the demolition sale of Lord Chandos's Cannons House in Stanmore in the same year, a sale which contributed to the glory of many English Georgian buildings. Even so, the cheeseparing vestry let the best set of gates go to New College Oxford.

Three years later we have our first view of the new building, by Chatelain, from the fields in Frognal to the south. He shows us the early tower before it was heightened and given a spire in 1784. It seems an incongruously urban structure, isolated on the Middlesex hillside as if waiting for the new town to come out and rescue it. This isolation is indicated as late as 1822 in Baynes' view southwards

*24, p. 38*

*28, p. 38*

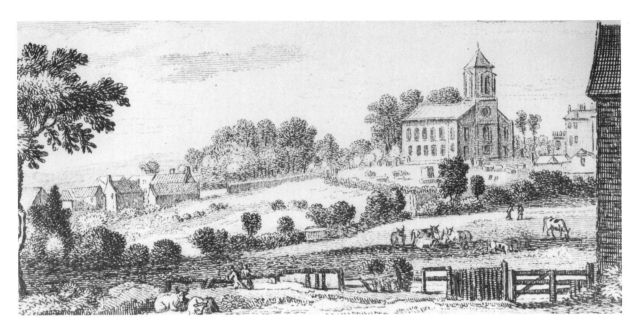

*24  St John's Church, when newly built; copper-engraving after Chatelain, 1750.*

*28  The view from St John's churchyard; lithograph by Baynes, 1822.*

from the churchyard over the fields of Hall Oak Farm (the old Manor Farm) towards what is now Finchley Road. The chest tomb in the foreground is that of the Godfrey family dating from 1756 and is still there today.

*30*      A later lithograph shows St John's just before the addition of transepts in 1843, the tower elongated to seem less of a stump that it really is. This print must have had an intriguing history. We have two states of it, with two minor alterations. In presumably the first, there are children playing a game round the foot of the tower and two dogs are scampering in the foreground. In the other, the children are

*31*  replaced by a calm, well-dressed couple and there is only one dog, gazing lovingly at his master. Did the church authorities request that the artist remove such a suggestion of improper activity in the churchyard from his earlier print?

The interior, more distinguished than the exterior, was clearly influenced by Gibbs' St Martin-in-the-Fields. Despite the location of the tower, the altar was left at the normal east end, with entrance doors squeezed uncomfortably on either

*35*  side of it. A lithograph of the 1850s shows the old box pews (the present ones are later) with 'brackets' or benches down the aisle for the poorer members of the congregation. The altar-piece is classical. The old pulpit is a 'three-decker'.

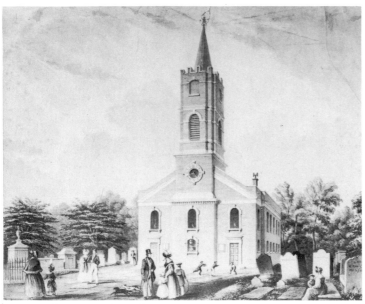

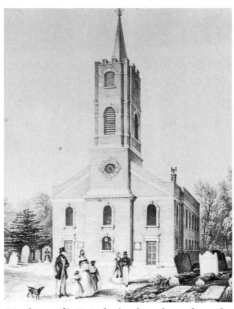

*30 St John's churchyard with children playing; lithograph, c. 1843.*

*31 (Detail) St John's churchyard made more respectable; lithograph, 1843.*

One mystery remains. Lysons, visiting the church in the 1780s, remarks on the fact that the altar is at the west end, where we know it was not moved until 1878 (see Chapter Nine). It cannot be a printing error, as why should he comment on the position of the altar if it was not unusual? The conclusion must be either that it was moved to the west end when the church was rebuilt as being architecturally proper, and then moved back in the early nineteenth century under pressure for liturgical orthodoxy; or that Lysons was himself confused into a mistake by the position of the tower.

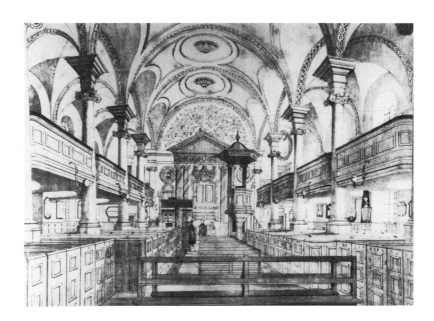

*35 St John's Church; tinted lithograph, c. 1857.*

Church Row is Hampstead's one instance of urban ostentation. Built as an early Wells speculation, it may lack the bravura of Bath, but it is no suburban backwater. Unlike Elm Row and Hampstead Square off Heath Street, it could afford to go on parade along what is one of the few level streets in the town. Its origins are obscure. Dean Sherlock of St Paul's is recorded as having died in a house here in 1707. But none of the existing façades appear to predate the Building Act of 1709, requiring the recessing of wood window frames to reduce fire risk.

The style and numbering suggest the earliest houses were on the north side, and it is here at Nos. 5–9 that the more irregular and (in the cases of Nos. 6 and 9) more spacious Queen Anne houses are seen. On the south side, Nos. 20–28 (refaced in the late nineteenth century) are sufficiently similar to imply a single speculative development, probably of the 1720s. Georgian builders tended to allow their joiners some individualism at least in the carving of the door hood brackets, but here even the acanthus scrolls on alternate entrances are from an identical pattern. Nos. 18 and 19, though clearly contemporary, could not quite run to this expense: perhaps the Wells were already in decline and the market saturated. Rocque shows the south side ending well short of the churchyard. These houses clearly post-date the 1774 Building Act (with windows recessed a full four inches).

The row would have been intended for subletting to visitors to the Wells. The proportions of the houses were modest and they had no individual mews behind (apart from some stables in the present Perrins Walk). Residents would have relied on the numerous coaching inns off the High Street and on sedan chairs and linkmen, whose torch-rests can still be seen outside a number of entrances. Yet it is hard to envisage much early success for the venture. The Wells' popularity was brief. The Row was cut off from the centre of activity by a warren of alleys, courts and slums on the site of what is now the southern arm of Heath Street, and the old medieval church was acknowledged as a local disgrace.

It would seem to be Hampstead's success as a weekend retreat rather than a spa which came to Church Row's aid. By the 1740s, with a new church filling its western prospect, it had plainly become a 'good address'. Its residents, says Barratt with evident pride, were now 'well-to-do merchants and professional men from the City, including several traders with the Orient, men who knew the Levant and the Indies'. So self-assured were these new middle-classes, he continues, that 'a promenade in Church Row was akin to a walk in the Mall of St James's Park'.

Hampstead at last had a fashionable townscape for the print-seller to market: the classic perspective of Georgian façades with promenaders, carriages and an architectural feature covering the vanishing point. Sanderson's east front of the church might not be a Gibbs or a Nash, but the new lantern storey and spire gave at least some vertical distinction. The 'view down Church Row' came to rival

Steele's Cottage on Haverstock Hill as the Hampstead entry in illustrated topographies.

Dugdale's 1843 engraving shows the street before the planting of the trees down the centre. A morning sun lights the normally gloomy front of the church while the town's residents go about their business in the foreground. Dugdale was a stickler for accuracy: even the dentillated cornices are carefully included on the earlier houses in the street. The trees provided shade for strollers and have since helped to slow down passing traffic cutting through to Frognal. Church Row is now rare among London's architectural set pieces in bearing two hundred years of history with scarcely a blemish. *39*

The eastern end of the Row was enclosed by the cottages of Little Church Row, dominated by Oriel House. The house, of which the surviving No. 5 Church Row might almost be a twin, had bay windows rising through its first and second floors, with views down Church Row and out across the fields of Frognal. It was one of the first in which Abbé George Morel held services for the French refugee colony in 1796. Twenty years later he was able to build St Mary's Roman Catholic Church on Holly Walk, founding the small enclave which now surrounds it.

Most prints understandably show the view out from the Oriel House rather than towards it. It was not until the imminent demolition of all of Little Church Row in the 1880s that local artists felt moved to record it. Arthur Evershed puts aside his Heathland sketchbook and gives us a marvellously textured etching of the house from 27 Church Row opposite. The print was used by Baines as the doubtless symbolic frontpiece to his *Records of Hampstead*, which appeared shortly after the house's demolition in 1887. *48*

Built-up Hampstead in Rocque's day was almost exclusively the area of the present High Street, Heath Street and New End. But on all sides it was surrounded

*39 Church Row; steel-engraving from Dugdale's* Curiosities of Great Britain, *c. 1840.*

*48 Oriel House in Little Church Row; etching by Evershed, 1890.*

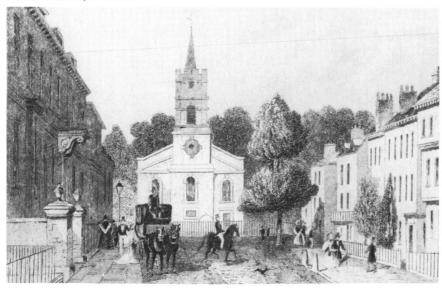

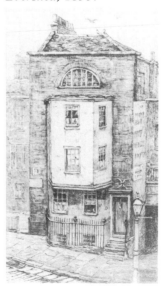

by houses and villas, most of them with large gardens, forming an outer bailey
between the alleys of the town itself and the Heath and manorial farmlands.
Moving anti-clockwise from Church Row, we reach first the three large houses
overlooking the town's southern approaches: Rosslyn House, Vane House and an
ancient building at the top of Rosslyn Hill known as the Chicken House.

Rosslyn House was the residence of one of Hampstead's many eminent
eighteenth-century lawyers, Alexander Wedderburn. As Lord Loughborough, he
served as Lord Chancellor and meted out harsh punishment to the Gordon rioters
in 1780. He was intolerant and unpopular and a catalogue of public complaints of
his character and sentencing policy hounded him from office in 1801.
Wedderburn's first Hampstead home was Branch Hill Lodge but in 1792 he
purchased Shelford Lodge, an old house in the fields north of Belsize. On his
retirement, he took the title of Earl Rosslyn, from his birthplace near Edinburgh.
The name has stuck to the house, the hill and even the pub, ever since.

Rosslyn's alterations to the house do not appear to have been extensive: the
fenestration in various Victorian illustrations suggests it was still essentially
seventeenth century. Presumably he added the large bow window and classical
49   entrance porch shown in Jewitt's wood engraving. As on many Hampstead
houses, the roof was crowned with a veranda from which visitors could admire
the view.

The grounds of Rosslyn House were by all accounts splendid, with magnificent
trees and a system of ponds and cascades. Shepherd's Well near the top of the
present Fitzjohn's Avenue lay at the western boundary and was an important
water source for this side of the town. It is shown in an engraving from Hone's
50   *Table Book* with children watching the watercarriers trudging across the fields to
fill their buckets. (The site of this well is marked by a tablet at the top of Akenside
Road.) To the east of the house an avenue of sycamores and chestnuts led down to
Rosslyn Hill above Hampstead Green. Their destruction in 1895 caused a local

*49  Rosslyn House; wood-engraving
by Jewitt, 1869.*

*52  Vane House;
copper-engraving, 1813.*

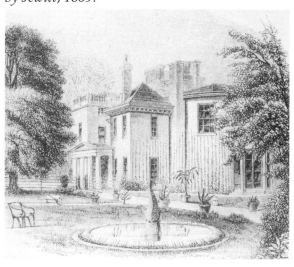

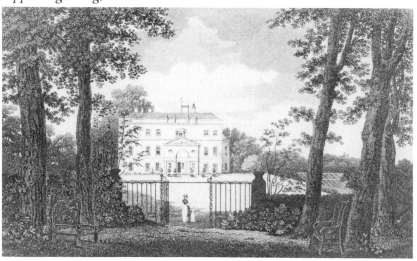

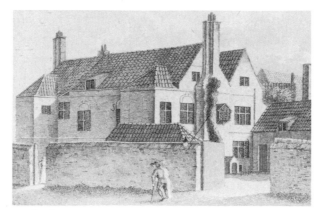

54 *Chicken House; copper-engraving by Malcolm, 1797.*

outcry, exacerbated by the loss of an owl's nest in the branches. Wedderburn and Lyndhurst Roads mark the boundary of the old garden. The present Rosslyn Lodge in Lyndhurst Road has no connection with the old house.

Due north of Rosslyn House and facing directly onto Rosslyn Hill was Vane House. This building also dated from the seventeenth century, having been owned by Sir Henry Vane during and directly after the Commonwealth. On Vane's execution in 1662, it passed through a number of hands before being acquired by the philosopher, Bishop Joseph Butler. Here in what a contemporary described as his 'most enchanting, gay, pretty, elegant house' he stored his collection of stained glass, reputedly gathered from churches and cathedrals all over Europe. The collection was removed after his death in 1752 to Branch Hill by the next owner, Sir Thomas Neave.

The Vane House which appears in the first published print of 1813 clearly has a 52 late-eighteenth century façade, with an attached portico in the Adam style. At this time it was in the ownership of Charles Pilgrim, who gave his name to Pilgrim's Lane. Later in the century, this most historic of all Hampstead's houses was converted and virtually obliterated to make way for the Soldiers' Daughters' Home (see Chapter Nine). It was demolished after the last war.

Just below Vane House on Rosslyn Hill stood the Red Lion pub, afterwards replaced by the local police station. A drinking fountain now marks the spot. On the east side of the road at this point, probably near the present Unitarian Chapel, was the curiously named Chicken House. The building's first and only claim to fame was a visit by James I and the Duke of Buckingham in 1619, remembered in an engraved window much reproduced in late-Victorian histories. In the eighteenth century, the house became a lodging for visitors to the Wells. A Malcolm print of 1797 shows a solid early-seventeenth century building with 54 casement windows; a couple are strolling past, the man curiously walking on a crutch. The name and ownership of the property is obscure, but by the nineteenth

century it was disreputable and described as a haunt of 'thieves and ne'er-do-wells', despite being so close to the police station. It had vanished by 1900.

The area now covered by Willoughby and Gayton Roads was portrayed by Rocque as fields and open Heath. Chatelain's south-westerly 'View of Hampstead from the Heath near the Chapel' – a reference to the converted old Long Room – *10* uses as foreground his familiar pastoral grouping, with cows, pigs and picnickers. A grove of trees clearly shown by Rocque covers the site of the present Willow Road. The backs of houses in Rosslyn Hill rise in the distance.

We now reach George Childs' Hampstead. His lithographs show a vivid appreciation not only of the local landscape and its trees, but also of the people who inhabited it. Each print seems to tell a story, with children, herdsmen, coachmen and travellers engaged in a ceaseless social intercourse.

*55* In Childs' *Advanced Drawing Book*, Plate 10 is of the old paupers' cottages beside what was then Lower Heath (now Willow Road) looking north-west. The water course in the bottom left-hand corner is the infant Fleet on its way from Flask Walk down to the watercress beds at the foot of the present Downshire Hill. A small boy is languidly beating a donkey with a stick. Plate 12 shows a basket *56* weaver at work on the Heath, just a hundred yards east of the last print. Behind him are the backs of houses in Well Walk, including the Wells Tavern with what is now Christchurch Hill running up to the left. To the right are the slopes of the

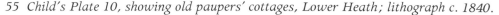

*55  Child's Plate 10, showing old paupers' cottages, Lower Heath; lithograph c. 1840.*

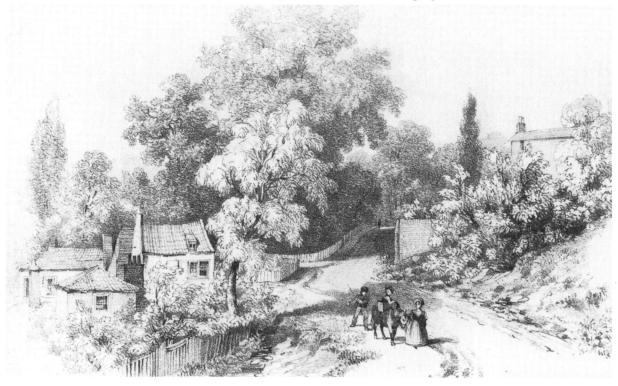

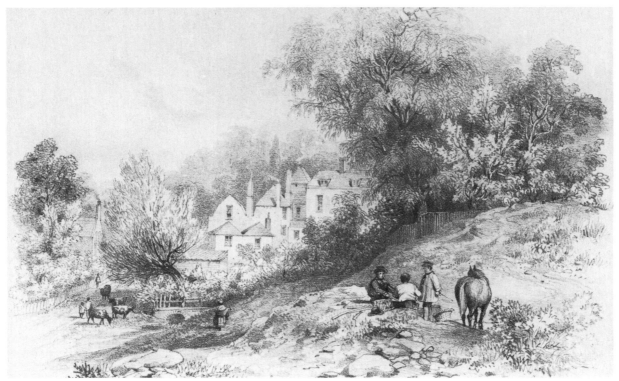

56 *Childs' Plate 12, a basket weaver on the Heath; lithograph, c. 1840.*

present Heathside. Along Well Walk, we reach the scene of Childs' Plate 2, by the *59* wall of the Pryors. This old house on the Heath, now two large blocks of flats, is also represented on a number of Hastings prints of the East Heath (described in Chapter Eight). Childs shows only its wall and the front of Foley House, his attention clearly captured by the massing of the trees overhead.

We now walk up East Heath Road (then known as Middle Heath) to another of the large houses which ringed this side of the town, Squire's Mount. Like the Pryors and Foley House, it took its name from an early owner, Joshua Squire. But again Childs is more interested in landscape and in the huddle of cottages which grew up round its walls on the picturesque Heath waste. Plate 23 shows East Heath Road with Squire's Mount to the left, and just possibly the same basket *58, p. 46* weaver we saw returning home in Plate 2. The two cottages abutting the wall are still standing, as is the row in the middle distance.

The area known as New End, which separated Squire's Mount from the town centre, developed in the early part of the eighteenth century in the angle of Flask Walk and Heath Street (then still known as the High Street). It was an irregular warren of small cottages, stables and inns which probably first sprang up in response to a demand for labour at the Wells. It rapidly became Hampstead's poorest district, despite its proximity to the large houses on Hampstead Square and the Mount. As a result, New End received much attention from both private

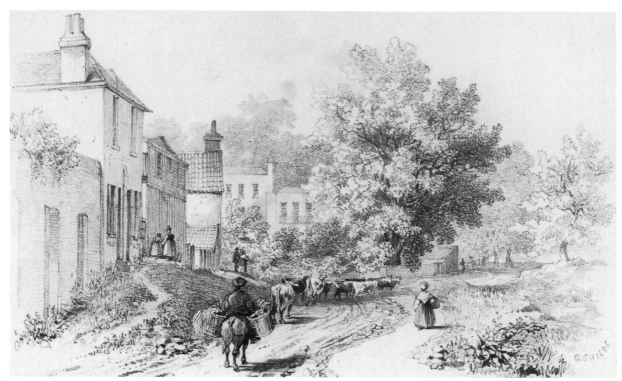

*58  Childs' Plate 23, East Heath Road and Squire's Mount; lithograph, c. 1840.*

and municipal philanthropy in the nineteenth century (see Chapter Nine).

Three etchings of the neighbourhood were made at the end of the nineteenth century, at a time when much of it was being cleared. They were produced by an unknown artist and included in a series entitled *Old Hampstead*, published in about 1900 apparently to record vanishing corners of the old town. One shows the *62* southern dogleg of New End, with the Dispensary on the corner and the spire of Christ Church in the distance. Despite their humble origins, all these buildings survive today – an impressive testament to Hampstead conservation. Another *60* shows the backs of cottages now vanished in Grove Place, running up behind *61* Christchurch Hill. A third shows old houses in Streatley Place, near the site of the present school. The prints are useful topographically but the omission of any local people from the series makes them seem disappointingly empty.

*62  New End; etching, c. 1900.*

No such criticism could be levelled against Ford Madox Brown's famous painting 'Work' now hanging in Manchester Art Gallery. This picture, whose popularity fortunately justified its engraving, is of a scene Brown witnessed near his lodgings in Hampstead one afternoon in 1852 (see *Camden History Review* No. 2). It shows men laying water mains, or drains, on the Mount by Heath Street while round them a busy town goes about its affairs. Brown described the appeal of the prospect in surprisingly detached terms: 'Studying as I did daily the British excavator, or navvy as he designated himself, in the full swing of his activity, with his manly and picturesque costume and with the rich glow of colour which exercise and hot sun will impart, it appeared to me that he was at least as worthy of the powers of any English painter as the fishermen of the Adriatic, the peasants of the Campagna or the Neapolitan lazzaroni.' (quoted by Barratt). One wonders what the workmen themselves would have said about it. The picture is full of incident: a child pulling a boy's hair, a well-groomed whippet starting at a scruffy terrier, a barefooted flower woman crowding the pavement with a prim girl lifting up her skirts.

*63 Ford Madox Brown's* Work; *wood-engraving, c. 1872.*

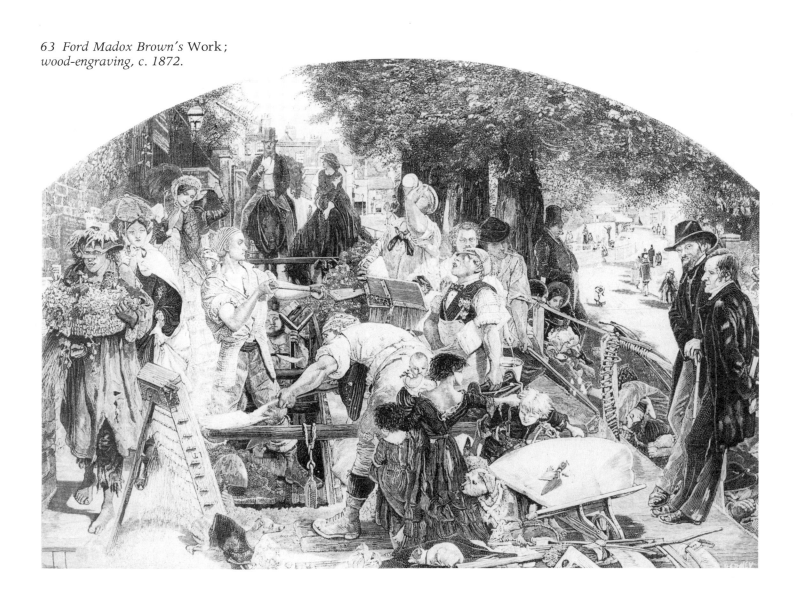

In the top right of the engraving, at what is the corner of New End, stands
Cherry Tree (sometimes Chestnut) House. This was a large Georgian building, also
*64*  illustrated in the *Old Hampstead* series, with pilasters decorating its street façade.
Before its demolition to make way for the hospital, it was well known locally for
the chemist shop set into its ground floor. This was run by a blind pharmacist
named Foster, who must have been a risky man from whom to buy medicine.

Across Heath Street and up through the Mount we reach the most intact district
of the old town, round the Grove and Holly Bush Hill. Even the neo-Georgian
section of Hampstead Grove itself is not unsympathetic. If we can shut our eyes to
the late-Victorian Medical Research Institue, no mean task, Holly Bush Hill with
its surrounding enclave typifies the anarchic layout of an old hillside settlement.
It is sometimes accused of prettiness. Yet it has none of the artificial chic of its
Parisian parallel, Montmartre. The architecture is a gentle, intimate vernacular
and contrasts well with the spacious estates and rectangular grids of the later town
beneath.

Once again it is Childs who best captures the character of the neighbourhood.
*65*  His print 'Holly-Bush Hill, Hampstead' shows houses piled up to the right and

*65* Holly-Bush Hill, Hampstead; *lithograph by Childs, c. 1840.*

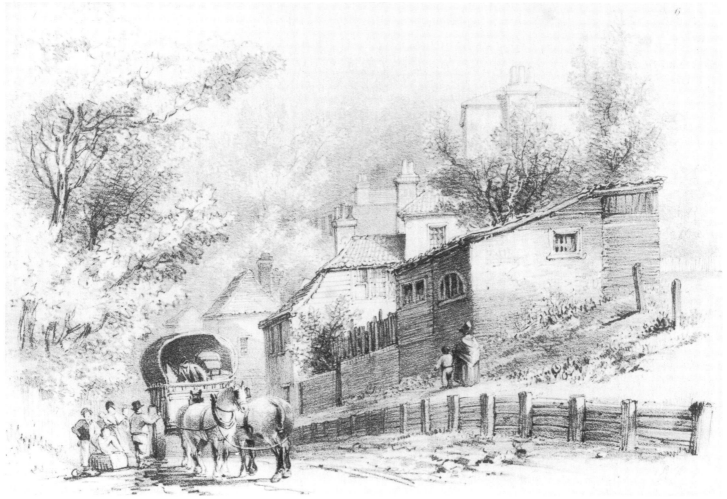

trees to the left, and this has proved confusing to topographers who cannot match it to the configuration of the Hill itself. Some have even suggested it is a view of a different Holly Bush Hill, the name once given to the incline of Sandy Road down into North End. The view was actually drawn with the artist's back to the present Hill. It shows what is now Frognal Rise looking north towards Branch Hill. The buildings of Windmill Hill are to the right and the site of the Medical Research Institute to the left. The key to this identification is a pencil sketch made in 1843 of a similar view by C. H. L. Woodd and clearly showing Windmill Hill in the background (at Swiss Cottage Library).

Facing this scene is the house built (from some old stables) by the artist George Romney in 1796. Romney was one of the first of his profession to see in the heights of Hampstead an opportunity to escape the constricting atmosphere of central London. 'Here he would show the world,' writes Barratt, 'how much more he was than a mere painter of fashionable portraits. Freed from town distractions he now resolved to paint pictures of exalted purpose and imaginative force that would give him an enduring fame.' The exploit was both an artistic and an emotional disaster. After spending over £3,000 rebuilding the property, Romney used it intermittently for less than three years before depression drove him home to Kendal. The house fetched only £357 on its sale in 1801 and Romney died a year later. The building subsequently became the Hampstead Assembly Rooms (after the eventual closure of the second Long Room in Well Walk) and was chiefly famous as the venue for Constable's lectures on landscape painting in 1833. Before the last war it was the home of the architect Clough Williams-Ellis. It appears in about 1900 in an etching from the *Old Hampstead* series. 67

Where Romney led, Linnell, Collins, Constable and Copley Fielding all followed over the next two decades. Constable's Hampstead prints are discussed below (see Chapter Eight) but a foretaste is provided by an 1891 etching of one of at least three paintings he did of the Grove (now Admiral's House) in Admiral's Walk. Topography takes second place to dramatic effect in the print, indeed some captions refer to it just as a 'romantic house' in Hampstead. The calmness of the 69, p. 50 animals drinking at Clock House Pond (then situated behind Clock House, now Fenton House) contrasts with the sunlight on the house, the soaring trees and stormy sky.

Admiral's House can be dated back to 1700 and has long been fixed in Hampstead legend as the late-eighteenth century home of Admiral Barton. Among his reputed exploits were running away to sea, shipwreck, ransom and eventual cashiering for the loss of his vessel. He retired to Hampstead with the rank of admiral, where he is said to have converted this house into an architectural galleon, adding a 'bridge' and even cannons, which he would fire off on suitable occasions. The Malcolm print of 1796 shows the house from behind, appropriately 68, p. 50

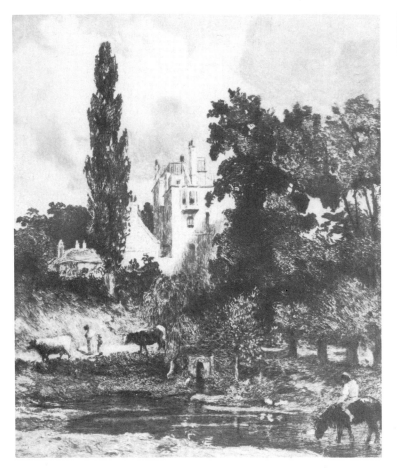

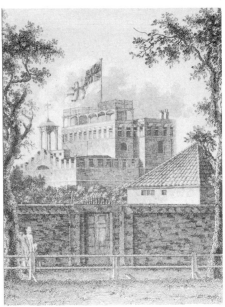

*68 (Detail) Admiral's House; copper-engraving by Malcolm, 1796.*

*69 Admiral's House; etching after Constable, 1891.*

decked out with a roof terrace as a bridge and a huge ensign.

Recent research by Felicity Marpole has demolished this story (*Camden History Review* No. 9). Admiral Barton (1715–95) did live in Hampstead, but at Vane House. The ratepayer on Admiral's House from 1775 to 1811 was Fountain North, also a sea captain (which explains the ensign). It passed to his wife and then to Edward Toller, a Hampstead lawyer who had previously lived in another 'Grove House', later Holford House, on East Heath Road. There is no explanation for the admiral legend, though it must have amused a later resident, the architect Sir George Gilbert Scott, to be living in a house so quirky in its design. By the time of Constable's painting, the house had been stripped of its nautical embellishment. Only the oriel window and roof terrace retained – as they still do – some feel of the sea. The grounds of North's old house were eventually sold to the New River Company for an extension of their reservoir.

We now reach Fenton House, grandest of the properties to the north of the town. The house dates from the 1690s, when it was called Ostend House, presumably a reference to the merchant activities of its first owner, Joshua Gee. The name was changed to Fenton House on its acquisition by Philip Fenton in

1793, then to Clock House, then back again to Fenton House. Apart from the small loggia on the Grove façade, inserted by Fenton's son James in about 1807, the house is a rare instance in London of virtually unadulterated William and Mary architecture.

From the Walford wood engraving recalling the house in 1780 to Way's lithograph of 1898, only the trees and gas lamps mark the passage of a century and nothing more has changed today. Sadly there is no illustration of the splendid 'Tijou' gates from the front garden onto Holly Bush Hill, nor do we know their designer. Anna Maxwell records a variety of theories: that they came from St Paul's, that they were brought over by a French family with Abbé Morel, or that they came from Cannons House like the railings to the parish church. The initials JG on them suggest they were erected for Joshua Gee. They were designed, so the National Trust guidebook indicates, 'under the direction of' Jean Tijou. Fenton House is now open to the public in summer and contains a fine collection of musical instruments. I can only add that there is no more enchanting place in Hampstead in which to feel the presence of its past, the silence only broken by the tinkle of harpsichords being played by students in upstairs rooms.

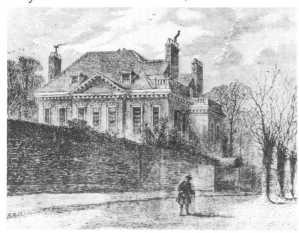

71 *Fenton House; wood-engraving from Walford's* Old & New London, *1877.*

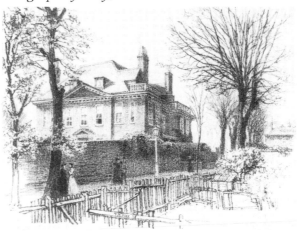

72 *Fenton House; lithograph by Way, 1898.*

# 4

# FROGNAL

The sunny south-west slope of the hill, well-drained and watered by two streams, would have been the natural location for the main farm buildings of the old manor of Hampstead. Why 'Frognal' remains a mystery, but the name occurs as early as the fourteenth century and there is no good reason to reject the Saxon derivation of 'frogen-hall', the hall of frogs. Attempts to discover any manor house distinct from the farm itself have been in vain and David Sullivan's meticulously researched plan, exhibited at Burgh House in 1981, showing Hall Oak Farm straddling the top of the present Frognal Lane must be considered the last word on the subject.

Sadly we do not know what this farm looked like, although it retained its monastic shape round a courtyard for some 750 years and presumably included a hall and manorial offices. The buildings were demolished at the end of the eighteenth century to make way for the present two houses, Maryon House and Maryon Hall, named after the family of the manorial lords. Various barns and outhouses survived a little longer on the south side of Frognal Lane, and may perhaps feature in one of the prints captioned 'Farm at Hampstead', reproduced in the Gallery section of this book.

We must wait until 1796 for our first certain views of Frognal, by Thomas Stowers. The first of his aquatints shows the church and next to it the cupola of Frognal Hall from a point on the main road above Oak Hill Park. The hall itself disappeared early in the twentieth century and the site is now covered by Frognal Way. Its gardens and their relationship to the churchyard can be seen in a Woodburn print of 1807 for *Ecclesiastical Topography*. The Hall was plainly a large house, occupied at the time of Stowers' print by the Lord Chief Justice, Lord Alvanley, who died in 1804. Its last use was as a Victorian boys' school. Next to it stood Priory Lodge, where Dr Johnson spent a brief summer in 1746. The print also shows what must be the early-Georgian façade of the existing house known as the Old Mansion.

The second Stowers aquatint presents Frognal more in the guise of a Dorset village, with maid, dog, pond, church and fields stretching into the distance. The pond is Clock House Pond behind Fenton House, which served as the reservoir

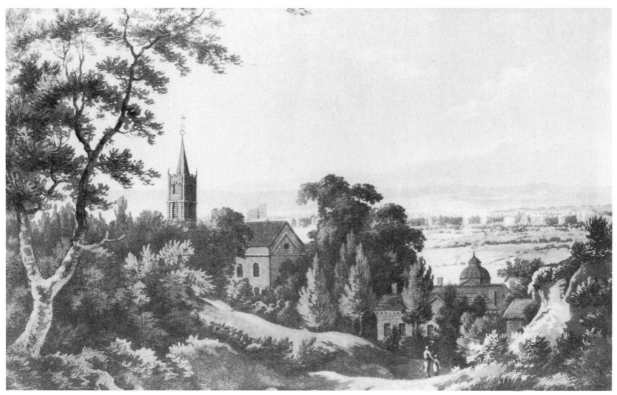

75  *The church and the cupola of Frognal Hall; aquatint after Stowers, 1796.*

76  *Clock House Pond; aquatint after Stowers, 1796.*

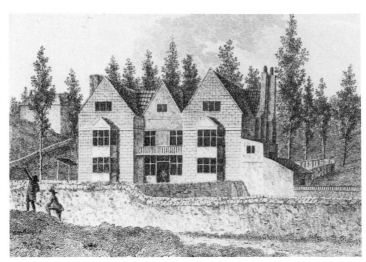

*77  Poor House at Frognal; copper-engraving by Malcolm, 1797.*

for the Windmill Hill area. It is this pond which Constable included in one of his paintings of Admiral's House. The print gives us a quaint view of the old parish poor house, shown with gables and (inaccurate) oriel windows in the middle distance.

The poor house building must have been one of the oldest in the town. It would appear to date from the seventeenth century, if not earlier. In the early eighteenth century it was a lodging house for visitors to the Wells and legend has it that the actors Colly Cibber and even David Garrick stayed there. Following the passage of the 1722 Parish Workhouses Act, the building was rented as the parish poor house for £20 a year. The establishment usually comprised some twenty inmates of which almost all (according to Geoffrey Harris in *Camden History Review* No. 4) were destitute women and children. It was constantly short of money, the matron was rebellious and the roof would admit rain 'like a sieve'.

In 1800 the house was condemned as 'decayed and incommodious' and the guardians eventually built premises in New End which were later to become the present hospital. Malcolm shows the building in 1797 looking almost as good as new – perhaps to create a better public impression. But within a few years, prints portray it as a tumbledown structure, its garden unkempt and with props holding up the chimney. It appears to have been demolished by 1807 and the site is now in the grounds of the National Institute for Medical Research.

Immediately south of the manor farm site lay a building equally appealing to artists of the Hampstead picturesque. Frognal Priory was built towards the end of the eighteenth century and had no link with any religious foundation of that name. (None existed, though Caroline White excelled even herself by suggesting Cardinal Wolsey may have lived there.) The building was the creation of John Thompson, a retired auctioneer and collector. Thompson clearly wanted to be to

Frognal what Horace Walpole was to Twickenham. In early prints the Priory appears as a conventional 'Strawberry Hill Gothick' house, crenellated and with Tudor windows. The Marshall engraving of 1826 shows the parish church in the background, and this view continues through the 1834 version. *81* *82*

By 1843 things had begun to change. Thompson now added new architectural features as and when material came to hand. A drawing in Barratt, purporting to be by Thompson himself, shows Renaissance windows and a porch, Dutch gables, turrets and a cupola. Yet within 15 years the house was falling into disrepair, and it appears to have been this, more than the eccentricity of its owner, which attracted artistic attention. Anna Maxwell visited it and recalls that 'in the late afterglow of a June sunset, we children expected at every turn of the long corridors to meet a shadowy figure in medieval costume. The odour filled us with a delicious horror.' Thompson himself died in the mid-1850s and the house slid gently into ruin in the hands of custodians. It appeared in *Reynold's Miscellany* of 1863 as a romantic castle propped up with buttresses, its garden run to seed. *85* The house was demolished in 1876.

From its earliest days, the road now known as Frognal was among the most prosperous in Hampstead. A rating assessment book published in 1811 by a Mr Abrahams (with the radical aim of proving the rich of the parish were evading

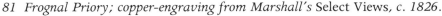

*81 Frognal Priory; copper-engraving from Marshall's* Select Views, *c. 1826.*

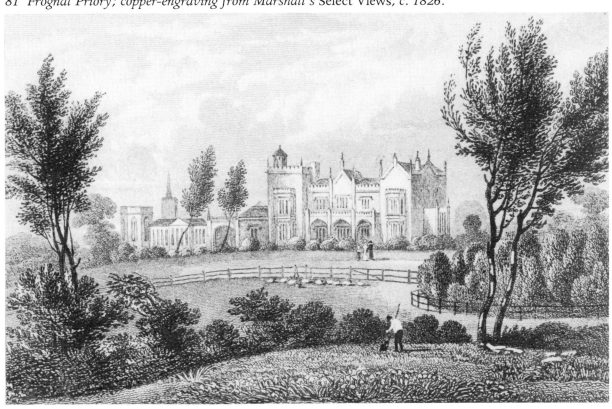

their rates) described it as 'a hamlet of handsome residences, surrounded by wooded groves and beautiful gardens of an extent begrudged by builders in these modern days'. From below the junction with the present Frognal Lane northwards, large houses continued up to Branch Hill, each with a confusing similarity of names: Frognal Priory, Priory Lodge, Frognal Hall, Frognal Lodge, The Old Mansion, Frognal House, Upper Frognal Lodge, Frognal Grove.

*87*    The last is the subject of an extraordinary print by Maria Prestel. In both the original painting (illustrated in the *Hampstead Annual* for 1900) and the print made from it in about 1790, the scene is used as background for what is clearly a portrayal of the parable of the Good Samaritan. At the entrance to Frognal Grove, the Samaritan is helping the robbed and wounded traveller while his horse waits to convey them to the inn. The artist has even included the Levite, walking by 'on the other side' down Frognal itself.

The house of Frognal Grove (seen on the right of the print) was also known as Montagu House from its occupancy in the eighteenth century by the lawyer, Edward Montagu. It was originally designed and built for his own use in 1745 by the architect, Henry Flitcroft. The site was magnificent, looking across to Holly Bush Hill and with a lime grove leading up to it from Branch Hill. Prestel allowed herself the licence of excluding any other building from the view, except for an unidentified mansion on the distant hillside.

The end of the Grove can be seen in the first of the Branch Hill prints. Edward
*90*    Finden's engraving of a William Westall scene shows the gated entrance to the Grove at the top of Frognal as it turns left into Branch Hill. Windmill Hill lies ahead. The house on the left still stands today, though shorn both of its projecting centre bay and of its fine trees. Our obtrusive friend, the Medical Research

*87 Frognal Grove; aquatint by Prestel, c. 1790.*      *90 Branch Hill; steel-engraving after Westall, 1829.*

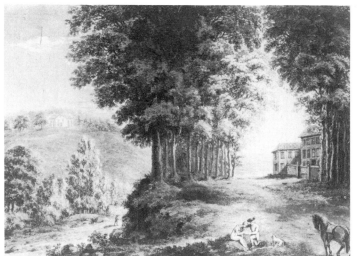
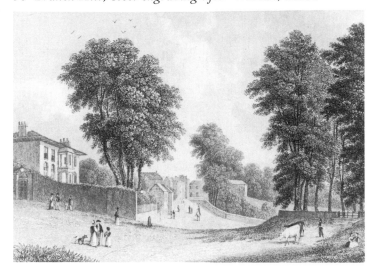

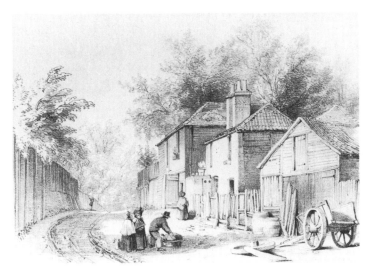

91 *The wall of Branch Hill Lodge, on the left; lithograph by Childs, c. 1840.*

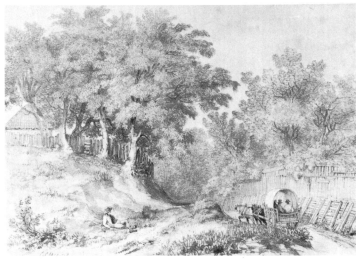

92 Road Leading To Holly-Bush Hill From The Heath; *lithograph by Childs, c. 1840.*

Institute, now fills the enticing field in the distance.

Turning north we recognise the first of Childs' two Branch Hill lithographs. On *91* the left is the wall of Branch Hill Lodge and opposite are the stables which in Childs' day belonged to a Mr Goddans. Ahead is the cutting through the West Heath dug during the eighteenth century to ease access from Frognal to the north, known at first as Cow Yard. There is a typically Childsian bustle of travellers and a clutter of timber and cartwheels in the foreground. Childs would only have walked 50 yards up the hill to turn back and draw his second sketch of the 'Road leading to Holly Bush Hill from the Heath'. Judges Walk leads up to the left and *92* apart from the substitution of bricks for wooden planks, the scene is virtually unaltered today.

Of Branch Hill Lodge, behind the fence on the right of Childs' view, we have *92* no prints earlier than the sequence of lithographs produced by Way for the estate agents Debenham and Tewson in 1899. The house had been bought and rebuilt in 1745 by the then Master of the Rolls, Sir Thomas Clarke, with the help of Flitcroft, building his own Frognal Grove next door at the time. With Alvanley at Frognal Hall and Montagu shortly to arrive at the Grove, Frognal was a nest of Georgian judges—hence one proposed derivation of Judges Walk on the Heath above. Branch Hill remained in legal hands until the turn of the nineteenth century, when a merchant named Thomas Neave moved from Vane House and bought a quantity of land in the neighbourhood to protect his privacy from building encroachment. Having thus cheaply acquired what Thompson calls 'his own private green belt', Neave blandly proceeded to develop it with a profitable villa estate in Oak Hill Park.

The Lodge passed through a number of hands before being rebuilt in the early

1870s by the then elderly Victorian architect, Samuel Teulon, designer of St Stephen's, Rosslyn Hill. The house was occupied by a local magistrate and member of a prominent Hampstead family, Basil Woodd Smith. Way's lithograph shows the new entrance in all its glory. Like much of Teulon's work, its neo-Tudor style is magnificent when new or restored but can look what Dickens called 'ghastly grim' when coated with dirt. The 1899 sale led to alterations in Teulon's design, but it was Camden Council who delivered the knock-out blow when they bought the house in 1965. An unsympathetic modern wing has been added to create an old people's home, and in 1970 concrete was poured down the garden slope to provide foundations for some of London's most exotic but impractical council flats.

*96 Branch Hill Lodge; lithograph by Way, 1899.*

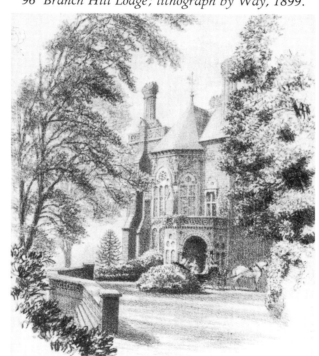

# 5

# NORTH END AND THE SPANIARDS

Of all the settlements which ringed the old town of Hampstead, none retains its pre-suburban character more completely than North End. Indeed it is hard to think of anywhere in what is still technically inner London which retains more meticulously the aura of a rural enclave. The isolated location and fusion of trees and landscape, roofs and chimneys have always made it a favourite artists' resort and it yields some of this book's most attractive prints. They are also the most challenging to identify.

The task begins easily enough. A community here is marked on even the earliest maps of Middlesex and can be traced back to the time of the Conquest. It was probably that mentioned as Sandgate in AD 986 and, much later, as Wildwood Corner. This 'corner' has long been a puzzle but lends a clue to the original road alignment. David Sullivan has shown that, before the steep North End Way cutting was dug in the mid-eighteenth century, the old road swung down from Jack Straw's Castle to the present Wildwood Avenue, at the foot of which lay the village pond. There, one branch ran left to the Bull and Bush tavern where it turned sharp right and down past Golders Hill, hence the corner. Another North End historian, Philip Venning, has suggested that a much earlier pub than the Bull and Bush (which is probably no older than 1700) called the Green Man possibly stood on another branch of the 'old' Hendon road to the west of Wyldes Farm. It is believed to have been on the site of the present Manor House Hospital.

North End was perhaps best known prior to the eighteenth century for the grisly 'gibbet elms' which dominated the Heath beyond Jack Straw's Castle. It was between them that the highwayman, Francis Jackson, was hanged in 1674 for a series of murders committed in the area. Such exemplary punishment was not as common as is often supposed, and Jackson's shrivelled skeleton was sufficiently unusual (and horrific) to be mentioned by travellers many years afterwards. The elms appear friendly enough in Childs' print of North End Road (now Way) a <span>*100, p. 60*</span> century and a half later, with cows sheltering underneath and his ubiquitous wayfarers scurrying past. Barratt records that the last of the elms fell in a gale as recently as 1907.

The staked embankment and guard-rail of North End Way are a feature of many

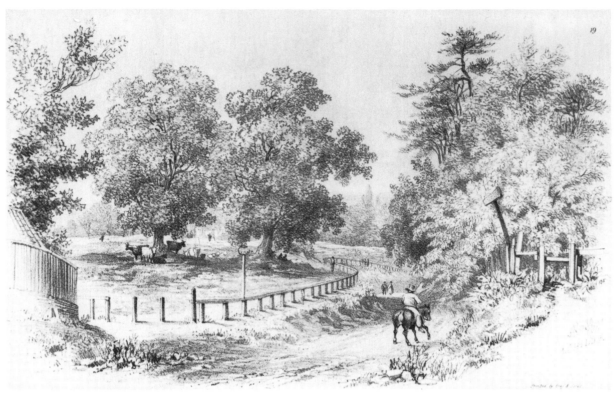

*100   The Gibbet Elms; lithograph by Childs, c. 1840.*

*97  North End Road (now Way); lithograph by Baynes, 1822.*

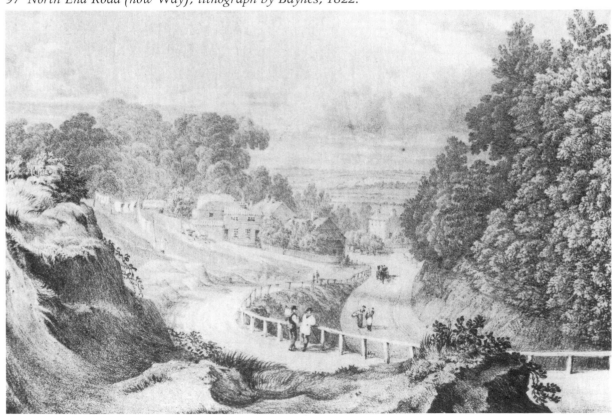

early prints of the area, and we can follow the rail down below the elms to the point at which Baynes stood for his lithograph of 1822. Then at the foot of the hill, *97* the Bull and Bush comes into view in a late etching of about 1890. Although the *105* weatherboarded cottage (which features in many North End prints) was demolished in 1893, and a wartime bomb removed the house behind it, the rest of this scene has remained remarkably unchanged since the eighteenth century.

Much has been made of the tradition that William Hogarth resided at the old Bull and Bush before it became a tavern, presumably in the early years of the eighteenth century. There is no evidence for this – indeed the state of Hogarth's career at this time makes it most unlikely. When he could afford a country home, he acquired it in Chiswick. Any artist would have been a likely patron at a Heath tavern and visits by the young Hogarth may account for the legend. But in claiming the greatest chronicler of eighteenth-century London for its own, North End chauvinism is probably going too far.

The Bull and Bush itself never achieved quite the fame of the Spaniards, though it offered a full complement of tavern, dining room, garden (shown in Fancourt's curious 1870 etching), skittle alley and, in the late nineteenth century, even music *104* hall entertainment. Its best-known attraction was Florrie Forde and the song for which she and the pub are famous is helpfully displayed, words and music, on the front façade. One of a row of cottages directly opposite the Bull, portrayed by Childs, later became Ambridge's tea rooms. Its hipped roof end is visible in a number of the prints looking down North End Road.

Cottages such as these may well have begun life as single shelters for herdsmen and foresters on the manor waste, but by the start of the nineteenth century their antiquity and seclusion rapidly brought them to the attention of visitors. The

*105 North End, including the Bull and Bush; etching, c. 1890.*

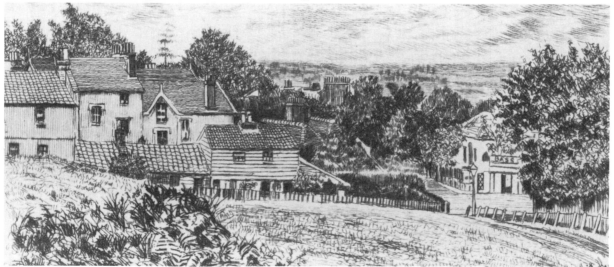

painter John Linnell was so taken with Hope Cottage, which stood on the south side of what is now confusingly called North End, that he rented it in 1822 and the following year graduated to Wyldes (then Collins) Farm round the corner. He stayed there for five years. No sooner had he moved out of Hope Cottage than his friend, the artist William Collins, appears to have rented it. The result was a procession of the English landscape school trekking over the Heath to visit them. Among them were William Blake, John Varley, George Morland and Samuel Palmer.

Although the eccentric Linnell was reason enough for this attention (poor Palmer was to marry his daughter and find him a most trying father-in-law), letters and diaries testify to the inspiration all found in the clear air and undulating contours of the north Heath. 'Here,' wrote Collins' son, 'he found his footsore trampers, the patched or picturesquely ragged beggars, the brutish or audacious boys . . . here he could live surrounded by some of the prettiest and most varied inland scenery, the beauties and pictorial capabilities of which he never wearied of exploring.' Blake might curse the evil consequences of his Hampstead visits: 'all places north of London always laid me up the day after,' he wrote. But Palmer recalls him playing happily with Linnell's children at Wyldes. And both artists would often wander over the hill together, the young Palmer deeply under Blake's influence and as yet untouched by his Shoreham revelations.

Here we feel the limitations of the print market. Both Linnell and Collins left Hampstead canvasses but neither produced the sort of work to justify commercial engraving. Even the venue for so much of their conversation, Wyldes Farm itself, *116* is reproduced only obliquely, to the right of a lithograph looking north towards *117* Golders Hill, and in a late wood engraving. The latter is captioned 'Heath Farm', which dates it to the last quarter of the nineteenth century. The steep-roofed barn on the right is wholly out of scale. The building is still a private residence (divided into two), the last of the heathside farms to survive in anything resembling its original form.

Eighteenth-century North End included two substantial mansions, Golders Hill House and North End House. The latter, located east of North End Road with its entrance onto Wildwood Avenue, was built in the 1760s by a financier and assiduous flatterer named Charles Dingley (see Venning, *Hampstead and Highgate Express*, 19 May 1978). It was apparently intended by Dingley explicitly for the use of the Prime Minister, William Pitt, whom he was courting at the time. It was here that Pitt retreated after his mental breakdown in 1767, to remain incommunicado throughout the summer and autumn of that year. He would see no one – even the King had to plead he would visit North End himself if Pitt (created Earl of Chatham in 1766) would not come to see him. Servants pushed food

through a hatch in an upper room where he had shut himself. And at various times he demanded that Dingley add dozens of extra rooms to the house or buy up every property he could see from his window to have them demolished.

All this was at a time when Chatham was officially head of a government on the brink of the American War of Independence. This latter fact stirred Baines to impressive antiquarian's megalomania: 'Had Lord Chatham not been there, but in health and at his post, the Boston tea duties would never have been imposed; and over the American continent the Union Jack . . . might this day be flying from San Francisco to York Factory.' Such is the debt America owes to the seclusion of North End. Chatham left North End for convalescence in Somerset in September of that same year, 1767.

The house in which Chatham took refuge (variously called North End House or Place, Wildwoods and Pitt House) would have been much as in Jewitt's wood engraving of a century later. In the top right hand corner of the building is the *118* garret window from which Chatham is said to have gazed out in despair towards Finchley. In 1905 the house was bought by Harold Harmsworth, later the newspaper baron, Lord Rothermere, and brother of Lord Northcliffe. It was he who undertook the extensive 'Edwardianisation' seen in Pimlott's series of etchings. A storey has been added, the Georgian doorcase has been moved into the *119–22* window bay and the building has acquired an extensive greenhouse. Pimlott also portrayed the interior – with, to the best of my knowledge, the only etching of a *122* Hampstead telephone.

The demolition of old North End House in 1952 on grounds of war damage – the present Pitt House is new – was as sad a loss to Hampstead history as that of Vane House in the High Street. But at least its garden, run spectacularly wild, has been added to the Heath.

North End topography now becomes more challenging. Today, the hamlet is accessible to vehicles from the north and south only. But at least until the interwar period, cars and even charabancs could use part of Sandy Road, running west from the Spaniards through North End to Childs Hill. This road had been built or

*116 (Detail) An oblique glimpse of Wyldes Farm; lithograph, c. 1840.*

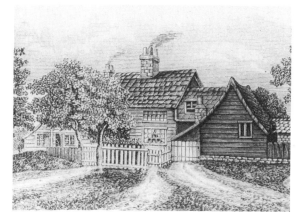

*117 (Detail) Wyldes Farm; wood-engraving, c. 1880.*

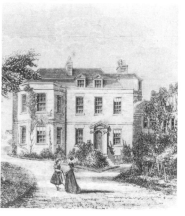

*118 North End House; wood-engraving by Jewitt, 1869.*

at least improved in 1734 as a private venture by John Turner, owner of The Firs near Spaniards End (see below). Once again our most engaging guide is Childs, who unhelpfully captioned all his North End prints as just 'North End'. My identifications are based in part on E. E. Newton's researches undertaken in the 1890s.

Childs' Plates 4, 11 and 15 would appear from the chimney configuration to show the house which Newton identified as owned by Thomas Poulter, who then lived on the north side of Sandy Road where it met Wildwood Avenue. The first of 123 these 'Poulter' prints is looking south from the lane to Wyldes Farm; the second is 124 looking west from a point just north of Sandy Road as it dips down into North End. This dip was sometimes called Holly Bush Hill. Plate 15 appears to be 125 'Poulter's House' from the south-east, showing workmen digging sand from the 126 Heath. I would also guess that Childs' Plate 5 is from the area of Wyldes, looking 127 west towards the rear of the old Hare and Hounds, and that his Plate 18 is taken from the top of Wildwood Avenue, an area called The Paddock, with the roof of North End House peeping through the trees in the distance.

Irrespective of such topographical minutiae, these Childs lithographs are superb. With his East Heath scenes they are the authentic expression of

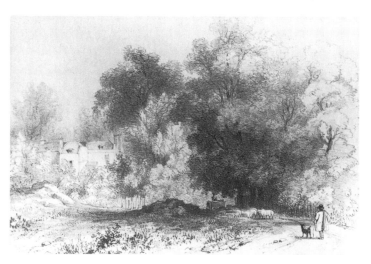

*123  Childs' Plate 4, 'Poulter's House'; lithograph, c. 1840.*

*124  Childs' Plate 11, 'Poulter's House'; lithograph, c. 1840.*

*125  Childs' Plate 15, 'Poulter's House'; lithograph, c. 1840.*

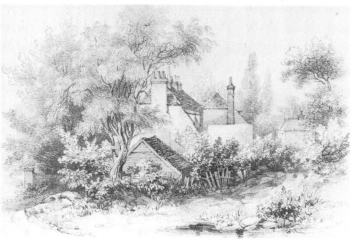

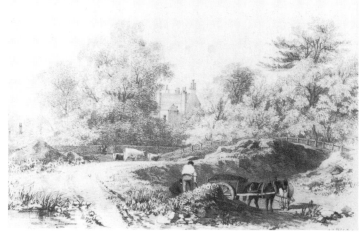

124

125

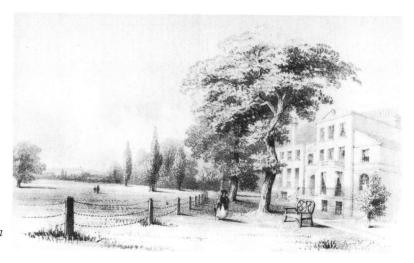

*130 Golders Hill House; lithograph from the auction catalogue, 1838.*

Hampstead in the early Victorian period before extensive development had altered the appearance of the Georgian town and equally extensive quarrying had begun to transform the Heath.

North of the hamlet lies the boundary with Golders Green in the old parish of Hendon (and modern borough of Barnet). To some local historians, this territory might be marked 'Here be Dragons', but old North End knew no such barrier. Golders Hill House was a large house dating from the eighteenth century, when it was built and occupied for a time by Charles Dingley. As law was to Branch Hill so medicine was to Golders Hill. From Jeremiah Dyson and Mark Akenside in the 1750s to Sir Spencer Wells in the 1890s it was noted for its doctors, though Philip Venning has shown that Dyson and Akenside probably lived not in Golders Hill House itself but in the Manor House on the opposite side of the road. Golders Hill House, according to Barratt, appears in a copper engraving of 1789, *131* though it is hard to see where. It must have been largely rebuilt by the time of its auction in 1838, since the catalogue lithograph shows it with an extraordinary *130* number of chimneys. The view is looking north-west with Harrow in the distance. A further auction was held in 1898 after the death of its last owner, Sir Spencer Wells. It was as a result of this sale that a subscription was raised to purchase the park as an addition to the Heath. As at the sale of Branch Hill Lodge, Debenham and Tewson employed T. R. Way to illustrate the catalogue and his lithograph *142* shows the lake looking south towards the clump of pines above North End. The house itself was demolished.

The pines in Way's print, often referred to as 'firs', dominated the western approach to North End. They made a particularly fine composition, with their spindly outline silhouetted against the horizon. A similar clump lay near the Spaniards and the two can be easily confused in prints. Both afforded excellent views west to Harrow. The North End pines are at their most theatrical in Edward

*139* Hassell's lithograph of 1837, with the roofs of North End in the distance. When Hassell returned to the scene on a later occasion he clearly noted a deterioration in the trees, for a second version of the print has a number of branches drooping or missing. Hastings also portrayed this view in an etching.

*143* The trees appear again as backdrop to a Monk etching of the Leg of Mutton Pond on the West Heath. The pond was dug as a local reservoir in 1825 by men on poor relief and was sometimes known as 'Hankin's folly' after the supervisor in charge. Until the opening of Golders Hill Park across Sandy Road (with the addition of a small zoo) this must have been one of the most out-of-the-way corners of the Heath.

Approaching North End from the west along Sandy Road brings us into the
*102* hamlet through Heath Passage, shown in another etching by Monk. This alley was severely damaged by a bomb in the war, which also wrecked the Hare and Hounds, but the cosiness of the neighbourhood conveyed by the print survives. A number of other prints showing cottages on the Heath are probably of the
*108* western fringe of old North End, including a Childs-like lithograph by Paul Gauci.
*109* Another by J. Skinner Prout shows the wooden stakes used for drying laundry, a long-standing bone of contention with the Heath keepers. This would appear to
*129* be the same view as that in Childs' Plate 13, looking north-east from the boundary of Golders Hill. The cottages are those which lined North End Way north of Ambridge's. Newton suggests the roof and chimney in the distance are those of the Bull and Bush.

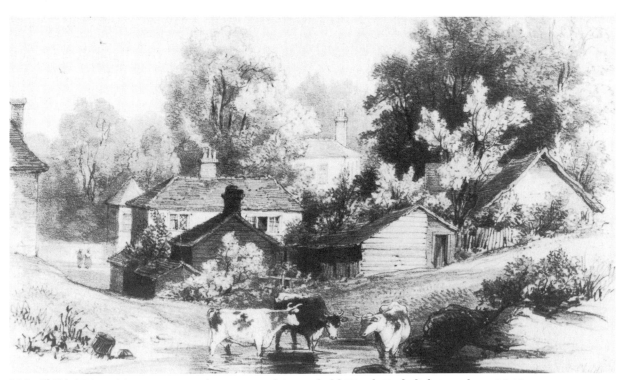

129 *Childs' Plate 13, cottages at the western fringe of old North End; lithograph, c. 1840.*

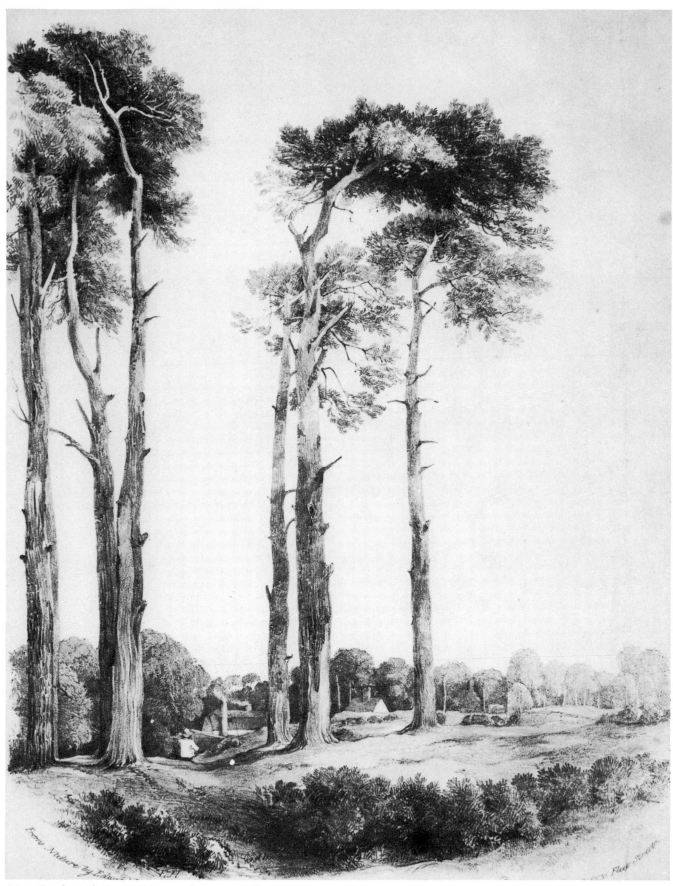

*139 North End pines; lithograph by Hassell, 1837.*

The walk from North End to the Spaniards is over terrain despoiled by sand digging in the nineteenth century but since returned to natural woodland. To the east it rises steeply to the promontory on which the improver of Sandy Road, John Turner, built himself (or converted) the house known as The Firs. In front of it he planted a grove of pines out on to the Heath to form what became the Firs Avenue. Although little of any avenue remains, pines still stand where they have done for over two centuries. There is no shortage of prints of them.

*145* Baynes' lithograph of 1822 shows the trees near the boundary of The Firs in a timeless Hampstead scene: ladies picking flowers on the Heath and a fastidiously dressed man walking his poodle up the footpath. The pines are drawn with exaggerated gracefulness. A more mundane engraving of 1844 shows workmen *146* drawing a sand cart along Sandy Road, with the wounds of excavation on all sides.

*147* A Barnard lithograph of six years later shows the same scene but from the opposite view, looking north-west. His contrasting of sun and shade, pines and donkeys makes this seem almost a Spanish landscape. The artist appears to have placed himself leaning against a tree.

The Firs building survives converted into three houses to the left of the entrance to Spaniards End, an aggressively modern neighbourhood built since World War II in what was Turner's Wood. Next to it, Heath End House and Evergreen Hill contain the remains of Erskine House, which guarded the end of Spaniards Road before it dipped past the old tollgate. The latter took its name from Lord Erskine, who moved here in 1788 and stayed for 33 years. He was probably the most distinguished of all Hampstead's many lawyers, achieving the Lord Chancellorship in 1806. He was an ardent advocate of reform – or as ardent as a wealthy lawyer was likely to be. Erskine defended Tom Paine and was a fierce opponent of Edmund Burke. Barratt relates how Burke, late in life, visited him and

*145 The Firs; lithograph by Baynes, 1822.*

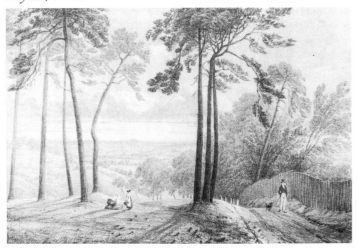

*147 The Firs, looking north-west; tinted lithograph after Barnard, 1850.*

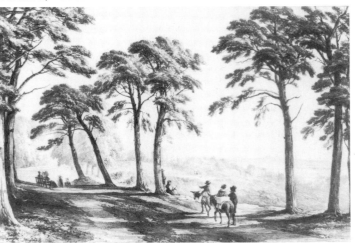

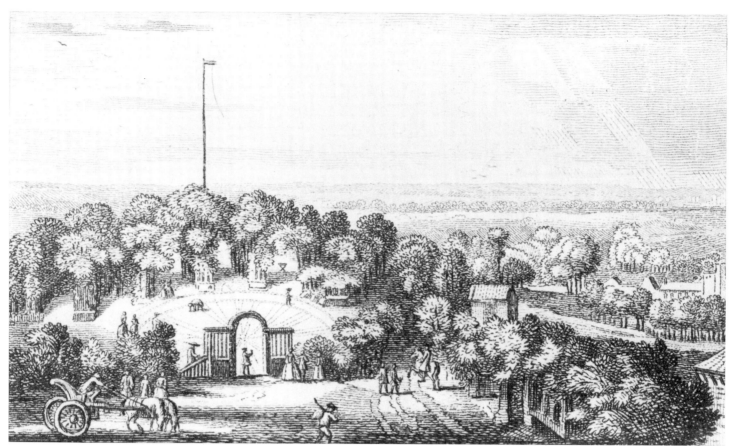

*161 The Spaniards Inn; copper-engraving after Chatelain, 1750.*

went walking with him in his Hampstead garden. Suddenly the whole panorama of London burst into view at sunset and Burke cried, 'Oh, this is just the place for a Reformer – all the beauties are beyond your reach!' An apt Hampstead motto.

As with so many English taverns, the origin of the name of the Spaniards is obscure. It was an ancient tollgate inn by the barrier on to the Bishop of London's estate north of Highgate. One legend suggests that a colony of Spanish refugees may have settled here round a house belonging to the Spanish ambassador in the reign of James I. Another says it commemorates the death of a local Spaniard in a duel. The most plausible is simply that an early proprietor was of Spanish origin.

The tavern had the name at the start of the eighteenth century and its pleasure garden, surrounding an artifical look-out mound, was clearly in full swing by the time Chatelain drew it in 1750. It included a set of mechanical surprises, mosaic *161* tableaux of the seven wonders of the world, summer-houses for tea and winding ornamental walks. The precise location of the mound is a mystery, though Christopher Ikin believes it stood just inside the present grounds of Kenwood House. The Chatelain would thus be a view south, perhaps with structures on the site of the present Mount Tyndal to the right.

The most famous incident in the tavern's history was during the Gordon Riots in 1780. The rioters had already sacked Lord Mansfield's house in town and stopped at the Spaniards for refreshment on the way to do the same to his new house at Kenwood. The landlord, Giles Thomas, was more than a match for them. He detained them with such quantities of liquor that there was time to summon the cavalry and arrest them. It is an indication of the attraction of Hampstead to the eighteenth-century legal profession that three present or future residents – Mansfield, Erskine and Loughborough – dominated the trials of the Gordon rioters. It was before Mansfield's court that a jury finally acquitted Gordon himself, after a brilliant defence speech by Erskine. So amazed was Erskine at this acquittal that he fainted.

A more light-hearted Spaniards incident occurs in Dickens' *Pickwick Papers*: the final come-uppance of the appalling Mrs Bardell at the hands of the equally *170* appalling firm of Dodson and Fogg. Onwhyn's etching shows the tea party thrown into disarray as Mrs Bardell is 'taken in execution on cognovit for costs' and conveyed forthwith to the Fleet.

*163* A steel engraving made for Dugdale in 1838 shows the forecourt of the Spaniards in Dickens' time, with the tollhouse to the left and the back of Erskine House behind. Despite recent pressure to remove the tollhouse to speed the passage of traffic, this scene is little changed today.

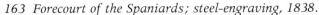
170 *An incident at the Spaniards; etching by Onwhyn, 1837.*

163 *Forecourt of the Spaniards; steel-engraving, 1838.*

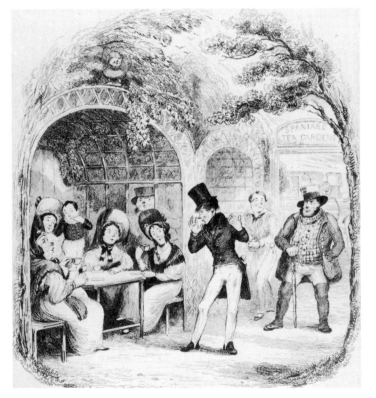

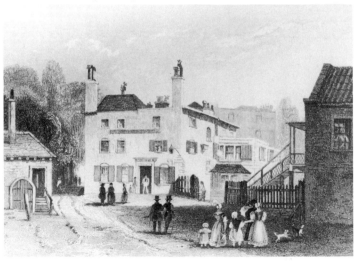

# 6

# VALE OF HEALTH

If North End seems at times a distant colony of Hampstead, the Vale of Health is virtually an independent state. Originally a dell below a plot known as Hatches Bottom, it was no more than a malarial swamp until it was drained and dammed in 1777. Shortly afterwards a row of paupers' cottages were constructed a short distance above the new pond, displaced from Heathbrow above. These cottages formed the copyhold bridgehead into the Vale. The paupers were displaced again and successive residents managed to obtain ever more of the Heath 'waste' round their property for gardens and then for new building and subletting.

The little community did not grow quickly. The area was clearly tainted by its past associations, and this is the most plausible derivation for the change of name from Hatches Bottom to Vale of Health. Yet from the start it provided artists with an ideal combination of trees, water, buildings and the familiar feature of St Paul's Cathedral on the horizon. All these components can be seen in our first print of the Vale, by Stowers in 1796. Cows are watering in the pond formed by the new dam. *176, p. 72* Behind them is the small pier constructed to help water carriers fill their buckets. Farther back is the roof of the Pryors with an alarm bell above it, and to the right is the façade of Squire's Mount. London smokes away in the distance. It is a view repeated in numerous later prints.

Not until 1804 do we have a sight of the early cottages themselves in an aquatint *177, p. 72* by Sarjent. Whether they were still occupied by paupers is not known, but they were clearly modest dwellings. The boundary of the settlement is marked from the Heath by a fence which can be traced in a number of later prints. Just two of these cottages survive today, much altered, as Hunt and Woodbine Cottages, tucked in behind the Villas-on-the-Heath.

Yet for all its simplicity, the Vale was within ten years a magnet for a most distinguished group of London's literary dissidents – much as North End was to be for landscape artists. In 1815 the poet and essayist Leigh Hunt retreated here after his release from prison for libelling the Prince Regent. He stayed in the Vale only briefly from 1815–18 and again in 1821, but his hospitality to such contemporaries as Shelley, Keats, Lamb and Hazlitt covered the place in reflected

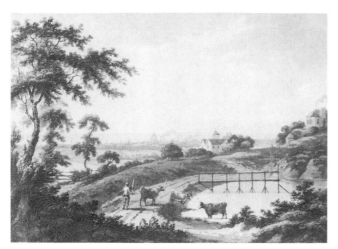 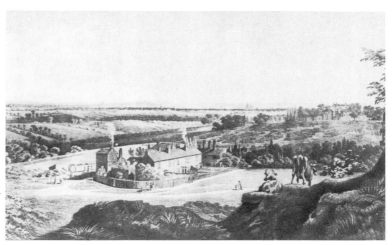

*176  Vale of Health; aquatint after Stowers, 1796.*          *177  Cottages of the Vale of Health; aquatint after Sarjent, 1804.*

glory and led a number of local houses to claim him as occupant.

　　Which one is right? An unofficial plaque declares that Hunt lived in a cottage on the site of the present South Villa, next to what has (confusingly) been named as Hunt Cottage. This attribution appears to rest chiefly on a local postman's recollection to Caroline White in the 1890s. Helen Bentwich, in her careful history of the Vale, debates this issue at length. She points out that Hunt at the time had a large family, a servant, a study and a piano, not to mention the considerable dining table now in Keats House. He was clearly able to entertain in some style. Nor was this just a bolt-hole. The Vale property was never rated as his and appears to have been lent to him by his wife's father, presumably a gentleman of means. Does all this really suggest one of those tiny cottages?

180　　In 1865, the *Art Journal* was firmly crediting the larger Vale Lodge as Hunt's
177　residence. This house, built sometime after the Sarjent print, appears at the near
178　end of the original row in a steel engraving of 1850. Barratt assumed it was Hunt's residence for at least one of his stays, and it appears from the rate books to have been the most substantial house in the Vale at the time. However, Edmund Blunden, in his life of Leigh Hunt, suggests the correct house is that shown in the
179　Shepherd engraving of the Vale in 1827. This would appear to be Pavilion Cottage, once occupied by Lady Dufferin and mentioned in an 1848 will as possessing 'garden, conservatory, coach-house and stable'. It was rated at £52, making it the second most valuable property after Vale Lodge. Pavilion Cottage is identifiable with the present Manor Lodge: indeed it still has the small conservatory shown in the 1827 print. The garden curtilage remains the same today, despite the intrusion of later dwellings on almost all sides. Whether this was indeed Hunt's residence is another matter. Vale Lodge must be considered the favourite.

184　　In the steel engraving of the Vale which formed the engraved title-page to a

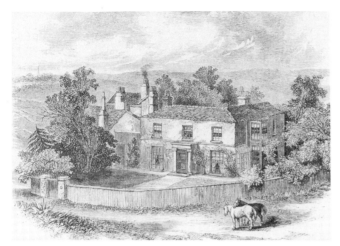

*180  Vale Lodge; wood-engraving, 1865.*

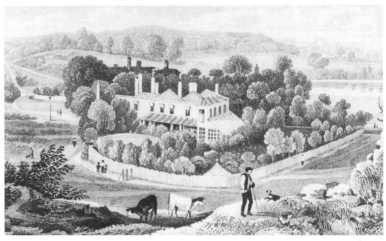

*179  Vale of Health; copper-engraving after Shepherd, 1827.*

biography of the poet George Crabbe in 1834, trees shield us from these properties. Instead we have a house on the site of the future hotel, with willows dipping delicately into the pond. The engraving is by Finden after a drawing by Clarkson Stanfield. Heath House, the Old Court House and Gangmoor (see Chapter Eight) are identifiable on the summit of the hill.

The middle years of the nineteenth century saw the Vale change its character out of all recognition from the small enclave Leigh Hunt would have known. In 1856 the developer, Donald Nicoll of West End (see Chapter Twelve), is recorded as purchasing property on the site of the old poor cottages, and by 1863 a hotel and new villas are mentioned in the ratebooks. The following year a lithograph advertisement was published showing a large building opened by the 'Suburban *190* Hotel Company', aimed at attracting visitors uphill from the recently opened Hampstead Junction Railway's station at South End. The hotel, which later became the Vale of Health Tavern, offered its guests tea gardens, assembly rooms, terraces, grottoes and boating on the lake. Other illustrations of the hotel show that it was not quite as grand as proposed. It certainly experienced an immense if brief *189*

*184  Vale of Health; steel-engraving, 1834.*

*190  The Suburban Hotel; lithograph, c. 1864.*

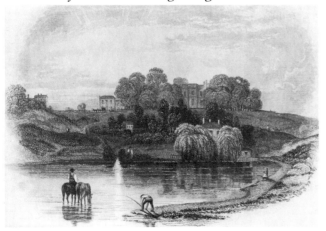

commercial success, drawing summer crowds reminiscent of the early Wells period. The poet James Thomson wrote caustically:

> Babble and gabble, you rabble,
> A thousand in full yell,
> And this is your tower of Babel,
> This not-to-be-finished hotel.

According to Mrs Bentwich, Nicoll sublet part of his property to a contractor recently returned from Bavaria, which may explain the deep, chalet-style gabling applied to his new speculation, the Villas-on-the-Heath. These villas can be seen on the left of the hotel advertisement. Indeed the whole Vale of Health enclave has been given a continental atmosphere by the artist, much in keeping with the Alpine enthusiasm of the time. In 1869 another smaller hotel was built to the west of the first, next to a large hall in the style of a chapel. This can be seen in a subsequent print of the 'Suburban Hotel', sandwiched between it and the Villas-on-the-Heath.

The Vale had just 14 houses on the rate books at the start of its 1860s expansion. By 1890 this number had increased to 53, all on copyhold land and all at a time of fierce controversy over the issue of encroachment on the Heath. Thompson points out that Donald Nicoll was at this time chairing meetings to petition against the Maryon Wilson estate's East Heath development bill on grounds of loss of public amenity. Nicoll was successful on all counts and the result of his hypocrisy, says Thompson, was 'the conversion of the Vale of Health from a few peaceful cottages into a raucous mini-town with gin-palace-style hotel and vulgar amusement gardens'.

The new Vale properties were of necessity small ones with minute gardens stretching down, if they were lucky, to the pond. Combined with the garishness of the two hotels, this gave the Vale the architectural character of an urban working-class neighbourhood rather than a Hampstead suburban one. (It retains some of this character today, even after successive waves of gentrification.) Gas lighting arrived early. And in 1882 the Salvation Army rented the second hotel, by then called the Athenaeum club, as its local headquarters. A permanent if rather scruffy fair was even installed on land next to the original tavern. Under the proprietorship of the Gray family it holds on to its right of tenure to this day. The tavern itself – called by the Salvationists the 'devil's barracks' – was later converted into flats and artists' studios and finally demolished in 1964. It is now, like the site of the Salvation Army hall, a block of flats: the only modern intrusions in an otherwise wholly pre-twentieth-century environment.

# 7

# SOUTH END AND DOWNSHIRE HILL

Pond Street in the seventeenth century was of sufficient importance to be mentioned on early maps in its own right. In the 1630s it was recorded as the only 'street' apart from the High Street. By the early Wells period it was already lined with prosperous residences, many of them occupied by doctors strategically placed on the route from London to the Long Room on Lower Heath. One of Hampstead's village greens was situated at the junction of Pond Street and what is now Rosslyn Hill, a sad fragment surviving behind the present St Stephen's Church.

Nothing marks the status of early Pond Street so much as the attention paid it by Chatelain. An engraving of 1745 shows the prospect up Red Lion (Rosslyn) Hill *191, p. 76* from the Green, the grove of trees on the right marking the turning down Pond Street itself. It is from this point that Chatelain would have taken his second view, *194, p. 76* looking east towards what is now South End Green.

The largest of the houses in Chatelain's second engraving is identifiable today by the three dormer windows of its top storey and stands just below the Roebuck pub. Most of the other buildings in the print also survive, though some are now buried behind later Victorian façades. This same row is also shown in the frontispiece of Dr Thomas Goodwin's 1804 propaganda tract intended to revive *196, p. 76* Hampstead as a health resort. The 'neutral saline' springs which Goodwin claimed to have found somewhere near the bed of the Fleet stream at the foot of Pond Street would 'relieve diseases connected with stomach and biliary functions, the usual companions of wealth and indulgence'. For good measure they were also 'excellent for weakly women who are desirous of being mothers' and as an added bonus the waters yielded precious stones 'similar to those brought back from the East'.

No more was heard of Goodwin or his cure, nor even of Hampstead's spa water. But the medical profession certainly had the last laugh on Pond Street. Behind the trees to the right of Chatelain's print was a succession of large houses which, by the mid-nineteenth century, included Bartrams, Bartram House and Tensleys (names more resonant of Surrey than Middlesex). These steadily vanished before an onslaught of hospital-building, creeping up from the working-class district

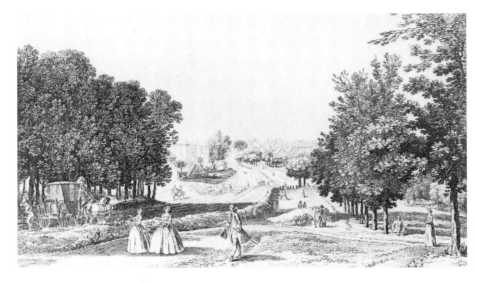

*191 The prospect of Red Lion (Rosslyn) Hill; copper-engraving after Chatelain, 1745.*

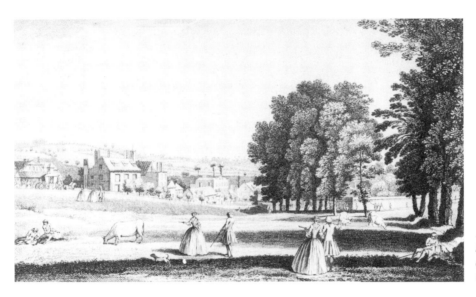

*194 The view towards South End Green; copper-engraving after Chatelain, 1745.*

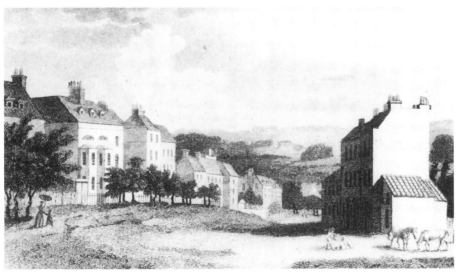

*196 Pond Street; copper-engraving, 1803.*

round what became Fleet Road. First was the North Western Fever Hospital, then the Hampstead General and finally in the 1960s the towering mass of the new Royal Free. Its bulk, overwhelming every local contour and destroying countless Hampstead vistas, is one of north London's architectural outrages.

The small pond from which the district takes its name stood where there is now more of a maelstrom, as traffic swirls round the tiny green. A copper engraving for *Marshall's Select Views of Great Britain* (1825–8) portrays South End as a tranquil *197* hamlet with a turf cart and boys fishing in the pond. The view is looking due east from the present triangle, with the site of South End Close on the right. Parliament Hill rises behind. The pond was filled in soon after this print was made and all the properties shown have since been demolished, first for the railway and then for the trams.

Childs now presents us with a conundrum. His Plate 22, 'From the fields near *198* Pond Street', shows according to Newton the backs of houses facing what was to become Fleet Road, though in Childs' day only a footpath marked its route. Neither in Cruchley's map of 1829 nor in Weller's of 1862 (straddling Childs' date of 1840) are any buildings shown as facing this footpath. However, the roofline and chimneys suggest this must be Clifton House, a large building which looked out west at an angle on to the green in the early nineteenth century. Paintings by Alfred de Bourgho and Kate Sowerby (see *Hampstead Annual* for 1901 and 1902) show views which corroborate this. Beyond Clifton House was the old White Horse Inn, removed in the 1880s. In the background of Childs' print are houses rising up Pond Street itself.

We now climb uphill from South End towards East Heath Road and encounter another challenge of Hampstead topography, ponds galore. At the time of Rocque,

*197 South End;*
*copper-engraving, 1828.*

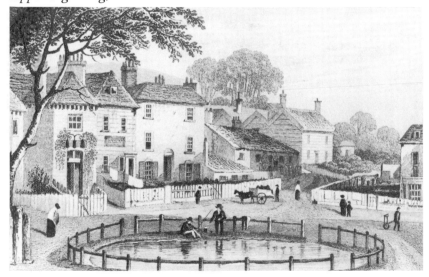

*198 (Detail) Childs' Plate 22,* From The Fields Near Pond Street; *lithograph, c. 1840.*

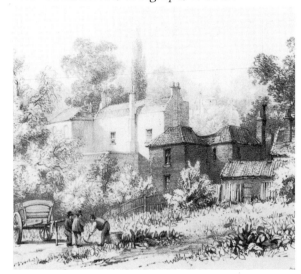

there were just two ponds on the lower Heath. Park in 1814 increased the tally to four, but by the end of the nineteenth century it was down to three, the present total. There were also ponds on either side of the viaduct on the East Heath, as well as the Vale of Health pond and seven out of our area on the Highgate side of the Heath, often referred to (including by Rocque) as 'Hampstead Ponds'. Artists and their engravers were not fussy about their captions.

It was in the sixteenth century that Tudor monarchs first sought to secure proper conduits for water supply to the cities of London and Westminster. Apart from the Thames, London's water came primarily from the Fleet, Hampstead's contribution to which rose in the Vale of Health and in the area of Willow Road. Westminster was supplied by the Tyburn, rising at Shepherd's Well behind Rosslyn House, and the Westbourne, one tributary of which began in Frognal near the church. Conduits for this were uncovered during the building of the new University College School at the start of this century. As we saw in Chapter One, these streams were not properly exploited until the formation of the Hampstead Water Company in 1692 (*Camden History Review* No. 3) when it was probable that the first Heath ponds were formed.

These reservoirs, augmented by that in the Vale of Health in 1777, were sufficient for the next century and a half. But in 1835 demand again exceeded supply and a well was sunk above the lower pond with a circular engine house to pump water to the surface. This structure, seen in a contemporary print, survived until 1907, ending its life briefly as a private residence. In 1856, the New River Company arrived across the Heath from Highgate, and Hampstead houses were gradually connected to mains supplies from the reservoir near Whitestone Pond.

The result of these measures was to render unnecessary the various wells and ponds which appear in numerous prints of the Heath and the town. Baines records their being filled in at Branch Hill and Windmill Hill (both painted by Constable), Frognal, Rosslyn Hill, Pond Street and the Lower Pond at the south-east extremity of the Heath. Of these, the last was the largest, marked today by the area of lush

*201 Lower Pond from the north; lithograph by Childs, c. 1840.*

*203 View from the Heath towards the back of Pond Street; copper-engraving after Chatelain, 1745.*

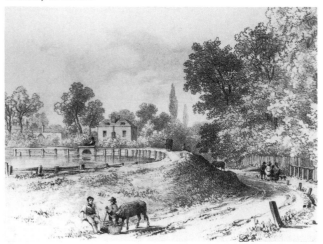

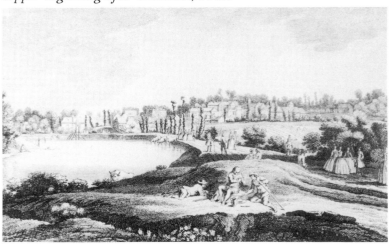

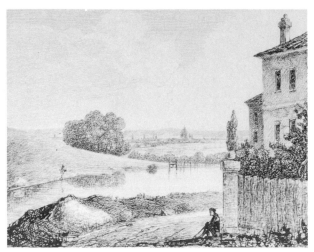

*202* Near Pond Street; *etching by Hastings, 1828.*

grass opposite the foot of Keats Grove. Standing as it did at the entrance into the Heath, it had been drawn by many Hampstead artists, including Childs and Chatelain.

Childs shows the Lower Pond from the north with the entrance to South End *201* behind. It was heavily banked and seepage must have meant winter misery to the cottages beyond. After the construction of South Hill Park in the 1870s, residents petitioned for its drainage on the grounds of public nuisance and this was finally done in 1892. This is the same pond as Chatelain used in his earlier, and therefore less bosky, prospect from the Heath looking towards the back of Pond Street. It is *203* one of his most characteristic prints: ladies from the Wells are strolling or sheltering from the sun, but the foreground is held by local herdsmen having a picnic. Their cattle are refreshing themselves in the water and a group of boys are taking a swim.

The Hastings print of a scene 'Near Pond Street' is as vague as ever, but has been *202* taken to be wrongly captioned and to show the Vale of Health pond with London in the distance. After seeing his original sketch (Swiss Cottage Library), I am prepared to take Hastings at his word and place it somewhere at the foot of Downshire Hill or Keats Grove, then in the course of construction. The corner of the house is similar to that shown in an 1833 watercolour of Downshire Hill by George Shepherd at Swiss Cottage Library, but we could be victims of more Hastings capriccio.

Between the foot of Pond Street and the area of the Wells there is nothing but open heathland on Rocque's map of 1745. This is the terrain crossed by a winding track (now Willow Road) in Chatelain's print of the Long Room seen in Chapter Two. Building on the Downshire Hill estate began shortly after 1812 under a lease taken by William Coleman. The builder/designer appears to have been William

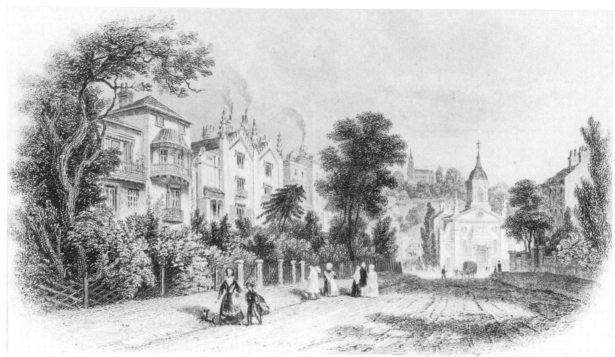

*204  Downshire Hill; steel-engraving, 1842.*

Wood, whom Prudence Hannay has shown to have been active in both
Hampstead and Brixton at this time (*Country Life*, November 1976). Apart from
some villas at the foot of what is now Keats Grove, building does not seem to have
begun in earnest until 1818. Downshire Hill is sketched in on Park's map of 1814
and appears on the Ordnance Survey for 1822. The whole district was completed
by the end of the 1820s, suggesting a pace and unity of development reminiscent
of Church Row a century earlier.

Downshire Hill was one of the first instances in Hampstead of comprehensive
estate development, though it proved to be comprehensive commercially rather
than stylistically. Its architecture is particularly intriguing, coming at a time when
Regency eclecticism was at its height. Gothic and neo-Tudor details jostle with
Georgian verandas and Regency bow windows, all united by a common stucco
façade to produce what Edmund Blunden has called 'elegance without
effeminacy' (guide book to Keats House).

204    One of the only two prints of Downshire Hill is a steel engraving of 1842. It
shows Nos. 4–8 on the north side of the hill, opposite the new St John's Chapel
with Highgate church on the far horizon. St John's gave a delightful visual focus
to the estate, set off-centre at the angle of the Hill and John Street (now Keats
Grove). Though originally intended as a chapel-of-ease for the parish church –
hence its name – it was opened in 1823 as a proprietary chapel for the estate itself.
It narrowly escaped demolition in the 1850s for a new parish church and is now

the last such chapel in London, held in trust for its congregation. William Wood, who appears to have produced the design himself, chose a florid classicism in a style normally referred to by architectural historians as 'debased' classical. The restored St John's now looks a simpler and more handsome building.

One indication of the success of Coleman's estate was the fact that among its first tenants was the antiquary, Charles Dilke. In 1816 Dilke took a villa, which he called Wentworth Place, jointly with his friend, Charles Brown. It was here two years later that John Keats sought refuge from his lodgings in Well Walk after the death of his brother. When Dilke moved out in 1819, his side of the house was taken by a Mrs Brawne with whose daughter, Fanny, Keats was deeply in love. There followed an intense courtship which ended tragically with Keats' departure for Rome and his death in 1821. Keats stayed at Wentworth Place for little more than a year, but it was the scene of so many of the incidents of his adulthood as to have taken on the aura of his presence. It is now a Keats museum, containing such memorabilia as Leigh Hunt's table (from the Vale of Health) and Joseph Severn's moving pictures of Keats in Hampstead. It also has an excellent set of Chatelains on display.

No print survives of Keats' time in Wentworth Place, nor of the house itself. But he gave his name to the seat on which he rested beneath the stable of Foley House in Well Walk. It was here that William Hone met him several months before his death, 'sitting and sobbing his dying breath into a handkerchief, gleaning parting looks towards the landscape he had delighted in'. It is this meeting which appears to be portrayed in the wood engraving of two figures at the Heath end of Well *206* Walk. The view is unchanged today. A new seat has been installed but with its great trees this remains one of Hampstead's more melancholy corners.

*206  Well Walk; wood-engraving, 1869.*

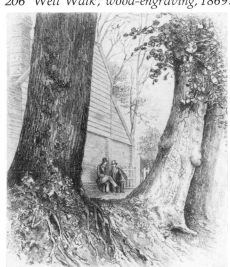

# 8

# THE HEATH

Hampstead Heath has so far been little more than a backdrop to our story. We must now bring it centre stage. As we saw in Chapter One, evidence of the Heath as a London resort dates back to the middle of the seventeenth century, although it was the development of the Wells at the turn of the eighteenth century which made a walk on the Heath a fashionable adjunct to a visit to the Long Room. The literature of the period mentions by name such locations as the Upper Flask, Whitestone Pond, the Bull and Bush, Mother Huffs (near what was until recently St Columba's), the Spaniards and New Georgia. However, none of these symbolised a visit to the Heath quite so much as the tavern known as Jack Straw's Castle, crowning the brow of the hill from every direction.

Little is known of the early history of this inn. Victorian rebuilding unearthed some Tudor brick foundations, and much research has gone into discovering some link with Jack Straw, whose activities during the Peasants' Revolt did not involve Hampstead. There is no evidence that Straw or his supporters called at Hampstead on the way to his rallying point at Highbury (paper to Camden Historical Society by Andrew Prescott in 1981). In 1898, Professor Hales argued convincingly that Jack Straw was merely a generic name for a farm worker: calling a farmer's pub Jack Straw's Castle, of which versions occur elsewhere in England, was rather like calling a seaside pub Jack Tar's Cabin (Hampstead Antiquarian and Historical Society, 1898). We have no knowledge of a castle on the site, though ancient earthworks would have been possible on such a prominent spot.

The first documentary evidence for the tavern is in 1713 when the owner of the Hampstead brewery in the High Street, John Vincent, is recorded as proprietor. Our earliest print, apart from glimpses at a distance, is a steel engraving of 1834 showing it free-standing with Regency bow windows. Shortly afterwards the Castle Hotel was added next door, seen in Ware's trade card of the 1840s. Jack Straw's was severely damaged by the land mine which exploded on Heathbrow on 19 March 1941, and it was not until the neo-Georgian architect, Raymond Erith, rebuilt it in 1961 that a structure approximating to a castle finally appeared.

The area of Heathbrow beyond was wiped out in the same explosion. Researches by David Sullivan (*Hampstead and Highgate Express*, 25 May 1979) have revealed that the vanished neighbourhood was not just a group of Georgian houses but a long-standing hamlet of heathland cottages, blessed with the humble name of Littleworth. Like many such settlements, it appears to have developed at times of laxity in manorial discipline, such as that caused by the loss of records in a fire in the 1680s. Although no trace remains of either Littleworth or its successor Heathbrow, one of its properties is possibly that shown in a print by the avid recorder of the antique, J. T. Smith, in 1797. The engraving was published in *215* Smith's *Remarks on Rural Scenery* and is of a man and his small cottage with a turf enclosure. Various rustic implements are scattered round about.

Historically, property development on the Heath usually began with just such a settlement. Gradually its occupant would acquire permanent status and be admitted to a copyhold 'under the custom and practice of the manor'. The copyholder would pay a fine for life to the lord at a session of the manorial court. Since there was plenty of land left for the remaining commoners and the arrangement suited both lord and copyholder, no one had much interest in restraining this form of commons appropriation – until the nineteenth-century Heath protectionists arrived on the scene. Settlement occurred on any level plot of land where building was feasible: the plateau round Whitestone Pond, near the Spaniards and on the Heath fringes at North End and Well Walk. It is these simple copyholds, often just squatters' cottages, which eventually blossomed into such huge blocks of flats as Bellmoor and the Pryors.

Thus we can assume the buildings round Jack Straw's Castle did not remain as in Smith's engraving for long. Littleworth's magnificent position with views both north and south across the Heath soon saw it become an enclave first of villas with names such as Crewe and Camelford Cottages and then, in the early nineteenth

*208 Jack Straw's Castle; steel-engraving, 1834.*

*215 Perhaps Littleworth; etching, 1797.*

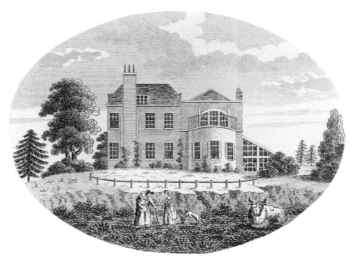

*220  Heathlands, residence of Sir Francis Willes;*
*copper-engraving, c. 1800.*

century, of a group of gentlemen's residences. These had confusingly similar names: Heath View, Heathbrow, Heath House, Heathlands, The Hill and Heath Lodge. Of these only Heath View (now misleadingly named the Old Court House) and the restored and extended Heath House remain eighteenth-century in appearance.

For most of these properties, we have engravings of the sort commissioned in the eighteenth century by local gentlemen to celebrate their suburban 'seats' –
*220*  anonymous and not dateable except from rate-books. Heathlands, nearest to Jack Straw's Castle, was the residence from 1777 of a civil servant named Sir Francis Willes. To extend his property, Sir Francis appears to have acquired three old properties at Littleworth and these were relocated below Hatches Bottom, where the land had been recently drained to create the Vale of Health reservoir. Sullivan has shown that Samuel Hatch, the early eighteenth-century owner of land near the Vale of Health, was also a holder of property at Jack Straw's. There was clearly some tenure connection between the two enclaves, and the improvement to the Vale property by drainage offered an excellent opportunity to Littleworth residents to relocate their less desirable neighbours and raise the tone of their community. It is ironic that since the wartime devastation, this whole district has been cleared and its site now provides a rare instance of residential property actually reverting to Heath use. The Vale of Health lives on.
*218*  Next came The Hill (or Hill House), home of Thomas Gattaker from 1797 until he sold it to Samuel Hoare in 1807. Hoare wanted a home for his eldest son on his marriage to Louisa Gurney, sister of Elizabeth Fry. It was from here that his grandson, John Gurney Hoare, presided over the Heath preservation battles of the mid-Victorian period. It remained in the family until the early twentieth century

when it was bought by William Lever, the future Lord Leverhulme, and amalgamated with Cedar Lawn immediately to the south. The rebuilt mansion later became Inverforth House and is now part of Manor House Hospital.

A small footpath divides The Hill property from what was Heath Lodge. This had been built in about 1775 on a plot of land flagrantly seized from the Heath by an actress named Mrs Lessingham through the good offices of the then lord of the manor (how 'good' we do not know). Barratt relates that she circumvented the protests of other copyholders (already incipient conservationists) by purchasing a small copyhold cottage in the vicinity and thus obtaining rights under the custom of the manor. Nonetheless, they tore down her fence and attacked her workmen before a court action found in favour of her beneficiary, the lord of the manor. Mrs Lessingham was apparently also a good friend of the judiciary. The Heath Lodge which appears in a print was owned at the time by James Kesteven. It was *219* acquired at the beginning of this century as yet another part of William Lever's aggrandisement. He then demolished the house and added its garden to that of The Hill. It is now a small ornamental park, open to the public and with access to the hospital's magnificent, and increasingly wild, rose pergola.

The angle between New End Way and Spaniards Road is dominated by the eighteenth-century façade of Heath House. Its most famous owner was the Quaker banker, Samuel Hoare, who bought it in 1790 and established a Hampstead dynasty which played a leading part in local life for more than a century. It was from here that Barratt records him setting out for his Fleet Street bank each day, the only commuter at the time who possessed a coach-and-four. He would gain in popularity – and doubtless bend many an ear – by offering others daily rides to and from town. Samuel Hoare was an enthusiastic philanthropist, locally and nationally. His campaigns against slavery and for prison reform, orchestrated from his Heath-top eyrie, played a large part in giving a progressive and enlightened reputation to a suburb which might otherwise have been regarded as merely prosperous. Wherever a local subscription had to be raised, a poor house rebuilt or a part of the Heath preserved, the name of Hoare was present.

We see Heath House (then called just The Heath) only in the background of Stanfield's view of the Vale of Health with the Old Court House and Gangmoor *184* also on the horizon. There appears to be no pre-Victorian print of the house itself. But its façade can be seen in the background of a Way chromolithograph of *221* Whitestone Pond, looking much as it does today but for a thick screen of trees.

Whitestone Pond is named after the $4\frac{1}{2}$-mile distance stone near the reservoir boundary. It was originally a dew-pond much appreciated by horses after the long climb up Heath Street – indeed at times it has been known as the Horse Pond. Today its shallowness makes it ideal for rescuing capsized boats and for skating in winter. The water is now supplied somewhat ignominiously from the mains.

222    The best view of the pond in the Georgian period is by Westall, engraved by Finden, looking south from in front of Jack Straw's Castle. The two Heath-side groups of Gangmoor and Bellmoor are to the left and the wall of the old Upper Flask Tavern is directly ahead at the top of Heath Street. Gangmoor also appears in
224    Hewetson's curiously contoured almanack engraving of 1867 with the spire of Christ Church rising over its roof. It comprised three houses, Gangmoor, Ludlow Cottage and the Lawn and fortunately no-one has ever been able to acquire them all at the same time and rebuild them.

222    The exchange of Bellmoor, tucked in behind Gangmoor in Finden's print, for the present block of neo-Tudor flats is a poor one. The name derives from the presence on the old house of one of the town's alarm bells: there were also at various times bells on Heath House, the Pryors, Cannon Hall (which survives) and
225    the old School House in North End. The bellcote can be seen in a Hastings etching, which shows Alsop's cottages on the Heath above the Vale of Health, cottages
226    which also appear in another etching by Hastings. The culvert under Bellmoor is either a well or a drain, in which case it might qualify as the highest known source of the Fleet. More baffling is Hastings' clump of trees, which are absent from the first print. Barratt states that the cottages were cleared in the late-nineteenth century. Such a loss of building rights on the Heath was extremely rare, but as the owner of Bellmoor from 1877, Barratt ought to know.

*222 Gangmoor and Bellmoor; steel-engraving by Finden, 1829.*

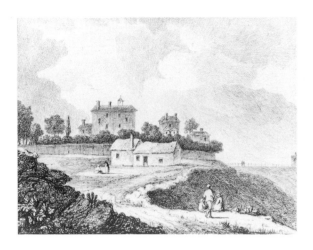

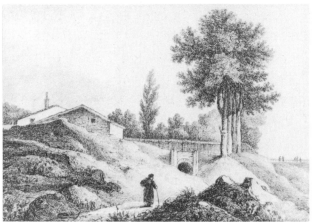

226

225  *Bellmoor, Gangmoor and Alsop's Cottages; etching by Hastings, c. 1825.*

226  *Alsop's cottages; etching by Hastings, 1825.*

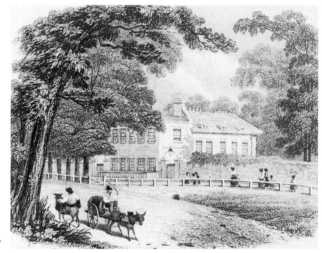

227  *George Steevens' residence; steel-engraving, 1836.*

227

The house at the top of Heath Street behind the trees in Finden's engraving is    *222*
the old Upper Flask (or Upper Bowling Green) Tavern. The inn appears to have
survived into the second half of the eighteenth century, when it was acquired by
the writer, George Steevens, annotator of Shakespeare and friend of Dr Johnson.
He is remembered for his anti-social habits and for the assiduity with which he
worked: at one point struggling all night over portions of his manuscript and
walking down to town at four each morning to get it to the printer on time.
Towards the end of his life, Steevens lived in virtual isolation, but his friendship
with Johnson merited a print by J. T. Smith in *Johnsoniana*. The wide shuttered    *227*
windows on the street front presumably indicate the former Upper Flask range,
while the rear extension may have been added by Steevens. The site is now
occupied by Queen Mary's Nurses' Home for the Royal Free Hospital but the wall
onto the High Street remains, as do the gateposts and lamp brackets. A donkey in
Smith's foreground is having to be whipped to go downhill.

Continuing round the pond, past the reservoirs and observatory, we reach a
triangular property which belonged in the eighteenth century to a Mrs Haycocks.

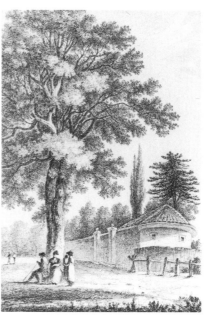

*232 Looking from the pond towards Judge's Walk;*
*etching by Hastings, 1824.*

*231  The village tree; etching by*
*Hastings, 1826.*

There are two views of it by Hastings and their typically exposed aspect contrasts
with the bustle of Westall's view of the same area. Hastings' first print shows the
232  pond looking south-west towards Judges Walk, with the house known as The
Grange in the right distance. The second is closer to the wall of Haycocks with the
231  'village tree' in the foreground. This tree, shown with locals resting on a seat
round its trunk, was a traditional speakers' corner. Here the preacher Edward
Irving is recorded as having 'held forth standing on the seat beneath the beech, his
hair blown by the wind, gesticulating violently'. The site was later incorporated
in the grounds of what became Tudor House – owned in the nineteenth century
by Mr Goode of the Mayfair china firm – and is now in the garden of Hawthorne
House. The tree ended its life a chained and pollarded stump, but even this
magnificent monument to the ancient Heath was blown down in a gale in 1911.

Across the tiny plateau beyond Hawthorne House, the limes of Judges Walk
look out across the West Heath towards Harrow. The Walk itself takes its name
either from the multiplicity of lawyers living below in Frognal and Branch Hill or
from an assize hearing held here in the open air during a seventeenth-century
plague. Although the former is more plausible, the Victorian antiquarian, G. W.
Potter, suggested the existence of legal documents implying that a session of the
High Court was indeed held in Hampstead to escape the plague. If so, it is yet more
evidence of Hampstead's pre-Wells status.

The Walk, sometimes also known as Prospect Walk and Upper Terrace Avenue, is
233  the subject of a Paul Gauci lithograph from a painting by George Stanfield (son of

Clarkson Stanfield, a successful Academician best known for his seascapes, who came to live in Hampstead in 1847, holding court at Stanfield House, near Greenhill, overlooking the High Street). The cottage of Capo di Monte can be seen on the left through Gauci's statuesque tree trunks. Capo di Monte was briefly the home of another artist, Copley Fielding, but it is best known for a visit in 1804 from the actress Sarah Siddons who was recovering from lumbago. It was here that she apparently tried a new electric shock treatment, which caused passers-by to rush in at the sound of her shrieks, assuming she was about to be murdered.

Ruskin praised Clarkson Stanfield as 'incomparably the noblest master of cloud form of all our artists'. It is ironic that this superlative should be applied to one artist of Hampstead, when the place was also the inspiration of another to whom the accolade is surely more appropriate. For it was here that John Constable came year after year, sketchbook in hand, to 'hear the trees and the clouds ask me to do something like them'. The results are so remarkable in the story of Hampstead prints that they merit a detailed account. (See also Olive Cook and others, *Constable in Hampstead*, Carlisle House Press, 1976.)

Constable's time in Hampstead began in the summer of 1819 when he rented Albion Cottage, next to Bellmoor by Whitestone Pond. The following year he returned with his family and produced his first Hampstead sketch, of The Firs,

*233 Prospect Walk with a glimpse of Capo di Monte; tinted lithograph after George Stanfield, c. 1850.*

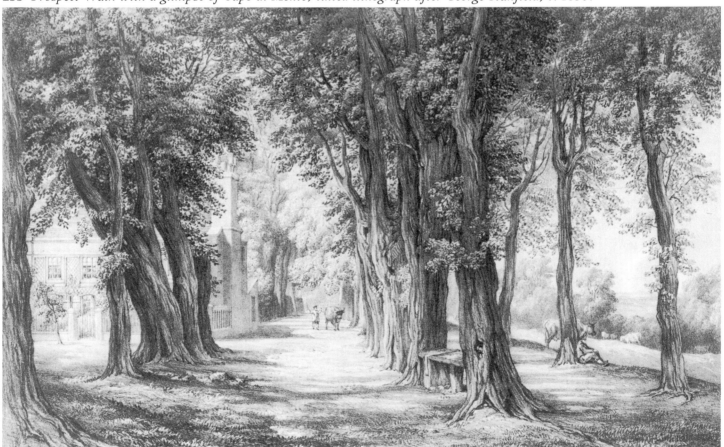

probably the work (now in the Victoria and Albert Museum) which Blake called 'not a drawing but an inspiration'. Constable paintings of Hampstead now came in abundance. He moved his family into lodgings at No. 2 Lower Terrace, not far from Judges Walk. And in 1822 he spent the summer on the Heath working intently on his studies of cloud formations and weather.

Writing to his friend, John Fisher, he recorded: 'I have made some studies carried further than any I have done before, particularly a highly elegant group of trees, which will be of as much service to me as if I had bought the field and hedgerow which contain them; I have likewise made many skies and effects.' His correspondent, C. R. Leslie, recalled later that 'Constable's art was never more perfect, never so perfect, as at this time'.

For the next decade, Constable was back and forth between Hampstead and his Charlotte Street studio, working constantly at sketches inspired by the clear air and long vistas of the Heath. Few of these pictures are of special topographical interest. Hampstead offered Constable neither East Bergholt Church nor Salisbury Cathedral. What it did offer him was sky. The landscape which lay at the foot of his Hampstead paintings was to mirror that sky. Fields and hillsides existed only to reflect its moods, its clouds, its storms, its sunlight, its time of day and its season of the year. Constable wrote that the 'landscape painter who does not make his skies the very material part of his composition neglects to avail himself of one of his greatest aids . . . the sky is the source of light in nature and governs everything'.

Despite this ardent naturalism, Constable regarded himself as in the mainstream of European landscape art. The lectures which he delivered in 1833 at the Hampstead Assembly Rooms in Holly Bush Hill were filled with references to the masters from whom he had drawn inspiration, Ruysdael, Claude and Poussin. His letters tell of his desire to convey what he termed the classical 'chiaroscuro of nature'. Yet his later works showed an increasing awareness of the impact of his contemporary, Turner. Like Turner, Constable began to use the tonal extremes of his palette, with paint often applied to the canvas with a palette knife, to heighten the drama of his landscapes. This characteristic was to cause him great anguish as he tried to have that drama reproduced in print form.

It was when Constable was given a successful exhibition at the Louvre in 1824 that there was first talk of making engraved reproductions of his pictures. Nothing appears to have come of this, but Fisher gave a revealing reaction to the news: 'I am pleased to find they are engraving your pictures, because it will tend to spread your fame: but I am most timid about the result. There is in your pictures too much evanescent effect and general tone to be expressed by black and white. Your charm is colour and the cool tint of English daylight. The burr of mezzotint will not touch that.'

Nonetheless the idea was formed. In 1829, spurred by the success of Turner's mezzotints in *Liber Studiorum*, Constable experimented tentatively with four plates engraved in the workshop of S. W. Reynolds by a mezzotinter named David Lucas. One was a scene of a Hampstead Heath sandpit. Encouraged by the reaction of friends, Constable then planned a series of prints of his most successful early *234* works. These were executed by Lucas, then aged just twenty-seven, in the course of 1830–31 and were published under the title *English Landscape Scenery*. The series initially consisted of twenty plates, though others were added in a second edition in 1833. Lucas published more in 1845 after the artist's death.

Constable professed that his purpose in producing the series was personal and educational rather than commercial. In the introduction he wrote that they were intended to 'promote the study of the rural scenery of England, with all its endearing associations and even in its most simple localities, of England with her climate of more than vernal freshness in whose summer skies and rich autumnal clouds . . . the observer of nature may daily watch her endless varieties of effect'.

The series was a commercial failure. Constable wrote to Lucas, as the latter struggled to complete the final plates, 'all my reflections on the subject go to oppress me, its duration, its expense, its hopelessness of remuneration'. In a mood of gloom he estimated he had lost £700 on the first edition alone. Constable lacked the popularity of Turner, as well as the critical support to rally a public behind him. In the event he recovered from the experience, emphasising defensively that it had not been intended to make money. David Lucas did not recover. He had hitched his career to Constable's star and though we know little of his later life, it appears to have ended in drunkenness and poverty. He died in Fulham workhouse in 1881, in Andrew Shirley's words 'dissipating as fine a talent as was ever bent to mezzotint'.

The prints made by Lucas from Constable's paintings and drawings comprise very different images from the ones we have discussed so far. The latter have been the work of topographical artists for the most part recording local views for reproduction on the eighteenth- and nineteenth-century print and illustrated book market. Most have been pictures of charm and skill and all have been of some topographical interest.

With Constable and Lucas we have artists who make their way into this book almost by accident. Theirs was a highly personal venture and the medium employed, mezzotint, rarely appears in landscape prints. The technique (see page 221) was a tonal one, capable of rich contrasts between light and shade. It was excellent for creating strong effects – hence its popularity for portraiture – but weak on line definition and detail. It was precisely this tonal quality which appealed to the only two major artists to use mezzotint for landscape, Turner and

234  *A sandpit on the East Heath; mezzotint by Lucas after Constable, 1831.*

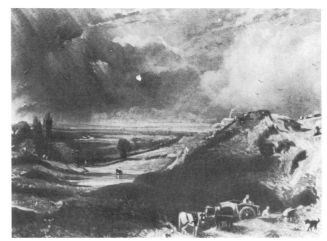

235  *Branch Hill; mezzotint by Lucas after Constable, 1831.*

Constable. But it required as much artistry in the engraving as in the original painting, treatment being all. Turner at various times employed more than half a dozen leading mezzotinters. Constable employed only Lucas, and it is this combination of talents which gives the Constable/Lucas prints their special interest.

Recreating Constable's impressionistic brush strokes gave Lucas unending trouble. The artist constantly criticised his work and demanded frequent changes to the plates. Their correspondence is littered with Constable's abuse. One plate, of which he had sent back an early state, 'looks as if all the chimney sweepers in Christendom have been at work on it and thrown their soot bags up in the air'. Of another he said, 'The sky is and always will be rotten.' Soot continually returns as a theme – a reference to Lucas' attempts to recreate Constable's sharply contrasting chiaroscuro. 'Avoid the soot-bag and you are safe,' Constable lectured him. 'Rembrandt had no soot bag, you may depend on it.' Lucas might have replied that Rembrandt did not have to work in mezzotint.

Yet on many occasions, Constable did show his appreciation of Lucas' work. He wrote of the 'beautiful feeling and execution' which Lucas brought to his plates and spoke of the 'lovely amalgamation of our works'. He was unusual among painters of his time in recognising the crucial relationship between artist and engraver in the production of a print. The results can seem sombre alongside the vitality of the oil originals, but they are works of art in their own right and achieved, in Shirley's words, 'a richness and depth of tone rarely surpassed' in this difficult medium.

Of the six Hampstead scenes painted by Constable and engraved by Lucas, three were for *English Landscape Scenery*. The others were either prepared during his life but not published, or were made by Lucas without Constable's supervision

after his death. The two West End views, both probably (by no means certainly) painted round the slopes of Telegraph Hill, are shown in Chapter Twelve alongside other prints of similar views. The print of Haverstock Hill with Sir Richard Steele's cottage, which first appeared in 1846 is discussed in Chapter Ten. An etching of one of Constable's paintings of Admiral's House (or The Grove), published in 1891, appears in Chapter Three. All are brought together for comparison in the Gallery.

This leaves the three Heath prints, two of the West Heath and one, the original vignette for *English Landscape Scenery*, of a sandpit apparently on the East Heath. *234* This identification is based on St Paul's Cathedral faintly visible in the background, though the pit itself looks remarkably like many Constable portrayals of the area of Branch Hill pond. The two views from beneath Judges Walk are the most characteristic of all Constable's Hampstead vistas, looking out to the west with the rugged landscape of Branch Hill in the foreground, the house known as the Salt Box (later rebuilt as The Grange) to the right, and a distant windmill located almost at random in the composition. But in both prints the real subject is overhead, the sky.

There are so many Constable paintings of Branch Hill that the Tate Gallery catalogue classifies them into types A and B. The first of our two prints, published in 1831 and normally captioned 'A Heath', is type A. The artist is at or near the foot *235* of the incline beneath Judges Walk, close to the pond and with the contours rising to left and right. This gives Constable the opportunity to heighten the shadows in the foreground and draw subjects such as donkeys and sand-diggers fully into the composition. The mound of the Salt Box is over-emphasised and the curve of the quarry rises up as if to meet the storm clouds overhead.

The other print, commonly known as 'The Bathers', was never formally *237, p. 94* published but is a Lucas masterpiece. It is from a higher viewpoint than the first and has the Salt Box moved into the distance (type B). The windmill makes an appearance just to the right of Branch Hill and the sun picks out the bathers in the pond to the left. Here Lucas' portrayal of the sky is truly remarkable, consummating all Constable's Middlesex storms in his mezzotint. Wind, rain, thunder, menace, disaster are all there in the heavens. Yet so too is the eventual clearance, a vision of sunshine and the promise of better things to come. Of all Constable's many paintings of this scene, none conveys quite the force of Lucas' velvety blacks and subtle greys. It is surely the greatest of all Hampstead prints.

Constable was not alone in his appreciation of this particular view and its combination of rugged foreground with pastoral horizon. A quarter-century earlier Stowers produced a remarkably similar print of the Branch Hill Pond, with *240, p. 94* farm carts and the cottage of the Salt Box on the brow of the present West Heath Road. A Lucas mezzotint of Marshall's view of the West Heath in a storm, published *241*

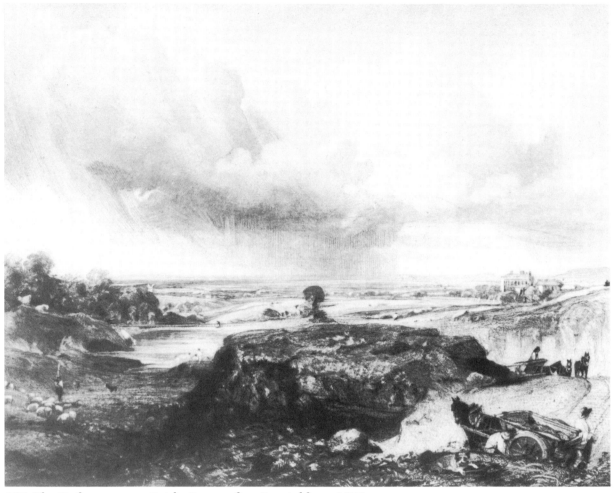

237  The Bathers; *mezzotint by Lucas after Constable, c. 1855.*

240  *Branch Hill Pond; aquatint after Stowers, 1796.*

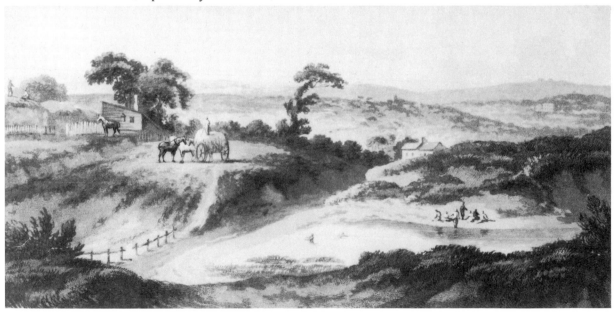

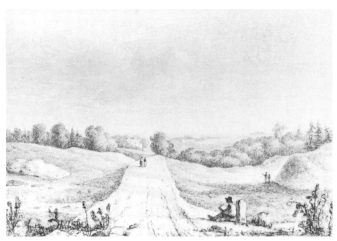

156 *Spaniards Road; etching by Hastings, 1823.*

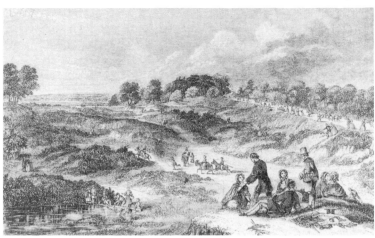

250 *Sandy Heath after quarrying ; wood-engraving, 1856.*

in 1832, is strongly reminiscent of his Constable prints.

The full impact of this quarrying on the Heath is hard to appreciate, so used are we to the sharp inclines it created. Sand and gravel had been taken from the Heath far back into time. The sand was of a high quality, used not only for building but for iron-foundry casts. Documents record that at the start of the nineteenth century, as many as twenty cartloads a day were passing south through Hampstead. The price paid to the lord of the manor varied from 1s. 6d. to 4s. 6d. a load, though copyholders could take it free for their own building. A popular quarry appears to have been on the West Heath at Branch Hill, but thousands of tons must have been removed from Sandy Heath as well. At the height of the Heath preservation battle in the 1860s, Sir Thomas Maryon Wilson sold a quarter of an acre of sand and ballast, from either side of Spaniards Road, to the Midland Railway Company for £1,500.

The result was to produce some spectacular changes in the topography of the Heath. Even allowing for Hastings' artistic licence, it is hard today to recognise his view of 1823, along Spaniards Road, with the Heath actually rising on either side *156* of the track. Yet a Victorian print of just thirty-three years later shows Sandy Heath totally despoiled, with Spaniards Road appearing as a precarious *250* embankment along a ridge – though this does not appear to have deterred picnickers and donkey-riders. It was not until the 1870s and the final preservation of the Heath (see below) that quarrying finally ceased and undergrowth crept back to cover its scars. Many of the quarries near the Spaniards were reused for wartime sandbags and then filled with rubble from blitz-damaged buildings after World War II: a satisfying case of returning to the land its own.

The East Heath was the natural setting for most views from Hampstead towards London. Here the Heath had to take second place to the distant feature of St Paul's

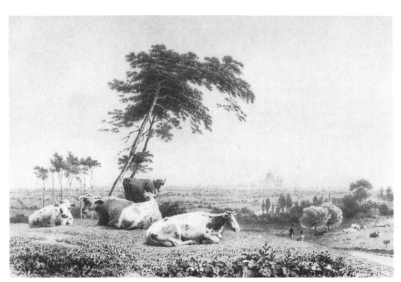

254 *A view from East Heath with St Paul's in the distance; lithograph by Nash, c. 1830.*

256 *The pump house on the right, with London in the distance; wood-engraving, 1876.*

254      on the horizon. In Nash's Cuyp-like print of 1830, with placid cattle filling the foreground, the dome of the Cathedral reaches across to Hampstead from what is by implication a dark and sinful city. Alternatively, St Paul's appears itself

256      engulfed in city smoke, as in an engraving of 1876 where London is presented as a vision of hell, with chimneys everywhere dominating the spires of churches. The sun's rays shine only on the clear air of the Heath. (The pump house above the Lower Pond is in the right foreground.)

     Eccentric as ever, Hastings does not include St Paul's in any of his six etchings of the East Heath produced in the 1820s. The contrast with Childs' lithographs of twenty years later could not be more striking. Childs' views, discussed in Chapter Three, all took as their subjects domestic buildings on the edge of the Georgian town. Hastings conveys the opposite mood. Always he is looking out towards the Heath horizon. Buildings are incidental and often hard to identify. He etched for the most part from cursory pencil sketches (some of them now in Swiss Cottage Library). His trees are mostly prim poplars, as against Childs' full-blown elms, oaks and beeches, and his people appear as anonymous sticks in an exposed, unfriendly landscape.

266      One of Hastings' etchings shows Squire's Mount in a scene identical in location

57      to that of Childs, but here looking out from Heath Cottages towards the horizon.

267      Further south we reach Foley House, with a view back up the hill towards the Squire's Mount enclosure. Next is another view back, this time from the corner of

270      the present Heathside with the Pryors in the background. (This view of the Pryors is similar to a contemporary one by Nevinson in Swiss Cottage Library.) The extent of the encroachment on to the Heath by the Pryors garden is clearly visible and formed the basis for the present-day intrusion of the block of flats of the same

name. Almost all Hastings' prints have a large boulder in the foreground despite the absence of such rocks in the Heath's geology. In the Pryors print, the boulder appears almost abstract in shape.

The last two in this Hastings series are views of and from the eminence now called Heathside. The first is of the present South Lodge, with its pediment *269* exaggerated and a grove of poplars on the Heath beyond. The second shows the view south-east from this slope. The poplars are bowing in a strong wind towards *268* the fields of Kentish Town in the distance.

The Hastings etchings celebrate the qualities of landscape which were to dominate the next stage in the Heath's history, the battle over the fate of the East Heath. This battle kept Hampstead in the headlines, in the courts and even before Parliament throughout the major part of Queen Victoria's reign. The cause of dispute was a plan presented in 1829 by the then lord of the manor, Sir Thomas Maryon Wilson, to build on his Hampstead property. Its resolution was the eventual purchase of the Heath by the Metropolitan Board of Works in 1871. The controversy was such that for half a century no prominent local citizen could remain aloof; it has scarcely abated even today.

The Maryon Wilson family were lords of the manor by line of descent from its purchase from the earls of Gainsborough by Sir William Langhorne in 1707. The land involved was extensive, covering most of Frognal and South Hampstead and the present Finchley Road area almost to West End Lane, It also included common

*266  Squire's Mount; etching by Hastings, 1828.*

*267  View from Foley House towards Squire's Mount; etching by Hastings, 1826.*

*268  Heathside with the fields of Kentish Town in the distance; etching by Hastings, 1828.*

*269  Heathside (South Lodge); etching by Hastings, 1825.*

*270  The Pryors; etching by Hastings, 1828.*

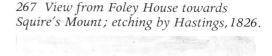

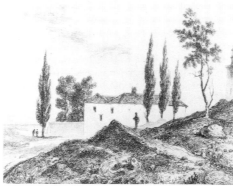

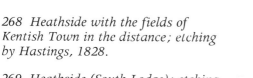

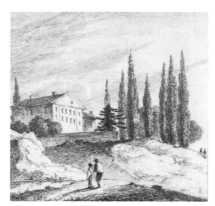

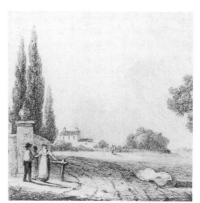

268                   269                   270

land of the Heath, where Maryon Wilsons had always enjoyed the right to fines on admission to copyhold. Crucially, it embraced sixty acres on the east of the present declivity on East Heath, running up to the boundary with the Earl of Mansfield's property of Kenwood. It was this which Sir Thomas Maryon Wilson later decided to develop as a villa estate, not dissimilar from that under way at the time at Belsize to the west. Like many landowners (including Chesterfield at Belsize) he needed Parliamentary powers to waive the terms of his inheritance and permit him to grant building leases on his land. He accordingly presented a bill to Parliament in 1829, and this bill included a clause granting the power to allow building leases also on 'Heath and other waste' under the custom of the manor.

As Professor Thompson has argued in his extensive apologia for Sir Thomas's actions, Maryon Wilson was not seeking anything unusual. His anticipated development was not on the Heath 'proper' and was no different in principle from dozens of suburban developments already springing up over north-west London. The same even applied to the threatened enclosure of the common land. What made it different in practice was its location. Already much of the East Heath had become part of what was regarded as Heath – Sir Thomas had not bothered to fence his boundary as Lord Mansfield had done at Kenwood. But the additional threat that leases might be granted on the Heath proper was explosive.

Hampstead included among its residents not just the new rich but what might be termed the new influential: bankers, lawyers, publishers and parliamentarians. There is no better indication of the emerging power of this group of Victorians than their Hampstead battle with and eventual victory over the landed gentry in the form of Sir Thomas Maryon Wilson. The emotion they mobilised may have been popular feeling for London's open spaces, but this was largely incidental to their main aim, which they pursued with single-minded determination. Any large-scale development anywhere near the Heath – as opposed to their own small-scale encroachments – was a threat to their personal amenity and to the value of their property. It was merely an added misfortune for Maryon Wilson that he lived at his family home at Charlton on the other side of London and could thus more easily be cast in the role of absentee landlord and villain of the piece.

Reaction to the Maryon Wilson bill was immediate. A member of the House of Lords, believed to be Lord Mansfield, sounded the alarm, a copyholders meeting was called, a letter appeared in *The Times*, speeches were made in the House of Commons and Sir Thomas's lawyers withdrew their bill in disarray. Thompson concludes that this first defeat 'for pre-Reform 1829, represents an astonishing trouncing for the sanctity of private property'.

From now until 1869, when Sir Thomas died and his cause with him, the Maryon Wilson interest presented a succession of estate bills to Parliament in a

bid to circumvent what the family felt to be an outrageous infringement of rights allowed to every other landowner in England. Against Maryon Wilson were ranged the men of Hampstead: Gurney Hoare, Holford, Toller, Fenton, Burgh, Neave, Woodd, Nicoll, Mansfield. Parliament was alternately petitioned and filibustered. *The Times* was constant in its vigilance, with editorials reminiscent of Trollope's 'Jupiter': 'Awake, arise, or lose the Heath for ever!' it cried.

Maryon Wilson remained impressively implacable. But as the years passed, a growing sense of the need to protect the few remaining metropolitan open spaces came to the aid of his opponents and the pressure on him mounted. He eventually offered to sell his Heath freeholds to the Metropolitan Board of Works for an astronomical £2.5 million. But it was not until after his death that his more amenable brother, Sir John Maryon Wilson, agreed to sell for £45,000. It was the first of a series of purchases, including Parliament Hill Fields, Golders Hill and the Heath Extension, which have created the Heath we know today.

The battle remains a subject of controversy. F. M. L. Thompson, in his history of Hampstead, turns aside from a scholarly account of the town's nineteenth-century expansion to deliver a sustained attack over two chapters on Sir Thomas's critics. In sideswipes at the Heath preservationists, he accuses them of practising 'unreason, prejudice, hypocritically disguised self-interest and unjust persecution of a single individual', (all this in a work published as recently as 1974). Sir Thomas's behaviour, he says, 'was remarkably restrained in view of the provocation he received, and it is a wonder that he did not completely devastate and disfigure the Heath in a peevish rage'.

This is all too much for the Heath historian, Christopher Ikin. Replying in the *Camden History Review* (No. 4), he points out how extraordinarily exposed Maryon Wilson's position appears to have been throughout the conflict – no one but his relations and employees came to his defence at any stage. The proof of the pudding is in the eating. Irrespective of their mixture of motives, the Hampstead gentry 'had for 40 years postponed development of East Park; they had roused metropolitan opinion; but above all they had created a tradition which has produced a Heath now 800 acres against 220 in 1871'. With a final flourish of pride, Ikin adds that 'Blackheath since 1871 has not increased at all!'

There is little by way of illustration to this drawn-out battle. The sketch plan of Maryon Wilson's East Park is now in the G.L.C. Records Office and shows that it would indeed have been the most lavish Regency development in London at the time. Only the central viaduct remains today, seen in a contemporary engraving *271, p. 100* forlornly surrounded by open Heath and with Highgate Church in the background. The subsequent municipalisation of the Heath did not altogether end the controversy. The Metropolitan Board of Works proceeded to iron out hillocks and plant trees, eventually stimulating the formation of the Heath and Old

*271 The Viaduct;
wood-engraving, c. 1890.*

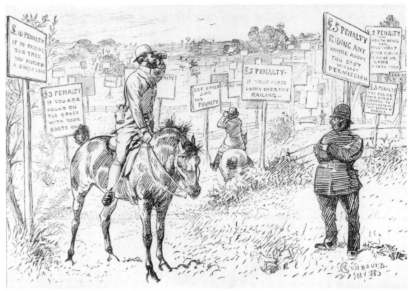

*274 The Heath restrictions satirised by Corbould;
wood-engraving, 1883.*

Hampstead Society in 1898 to oppose excessive landscaping. The restrictions then imposed on those using the Heath made Maryon Wilson seem positively *274* libertarian. These controls were satirised in an 1883 cartoon by Courbould, showing a lone horse-rider surrounded by official notices of penalties for every conceivable Heath enjoyment.

Londoners needed no persuading of the value of the Heath to the metropolis generally. As the century progressed they visited it not in thousands but in tens of thousands. The arrival of the Hampstead Junction Railway at the foot of Pond Street in 1860 provided ready access to the Heath from the East End to add to the omnibus traffic from west London. The Bank Holidays Act introduced by Sir John Lubbock in 1871 gave its popularity a further boost. 'Lubbock-land is London/His shrine is Hampstead Heath', wrote one contemporary poet. It was estimated that on a bank holiday in the 1870s the area absorbed well over 300,000 people.

In his history of London railways, H. P. White relates how officials at the tiny Hampstead Heath station would anxiously watch the sky on a busy summer afternoon, knowing that sudden rain would produce a possibly uncontrollable stampede onto their platforms. It was in just these circumstances that probably Hampstead's worst single disaster occurred on Easter Monday in 1892. A huge crowd tried to get on to the home-bound platform and eight people were crushed to death on the staircase. The arrival of the Tube at the top end of the High Street in 1907 finally relieved the pressure on the station, which is now a forlorn little place.

Not since the mid-eighteenth century had Hampstead featured so prominently

in contemporary literature and journalism. A wood engraving from the *Graphic* of   *275*
1871 typifies the atmosphere of a 'day on the Heath': a boisterous scene of
pleasure, flirtation, argument and daylight robbery all taking place in the
neighbourhood of the flagstaff. Barratt quotes an appropriate verse by 'Dagonet',
with more glorification of Lubbock:

> I've lounged about Lugarno
> When August suns were high.
> I've Lubbocked where the mountains
> Stand white against the sky.
> With vine leaves in the Rhineland
> I've twined St Lubbock's wreath.
> But not found in the wide world,
> The joys of Hampstead Heath.

Two illustrated sheet music covers which appeared in about 1863, two years after
the coming of the railway, show Londoners besporting themselves on the Heath.

*275  The pleasures of the Heath; wood-engraving, 1871.*

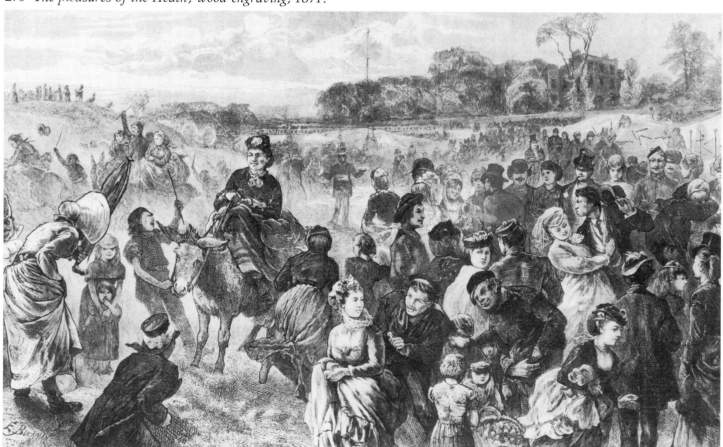

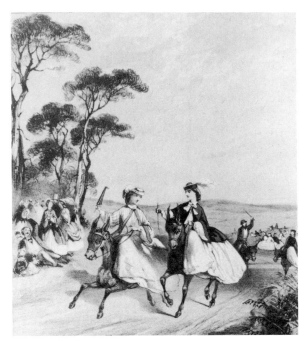

*277  A donkey race;*
*chromolithograph, c. 1865.*

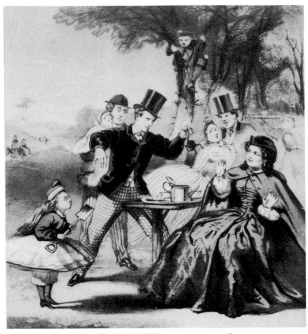

*279  Hampstead Is The Place To Ruralise;*
*chromolithograph, c. 1863.*

277   The 'Comic Quadrille' has ladies apparently engaged in a donkey race, cheered on
279   by visitors. And the popular song, 'Hampstead is the Place to Ruralise', enhanced
its appeal with a curious print of a particularly horrible spider being discovered in
a picnic teapot. It was 'sung with immense success by the principle vocalists of
celebrity'. According to Mr and Mrs Shields (*Camden History Review* No. 2), the
tune was that of 'Here we sit like birds in the wilderness'.

Augustus Mayhew's novel, *Paved with Gold, or the Romance and Reality of
London Streets*, appeared in 1857. Like his brother Henry, Mayhew was fascinated
by the social status of London characters and the thin boundary which separated
crime from respectability. Two scenes from the book were illustrated by
280   Hampstead prints. One of them portrays a wild midnight picnic with a fiddler
supplying the entertainment, while in the background a reveller is beaten by
robbers. The frequency with which Victorian prints show visitors being attacked
suggests robbery was a regular hazard of a trip to the Heath. It seems to have been
no more of a deterrent to the visitors than deportation was to the robbers.

Finally in this Heath series, we have two lithographs of its famous denizens, the
donkeys. The practice of taking rides near Whitestone Pond dates back at least to
the eighteenth century, and probably earlier. The donkeys were native to
Hampstead and their keepers (now the Newman family) have long been well-
known local figures. It can be assumed that gypsies, who are recorded camping on
278   the Heath until the 1830s, plied the same trade. In the first lithograph a well-
dressed group of visitors can be seen sitting incongruously on the long-suffering

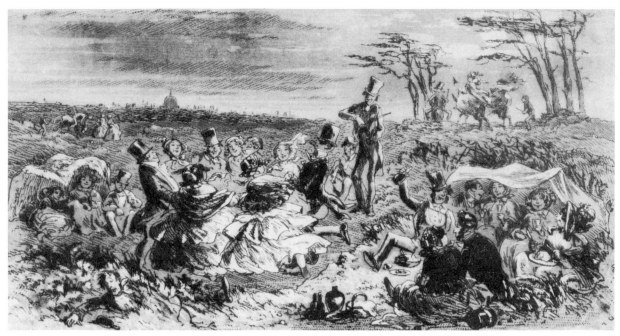

280 *Midnight revellers on the Heath; steel-engraving, 1857.*

creatures. In the other, the landscape artist Nathaniel Green produces a serene    *282*
Heathland study of two boys and their donkeys at the end of a day's work. The
print well demonstrates the lithograph's technical flexibility in reproducing tones
of light and shade.

The area round the summit of the Heath was the only large open space where
Hampstead people could congregate at times of mass rejoicing – or mass alarm. In
the seventeenth and eighteenth centuries, a beacon to be lit in time of danger (such
as the coming of the Armada) stood near the present flagstaff. It was replaced by
the semaphore on Telegraph Hill in the 1790s. On a number of occasions the Heath
was host to Londoners fearing some predicted inundation of the capital.

278 *A donkey ride;*
*lithograph, c. 1850.*

282 *Donkey boys; tinted lithograph*
*by N. E. Green, 1854.*

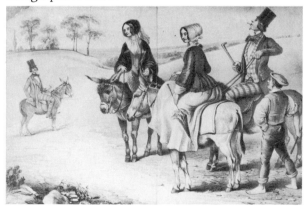

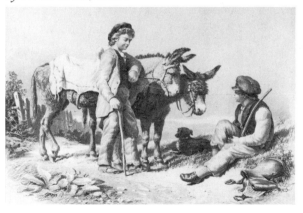

286 *The triumphal arch near Whitestone Pond; copper-engraving, 1835.*

285 *Building the bonfire; wood-engraving, 1863*

Instances of such gullibility are recorded up to the mid-eighteenth century, but the most graphic was in 1524. Soothsayers had declared that London was to be wholly destroyed in a vast torrent and so firmly was this believed, according to Barratt, that 'by the middle of January all the vacant spaces around Hampstead and Highgate became dotted with huts in which affrighted families were taking sanctuary. Not only the poorer classes but people of rank flocked to the heights . . . the Court retired to Windsor.' The soothsayers later beat a hasty retreat, explaining they had been wrong in their calculations by a century.

286     To commemorate a happier occasion, a triumphal arch was erected near Whitestone Pond in 1835 to honour a visit from King William IV. The structure is shown decked with flags and filled with local maidens.

    Half a century later, the Heath celebrated the first jubilee of Queen Victoria. The *Hampstead and Highgate Express* reported that the day was a general holiday and 'at night various business premises were illuminated and a huge beacon fire

285 was lighted on the summit of the Heath'. A print shows a group of citizens helping with, or at least watching, the construction of the bonfire. It appears to include large barrels of oil to assist combustion. A jubilee subscription was raised to pay off the debts of local hospitals and to build the new drill hall in Heath Street.

    Before leaving the Heath, we must mention a number of prints which are impossible to identify topographically but which form part of any gallery of Heath pictures. Many of these are simply of trees, of which the most popular was

the gnarled trunk of 'Richard Wilson's Oak'. None of the prints of this tree enables us to locate it. The stone marked 'PP' in the Powell lithograph of 1821 suggests it was *290* possibly near the St Pancras Parish boundary. There is just such a parish mark on Newton's map of 1762, on the border of the East Heath at Parliament Hill. But this is pure conjecture.

We have also included a series of soft-ground etchings of London trees by *292–4* Harriet Gouldsmith. They appeared in the early 1820s and most of them clearly have Hampstead backgrounds. In the case of the ash, the wholly out-of-scale dome of St Paul's in the distance illustrates a common problem for Hampstead *294* artists: how to make the famous building visible from the Heath as anything more than a dot on the horizon.

No Hampstead artist is more vexing than the Victorian, Arthur Evershed. His wispy and apparently incomplete etchings can leave the topographer in a state of perpetual frustration. Yet in many ways, Evershed is the most typical Heathland artist. Like Hastings, his fascination is not so much with detail as with horizon. His foregrounds are composed so as to contrast trees and roofline with the wide, sweeping contours of the Heath. The appeal of his pictures is in seeing a possibly familiar building start out from among the trees and then as quickly recede again. He captioned most of his prints simply 'On Hampstead Heath'. For better or worse, most of them must remain there, their locations lost in his memory.

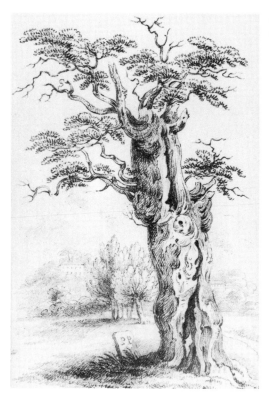

*290  Richard Wilson's oak; lithograph by Powell, 1821.*

*294  Ash near Hampstead; soft ground etching by Harriet Gouldsmith, 1823.*

# 9

# VICTORIAN HAMPSTEAD

Victorian London's appreciation of Hampstead was reflected, like the Georgians' enjoyment of the Wells, in further suburban expansion. While the Georgians recorded this expansion in prints of their houses and of the Heath, the Victorians reacted differently. They celebrated instead their public buildings, monuments to religion, philanthropy, and municipal pride. Although the picturesque tradition continued well into Victoria's reign, to be revitalised later in the century by artist-etchers such as Evershed and Monk, Victorian Hampstead was portrayed best in book and magazine wood engravings. Often these were intended simply to record a new building erected or shop opened. However, they help bring to life a community emerging from the status of a rural satellite town into a fully fledged modern suburb.

Hampstead, as described in the Introduction, was always a wealthy community. Victorian development consolidated that exclusivity. Charles Booth's analysis of the London census of 1889 showed Hampstead as the district with the highest percentage of its population 'comfortable', above even such areas as Kensington and Marylebone. By the end of the nineteenth century, the ratio of domestic servants to households (81 : 100) was higher than in any other borough in London. Although it fared less well in its equivalent percentage of butlers, falling to sixth place, Booth described it as essentially a district for 'middle- and upper-class business and professional men, merchants, authors, journalists, musicians and others' (see Thompson). The change from the lawyers and civil servants of the seventeenth and eighteenth centuries had not been a radical one. Most remarkable of all, Hampstead managed to sustain this social elevation over a period, 1840–1900, when its population experienced a phenomenal growth, from 10,000 to 82,000.

This population needed churches. For Anglican worshippers, the parish church of St John had already been supplemented by the chapel in Well Walk and by St John's Downshire Hill. The Well Walk chapel had done service for over a century and in the process had become, if anything, the most fashionable of the Hampstead churches. Barratt lists among its regular worshippers the Holfords, the Pryors, the Tollers and even the erstwhile Quakers, the Hoares. It was the Hoares

who in 1849 led the subscription for the construction of a new church, to be named Christ Church.

The new building was located on a patch of open ground between the back of Holford House and Hampstead Square. It was designed by a Gloucestershire architect named Samuel Daukes, though Baines attributes it to a local man, Ewan Christian. It is possible that Christian, who was then architectural adviser to the Ecclesiastical Commissioners, may have been asked to act as consultant and may have recommended Daukes, who had recently designed the (more distinguished) St Andrew's Wells Street. Christ Church was consecrated in 1852.

Daukes' church is chiefly remarkable for its spire. Its broaches, lights and pinnacles can be seen from most points east across the Heath, as if pinning the town of Hampstead to the hillside. It is all the more curious that this feature should be totally obscured in the Rock and Co. letterhead, designed presumably for the *312* church notepaper, which shows the building shortly after completion. The windows are inaccurate, but the oval of the print well captures the curvaceous contour of the site. A later wood engraving shows the church after alterations in *314* the 1880s. These included a new gallery, the one modest Hampstead work by the town's most outstanding resident architect, Sir George Gilbert Scott. It is sad that neither of Hampstead's parish churches could engage the talents of the distinguished architects in their congregations at the time of rebuilding. Was this false humility or a case of 'prophets without honour'?

Meanwhile, the same pressure for expansion was being felt at St John's parish church. In 1843, transepts were added, doubling the seating capacity by allowing a large gallery to be built. In 1870 the state of the tower was causing concern and the vestry eventually decided on a competition for a completely new church. This was won two years later by F. P. Cockerell, yet another local architect and designer of the new buildings for Highgate School.

Cockerell's winning design was for a much larger building on a cruciform plan with a central dome, all in 'a modified Italian style'. He also offered a second

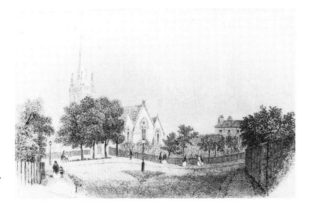

*312 Christ Church, letterhead by Rock & Co.; steel-engraving, 1860.*

design, similar but basilican in plan and with a tall spire. However, it was a third
*316*   design of which a lithograph was eventually issued to parishioners in 1874 for comment. This was closely allied to the existing Georgian plan, but bigger and with an apse and two transepts. Cockerell was aware of the architectural sensitivities of parishioners who included many of his own profession and remarked for good measure that 'should the Gothic style be preferred to the Italian, the plan, general composition and proportions of this design are equally suitable to either style'. At any rate, he added, the tower was unstable and would need rebuilding whatever was done to the church itself. He was perhaps scenting defeat.

Most of the vestry comments reflected the same obsession with costs as had afflicted Sanderson's design for the original Georgian church. More serious opposition arose from a lobby led by Sir Gilbert Scott's son, G. G. Scott, who lived at 26 Church Row and was one of those beaten by Cockerell in the original competition. He produced a pamphlet the same year which included the claim that the tower was not in any danger whatsoever. The result was the formation of a 'Committee for the Preservation of the Tower of the Parish Church of St John Hampstead', which was supported by a devastating array of architects and artists: Basil Champneys, Richard Norman Shaw, G. F. Bodley, Alfred Waterhouse, William Morris, Dante Gabriel Rossetti, Holman Hunt, Gerald du Maurier, even Anthony Trollope. Referring to the setting of the tower at the end of Church Row, the petitioners wrote: 'Such a group of English Architecture is almost unique in or about London, and the proposal to destroy or to transform its principal ornament will be condemned by every man of taste.' (Quoted by Gavin Stamp in *Camden History Review* No. 7.)

Would that all London monuments could have called on such exalted defenders, though many of these architects were at the very same time vandalising other parts of the capital. Poor Cockerell was no match for them and a tight-fisted vestry was glad of any excuse for forgoing expense. In 1876, they decided instead on a proposal to extend the church westwards, and it was not until 1878 that alterations were finally carried out. The altar was moved to the west end, where Cockerell prepared plans for pushing out a new chancel. The interior was also redesigned by the Oxford architect, Thomas Jackson, who was responsible for decorating the chancel interior. Jackson's dark Victorian encrustations were cleaned off in the 1950s and the church has recaptured at least some of its former Georgian simplicity.

We have fewer prints of Hampstead's many nonconformist places of worship, and sadly none of Abbé Morel's charming Roman Catholic church of St Mary in Holly Place. Most of these gatherings were held in private houses or temporary chapels, expanding in the nineteenth century usually because of the arrival of a

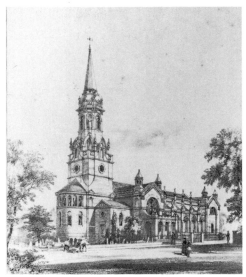

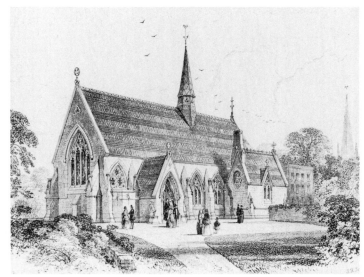

*316 St John's Church as it might have been; lithograph, c. 1874.*

*317 Unitarian Chapel at Rosslyn Hill; lithograph, c. 1862.*

preacher of special popular appeal. Thus it was Dr William Brock who filled the new Baptist chapel on Heath Street in 1861; the Reverend Robert Horton who packed Waterhouse's handsome Congregational Church on Lyndhurst Road in 1884; and Dr Thomas Sadler whose work with the Unitarians necessitated their move into the new Rosslyn Hill Chapel at the top of Willoughby Road in 1862.

Of these, the Unitarians can claim the earliest foundation, with a previous chapel dating back to 1691. The present building was designed by J. Johnson and is reminiscent of Sir Gilbert Scott's work at this time. It makes a modest but *317-19* interesting comparison in Hampstead ecclesiastical architecture with the Christ Church of ten years earlier and Cockerell's St John's design of ten years later.

The 1860s and 70s in Hampstead, as in the rest of London, saw a considerable increase in public works. Reforms took place in local government, health, sanitation and education, with Hampstead's first elected vestry taking office in 1855. This was also the date of the formation of the Metropolitan Board of Works, saviour of the Heath and forerunner of the London County Council. A new vestry hall was built on Haverstock Hill in 1876.

The result was the most drastic alteration ever to the appearance of central Hampstead. Indeed it was the intensity of redevelopment in the thirty years after 1860, much of it concentrated at the junction of Heath Street and the High Street, which has saved the town from the more severe depredations of the twentieth century. While the Georgian shopping streets of centres such as Uxbridge and Richmond have been torn apart and replaced by modern buildings, Victorian Hampstead remains a florid parade of neo-Gothic, neo-Renaissance and neo-Jacobean.

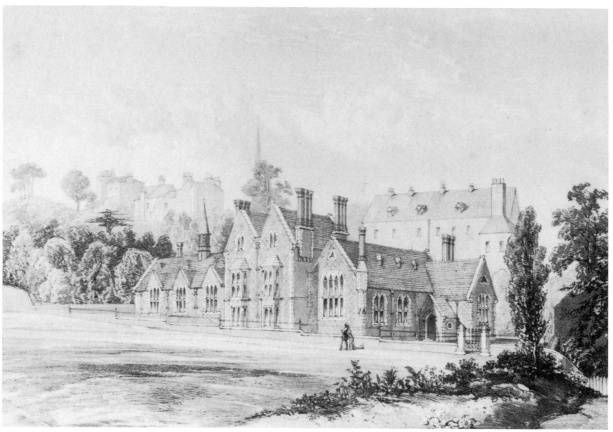

320 *Hampstead Parochial Schools; lithograph, c. 1855.*

First into action was the indomitable vicar of early Victorian St John's, the Reverend Thomas Ainger, who sponsored and built the new parochial school on a plot of land behind Church Row. Designed by the Habershon brothers (architects
320 of Marylebone Grammar School), it is shown in a contemporary lithograph with Holly Bush Hill and the old drill hall rising behind it. In 1853, the same Thomas Ainger was the moving spirit behind the establishment of a dispensary and soup
321 kitchen in New End, immediately below the old workhouse. A plaque on the wall commemorates the thanks of the local people for deliverance from the cholera epidemic of 1849. (Thompson laconically suggests that Hampstead escaped the epidemic because it was 'too wealthy, too thinly populated and too high-lying'.) The building, tucked away in what was then Hampstead's small working-class district, is simplicity itself compared with the Gothic exuberance of the parochial school.

Grander by far was the fire station, opened in 1874 on the site of the old police station at the foot of Holly Hill. It provided, and still provides, a strong visual pivot for the turn of the High Street into Heath Street. The architect was George Vulliamy in what might be termed 'Sienese municipal' style. The tower rises
323 against the hill in Esther Bakewell's etching as if in a Tuscan fortress village. The

building's ground floor has been ruthlessly converted into one of Hampstead's ubiquitous building societies. But we can still imagine the horse-drawn fire engine tearing noisily out of the entrance, its officers hoping the emergency did not involve an immediate sharp turn up Heath Street.

A Sharpe etching of 1881 shows a view south past the station shortly before the demolition of Bradleys Buildings and Little Church Row on the right. It is a rare sight of the Victorian High Street, with a cart left casually in the middle of the hill and early morning shadows throwing the façades into deep relief. Another view is by Monk, whose etching of Flask Walk shows the bridge house before its demolition in 1911. A lady in Edwardian dress is stepping off the pavement and the old shop fronts of Flask Walk can be seen in the background.

For the remainder of the town centre, we are chiefly dependent on commercial pride. Just as the owners of large houses or institutions looked to letterhead engravers to celebrate their buildings, so Victorian merchants looked to the producers of trade cards. These varied from the simple façade of 'C. Franklin, Wine and Spirit Merchant' to the architecturally more explicit elevation of 'Joseph Lane MPS'. The latter's pharmacy at No. 29 High Street, next to the old Parsonage, was burned down in 1870 but was rebuilt and remains a chemist shop today.

Hampstead was well endowed with breweries at various stages in its history. There are records of brewhouses on Windmill Hill, in Pond Street and at New End.

*324*

*325*

*326*

*327*

323 Fire Station; etching
by Bakewell, c. 1890.

324 A rare glance of the Victorian High
Street; etching by Sharpe, 1881.

325 Flask Walk; etching
by Monk, 1901.

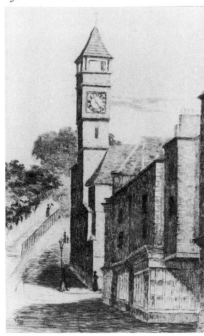

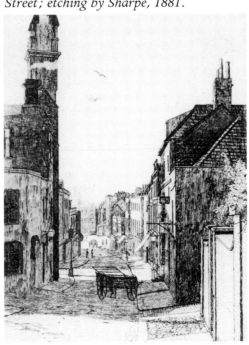

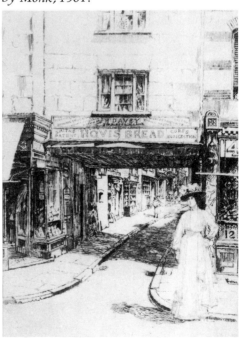

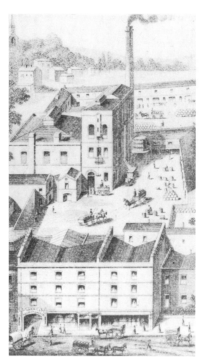

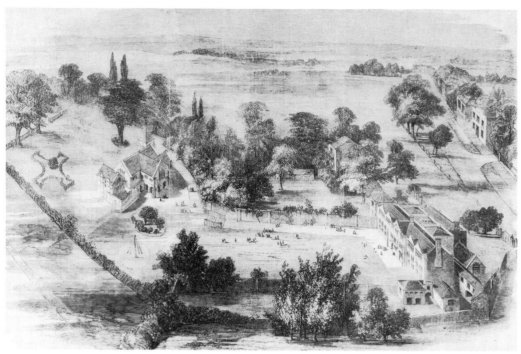

*328 Hampstead Brewery;*
*lithograph, 1872.*

*330 Soldiers' Daughters' Home;*
*wood-engraving, 1858.*

The only major brewery firm was the one established just off the High Street by John Vincent in the early eighteenth century. It was Vincent who persuaded the Wells Trustees to permit him the sole right to pipe water from the upper spring to his premises, located behind the King of Bohemia tavern in the High Street.

A Mr Harris presumably bought the company from the Vincent family some time in the early nineteenth century. It was he who produced a card, decorated 328 with hop leaves, which shows the brewhouse, complete with hoists, piles of barrels and a general bustle of dray carts and men. St John's Church is shown in the top corner (topographically out of place). Although the frontage to the High Street has been buried behind the 1935 façade of the King of Bohemia, the main original building survives, recently converted into offices.

The Crimean War of 1853–6 left two significant Hampstead memorials, both homes for the orphan daughters of lost servicemen. The Soldiers' Daughters' Home came to rest in 1855 at old Vane House (see Chapter Three). Three prints show it before and after alterations which involved a completely new façade and new buildings in the grounds. Even in those days, such changes to an historic house were controversial. Baines remarks, 'By some inhabitants the destruction in part of this ancient mansion is held to be an act of vandalism; by others the worthy appropriation of a site well suited to beneficent use.'

330 The overall perspective of the new institution, from the *Illustrated London News* of 1858, curiously removes the entire town of Hampstead from the

*332 New schoolroom and chapel of the Soldiers' Daughters' Home; wood-engraving, c. 1858.*

background. Only Clarkson Stanfield's home by Greenhill and a few houses in the High Street are permitted to peep surreptitiously through the trees. The engraving shows old Vane House encased completely in its neo-Gothic extension. A later print shows the new schoolroom and chapel erected in the grounds. This *332* group, designed by William Munt, is a gem of mid-Victorian institutional architecture. Although the old Vane House is now recalled by nothing more than its gateposts on to the High Street, Munt's buildings have been carefully converted and are part of Fitzjohn's Primary School.

The Sailors' Daughters' Home was a more modest affair. It started life in Frognal *335* House in 1862 and moved to its present site at the top of Fitzjohn's Avenue in 1869. The style chosen was an unremarkable neo-Jacobean, but it made a fittingly eclectic beginning to the luxuriant architecture of the avenue which was shortly to be constructed to its south. The building has since been converted into old people's flats.

*335 Sailors' Daughters' Home; wood-engraving, c. 1869.*

Now for Hampstead's most notorious ugly sisters. It is hard to believe The Logs
*338* would have survived anywhere but overlooking the Heath. It was designed by
J. S. Nightingale on Heath waste in what Thompson suggests was an act of
defiance by Sir Thomas Maryon Wilson against the Heath preservationists. It is
'horror Gothic' at its most formidable, though the style was doubtless regarded as
studious French Renaissance in its day. The top-hatted gentleman at the gate
might be Sherlock Holmes making a house call.

At least The Logs is discreet, unlike the North London Consumption Hospital
*339* (now the Medical Research Institute) which towered, and still towers, over the
gentle roofs and contours of Holly Hill. It was the work of T. Roger Smith and
appeared in 1880 on the plot of land once occupied by the old parish poor house
(see Chapter Four). Pevsner rightly remarks that in the context of Holly Bush Hill,
'it cruelly broke the spell and dwarfed all the rest by its pretentious mass'. The
style is a free variant on a number of Loire *châteaux* and nothing could be less
appropriate to Hampstead. But its turretted roofline does at least have a touch of
romance to it: not here the brutal horizontal of the Royal Free at South End.

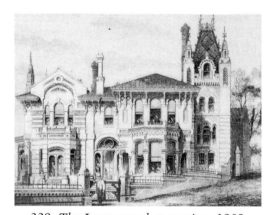

*338 The Logs; wood-engraving, 1868.*

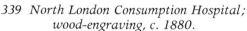

*339 North London Consumption Hospital;*
*wood-engraving, c. 1880.*

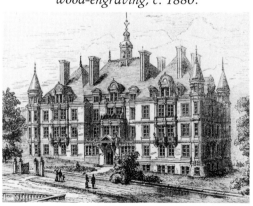

# 10

# BELSIZE AND SWISS COTTAGE

W̲e now come down from the heights of Hampstead to look at the outskirts of the old town, south towards the boundary with St Pancras and St Marylebone and west towards Kilburn and the Edgware Road. The estate of Belsize, from Pond Street down Haverstock Hill to England's Lane, has been the property of church authorities since the Middle Ages. There appears to have been a house at Belsize since the late sixteenth century, which was occupied like many others of the 'northern heights' by a succession of servants of the Crown. After the Restoration in 1660, the lease was acquired by a staunch royalist, Colonel Daniel O'Neill, and his wife the Countess of Chesterfield. It was O'Neill who built or rebuilt the house and it is this building which appears in the earliest prints, Dutch Renaissance in style, with dormer windows and a central clock tower.

The house passed through a succession of Chesterfield offspring and subtenants. For a while it was distinguished enough to feature in the suburban peregrinations of both Pepys and Evelyn. The former remarked that at Belsize he had come across a fine collection of oranges and lemons grown in gardens which, he said, were 'too good for the house'. For his part, Evelyn described it as 'very particular for India cabinets, porcelain and other solid and noble moveables. The gallery is very fine the gardens very large but ill-kept.' He added that the soil was 'a cold weeping clay, not answering to expense'. Modern Belsize gardeners might well agree.

However, in the early years of the eighteenth century, the name of Belsize came to have a very different ring. Another Chesterfield subtenant, a retired coal merchant, Charles Povey, took a lease on the property in 1700 and ran a series of eccentric money-making schemes, which included a marriage chapel and a deer hunt. In 1721 he handed over to a man named Howell, who converted house and grounds into a fully fledged pleasure garden. It is his handbill of that year which displays our first engraving of the house. *341, p. 116*

Howell's Belsize was immediately popular. It was a major counter-attraction to Duffield's enterprise at Hampstead and played a part in the latter's demise. Indeed for a while it appears to have rivalled even such resorts as Vauxhall. In 1721, the

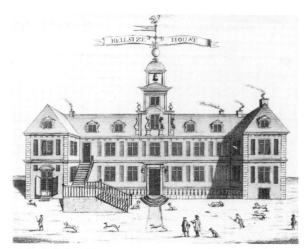 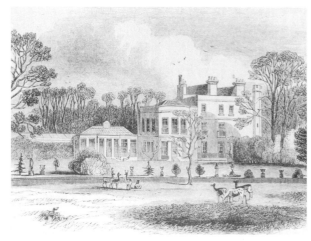

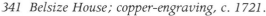

*341  Belsize House; copper-engraving, c. 1721.*          *347  Belsize House; wood-engraving, 1845.*

Prince and Princess of Wales honoured it with a visit. And Barratt quotes the *St James Journal* of 1722 as reporting: 'On Monday last the appearance of nobility and gentry at Bellsize was so great that they reckoned between three and four hundred coaches, at which time a wild deer was hunted down and killed in the park.'

The house nonetheless endured the same cycle of fashionability, vulgarity, degeneration and ruin as overtook Duffield's Wells. A contemporary 'Ballad of Belsize' celebrated its 'beaux who love sporting, young virgins courting', but went on to admit there were also 'young strumpets staring, at new garbs wearing, while gamesters swearing, from dawn to dark'. Soon it was attracting a thoroughly disreputable clientele. Howell struggled to keep a room in the house separate for his more genteel customers, but to little avail. In its declining days a satirist exclaimed that 'Sodom of old was a more righteous place'. As at Hampstead a decade earlier, the organisers had to double the number of guards to escort customers back along Belsize Lane and Haverstock Hill.

Various entertainments appear to have continued throughout the 1730s and 40s, but at some point the state of the old house must have called for demolition. A wood engraving shows Belsize in 1800 as a typical mid-Georgian mansion and no trace of the former structure. Its occupant was the lawyer Spencer Perceval who took it in 1798, leaving nine years later to become Chancellor of the Exchequer and eventually Prime Minister. By then Chesterfield had clearly decided the time had come to obtain parliamentary powers to sell his interest and capitalise on the popularity of the area for suburban development. In 1807, the lease was put up for sale and the estate was eventually divided into eight parcels of land.

Over the next two decades, the Belsize Estate saw a series of Regency mansions and villas extending the length of Haverstock Hill. Now almost vanished, this first phase of the estate's development was lavish, achieving more completely the same

*586*

aura of *rus in urbe* for which Nash was striving in Regent's Park to the south. Thompson has counted thirty-eight houses in all, 'each set in its few acres of park-like grounds and surrounded by its own paddocks and meadows to give a perfect impression of a country estate in miniature, rural illusion which was yet more than a half-truth'.

Our last view of Georgian Belsize House shows it in just such a setting, with conservatory to the rear and still with its ornamental garden and deer park. It *347* survived until 1853 when the whole property was finally handed over to builders, to emerge as Belsize Park, Belsize Avenue and Belsize Park Gardens. The old house originally stood at the junction of the latter two streets, just below the small village green on Belsize Lane. Apart from some garden walls, mews, gatehouses and the 'Gothick' Hunters Lodge in Belsize Lane, nothing of the district's Regency magnificence remains.

The backbone of the estate was Haverstock Hill. Until the building of Fitzjohn's Avenue to the west and Fleet Road to the east, this hill was the only direct access to Hampstead from London. Like most such thoroughfares, it was a road of taverns, robbers and mud, but it was also famous for the small house which stood on a mound just where the hill rose steeply above Chalk Farm.

This was the cottage to which Sir Richard Steele retreated from his overwhelming troubles with the *Spectator* in the summer of 1712. It was from here that his friends would collect him on their way to dinners of the Kit-Cat club in Hampstead. Although Steele only stayed one summer, he invested the cottage with the romance of a writer wrapped in solitary gloom. This, together with its picturesque appearance and view of St Paul's, made it one of the most popular subjects for Hampstead engravers.

The most characteristic view is that taken by Freebairn in his 1805 print. It shows the cottage on its hill, guarded by a fence and shed and with a steep path *348* leading to the front door. Smoke drifts from the chimney, bespeaking a warm hearth. In the distance are the towers of London dominated by the great dome of St Paul's.

*348 Steele's Cottage; copper-engraving after Freebairn, 1805.*

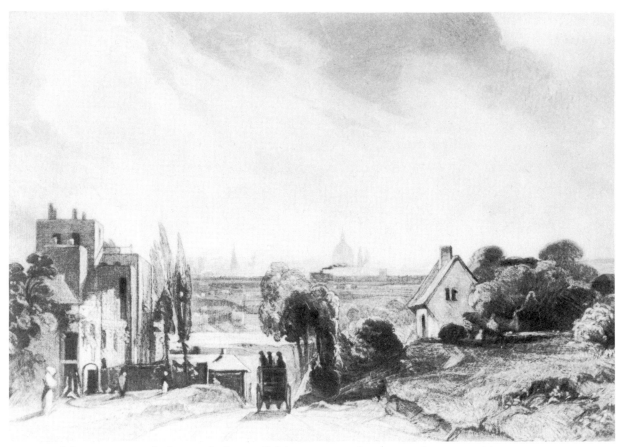

364  *Steele's Cottage, with the Load of Hay (left); mezzotint by Lucas after Constable, 1845.*

365  *Steele's Cottage, with the Load of Hay (right); steel-engraving, 1829.*

Where others found quaintness, Constable found atmosphere. Lucas' mezzotint  *364*
of his famous view down the hill shows the Load of Hay pub on the left, while an
evening coach trundles down the road ahead. The late sun is bathing the scene in
light, but a Constable storm is brewing overhead, reproduced by Lucas' shadows
as a velvet black.

At some point in the late 1840s, Steele's Cottage was adorned with *cottage orné*
decorations: dog's-tooth bargeboards and a carved centrepiece are to be seen in a
number of etchings of the 1850s. However, this was not enough to save it from the
developer's sledgehammer, and a sad engraving from the *Illustrated London News*  *363*
for 1867 shows it in course of demolition. In its place rose Steele's Road and
Steele's Mews (the site of the cottage is in the southern one). A trade card of about
1860 for Norman Neame's 'Teas, Coffees and Colonial Produce' conveys a flavour  *368*
of the mid-Victorian neighbourhood. The shop now sells antiques, conveying a
taste of the present one.

A Finden print from *Great Britain Illustrated* (1830) shows the Cottage and Hill  *365*
unusually from the south with the Load of Hay on the right. This ancient inn, once
called the Cart and Horses, was a popular half-way house on thc route to the
Wells. In later years it was also widely known for the oddity of its landlord, Joe
Davis, nicknamed the 'Host of Haverstock Hill'. He merited the following
obituary in the *Gentleman's Magazinc* of 1806 (quoted in Norrie's *Book of
Hampstead*): 'The publick are well acquainted with the character and
eccentricities of this *huge* man, whose caricature has long figured in the window of
most of the print-shops of the Metropolis . . . He died as he had lived, in the arms
of the Jolly God [Bacchus], for having spent another of his happy days, he at night
threw himself prostrate at the bar and, this being no novelty, remained there
unnoticed till bedtime, when he was found dead.' He appears in the
accompanying print with pipe, jug and paunch, clearly saying something  *367*
outrageous to a passing traveller.

*367  Joe Davis, landlord of the Load
of Hay; copper-engraving, c. 1806.*

The Load of Hay was rebuilt in 1863 and was later renamed the Noble Art in honour of the local Belsize Boxing Club, which used to meet on its premises. It has recently reverted to its previous title. The larger buildings in Finden's print are still visible in the terrace immediately below the new pub. They are presumably on the site of the house to which Moll King, the Covent Garden coffee house owner and dance teacher, retired in the 1740s, to be followed by her celebrated pupil, Nancy Dawson. A Chatelain print of 1750 is entitled 'A View of Hampstead Road near Tom King's House'. Tom King, Moll's husband, had died in 1739 before his wife retired to Hampstead (after a sequence of prosecutions for keeping a disorderly house). The Chatelain title is therefore probably a mistake. A different Tom King, the highwayman, was doubtless active on Haverstock Hill, but was hardly likely to have established a residence there.

Weller's map of 1862 shows the west side of the hill still lined with individual houses backing onto the slopes of Belsize behind. But formal estate layouts are creeping up on all sides. South Hampstead is already sprouting stucco villas, as is Belsize Square. The Eton College Estate has laid out Adelaide Road. Across Haverstock Hill streets dignified by the name of 'park' are curving and looping in all directions. And Swiss Cottage is now a well-established community.

Weller's Belsize represents the extent of the Italianate phase of the estate's development. Its early-Victorian builders had no doubt as to the preferred style for their market: it was the urban façades of Rome and Florence, miniature *palazzi* with heavy pediments, cornices and Tuscan porches all liberally coated with creamy stucco. In the course of the 1870s this changed completely. The later speculations of Belsize and Fitzjohn's Avenue moved north in style, to French, Dutch and particularly old-English vernacular, and stucco was nowhere to be seen. The new Hampstead was of brick, stone, terracotta, hung tiles, half-timbering, tall chimneys and deep, swooping gables.

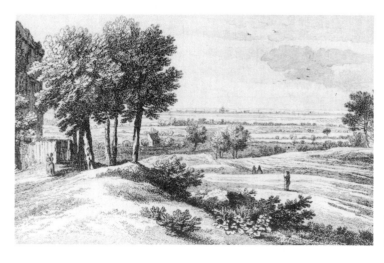

369 Hampstead Road, near Tom King's House; *copper-engraving after Chatelain, 1750.*

A similar change took place in the style of suburban churches, though here Italian inspiration had not been present since the 1820s (at St John's Downshire Hill). Vestries, often composed largely of newcomers to a neighbourhood, had to decide on designs for their places of worship amid a flurry of architectural controversy. Since the 1830s, English Gothic had been accepted as the proper, if incongruous, accompaniment to an Italianate residential estate, and from 1841 the *Ecclesiologist* attacked any lapses from its preferred 'middle-pointed' or Decorated Gothic. Each nuance of design and internal organisation was invested with liturgical significance. Church architects did not care, or did not dare, to ignore it.

Belsize was not the sort of suburb to try. The neat villas and terraces of Haverstock Hill and Swiss Cottage were interspersed with pointed spires and (where they could afford it) wide-traceried windows which might have been plucked from the Lincolnshire wolds. St Peter's Belsize Square, St Saviour's Eton Road, St Stephen's Avenue Road were all built (as was Christ Church) in 'estate Gothic'. St Stephen's, seen in an 1860s lithograph, was demolished after the last war, but St Saviour's survives. Completed in 1856 it is normally attributed to E. M. Barry, jack-of-all-trades to mid-Victorian architecture, but a print of 1848, the year the church was founded, suggests that initially at least the design was closely related to a rejected scheme by H. E. Kendall. *381*  *377*

In the event, shortage of money meant that the spire of the church was not added until some years later. The *Illustrated London News*, which published an engraving only of the interior, remarked dismissively that 'the church is built of Kentish stone rag with Bath stone dressings and owing to economical reasons presents little externally'. Even the Decorated windows proposed in the original design were abandoned in favour of cheaper three-light lancets. *380*

By the mid-1860s, church vestries and their architects were being allowed greater stylistic freedom by the arbiters of ecclesiastical taste. The pointed arch

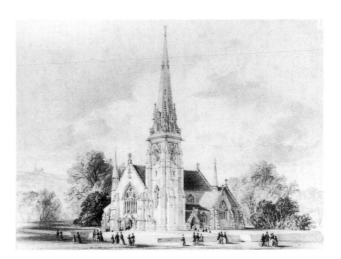

*377  St Savour's Eton Road; lithograph, c. 1848.*

was no longer the Church's one true index finger to God, nor was Decorated Gothic the only form it could take. Romanesque began to make an appearance and with it polychromatic brick and stone, to take the place of the familiar (now crumbling) Kentish rag.

Samuel Teulon had designed St Paul's Avenue Road in 1859 in what would appear a robust defiance of the conventions of the period. (The building was bombed in the last war.) A decade later he was invited to prepare designs for a new parish church for the growing south-east area of Hampstead. Originally a church to replace St John's Downshire Hill was considered, but mercifully the site proved too small. Instead a large portion of Hampstead Green at the top of Pond Street was appropriated.

*383*     St Stephen's Rosslyn Hill was, and still is, Hampstead's most impressive church building. It crouches beneath the hillside as if Teulon intended it to leap out and grab worshippers off the pavement, especially any daring to visit his architectural rival, Alfred Waterhouse's Congregational Church opposite. The fusion of Gothic and Romanesque seems the embodiment of 'muscular Christianity'. It is only sad that Teulon's great buttresses have been unable to support either the church or its congregation. The building is now deserted and reportedly in danger of slipping down the hill.

*539*     An Evershed etching of St Stephen's from the top of Rosslyn Hill includes the turret of the former Bartrams Convent, located behind the George pub in Rowland Hill Street. This was an austere group of school, orphanage and chapel on the site of a house called Bartrams and next to another, confusingly called Bartrams House. This had been the home of Sir Rowland Hill, Victorian inventor of the flat-rate postal service (of fond memory). The convent has since been replaced by a modern block.

Churches now proliferated throughout the southern part of the borough. Like most of them, Haverstock Chapel in Maitland Park was portrayed with perhaps exaggerated graciousness, and with its proximity to the more fashionable Haverstock Hill carefully stressed. Even Holy Trinity Church, deep into Camden *390, p. 124*     Town, was described as being 'for the Haverstock Hill district'. The print of the chapel shows not only the spire of Christ Church in the distance but also the corner of one of the two philanthropic institutions established on the Maitland Park estate.

The Orphans' Working School was, according to Baines, 'one of the most admirably managed charities that London can boast of . . . With wise discernment it gives as good an education to girls as to boys.' It was moved here from Hoxton in *396, p. 124*     1847 and could accommodate over 600 children. The Palladian façade suggests a mansion in Park Lane rather than a suburban orphanage; it must have been the largest Hampstead building in its day (though in fact just over the parish

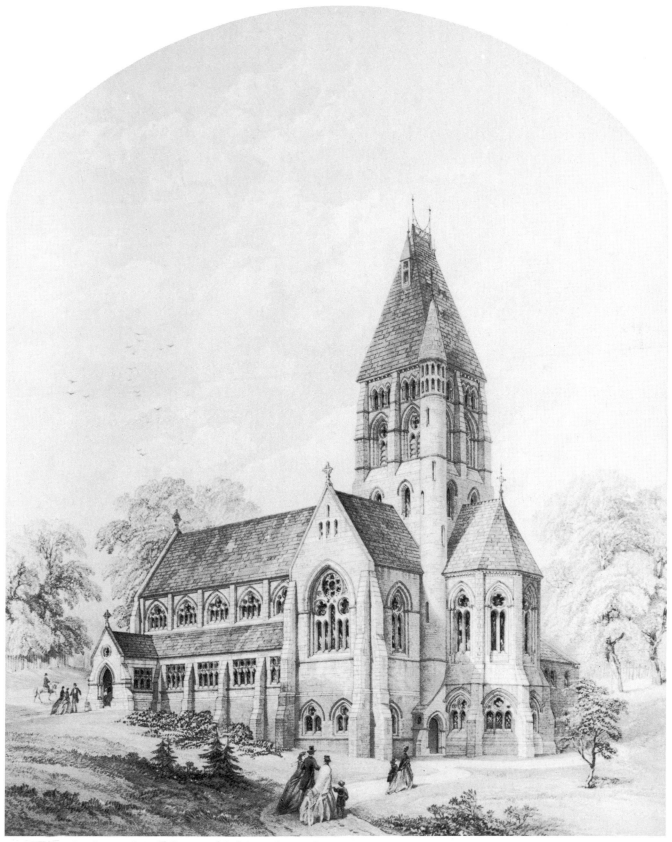

*383 St Stephen's Rosslyn Hill; tinted lithograph, c. 1869.*

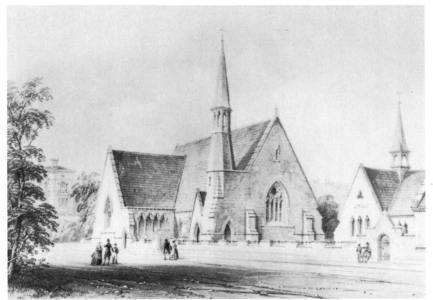

*390  Haverstock Hill Chapel;
tinted lithograph, c. 1848.*

*396  Orphan Working
School; steel-engraving, 1848.*

*408  Tailors' Asylum;
wood-engraving, c. 1845.*

*396*

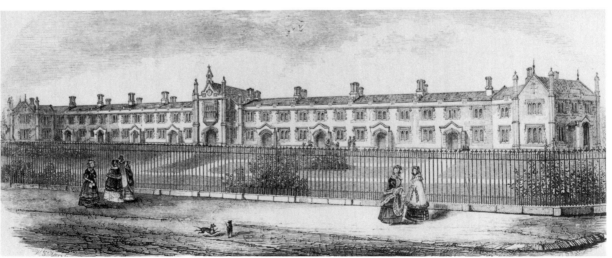

*408*

boundary). Numerous prints of it survive and most pay more attention to the benefactors than to the orphans.

Almost opposite was the Tailors' Asylum, known with Victorian prolixity as the Benevolent Institution for the Relief of Aged and Infirm Journeyman Tailors. The design, in contrast to the orphans' home, was that of a traditional almshouse with neo-Tudor adornments. An engraving shows the building neatly fenced, *408* while smartly dressed residents promenade past as if to emphasise that it was in no way letting down the social status of the neighbourhood. This was a faint hope. Maitland Park never achieved the ambitions of its developers, and orphanage, asylum and chapel have all vanished beneath an extensive council estate.

Another charitable Hampstead institution long since swept away was the Blind School, which stood until World War II just north of the present Swiss Cottage *410* underground station. Designed by H. E. Kendall, co-architect of the Vestry Hall, it included a printing press for producing books in Lucas' type, forerunner of Braille. Adjacent to it was a nonconformist theological college, New College, *412* providing a touch of architectural medievalism among the villas of South Hampstead. It was demolished, along with the Blind School, in the 1930s, when New College was moved further up Finchley Road. This building is now Westfield College. The original site is recalled by College Crescent.

The Swiss Cottage tavern appears to have been opened in the early 1840s at the *415, p. 126* time of the building of the new road to Finchley (see Chapter Twelve). The road was entered by a tollgate and, as at the Spaniards, the normal accompaniment to a tollgate was a pub. The name apparently derives from the craze for all things Swiss brought about by the success of an opera called *Le Chalet* in Paris in 1834. Even without this stimulus, Alpine chalets were among the many picturesque styles

*410 Blind School, designed by H. E. Kendall Junior; lithograph, c. 1848.*

*412 New College; steel-engraving, 1851.*

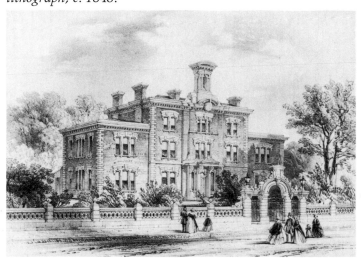

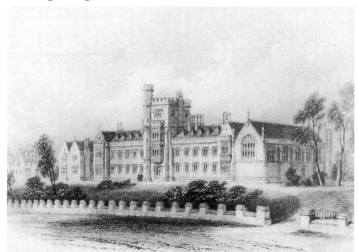

recommended by the landscape architect, J. C. Loudon, in his *Encyclopaedia of Cottage, Farm and Villa Architecture*, much in vogue at this time. Traces of Loudon's patterns can be seen across much of early-Victorian Hampstead, and the chalet motif is reflected in Villas-on-the-Heath in the Vale of Health.

The Swiss Cottage inn was famous as a starting point for races run up and down the new Finchley Road. The original pub has long since been replaced, though its style has been retained. The rest of Swiss-Cottage-in-Hampstead has been laid waste by bombs, developers and local councillors in equal measure. The local history collection at Swiss Cottage Library is its redeeming feature.

*415  Swiss Cottage tavern; wood-engraving, 1845.*

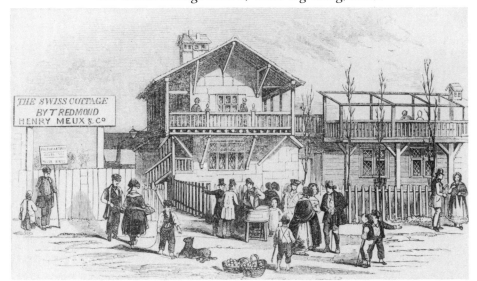

# 11

# PRIMROSE HILL

Primrose Hill lay on the southern boundary of both the Eton College Estate and the old parish and borough of Hampstead. The land formed part of the manor of Chalcots, on which stood the two farms of Upper and Lower Chalcots. The first was situated at the southern end of the present Englands Lane near the junction with Belsize Park Gardens and the second appears from the manor maps to have been just east of it on the other side of the lane. It is traditionally (but it would appear wrongly) associated with a third farm to the south which became Chalk House Farm – this being a corruption of Chalcots, unless it refers to another name once given it, that of the White House. It has nothing to do with chalk. This farm gave its name to the area and to the Chalk Farm Tavern which still stands on the site. The tavern with its garden was just south of the Hampstead boundary.

A Jacobean ballad remarking simply 'Methinks it is a pleasant thing to walk on Primrose Hill' (quoted in Wade's *More Streets*) shows that the Hill was attracting visitors by the early seventeenth century. But our first sight of it is in 1775 when an engraving for Harrison's *History of London* gives a view north from the summit *420, p. 128* with visitors looking out through a strangely ragged row of trees. Apart from the Chatelain of Hampstead church from Frognal, this is the only print we have of the *24* temporary tower before the addition of its spire. We can also make out what is presumably Rosslyn House and the cluster of buildings round Pond Street.

A more facetious early portrayal of the Hill's delights comes from the Scots caricaturist, Isaac Cruikshank, father of George. His 'Pastimes of Primrose Hill' *422, p. 128* appeared in *Attic Miscellany* in 1791 and includes a satirical account of a day's outing to accompany his print. Cruikshank relates the weekend activities of two characters of his acquaintance, one a cheesemonger, Tom Cheshire, and the other a tallow-chandler, Zachary Saveall. Cruikshank takes up the story:

Zachary's week-days are spent so very much alike his neighbour's that it would be inhuman to separate them on the Sabbath – they are therefore frequently seen upon the same party; but as Tom's hobby-horse is perspective on that day, so is Zachary's exercise. For that reason Zachary has provided a vehicle, such as may be observed in the plate, in which he crams

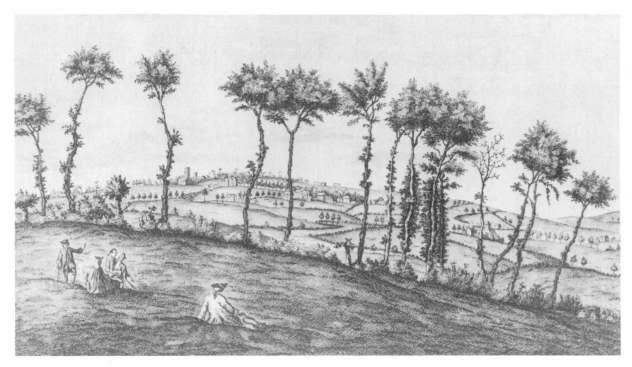

*420  Primrose Hill; copper-engraving, 1775.*

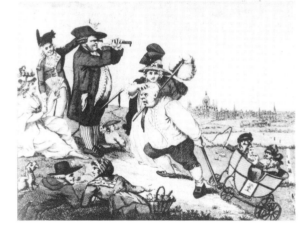

422  Pastimes Of Primrose Hill;
*copper-engraving, 1791.*

four of his children and, by lugging them up the side of a forty-five-degree angle, hopes to reduce a corporeal magnitude which, however great, is rather inconvenient in the duties of his counter.

Mr Saveall is doing no more than the joggers who take excruciating exercise on the hill today.

The prospect south from Primrose Hill was much reproduced in prints demonstrating the advance of built-up London in the direction of Hampstead and *425* Highgate. Our first view, looking south-east, shows the Georgian terraces of *558* Bloomsbury marching like George Cruikshank's regiments of bricks and mortar across the fields of Camden Town. The second, looking south-west, is a Westall *426* drawing of 1825. The Regent's Canal is in the foreground with what is now Prince

425 *London from Primrose Hill; copper-engraving, c. 1810.*

426 *Regent's Park from Primrose Hill; steel-engraving, 1825.*

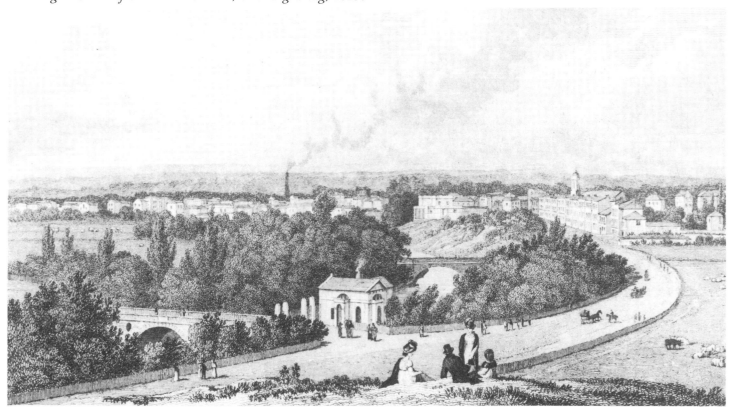

Albert Road curving round the park to St John's Wood in the distance.

The conversion – or partial conversion – of the old Chalk House (or White House) farm into an alehouse occurred at the end of the seventeenth century. In 1678 it was used as resting place for the body of Sir Edmund Berry Godfrey, who had been murdered and dumped in a ditch on the far side of the Hill. The incident occurred at a time of anti-Catholic feeling and attracted widespread attention. It is almost certain that the three men hanged for the murder were not guilty of it.

A list of licencees of Chalk Farm Tavern given by Anthony Cooper shows that it was known in the eighteenth century as the Stag and Hounds, though by the time Thomas Rutherford acquired it in 1790, it had reverted to its old name as a 'tavern

429 and tea gardens' (*Camden History Review* No. 6). The earliest print of it dates from this time. What are presumably the old farm buildings can be seen to the right, with the recently built Long Room visible through the trees of the garden. Primrose Hill behind is crowded with visitors. Cooper quotes an advertisement of the period: 'T. Rutherford solicits the patronage of the public in general – his wines being real and his other liquors of a superior kind. Tea and hot rolls as usual.'

It may be the same Rutherford uncorking one of his renowned bottles in an

439 engraving of the tavern garden, with his customers waiting in booths or on benches in the open air. The view shows the first-floor Long Room with an outside staircase leading up to it. A late sun is setting through the trees of the Hill – unless this is meant to portray a moonlit night.

The original buildings appear in a number of nineteenth-century engravings purporting to show the spot as it might have been before becoming a tavern. One

430 caption even hints at the unsubstantiated legend that this had once been Ben Jonson's house. In the 1820s these older buildings were demolished and replaced by a Regency range which oddly faced north-east, away from the view of the Hill.

434 This range, shown in a steel engraving of 1834, was three bays wide with arched windows and a handsome balcony.

436 Within four years, the extension was clearly inadequate. A print of 1838 has it doubled in length, crowded with visitors and flying a flag from its mast. The outside staircase has been straightened and juts out awkwardly into what had been part of the garden. The original track from Haverstock Hill up on to Primrose Hill had previously passed to the north of the tavern. The 1840 Fitzroy plan,

437 however, involved an avenue of villas south of it and a wood engraving of 1847 shows this road widened into what is now Regent's Park Road, inconveniently cutting off the pub from its garden. In this print, Chalk Farm looks not unlike a frontier post in the American west.

These buildings were finally demolished completely in 1853. Our last sight of

438 them is from the *Illustrated London News* for that year, showing the old Long

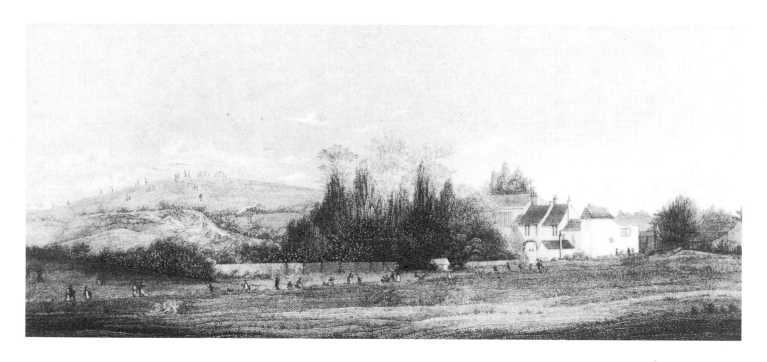

429  *Chalk Farm Tavern; copper-engraving, c. 1790.*

439  *Chalk Farm Tavern Tea Garden;*
*copper-engraving c. 1820.*

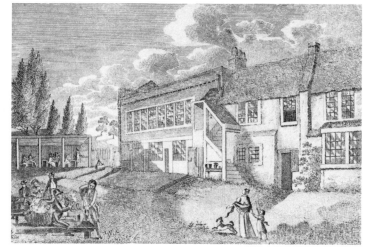

434  *Chalk Farm Tavern; steel-engraving, 1834.*

437  *Chalk Farm Tavern; wood-engraving, 1847.*

439

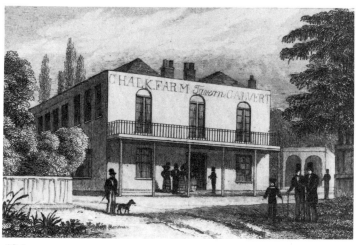

434

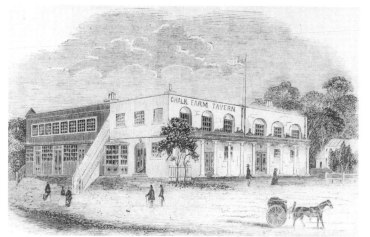

437

Room from the rear and the name of Sparkes on the wall of the extension. Since Sparkes gave up the tavern in 1828, before this last part of the extension was built, the sign is a mystery, unless the *Illustrated London News* was making use of an old block rather than commissioning one especially for the demolition. A new tavern was built the following year, facing directly onto the new Regent's Park Road, then in course of development. The builder repeated the Regency style of the old structure in his new façade, which still stands today.

The gardens survived into the 1860s, the site roughly bounded by the loop of modern Berkley Road and Sharpleshall Street, where a later style of architecture indicates a more recent date than in Chalcot Square. The gardens were popular right up to the time of their sale for building. Cooper relates that at one point the pub embraced a Music Hall, a Chinese bandstand and a dance floor which could take a thousand people.

442   A few yards along the road towards Primrose Hill was another tavern which enjoyed a briefer existence. Again it is to a satirist member of the Cruikshank family that we must look for a print record. Percy Cruikshank would seem to have been seeking to emulate his grandfather, Isaac, in his *Sunday Scenes in London and the Suburbs*. The tavern, opened in 1846, was called simply the Primrose, and under a curious sign for 'Larchin and Co. Entire' Cruikshank gives us a tableau of Londoners enjoying themselves in and round its premises. He also gives a moral commentary on his print with a fascinating insight into the early-Victorian weekend.

> Let us see what people do on a Sunday who, living within reach of the Regent's Park, are not of that class who live in terraces or can subscribe guineas to gardens. Pass out over the Suspension Bridge (over the canal), turn to the right, and you have before you the conical hill, green in the spring and brown and bare before the end of the summer, with the treading of many hundred thousand feet, which gives to many small children their first idea of a mountain.

The clientele of Primrose Hill, says Cruikshank, is not that found at the Trafalgar in Greenwich or the Star and Garter on Richmond Hill, but comes in 'gaily painted vans and costermongers' carts'. Their tragedy was the demon drink. He accordingly sketched the 'neat but unpretending façade' of the Primrose Tavern where, 'if thirsty, you will have considerable difficulty on a hot Sunday in making your way to the bar, where a light lively conversation of gents on the Sunday spree, addressed to ladies of the same mind, is unharmoniously diversified by the cries of the unhappy infants, and the remonstrances of prudent wives, endeavouring to get their husbands home with some remains of a week's wages'.

Cruikshank concludes that 'the foot of Primrose Hill, in spite of the subduing

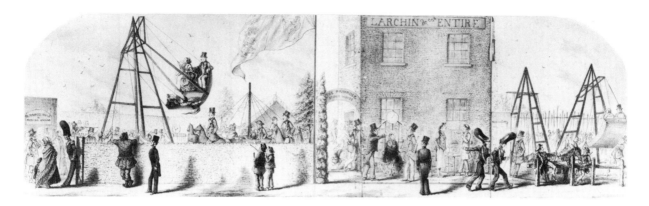

442 *Primrose Tavern; lithograph by Percy Cruikshank, 1854.*

444 Metropolitical Gunnery; *copper-engraving, 1790.*

presence of policemen, is a scene likely to produce no elevating effect on the moral tone of the rising generation'. The Primrose closed in 1853, soon after these lines were written, and the site was turned into building plots. The tavern's façade can still be detected, however, as No. 75 Regent's Park Road.

The vicinity of Chalk Farm was notorious throughout the eighteenth and early-nineteenth centuries as a suitable place for settling old scores. The challenge to 'meet at Primrose Hill at dawn' became a frequent solution to a quarrel the night before. Although duelling died out in London in the 1840s with the advent of more efficient police patrols, a number of prints continued to portray both its serious and its ridiculous aspects. One, 'A Trial of Nerves', shows a contest on the 443 Hill with the tavern and London in the background. Another portrays a reluctant 445 duellist being pushed into the challenge by his laughing seconds while his opponent looks on in contempt.

Nor was this the only form of shooting on the Hill. The time of the Napoleonic threat saw Primose Hill, like Hampstead Heath and Childs Hill, used as an exercise ground for volunteers. Shooting butts were established, though not always supervised. A cartoon of 1790 entitled 'Metropolitical Gunnery' shows one such 444 party preparing to repel the French in chaotic fashion. Muskets are being fired in all directions. A duck and a dog have already met their doom and an owl appears

to be in imminent danger. The ascription of this print to Primrose Hill is uncertain.

By the start of Queen Victoria's reign, London's suburban developers were beginning to look covetously at the land surrounding Primrose Hill and Chalk Farm. The Fitzroy Estate had acquired the property immediately east of the Hill, including the tavern, to add to its Camden Town holdings and this was marked out for villas and sold at auction in 1840. To the north and west, the Eton Estate was already considering building on its Chalcots land in 1825, and the following year it obtained Parliamentary powers enabling it to grant 99-year leases.

In view of the fame and social status of John Nash's Regent's Park development, Eton's attention was understandably concentrated on Rugmoor Field, covering the slope between Primrose Hill and the Regent's Canal. However, the late 1820s were a time of slump in the London building market and (mercifully) no housing developers came forward to take up leases. Instead, the Estate found itself having to entertain a bizarre series of proposals for all or part of Rugmoor Field throughout the next decade (see Ralph Hyde and Felix Barker, *London As It Might Have Been*, Murray, 1982).

The first and undoubtedly the most spectacular idea was to cover Primrose Hill in a giant mausoleum. The proposal originated in a campaign launched by George Carden in 1824 for the building of public cemeteries as alternatives to the over-crowded graveyards of central London churches. Carden pointed out that the French and Americans had created cemeteries which were not only hygienic but even 'places of resort for the neighbouring population'. Liverpool and Glasgow, in part because of their large dissenting communities, took the lead with architect-designed necropolises located on their outskirts. But it was not until 1830 that pressure for a London cemetery became widespread and not until 1832 that the first Parliamentary bill was sought to establish one.

Carden had seen Primrose Hill as an ideal site for his project. It was on undeveloped land yet near the city and in the sort of district where fashionable people would be glad to buy plots and promenade among carefully tended avenues. However, in 1829, the architect Thomas Willson surpassed Carden's vision with an astonishing proposal for a pyramid to contain five million bodies. The structure would cover eighteen acres and rise steeply to an apex taller than St Paul's Cathedral. No more extraordinary building has ever been suggested for London. Willson estimated the construction cost at £2.5 million, but with vaults selling at £100–£500 freehold, the profit would be four times that sum. He was an ardent salesman for his project. He placed great emphasis on its wholesomeness, being prepared 'to answer for it with life'. He added, 'The whole will form a *coup d'oeil* of sepulchral magnificence unequalled in the world.'

Meanwhile others were at work. In 1830, the architect Francis Goodwin put forward an equally grandiose but less drastic plan for a cemetery based on the

448 *F. Goodwin's proposed National Cemetery; lithograph, c. 1830.*

buildings of antiquity. It appears in a splendid lithograph, executed by   *448*
Goodwin's pupil Thomas Allom, with the Parthenon in the centre and
surrounding columns, arches, walls and temples covering 150 acres. The design
was applicable to any chosen site and is not topographically specific, though
Primrose Hill and Kidbroke were considered suitable. Another print shows a view   *451*
inside the cloister of the proposed mausoleum. The project was carefully costed:
'facsimiles of some of the most famous remains of Greek and Roman architecture
. . . may be made places of interment for persons whose wealth shall enable them
to appropriate them.'

It was not to be. The directors of the newly formed General Cemetery Company
eventually rejected such *Beaux Arts* ambitiousness and opted instead for the
picturesque tradition of Paris's Père Lachaise. One reason was the sound
commercial one that many plot-holders would want their graves and monuments
designed to their own taste. The first London cemetery was at Kensal Green, west
of Paddington, followed by others at Norwood and, most extravagantly, at
Highgate.

Where Willson and Goodwin had failed, others were keen to try. The striking
contours of Primrose Hill so close to central London stimulated the architectural
imagination throughout the early-Victorian period. In 1832 an architect named
W. B. Clarke came forward with a plan to establish a major botanical garden on its

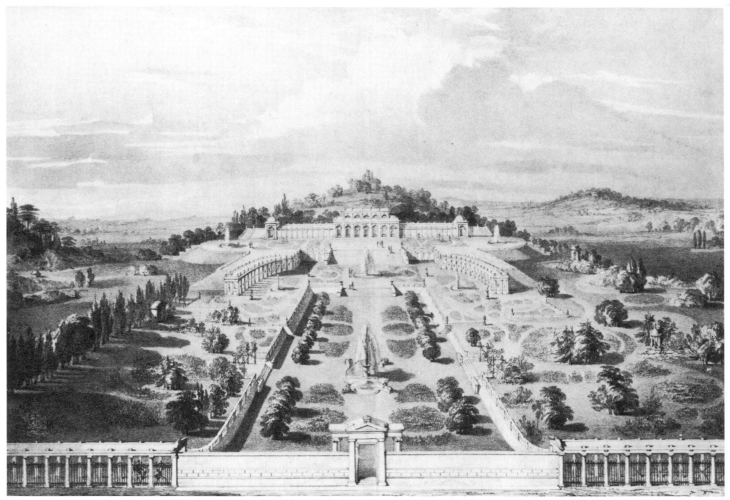

*447  W. B. Clarke's proposed Ornamental Garden; lithograph, 1832.*

slopes, to complement the new Zoological Gardens in Regent's Park to the south. A
447 lithograph shows an ornamental colonnade climbing up to a belvedere on the
summit. Pavilions and avenues of trees line either side of a series of paths, and the
'Northern Heights' in the distance are portrayed as an idealised Claudian
landscape. Chalk Farm is just visible to the right. The project appears to have sunk
without trace.

   Then, in 1836, further discussions were held between the Eton College Estate
and a new London Cemetery Company over a possible revival of the idea of a
burial ground. These reached the point of a North Metropolitan and Portland
Cemetery bill introduced into Parliament the following year. But local opposition
was strong and finally in 1838 the Commissioners of Woods and Forests (the
present Crown Estate) were persuaded to make an offer to Eton College to buy the
entire Hill for public recreation. The purchase was completed in 1842, ahead of
the preservation of Hampstead Heath by some thirty years.

The concept of public recreation was taken seriously by the Commissioners. Not content with simply leaving the Hill for general enjoyment, the authorities set up there a public gymnasium, shown in an engraving from the *Illustrated London News* for 1848. A more satirical view is provided by a cartoon, probably directed at this gymnasium and entitled 'Gymnas(s)t(r)icks'. The caption reads: 'Professor Voelkickups school for the instruction of Gentlemen of all ages in the arts of Running, Tumbling, Leaping, Scrambling, Crawling, Creeping, Climbing, Punching, Poking and Hobby-horsemanship'. The exercise area remains on the Hill, though the range of equipment is sadly depleted since the Professor's day.

Still the visionaries refused to admit defeat. In 1853 a proposal designed by C. R. Cockerell was put forward for a 300-foot-wide boulevard curving from Regent's Park over Primrose Hill to Belsize Avenue. The route then passed down Pond Street and the boulevard was resumed on the East Heath, taken up to the Spaniards and round North End to Telegraph Hill. The *Builder* lauded the scheme. In a style rare in architectural journalism today it claimed that 'nature has formed [this park] for the purpose and art would seek in vain to improve it'.

Seven years later, a diluted version of the idea was designed and published by W. H. Twentyman. It was for a 'Royal Champs Elysées' beginning at Regent's Park and passing to the left of Primrose Hill – seen crowned with a pagoda in a print which accompanied the plan – on a wide curve to Telegraph Hill via Frognal. When this also foundered, a more modest 'Prince of Wales Avenue' was proposed in 1864 by John Leighton as an adjunct to a national monument to Shakespeare on his tercentenary. This avenue ran straight across Regent's Park from Park Crescent, mounted the left flank of Primrose Hill and descended to join Finchley

455 *The Open Air Gymnasium at Primrose Hill; etching, c. 1848.*

452 *W. H. Twentyman's proposed Champs Elysées; lithograph, c. 1854.*

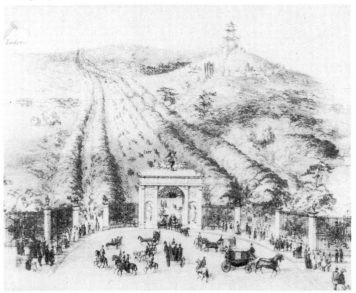

Road at Swiss Cottage. A huge statue of the bard was to crown the summit. According to Ralph Hyde, this was a revival of an earlier idea by the French sculptor, Chardigny, for a 70-foot Shakespeare on the Hill.

*460–2*

Once again the plan was abortive. A Shakespeare commemoration was indeed held in 1864, involving the planting of a special oak tree donated by Queen Victoria. The occasion was not a great success. As Richard Foulkes has shown (*Camden History Review* No. 9), lack of alternative sponsorship left it in the hands of a body called the Working Men's Shakespeare Committee, which had considerable cross-representation with the Garibaldi Welcoming Committee, then the focus of radical enthusiasm. The tree planting was followed by a vigorous political meeting on the subject not of Shakespeare but of Garibaldi, and this in turn was broken up by the police. Plans to subscribe to a Shakespeare statue for the Hill were abandoned.

Eton had meanwhile turned north in search of less eccentric profit from its Upper Chalcots fields. Adelaide Road was laid out for building in 1830, but it too found the going slow. A small colony of stucco villas grew up round the present St Saviour's Church, but it took the estate a full two decades to reach its western limit at Swiss Cottage. Its course was dogged, and eventually dominated, by the most traumatic event in the neighbourhood's history: the arrival of north London's first railway and the building of its first great monument, the Primrose Hill tunnel.

The line was that of Robert Stephenson's London and Birmingham Railway into Euston. The project received Parliamentary approval in 1833 and was finally opened from Euston to Boxmoor in Hertfordshire in 1837. So steep was the incline down to its terminus at Euston that in the early years the carriages had to be rope-hauled up to the Camden Town depot before they could be coupled to a locomotive. The tunnel itself took three years to build and ran for three quarters of a mile from Chalk Farm to Alexandra Road in South Hampstead. The Eton College Estate, understandably concerned about the line's impact on its developments, was strict as to its design. The enabling act stipulated that it 'shall be constructed of sufficient strength to admit of buildings being erected thereon, except where the crown of the Tunnel is within 15 feet of the surface.'

To early travellers passing through it in open coaches, the tunnel entrance must have seemed the very gate of hell. A contemporary enthusiast admitted that 'it usually excites strong anxieties and terrors in the timid mind'. Perhaps for this reason its architect, W. H. Budden, designed it to look the epitome of solidity and strength. The arch was heavily rusticated and the massive retaining walls were topped with turrets and exaggerated cornices. Nothing should suggest to the company's passengers that they were about to enter a smutty, noisy, dripping hole in a hill.

Such monuments to modern technology, coming as they did when the

lithograph was achieving widespead popularity, called for celebration. Gareth Rees, in his study of early railway prints, points out that 'railways were receiving the kind of commemorative attention normally reserved for coronations'. Medals were struck, mugs and jugs produced and souvenirs sold, all glorifying each new advance of the iron road. Individual prints were made to be distributed to sightseers on the day of opening and special albums were published, often under the sponsorship of the railway companies.

The London and Birmingham was fortunate in having two of the best railway artists to illustrate its achievement. John Bourne and T. T. Bury travelled along the line during its construction and left a graphic record of the impact the railways had on the English countryside. Ackermann published bound volumes of prints by both of them.

None of Bury's views falls within the scope of this book, but Bourne provided a  *463* lithograph of the Primrose Hill Tunnel, showing it still under construction. Stone is being moved on a truck and the embankment swarms with workmen. Unlike many early railway artists, Bourne did not dissemble. To him the railway was plainly a shock to the landscape, tearing great scars across it, and graphic passages from Dickens are often used to accompany his prints. One, from his *Miscellaneous Papers*,

*463 Primrose Hill Tunnel; lithograph by Bourne, 1839.*

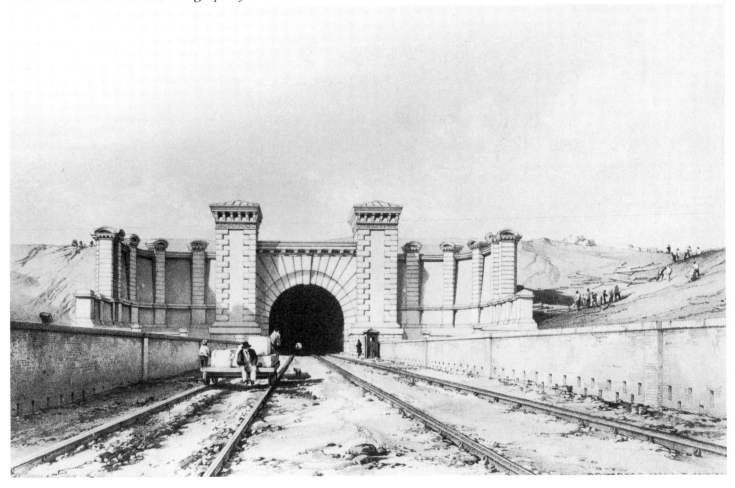

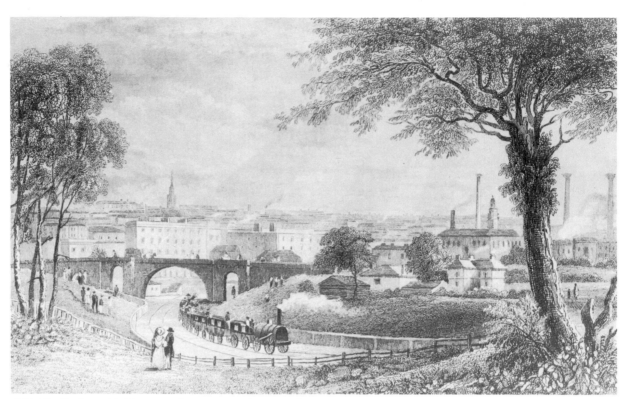

*469* Chalk Farm Bridge; *steel-engraving by Fussell, 1839.*

describes this same line under construction: 'The yet unfinished and unopened railroad was in progress, and from the very core of all this dire disorder, it trailed away smoothly upon its mighty course of civilisation and improvement.' Bourne's volume, though well received, was not a financial success. Russell suggests that 'the early Victorians, intrigued by railways though they may have been, wanted to look at pictures of cows rather than of trains and preferred ruins to excavations'.

In 1837 the trains began running and from then on no railway print was complete without one. Visitors flocked to Primrose Hill to see the engines as they emerged hissing and clanking from the tunnel entrance. Later prints show these sightseers gathered on the Chalk Farm embankment. Ornamental paths have been laid out and trees have sprouted beneath the entrance walls. Budden's titanic arch remains in use today across British Rail's London Midland main line, indeed it was accorded the honour of being duplicated when the line was widened later in the century.

469   A steel engraving by Fussell taken from the same bank in 1839 for Trotter's *Selected Illustrated Topography* shows the view in the opposite direction looking south towards Camden Town. An early train, its carriages still designed like stagecoaches and with passengers sitting on top, can be seen making its way north shortly after having transferred from rope-haul to locomotive. The chimneys in the right distance were for the winching machinery which drew the carriages up

from Euston. The view was a rare industrial intrusion into Trotter's series: Ronald Russell comments, 'the view is framed with trees; the spirit of the picturesque just survives'.

The arched bridge was demolished at the time of the line's widening, but it corresponds to the present mural-painted Paradise Bridge at the end of Regent's Park Road. On the right-hand bank of the cutting we have a glimpse of the fields towards Chalk Farm Tavern shortly before they vanished beneath bricks and mortar. The small two-storey house was Bow Cottage, which was later incorporated into the home for 'The Training and Maintenance of Destitute Boys not Convicted of Crime', which arrived in 1865.

Known as the Boys' Home, its premises at the foot of King Henry's Road are shown on the cover of its old-boys' magazine, *The Budget*, for 1883. It could *471* accommodate up to 150 pupils, most of whom were trained as craftsmen. Gladys Beck (*Camden History Review*, No. 2) relates how each year Scaninavian wood was brought from Sweden through Limehouse dock and along the canal to Camden basin for the Home's workshop. The Home's chapel is now the warehouse of 111 Regent's Park Road. It was closed in 1920 but, after a fierce local struggle in 1981, its main buildings have been saved from demolition.

*471 Regent's Park Road Boys' Home; wood-engraving, 1883.*

# 12

# POINTS WEST

The remainder of this book is concerned with the three hamlets which stood on the western outskirts of the parish of Hampstead: Childs Hill, West End and Kilburn. Prints of them can be of little more than historical interest. Few traces of their buildings remain from the period with which we are dealing. Yet all three were characteristic villages of the Middlesex weald, and their transition from agricultural to suburban communities makes a quiet contrast with the more spectacular Hampstead story.

Of the enclave of Childs Hill, most of it over the parish boundary into Hendon, we know little. It dates back to the Child family who held land in Hendon and Hampstead in the fourteenth century, and was a natural place of settlement on the well-watered and well-drained western flank of the Heath. Rocque's map shows a cluster of cottages round a pond, but it is more likely to have been a straggling village along the track from Hampstead to Cricklewood. Its highest point was a limb of the Heath where a telegraph station was erected in 1798 as part of the Duke of York's intelligence network during the threat of Napoleonic invasion. This was later converted into an Admiralty signal point.

The view north and west from Telegraph Hill was superb. Three Dibdin lithographs executed in the 1850s are set in the vicinity, one of them apparently showing the small cottage which may have taken the place of the telegraph. It was probably from this area that Constable painted his vision of 'Noon: West End Fields' from which Lucas produced his 1830 mezzotint for *English Landscape Scenery* (see Chapter Eight). The print shows a lane running along the side of a hill to the left. The windmill in the distance, picked out by a ray of characteristic Constable sunlight, would have been the one which stood on Shoot-up Hill in Cricklewood. A second Constable/Lucas print was probably executed in this area, perhaps from West Heath Road, entitled 'Hampstead, Harrow in the distance'. It was one of those contemplated for inclusion in the 1830 series but not produced until 1845.

Immediately beneath Telegraph Hill stood Childs Hill House. This was a small villa which we know was occupied by Thomas Platt in 1811 and which is shown in an 1813 engraving by C. Pote. The house was bought by Joseph Hoare, brother of

*238* Noon; *mezzotint by Lucas after Constable, 1830.*

*239* Hampstead Heath, Harrow in the Distance; *mezzotint by Lucas after Constable, 1845.*

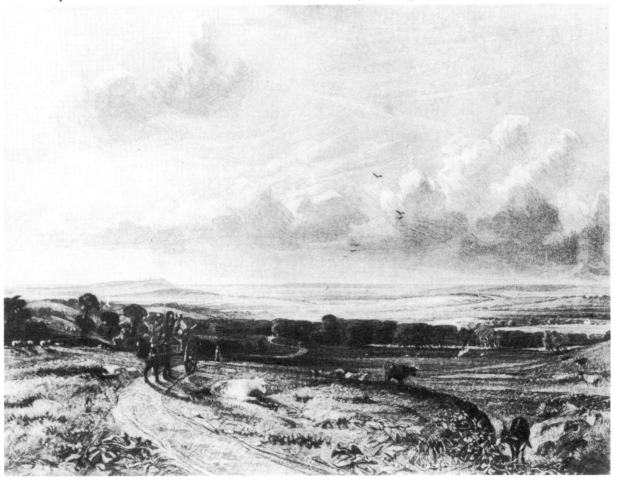

John Gurney, in 1846 and he lived here until his death in 1886. It appears to have been demolished soon after.

Of the village street itself, on the line of Hermitage Lane/Cricklewood Lane, there is now no trace. It was obliterated by the building of the new Finchley Road in the late 1820s. A handful of nineteenth-century chapels and some terraced housing are the remaining witnesses to what was a predominantly working-class neighbourhood. The higher ground towards Telegraph Hill, by way of contrast, has been covered with sweeping drives and large mansions, and in places it seems more akin to Pasadena than to Hampstead.

We have only one view which appears to show Childs Hill in its original village
*480* form. The Rathbone aquatint normally identified as of North End is, in my opinion, of Childs Hill, looking roughly south-east with Telegraph Hill off to the left. The track is flanked with cottages and in the distance is the chimney of a kiln. We know of no such kiln in North End, but there had been one recorded in the
*481* centre of Childs Hill since before 1521 and a kiln was there in 1814. A small print of it exists as further evidence.

More puzzling is the structure in Rathbone's left distance, looking like a castellated fort or a house with large chimneys and with a giant weathervane on top. The date of the print is 1797 and our only clue is provided by an engraving by John Peltro made in 1784. This is a pastoral scene simply entitled 'The Happy
*479* Shepherd with a view of Childs Hill'. In the foreground a young man courts his girl and behind are cottages on what is presumably the slope of Telegraph Hill. But what is the shape to the right of the tree? Close examination of the engraving suggests that the H-shaped object is plainly a folly or turret of the sort which no artist would have invented were it not there. It looks like a side view of the same structure as that shown by Rathbone.

Two routes ran west from Childs Hill, one across to Cricklewood on the Edgware Road and the other south-west to Fortune Green along the line of the present Platts Lane. This latter then turned south and entered West End. Had it not been for its valley location and a consequent tangle of Victorian railway lines, West End might have expected to become Hampstead's most prosperous neighbourhood. Its land was fertile and it lay on the western, 'country' side of the town. Here the Maryon Wilson and other estates encountered no popular resistance to their eventual redevelopment plans. Access to London down the Edgware and Finchley roads was easy, and since the eighteenth century many of Hampstead's most prominent residents had lived there.

First among these was Josiah Boydell, 'leading citizen' of the town in the late eighteenth century. The name of Boydell cannot be omitted from any book on London prints, despite the lack of any showing his own house. Josiah came to West End in 1781 shortly after he had entered into a partnership with his uncle,

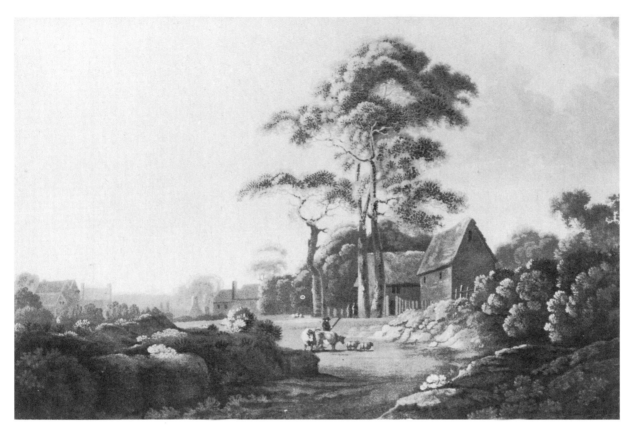

480  *View wrongly entitled* North End *;*
*aquatint after Rathbone, 1799.*

480  *(Detail) The Kiln.*

479  *(Detail) The Happy Shepherd;*
*copper-engraving by Peltro, 1784.*

Alderman John Boydell, in a print business which preceded and rivalled Rudolph Ackermann's. His engraved reproductions of famous paintings as well as of topographical scenes were sold throughout Europe. As Ronald Russell remarks in his study of British topographical prints, Boydell's patronage 'meant more to many an English painter than did that of His Majesty and a dozen dukes'.

Boydell Senior amassed a large fortune and rose to be Lord Mayor of London. The climax of his career was a project to establish a gallery of Shakespeare scenes by the leading artists of the day, coupled with a published collection of engraved prints of them. The scheme was planned during a dinner at his nephew's West End home in 1786 at which two of the artists involved, George Romney and Benjamin West, were also present. The gallery, comprising over 100 paintings, was opened in Pall Mall in 1789. However, a combination of the collapse of the Continental print market during the French wars and the sheer scale of the project itself – with artists' fees at up to £1,000 a painting – proved disastrous to Boydell. The entire gallery had eventually to be disposed of by lottery in 1803.

Josiah Boydell, as well as being a painter and engraver in his own right, was a passionate Hampstead enthusiast. He followed his uncle as a City alderman, was a local magistrate and promoted the rebuilding of the Frognal poor house and the formation in 1799 of the Loyal Volunteers. He was clearly a master of rhetorical hyperbole. On receiving the Hampstead brigade's colours, he exhorted the men of the town to 'remember the noble and martial fire which blazed in the hearts of our ancestors' among whom he numbered Boadicea, Caractacus, Alfred the Great and the victors of Crécy and Agincourt. Josiah finally left Hampstead in 1806 and died in 1817.

The West End of his day comprised a group of houses on either side of the section of West End Lane from the present railway station north to the Green.

*489  Hampstead from West End Lane; etching published by J. Hewetson, 1867.*

*491  Buildings round West End Green; etching, c. 1840.*

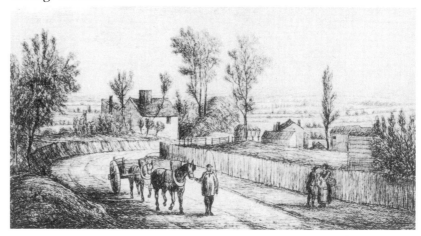

Buildings such as West End House, Sandwell House and West End Hall suggest it was as wealthy a district as the contemporary Haverstock Hill, though never quite substantial enough to sustain a large number of shops or a church. This seclusion was well captured in Hewetson's view of Hampstead from West End Lane. The *489* artist was presumably looking east up what is now Frognal Lane. This track was at the time still a wholly rural link between the town and its western outpost. Caroline White recalls it as enclosed by 'grassy slopes with their old-fashioned hedgerows broken by elm and oak trees and brightened in spring and summer with whitethorn and elder bloom'.

Fancourt's 1840s view west in the opposite direction and from roughly the same *491* point shows the buildings round West End Green. Ahead is the Green itself while on the right with a prominent chimney and roof gable is the old Cock and Hoop tavern. The Cock and Hoop was the best-known local institution and became the focal point for the West End fair, one of two held each year in Hampstead (the other was at Flask Walk). The event lasted for three days in July and by the early nineteenth century was causing serious disruption to the calm of the district. The 1819 fair was particularly violent. It was recorded that a gang of 200 youths invaded the neighbourhood, beating and robbing the customers and even wrenching earrings from ladies' ears. Fairgoers had to wait for the curfew recalling soldiers to their barracks and walk along with them for protection.

The fair was finally suppressed in 1821 but its reputation appears to have lived on to blight the Cock and Hoop. The customers reputedly included 'famous highwaymen and robbers'. Even at the end of the nineteenth century it was producing opposition from local people. The pub's last landlord was disqualified from holding a licence. Research by Michael Redley (in *Camden History Review*, No. 9) suggests much of this opposition was from local temperance groups opposed to pubs of any sort. According to Redley, the Cock and Hoop's eventual disappearance beneath the present Alexandra Mansions owed more to rationalisation by the turn-of-the-century Watneys Brewery, eager to reduce competition with their own Old Black Lion opposite.

The only sight we have of the large houses of pre-Victorian West End is an undated lithograph of Treherne House, probably from 1835. It shows a two- *493, p. 148* storey villa typical of the period set in spacious grounds. The house was occupied in the 1820s by a Mr Binns, who was known locally as a prominent objector to the new Finchley Road. The plan for this road emanated from Colonel Henry Eyre, landlord of much of St John's Wood to the south. By 1819, he was developing the northern part of his estate and his declared intention was both to enhance that property and provide a natural route to the north, avoiding the steep slopes of Haverstock Hill. He was bitterly resisted by a number of prominent Frognal and West End residents.

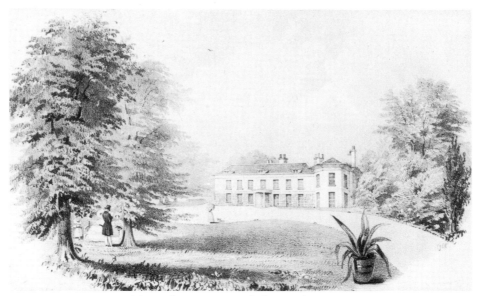

*493  Treherne House; lithograph, c. 1835.*

John Miles, who lived in West End Hall (sometimes called New West End House) and who had taken over from Josiah Boydell the mantle of 'squire of West End', protested that the new road would remove part of his precious shrubbery. Mr Binns complained that 'in my opinion the beauty and privacy of Hampstead will be totally destroyed'. But no antagonist was more articulate than the lord of the manor, Sir Thomas Maryon Wilson. Indeed it is ironic that the best account of nineteenth-century Hampstead's image of itself should have come from its absentee landlord and potential despoiler of much of the present Heath. He wrote:

> It is desirable in order to meet the taste and choice of the Residents there for privacy, not to put in practice any measure to make it more public. The Gentlemen there who fill official situations, or are in professions, or are Merchants of the first rank in the Metropolis, wish to preserve about their Dwellings the quiet and privacy which the country should secure for their refreshment and necessary retirement from active duties and pursuits daily prosecuted in the Metropolis. This quiet and privacy will be disturbed and diminished if, by a new Road as designed, the idle or pleasurable (not to say vicious) members of any portion of the Metropolis are to be drawn to Hampstead for objects of pleasure or crime. (Quoted by Thompson.)

Despite this eloquence, Colonel Eyre had his way. A Finchley New Road bill was passed through Parliament in 1826 and by the end of the decade the road was completed as a turnpike with a tollgate at Swiss Cottage. Pressure for building development now crept up on West End from both south and west. By the 1840s there was a need for a schoolroom to supplement the national schools being

*494  West End School; tinted lithograph, 1844.*

proposed for central Hampstead. Two chapels were provided for the Anglican residents of the eastern part of the town, and so it was not unreasonable for West End to claim one for itself.

No Hampstead community was ever short of a resident architect and in this case it was Charles Miles, whose family lived at West End Hall. He produced two lithographs to accompany plans for a proposed chapel and school located near the Green. The small gathering in the foreground of the print of the school might *494* almost have been contributed by Childs. Although the chapel eventually gave *495* way to the much larger Emmanuel Church on the east side of the Green, the school remains much altered amid the present Emmanuel School buildings at the top of Mill Lane. In the background of Miles' school print is a glimpse of Cholmley *494* Lodge, typical of the Italianate mansions which filled in the gaps of West End Lane in the mid-Victorian period and for a while gave it the character, as Thompson says, of Hampstead's 'millionaires' row'.

Whatever might have been West End's prospects as a suburb of gracious villas, the coming of the Hampstead Junction Railway and its successors transformed them. Central Hampstead had no railway nor, given its contours, was it likely to get one. The stations at South End and West End thus had the effect of containing the poorer commuting communities, largely City and Westminster clerical and distributive workers, in the neighbourhoods of Fleet Road and West End Lane. This in turn increased the pressure for more intensive development of the adjacent land and correspondingly reduced its appeal for 'carriage folk'.

Already West End had seen the coming, and passing on, of the London and Birmingham Railway to the south. The company did not deign to site a station in

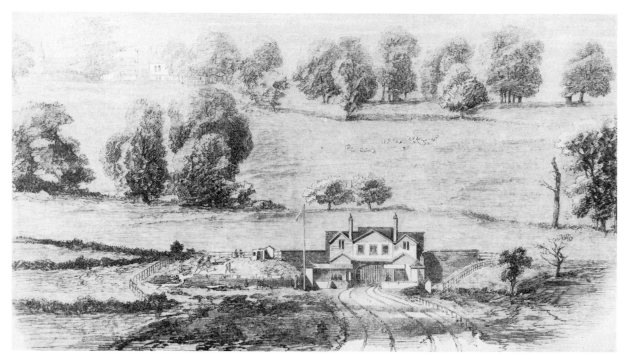

*499  Finchley Road Station; wood-engraving, 1860.*

the district, though one was built at Kilburn in 1852. Thus the first West End
station was the Hampstead Junction's halt at Finchley Road, opened in 1860 and
celebrated by the *Illustrated London News* in one of that magazine's most engaging
*499*  Hampstead prints. It shows the new station standing alone in the fields, its empty
tracks patiently awaiting the arrival of houses, roads, passengers and profits. The
platform approach is still being excavated and sheep are grazing in the fields of
Hall Oak Farm beyond, innocent of the great new avenue (Fitzjohn's) which is
about to obliterate their pastures.

Within two decades, West End was smothered in railway. The London and
Birmingham, the Hampstead Junction (later the North London), the Midland and
the Metropolitan, together with the Great Central, were all cutting swathes across
its fields.

The spirit of this new age was perhaps best characterised by the owner of the
*500*  neo-Tudor Oaklands Hall. The house was built in the 1850s south of West End
House on the lane to Kilburn and was acquired in 1861 by Donald Nicoll. The
embodiment of one sort of mid-Victorian entrepreneur, Nicoll began life as a
merchant with an outfitting business in Regent Street. He thus made himself a
fortune, graduated to Liberal politics and developed a remarkable zest for
property speculation. He was a campaigner for penal reform and ardently
supported the protest movement against Maryon Wilson's East Heath enclosure.
Yet he was himself the prime developer – and ultimately vulgariser – of the

Victorian Vale of Health on the other side of the parish.

Where Nicoll's predecessors among West End residents had fought tooth and nail against the coming of the Finchley Road in the 1820s, Nicoll approached the railway invasion with commercial gusto. He bought up land in its path, in the anticipation of benefiting from compensation. He became a director of the Metropolitan and St John's Wood Railway Company. And in 1871 he happily seconded a motion that its line be extended across his land (see Michael Alpert, *Camden History Review*, No. 7).

The result of this development was to submerge the lower part of West End in the sooty detritus of heavy industry – sidings, coal bunkers, carters' yards, sheds and workers' lodgings. The impact of the last could alone destroy the reputation of the most salubrious neighbourhood. Old West End House found itself trapped between the tracks, on the one side, of the Hampstead Junction and on the other of the Midland Railway. It became first a 'girls' laundry and training institute' and finally a lodging for railway workers. Meanwhile, Nicoll was busy with schemes for building streets of 500 houses at a time.

Not one of West End's major eighteenth- or nineteenth-century houses is standing today. But the cemetery built in 1876 on Fortune Green Road is still as it appears in a contempory wood engraving from the *Builder*. Only the 501 enticing open fields on the horizon have gone. It is a delightful work of mid-Victorian architecture. The two small chapels, designed by Charles Bell, have been well restored and the cemetery is a calm retreat from traffic which here is itself seeking an escape from the ever-rolling stream of Finchley Road.

*501 Hampstead Cemetery; wood-engraving, 1876.*

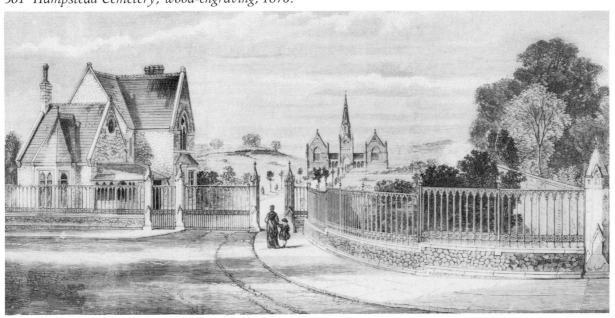

The path of West End Lane meandered on through the fields south from West End past Oaklands Hall to Kilburn – as it meanders still. To its north was the course of the old Kilburne, a tributary of the Westbourne which met the Edgware Road at the village of the same name. Its rural character lasted well into Queen Victoria's reign, illustrated in the pastoral wood engraving reproduced by *502, 505, 503, 506* Walford and in prints by Childs, Dillon and Green of farmsteads in the area. Childs' oak tree in front of a substantial three-storey cottage is typically noble.

Kilburn would almost certainly have enjoyed a reputation for its spring water back into the Middle Ages. There was a mild chalybeate well in the grounds of its priory (see Chapter One) which served as a stopping place for pilgrims to St Albans, but it was not until the proven success of Hampstead's chalybeate well that the attraction of Kilburn was realised or exploited. In 1714, Kilburn is mentioned as one of Hampstead's two wells, with waters served somewhere behind the original Bell Inn. The chalybeate was blessed with the accolade of a local medical practioner and was even proclaimed to have a greater content of carbonic acid than any other in England. The Bell, dating back to 1600, duly converted itself into a spa with tea gardens to cater for its new clientele.

We have scant record of the history of Kilburn's wells. An advertisement of July 1733, quoted by Park, declares that the 'waters are now of the utmost perfection; the gardens enlarged and greatly improved; the house offices repaired and beautified in the most elegant manner. The whole is now opened for the reception of the public, the great room being particularly adapted to the use and amusement of the politest companies.' The proprietor added that the wells are 'but a morning's walk from the metropolis'.

*512* A print of the Bell in 1789 shows a modest building more appropriate to a pub than a spa. A coach-and-four passes south down Edgware Road on its way to the *513* Kilburn tollgate in the distance. An engraving of the Bell of just eight years later shows it as 'Kilburn Wells', with an arched entrance to its tea gardens. An undated *514* engraving by Vivares goes even further. It purports to show 'The Long Room at Kilburn Wells' in the late eighteenth century as a handsome classical assembly room. The church in the background is inexplicable (unless the artist was presuming Kilburn Priory) and the identification of this print must be doubtful. The Bell continued as Kilburn Wells into the 1860s, though there is no account of its 'waters' beyond the 1840s. It was demolished and rebuilt in 1863 at the time of the railway invasion and now stands next to Kilburn High Road station.

Next door to it was the Red Lion, claiming an even older history back to 1444. There is no reason to doubt this. Such an establishment was likely to find a market alongside the probably more sparse hospitality of the priory next door. The pub, *512* whose sign is just visible beyond the Bell in the 1789 aquatint, is shown in a *515, p. 154* striking Rathbone also of 1789 with a large covered wagon in the foreground.

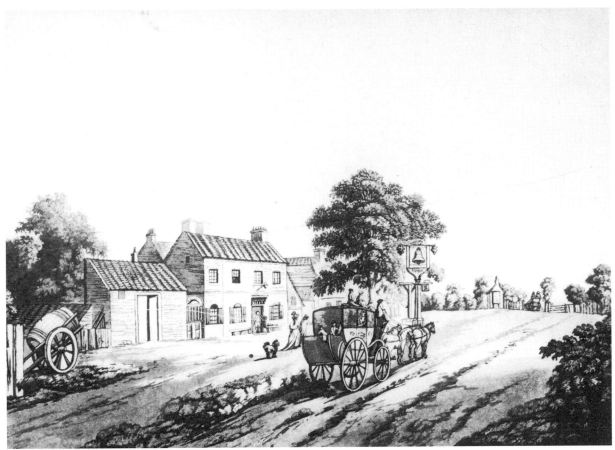

512 *The Bell at Kilburn; aquatint, 1789.*

514 *(Detail) The Long Room at Kilburn Wells; copper-engraving by Vivares, c. 1750.*

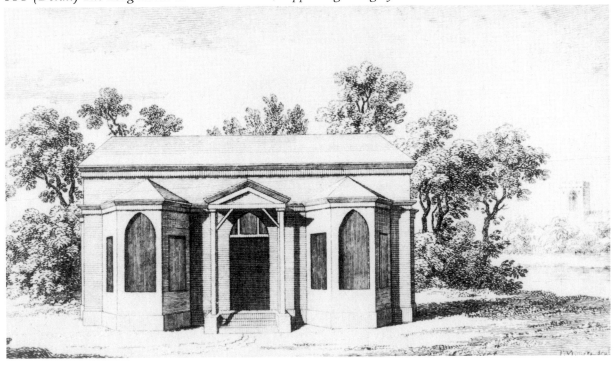

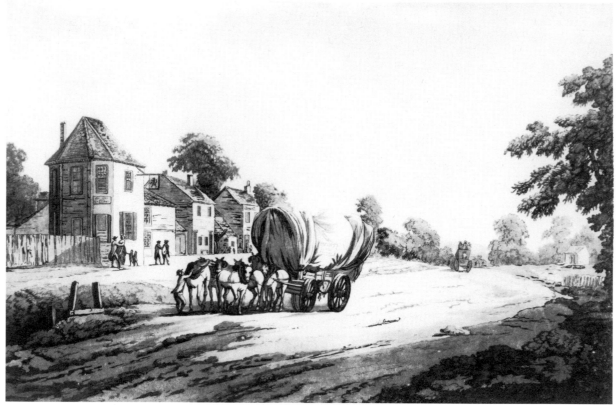

515  *The Red Lion at Kilburn; aquatint after Rathbone, 1789.*

520  *Victoria Rifle Ground; lithograph, 1860.*

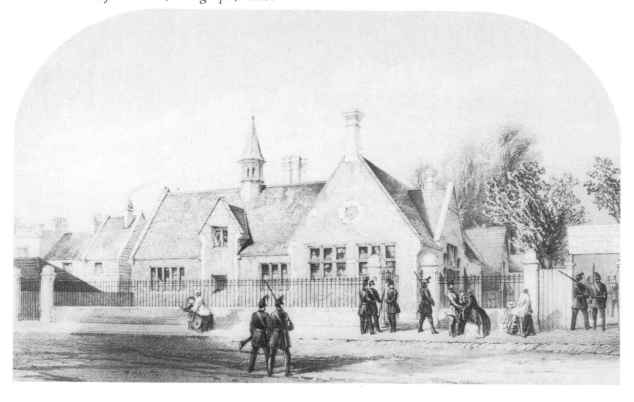

In the 1850s, the tide of suburban development began to surge up Edgware Road towards the Hampstead boundary. To the south, it submerged the estates of the Eyre family and of the Bishop of London in St John's Wood and Maida Vale respectively. It lapped at the slopes of Brondesbury to the west, and by the time of Weller's map of 1862 it has already encircled the Bell and Red Lion Inns. There were stuccoed villas on the former Howard estate in Greville Road and north over the railway tracks in Priory Road and St George's Road (now Priory Terrace). 'Suddenly a potent spirit touches the fragrant fields of Kilburn,' wrote the rhapsodic Baines of these developments. And Caroline White described them as 'genteel villas, a struggling ground for newly started professional men and tradesmen of large hope and small capital, with ultimate success as the prize for those who can play a losing game longest.' Kilburn was, in other words, for those who could as yet only aspire to Hampstead.

In 1856 St Mary's Church was built at the far end of Priory Road in a *517* conventional Gothic style remarkable only for its scale. It could seat over 1,000 worshippers, indicating that the church authorities had no doubt as to the fate of the fields which still lay invitingly to the north and east. The local architect, Charles Miles, put forward a proposal for the community's first school in an etching from his own hand. This building appears again in a lithograph of 1860 *519–20* with an extra classroom and, next to it, the entrance of the Victoria Rifle Ground. This ground, although outside the parish boundary on the west side of Kilburn High Road, was similar to those at Childs Hill and Primrose Hill. A number of prints show both professionals and 'loyal volunteers' at shooting practice in the 1850s.

Already Kilburn was beginning to grow apart from its distant cousin, Hampstead. Its loyalties were always divided with the parish of Willesden to the west and its character became progressively (though never totally) dominated by the Irish community who colonised it between the wars. Today, the historical link with Hampstead has come to seem more administrative than real. The more Hampstead has succeeded in preserving its own past identity, to which prints of the eighteenth and nineteenth centuries bear such beguiling witness, the more it has come to seem separated from its neighbouring areas to the south and west. Here the change from a rural to an urban landscape came later, more suddenly and with more devastating effect.

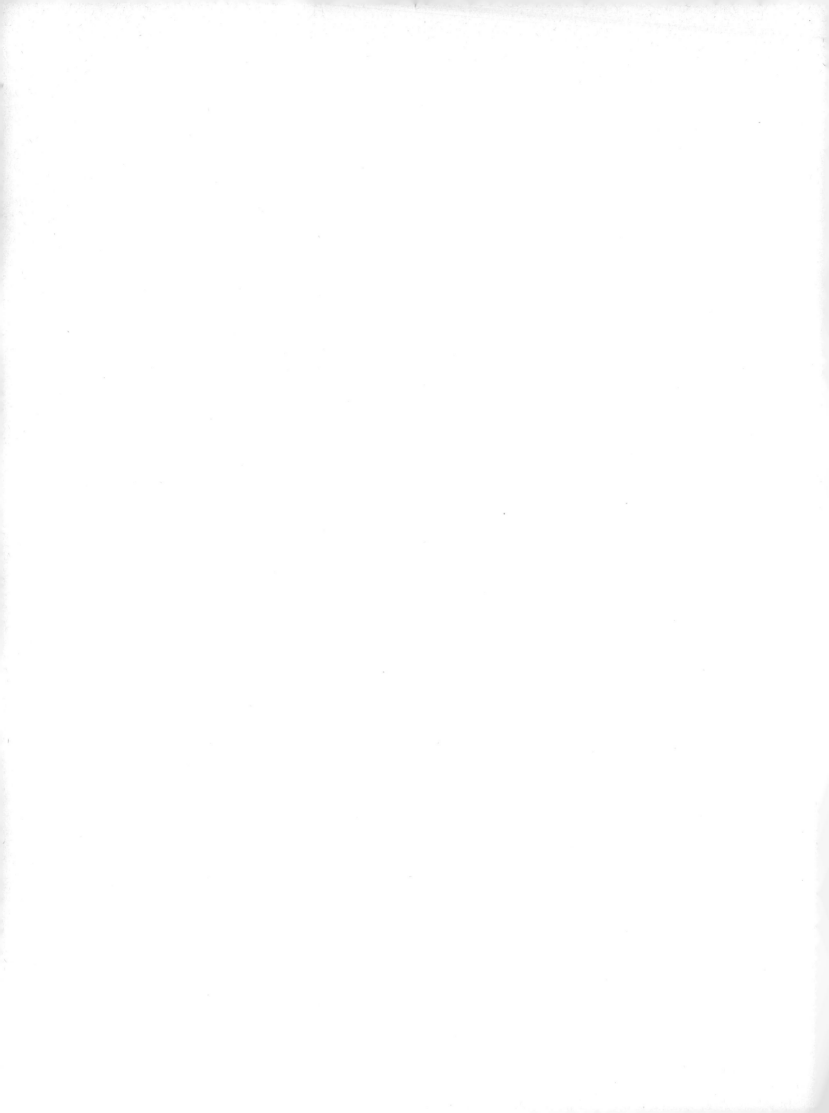

# GALLERY

## HARRIET and PETER GEORGE

We have reproduced in the Gallery all views up to 1860, and any of particular artistic or topographical interest after that date, within the old parish and borough of Hampstead. The area stretches to Kilburn in the west, to Swiss Cottage and Primrose Hill in the south, to the borders of Highgate in the east, and to the upper edge of the Heath and Childs Hill in the north.

Wherever possible the prints are arranged by subject, so that all views from a particular position or of an individual building will be found together. This often makes plain the chronological development of an area, and it will help in identifying any print which is without letters or has had them trimmed. The occasional exception to this arrangement results from the distinction made between 'Georgian' and 'Victorian' Hampstead, a few buildings (such as Vane House) making appearances in both sections. Minor variants of views, not worth separate reproduction in the Gallery, will be found listed and described in the Catalogue as part of the general entry for that particular view.

The following are the headings under which the prints are arranged, together with the numbers of the prints in each category:

Hollow Elm    1–5
Wells  6–19
St John's Parish Church    20–37
Church Row    38–47
Georgian Hampstead    48–73
Frognal and Branch Hill    74–96
North End    97–160
Spaniards Inn    161–171
Vale of Health    172–190
South End and Downshire Hill    191–207
Jack Straw's Castle    208–214
West Heath    215–252
East Heath    253–291

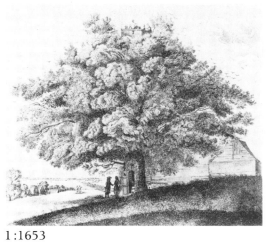

1:1653

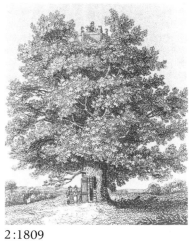

2:1809

3:1813

4:c.1870

5:c.1835

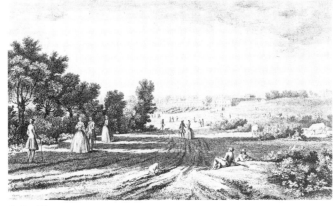

6:1745

7:1869

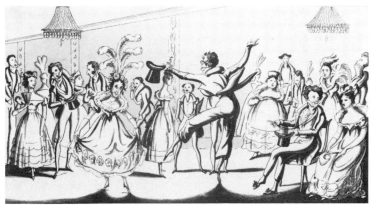

8:1822

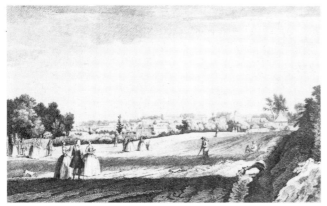

9: 1745

10:c.1745

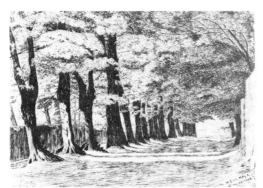

11:1754

12:1754

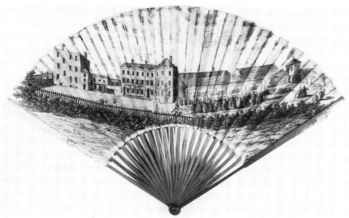
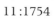

13:1878

14:1906

15:1906

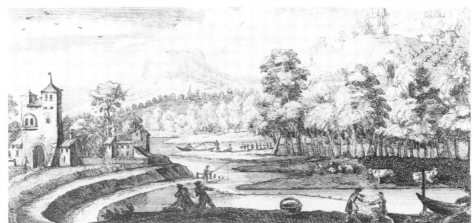

16:1738

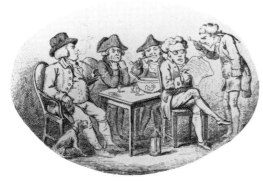

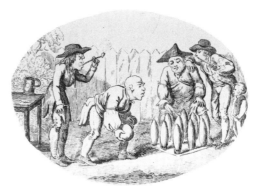

17:1796

18:1793

19:1796

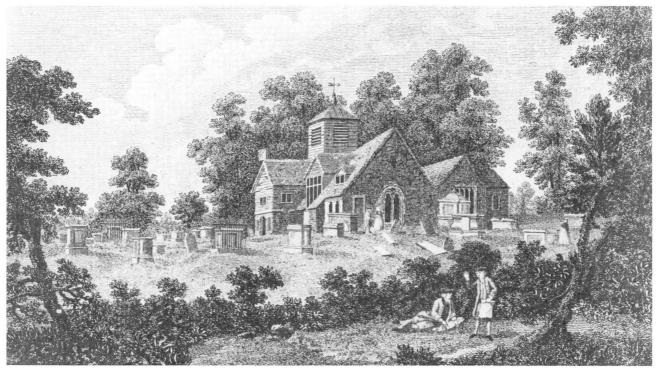

20:1785

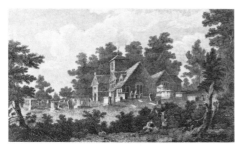

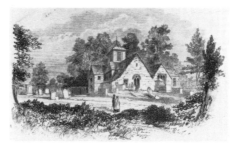

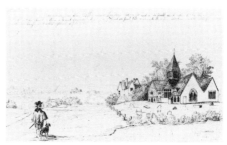

21:1814

22:1869

23:c.1870

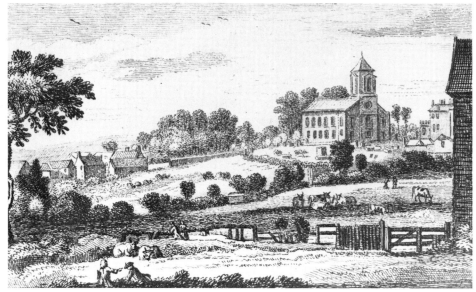

24:1750

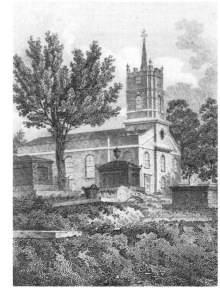

25:1805

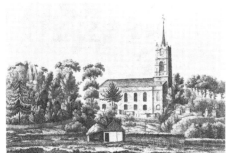

26:1807

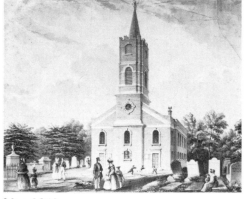

27:1814

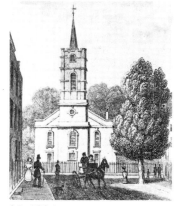

28:1822

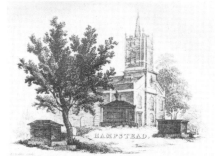

29:1834

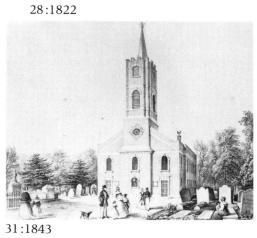

30:c.1843

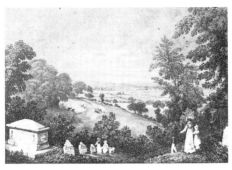

31:1843

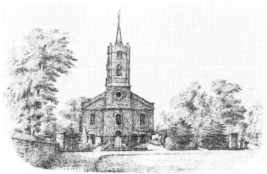

32:1868

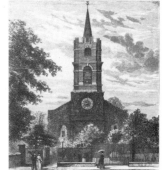

33:c. 1886

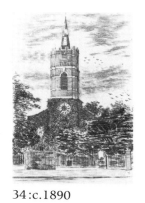

34:c.1890

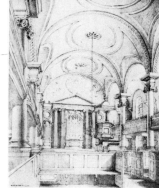

35:c.1857

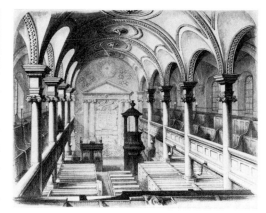

36:c.1857

37:c.1860

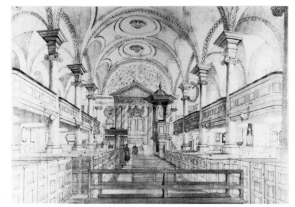

38:1827

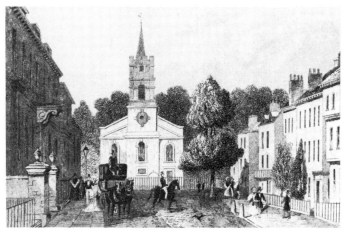

39:c.1840

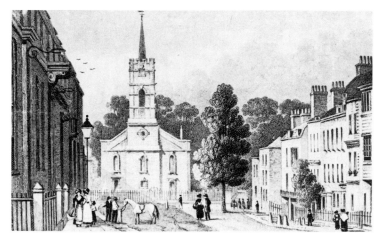

40:c.1880

41:c.1890

42:c.1878

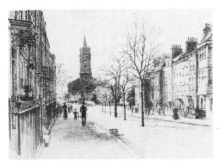

43:1898

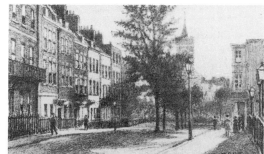

44:1908

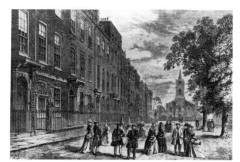

45:1877

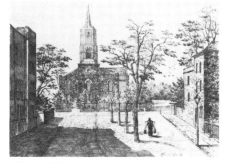
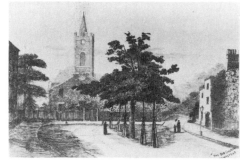
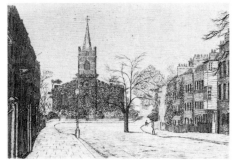
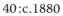
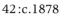

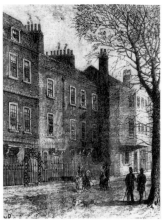

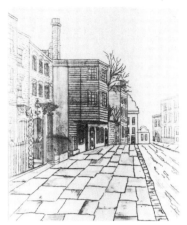

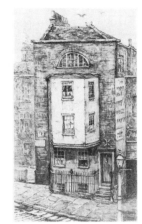

46:c.1877

47:c.1900

48:1890

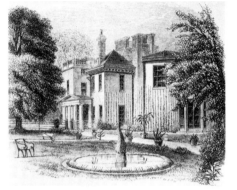

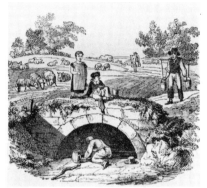

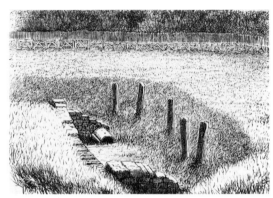

49:1869

50:1827

51:1874

52:1813

53:1869

54:1797

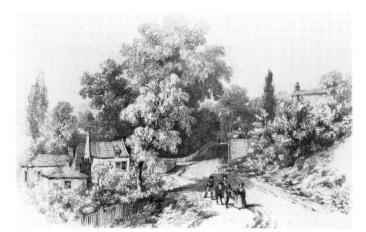

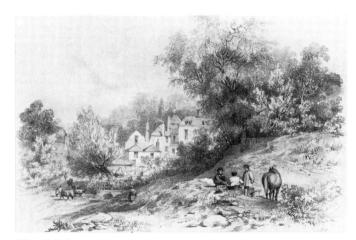

55:c.1840

56:c.1840

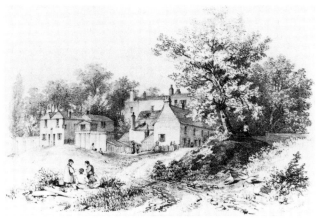

57:c.1840

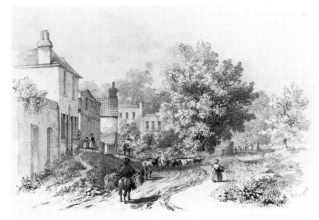

58:c.1840

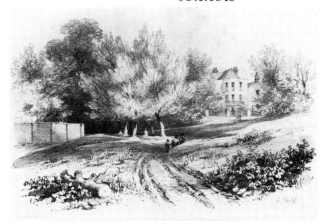

59:c.1840

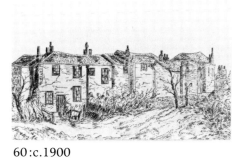

60:c.1900

61:c.1900

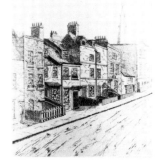

62:c.1900

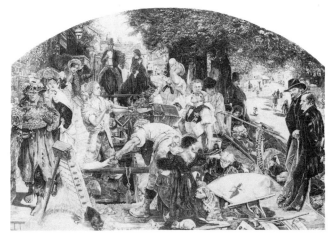

63:c.1872

64:c.1900

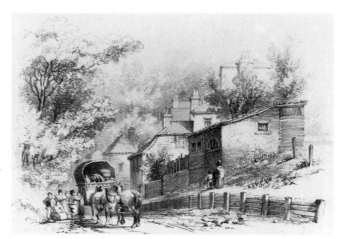

65:c.1840

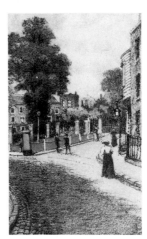

66:1908

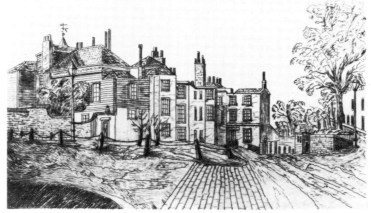

67:c.1900

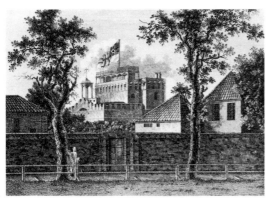

68:1796

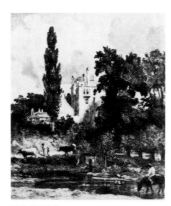

69:1891

70:1880

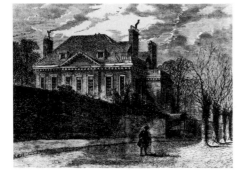

71:1877

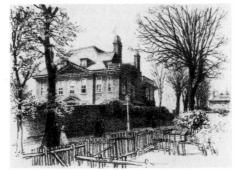

72:1898

73:c.1910

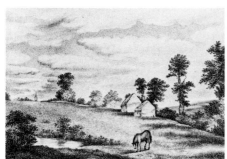

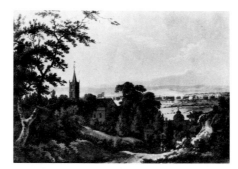

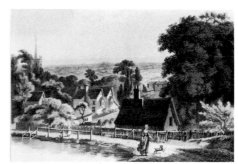

74:1790                                75:1796                                76:1796

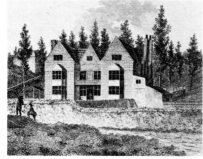

77:1797                                78:1814                                79:1869

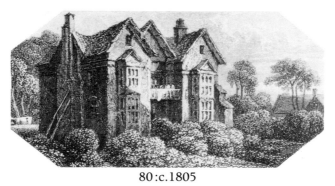

80:c.1805

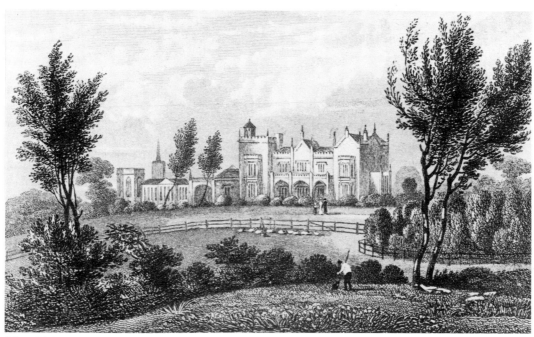

81:c.1826

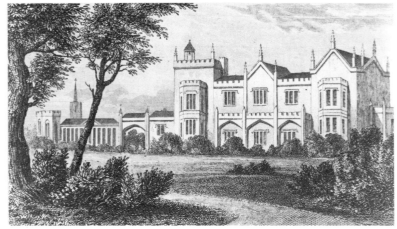

82:1834

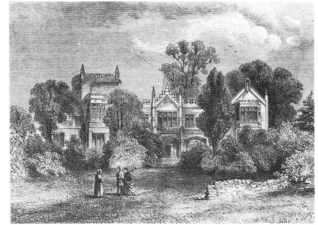

83:1877

84:1843

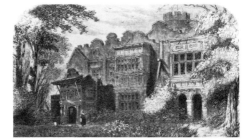

85:1863

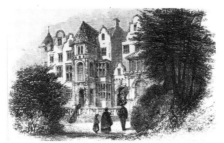

86:1869

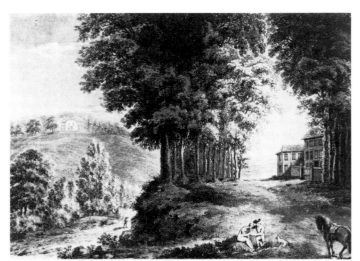

87:c.1790

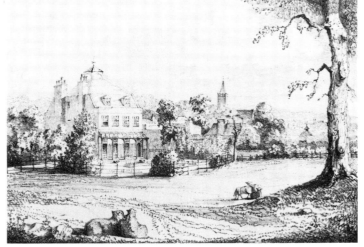

88:c.1840

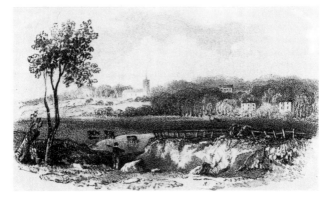

89:c.1842

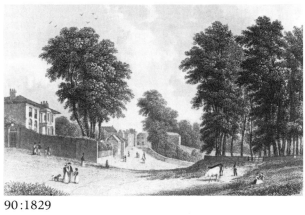

90:1829

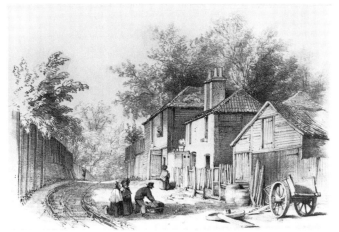

91:c.1840

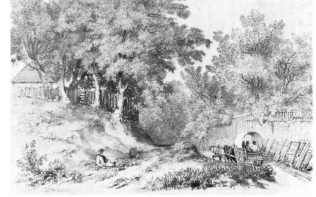

92:c.1840

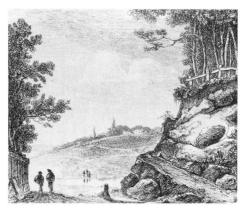

93:1825

94:1899

95:1899

96:1899

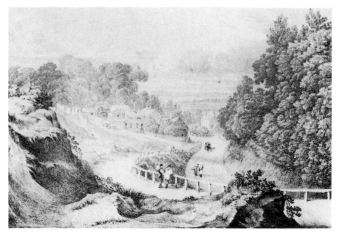

97:1822

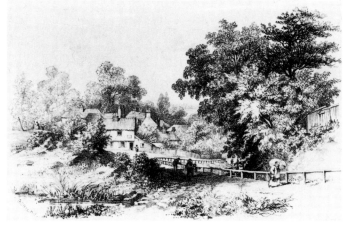

98:c.1840

99:1796

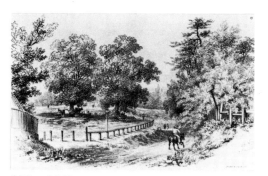

100:c.1840

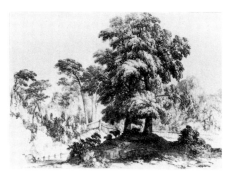

101:1844

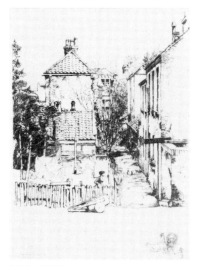

102:1898

103:c.1910

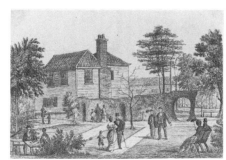

104:1870

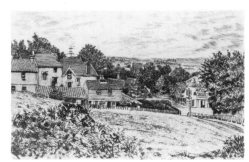

105:c.1890

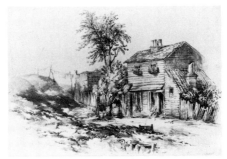

106:1859

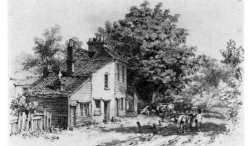

107:c.1840

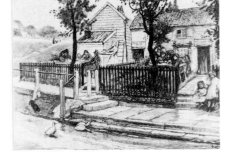

108:1859

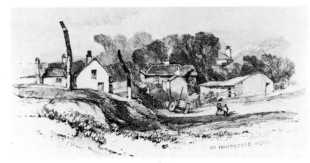

109:c.1850

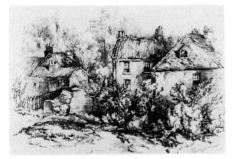

110:1883

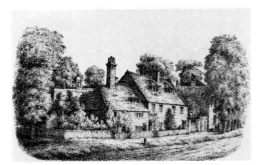

111:1868

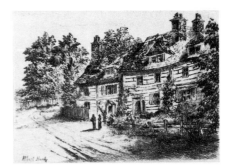

112:c.1880

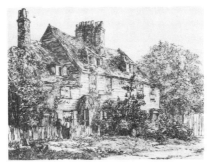

113:1879

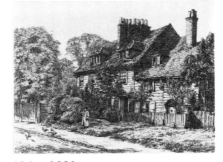

114:c.1880

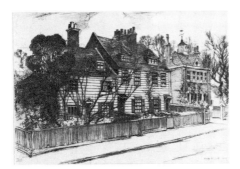

115:1905

116:c.1840

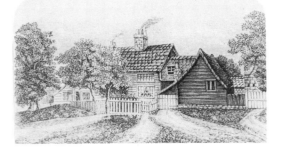

117:c.1880

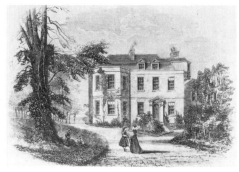

118:1869

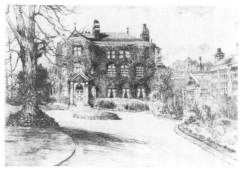

119:1905

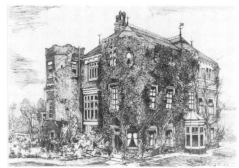

120:1905

121:c.1905

122:c.1905

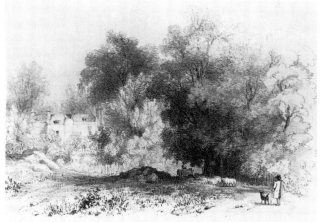

123:c.1840

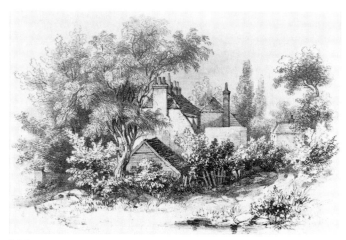

124:c.1840

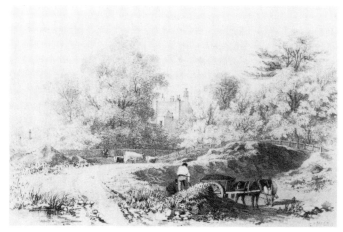

125:c.1840

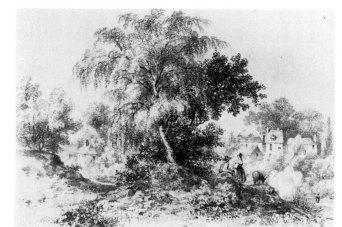

126:c.1840

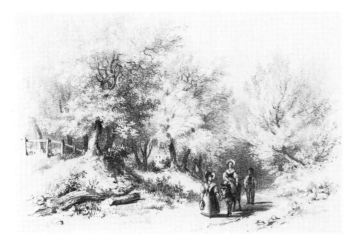

127 : c.1840

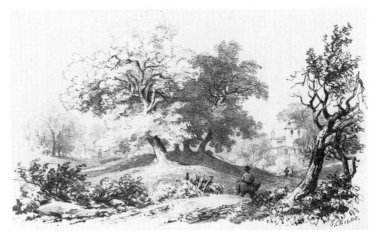

128 : c.1840

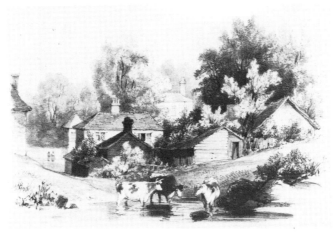

129 : c.1840

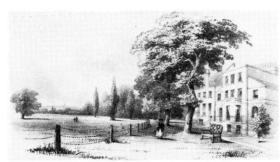

130 : 1838

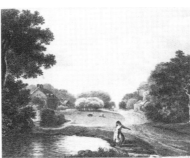

131 : 1789

132 : 1908

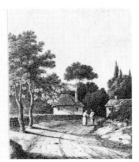

133 : 1822

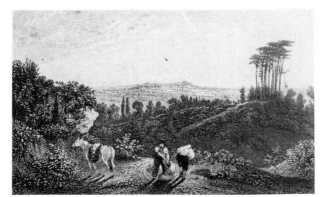

134 : c.1820

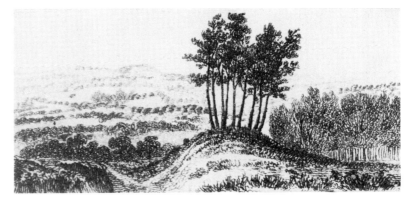

135 : c.1820

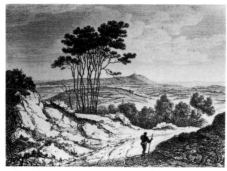

136:1825

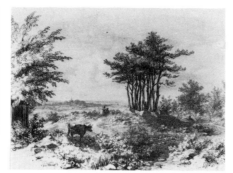

137:c.1840

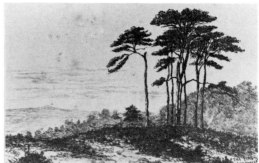

138:c.1890

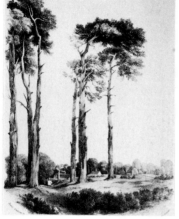

139:1837

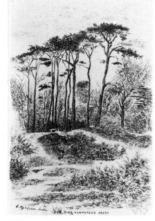

140:c.1890

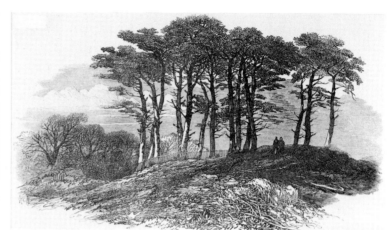

141:c.1871

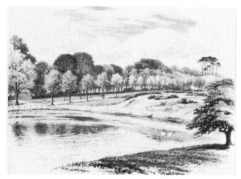

142:1898

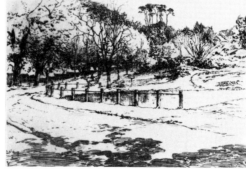

143:1898

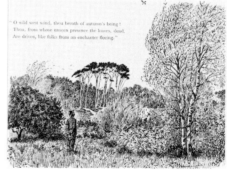

144:1891

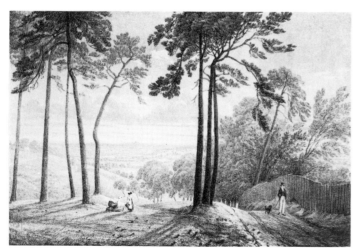

145:1822

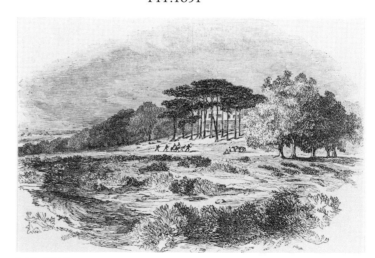

146:1844

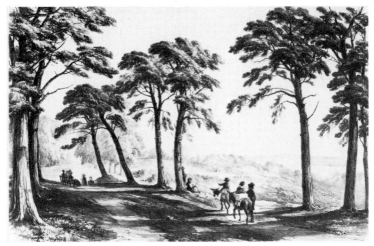

147:1850

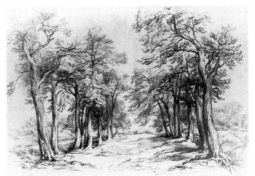

148:1859

149:1864

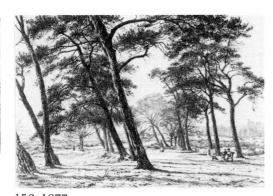

150:1877

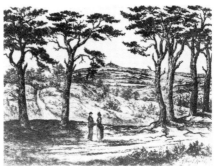

151:c.1880

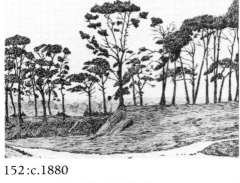

152:c.1880

153:c.1890

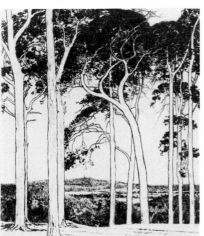

154:1900

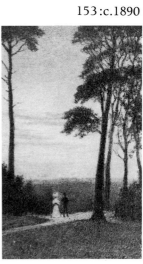

155:1908

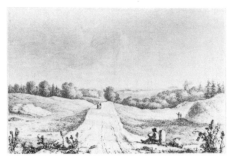

156:1823

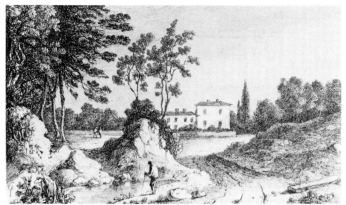

157:1824

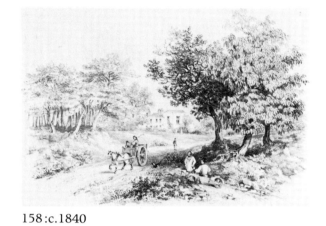

158:c.1840

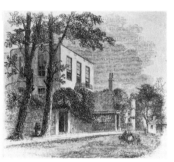

159:1869

160:1808

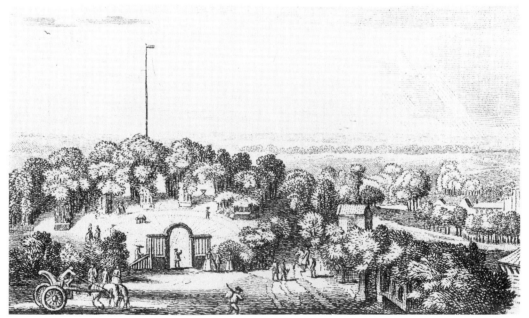

161:1750

162:1869

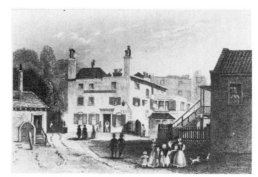

163:1838

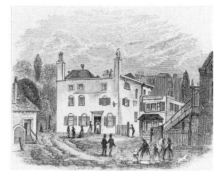

164:1872

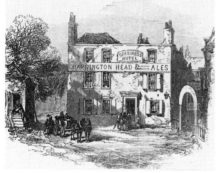

165:1871

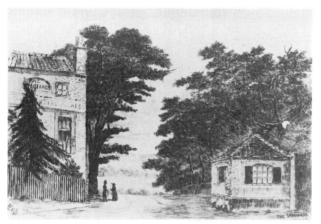

166:1877

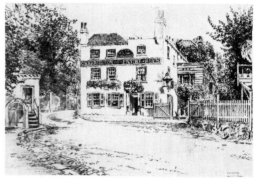

167:1899

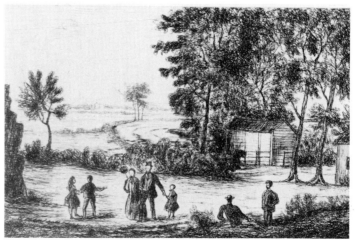

168:c.1890

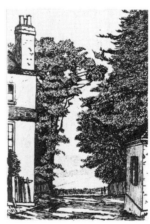

169:1878

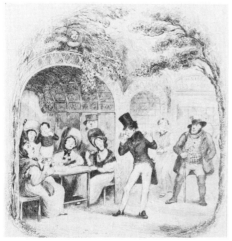

170:1837

171:c.1870

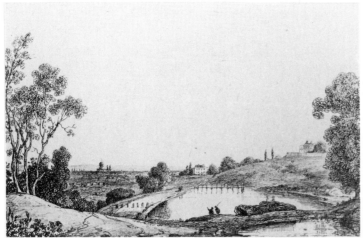

172:1831

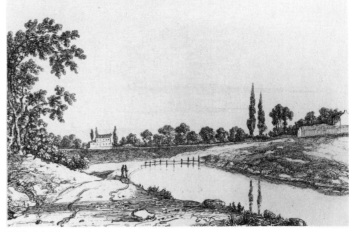

173:1825

174:c.1810

175:c.1820

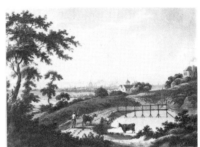

176:1796

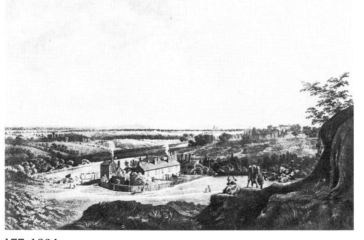

177:1804

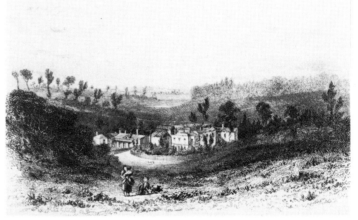

178:c.1850

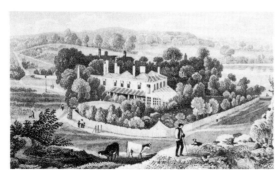

179:1827

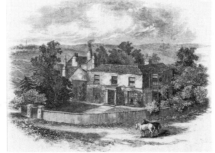

180:1865

181:c.1900

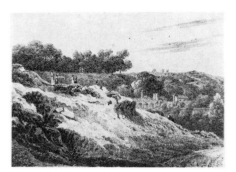

182:c.1825

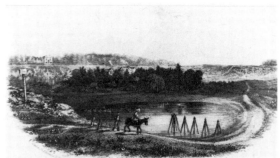

183:c.1850

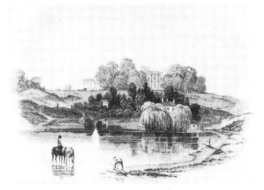

184:1834

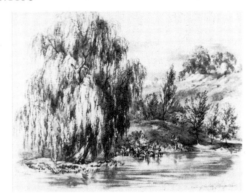

185:1859

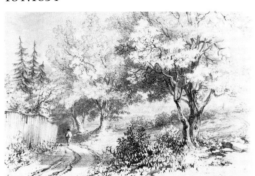

186:c.1840

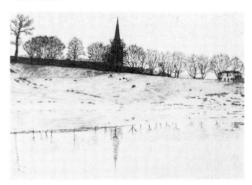

187:1878

188:c.1880

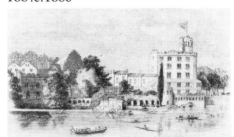

189:c.1869

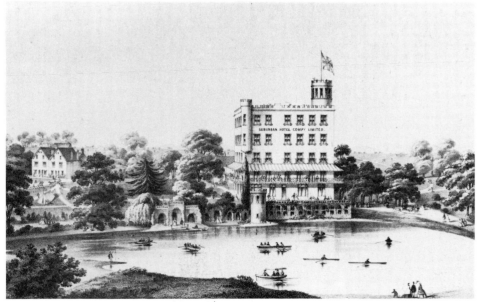

190:c.1864

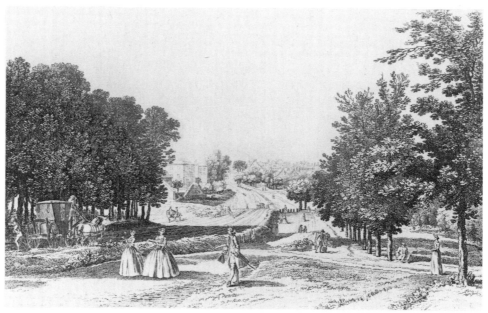

191:1745

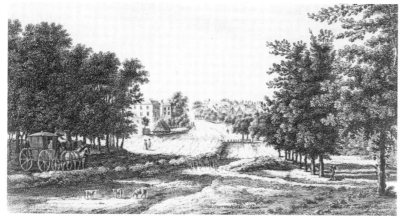

192:c.1773

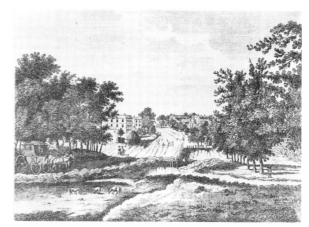

193:1784

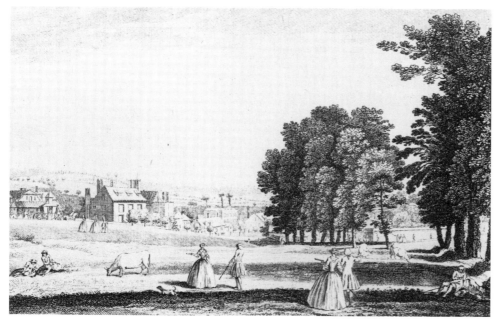

194:1745

195:1877

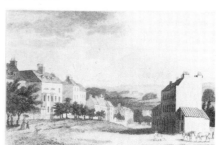

196:1803

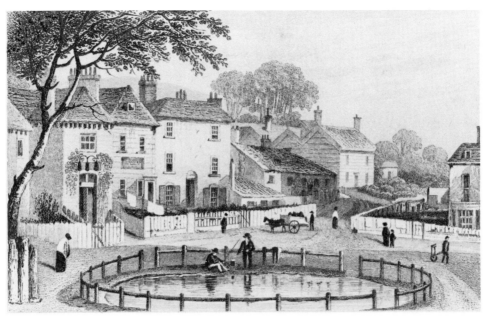

197:1828

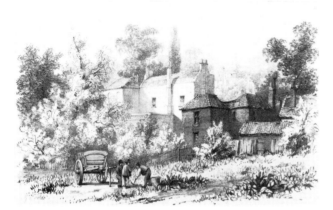

198:c.1840

199:1850

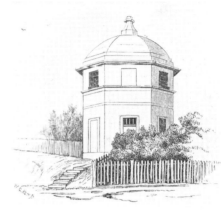

200:1889

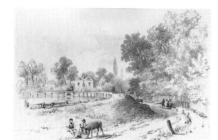

201:c.1840

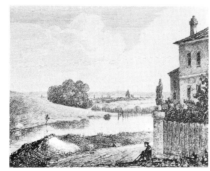

202:1828

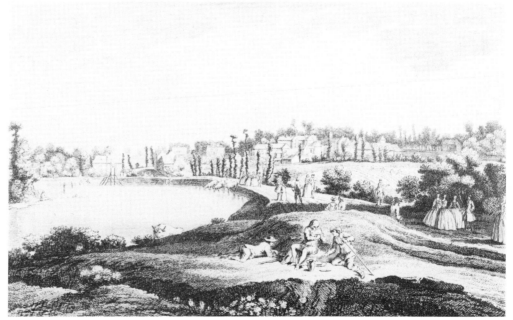

203:1745

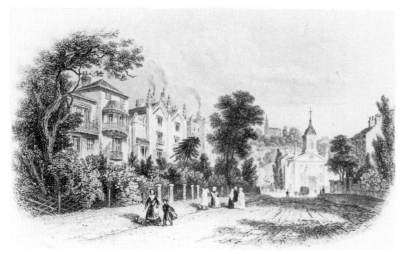

204:1842

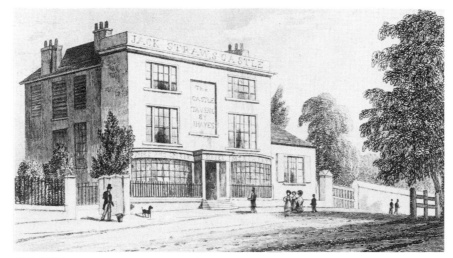

205:c.1835

206:1877

207:1869

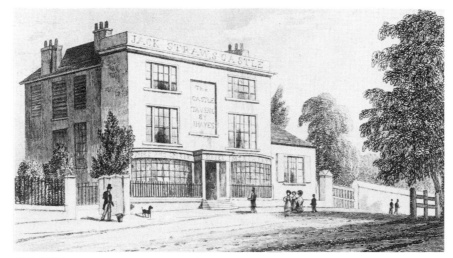

208:1834

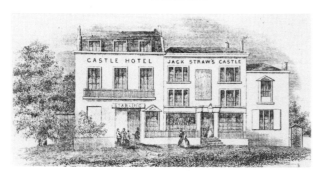

209:c.1840

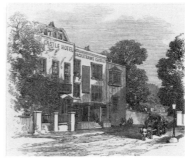

210:1871

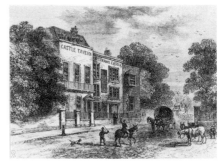

211:1877

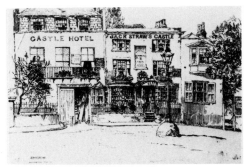

212:1898

213:1898

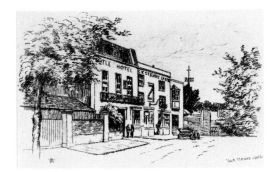

214:c.1910

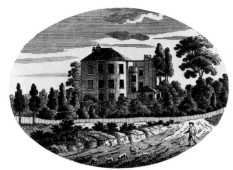

215:1797

216:c.1840

217:c.1880

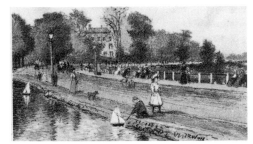

218:c.1800

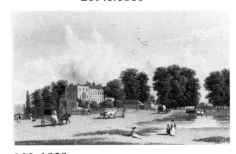

219:c.1810

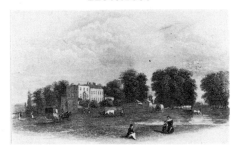

220:c.1800

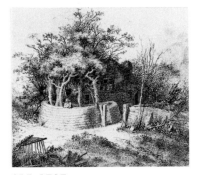

221:1908

222:1829

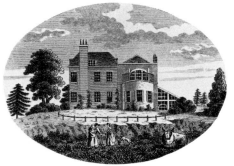

223:c.1850

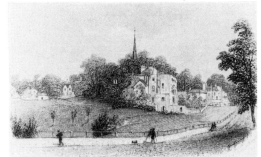

224:1867

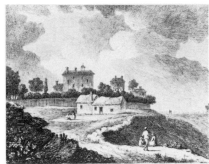

225:c.1825

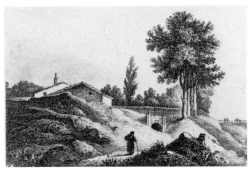

226:1825

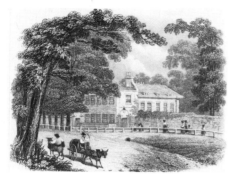

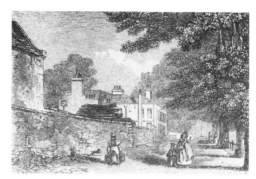

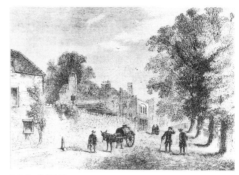

227:1836

228:1840

229:1877

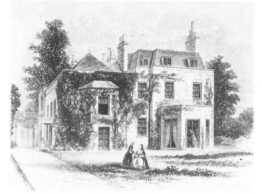

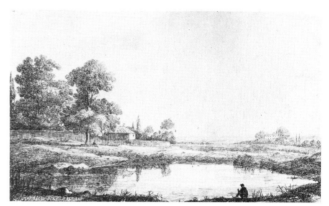

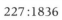

230:1869

231:1826

232:1824

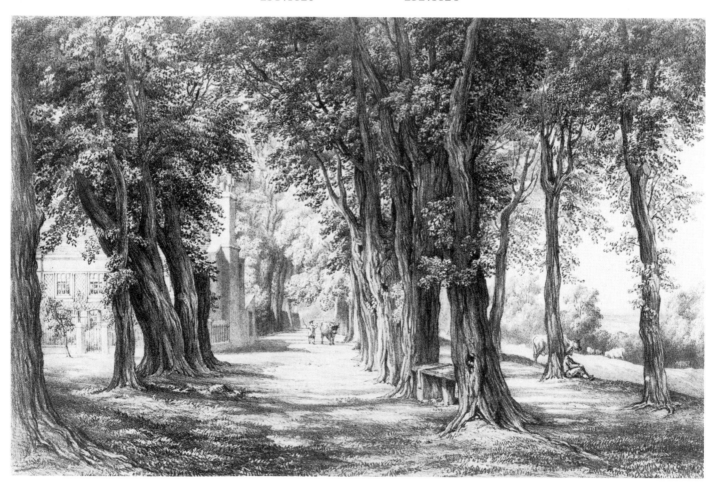

233:c.1850

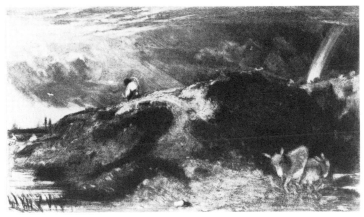

234:1831

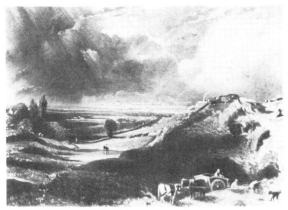

235:1831

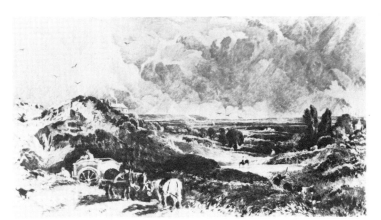

236:c.1831

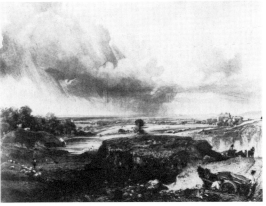

237:1855

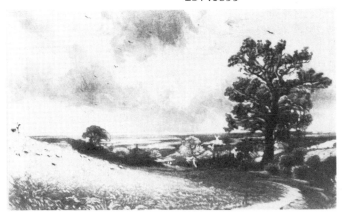

238:1830

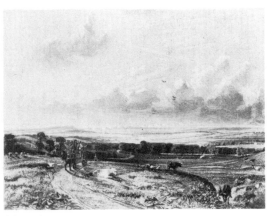

239:1845

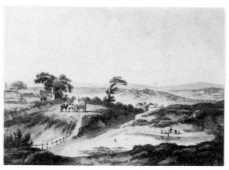

240:1796

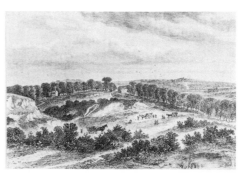

241:1832

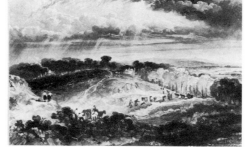

242:1877

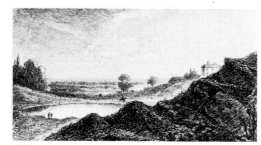

243:1823

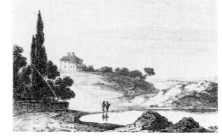

244:1825

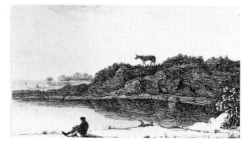

245:1824

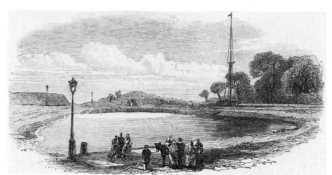

246:1871

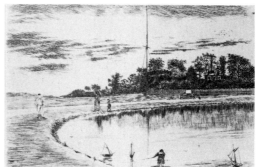

247:c.1890

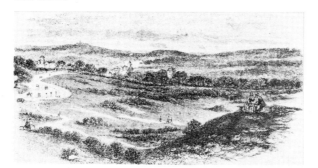

248:c.1870

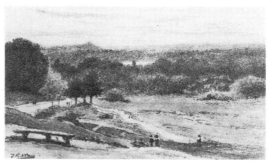

249:1908

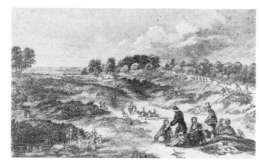

250:1856

251:1898

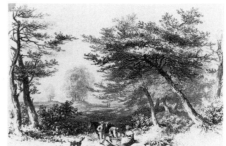

252:c.1840

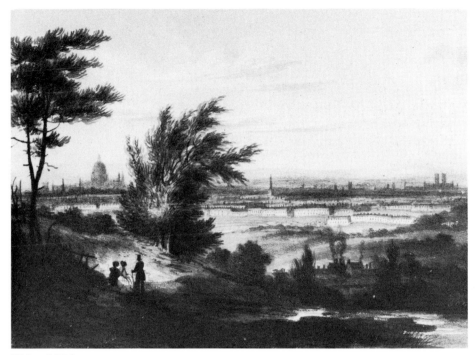

253:c.1830

254:c.1830

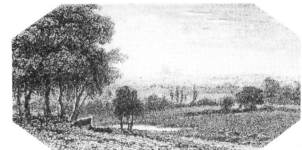

255:c.1810

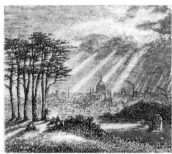

256:1876

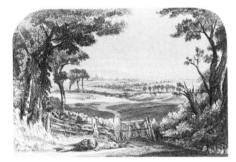

257:c.1860

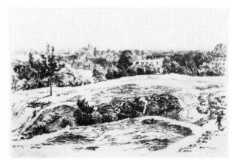

258:1900

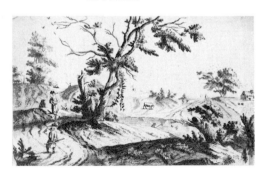

259:c.1760

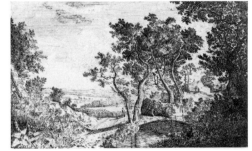

260:c.1820

261:1818

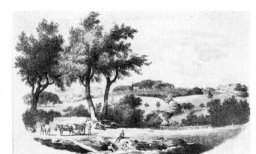

262:c.1842

263:1854

264:c.1885

265:1825

266:1826

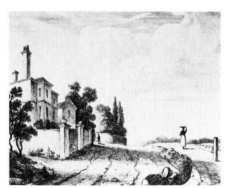

267:1826

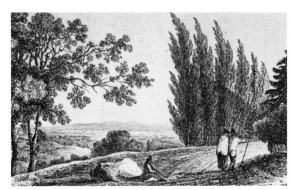

268:1828

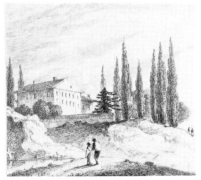

269:1825

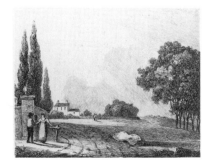

270:1828

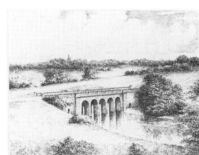

271:c.1890

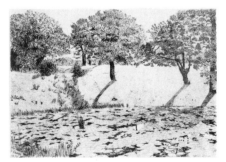

272:1878

273:c.1853

274:1883

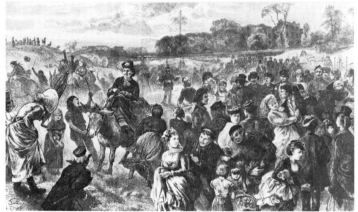

275:1871

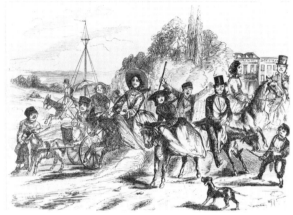

276:1859

277:c.1865

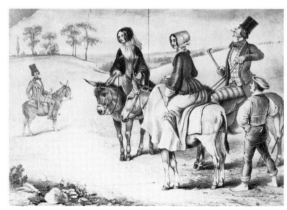

278:c.1850

279:c.1863

280:1857

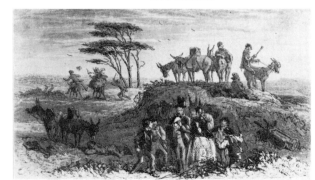

281:1857

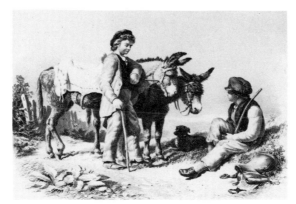

282:1854

283:1859

284:1856

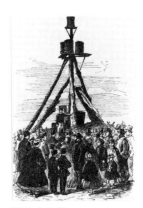

285:1863

286:1835

287:1860

288:1855

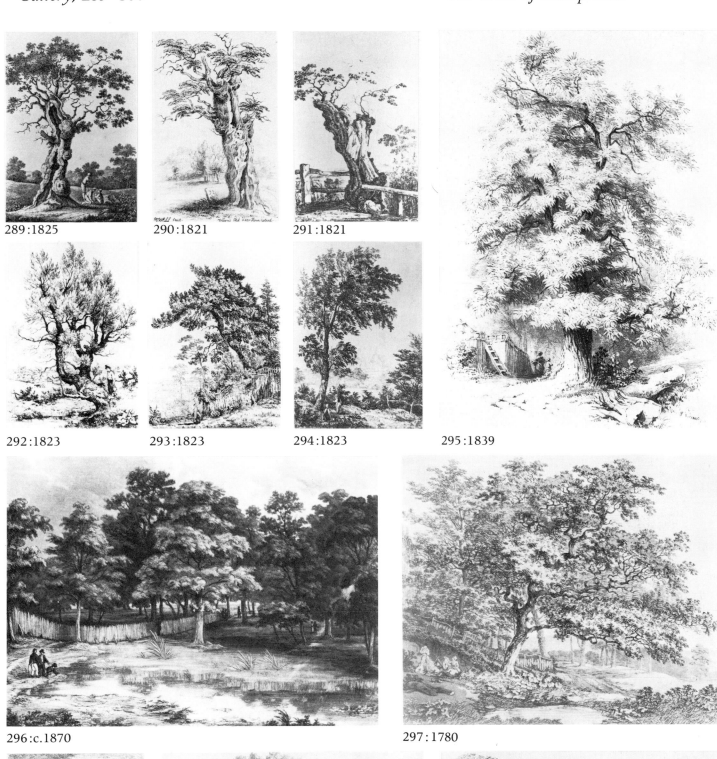

289:1825

290:1821

291:1821

292:1823

293:1823

294:1823

295:1839

296:c.1870

297:1780

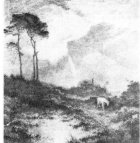

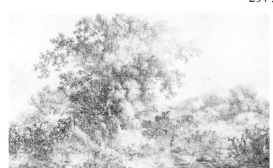

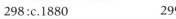

298:c.1880

299:c.1812

300:c.1868

301:1782

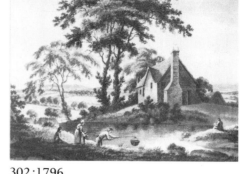

302:1796

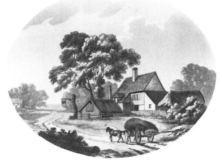

303:1783

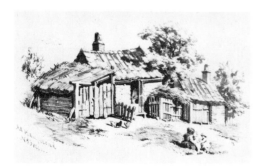

304:c.1790

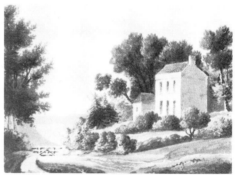

305:c.1800

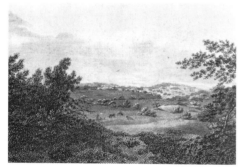

306:1805

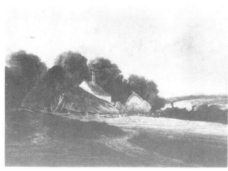

307:c.1852

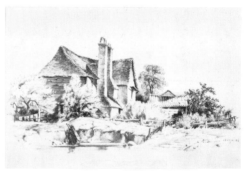

308:c.1860

309:c.1850

310:1881

311:1841

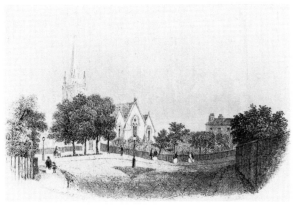

312:1860

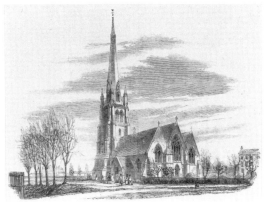

313:1860

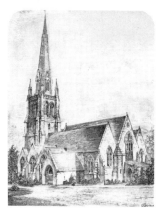

314:c.1885

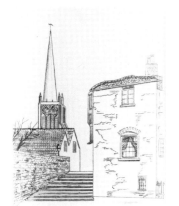

315:c.1900

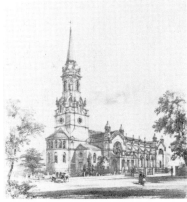

316:c.1874

317:c.1862

318:1862

319:1862

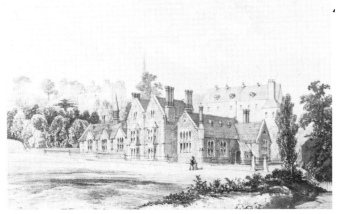

320:c.1855

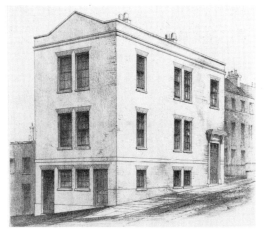

321:1852

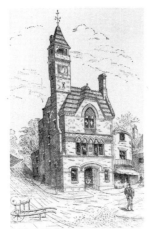

322:1874

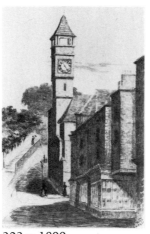

323:c.1890

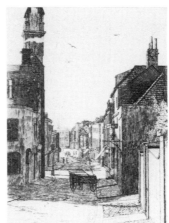

324:1881

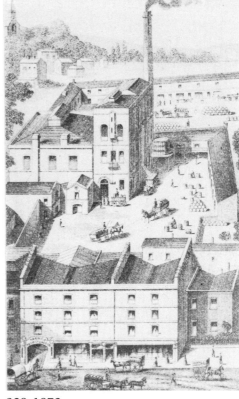

325:1901

326:c.1835

327:c.1860

328:1872

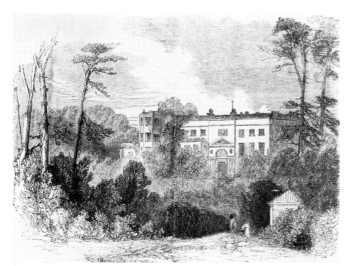

329:1855

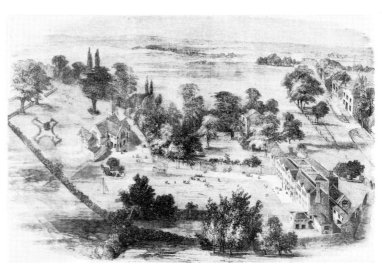

330:1858

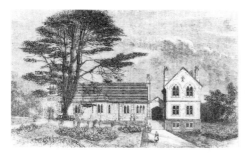

331:c.1858

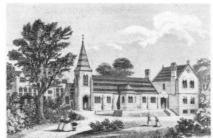

332:c.1858

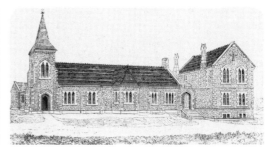

333:c.1858

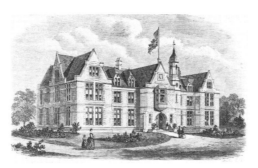

334:1869

335:c.1869

336:c.1869

337:c.1870

338:1868

339:c.1880

340:c.1880

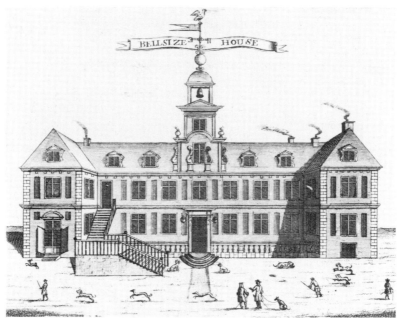

341:c.1721

342:1845

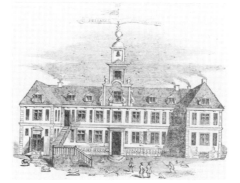

343:1854

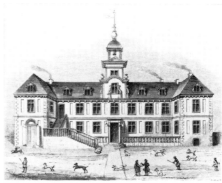

344:1869

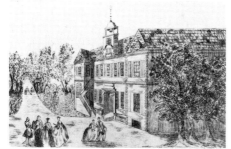

345:c.1860

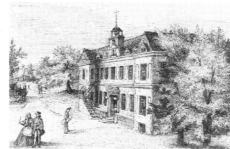

346:1875

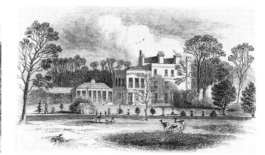

347:1845

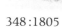

348:1805

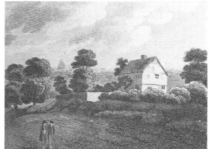

349:1818

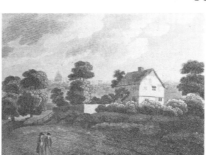

350:1818

351:1824

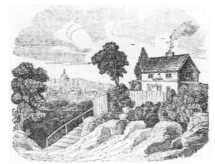

352:1837

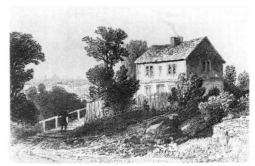

353:1843

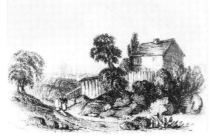

354:c.1848

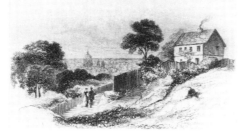

355:1869

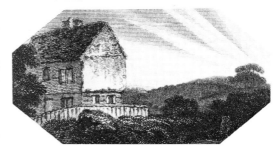

356:c.1820

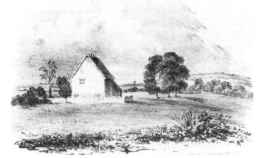

357:1836

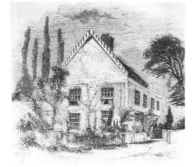

358:c.1850

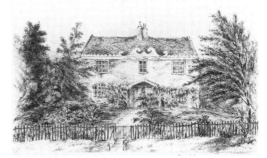

359:1853

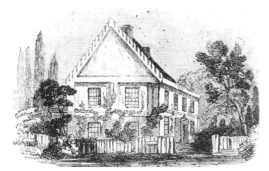

360:1858

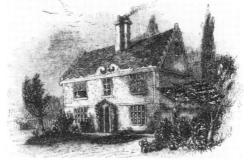

361:c.1855

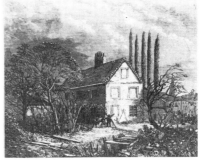

362:1867

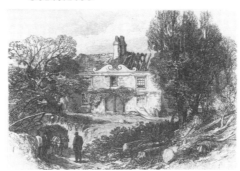

363:1867

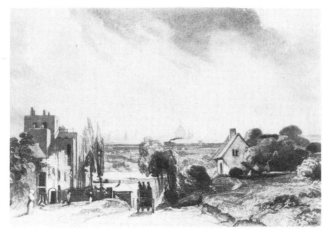

364:1845

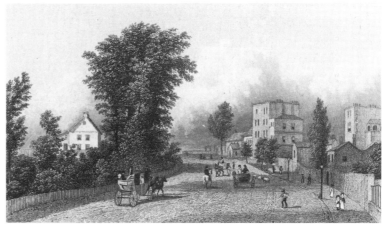

365:1829

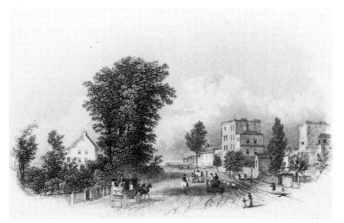

366:c.1850

367:c.1806

368:c.1860

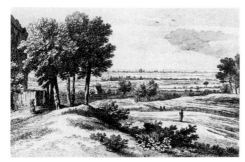

369:1750

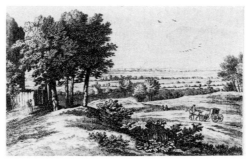

370:1794

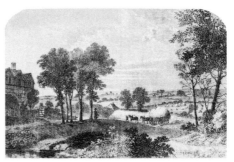

371:1877

372:c.1790

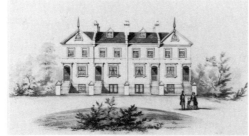

373:c.1855

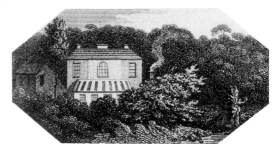

374:c.1810

375:1750

376:1845

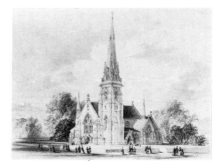

377:c.1848

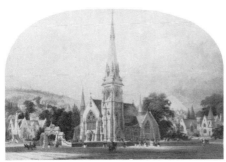

378:1848

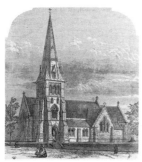

379:c.1856

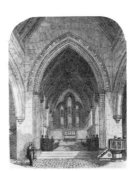

380:1856

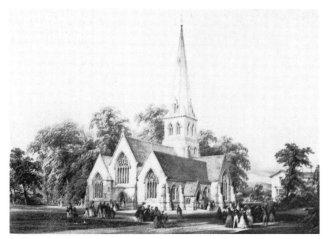

381:c.1869

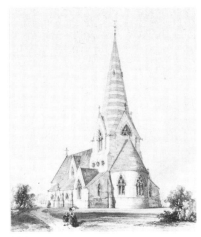

382:c.1859

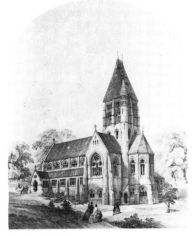

383:c.1869

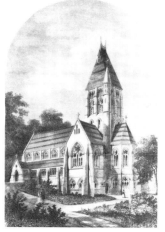

384:1869

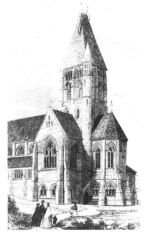

385:1872

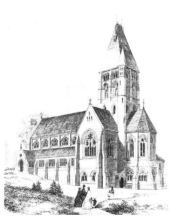

386:1869

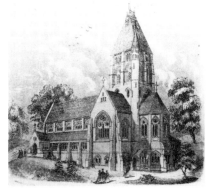

387:c.1870

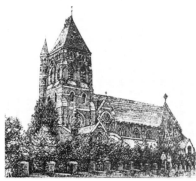

388:c.1880

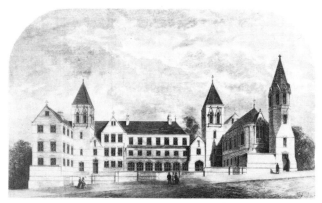

389:c.1888

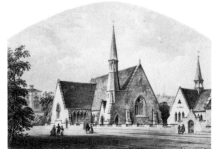

390:c.1848

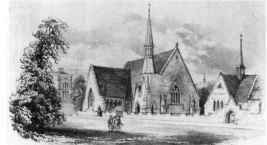

391:c.1848

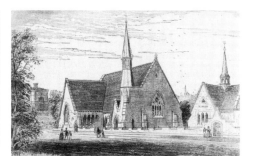

392:c.1848

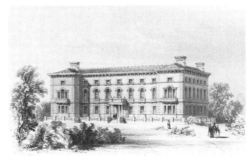

393:c.1846

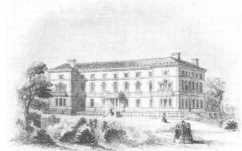

394:1846

395:c.1847

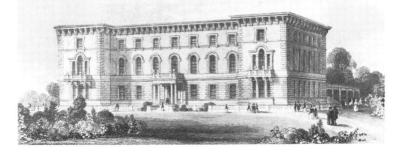

396:1848

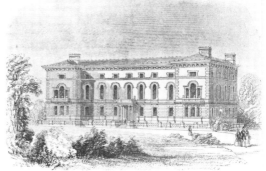

397:1848

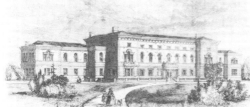

398:c.1850

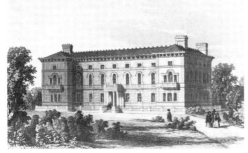

399:1852

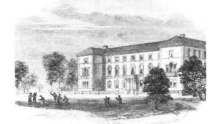

400:1858

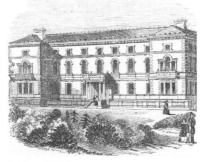

401:c.1860

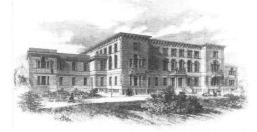

402:1861

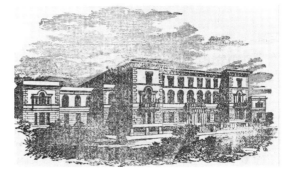

403:c.1865

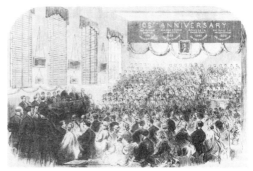

404:c.1866

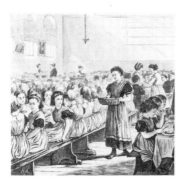

405:1870

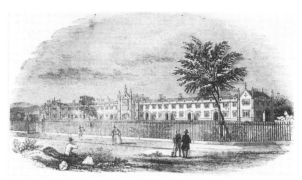

406:1843

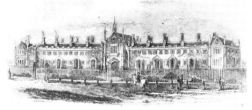

407:1843

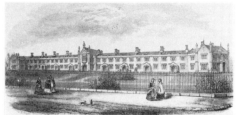

408:c.1845

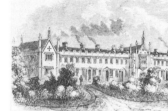

409:1850

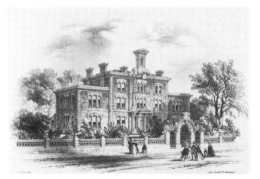

410:c.1848

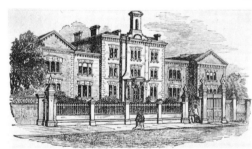

411:c.1870

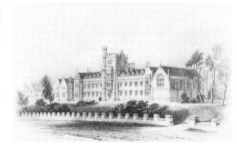

412:1851

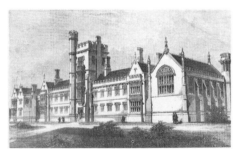

413:1851

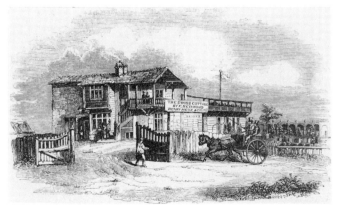

414:c.1844

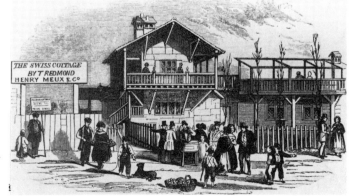

415:1845

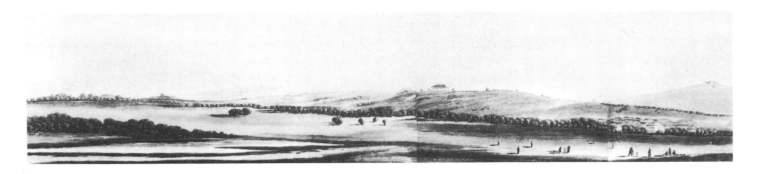

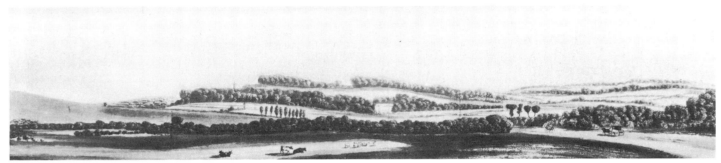

416:1831

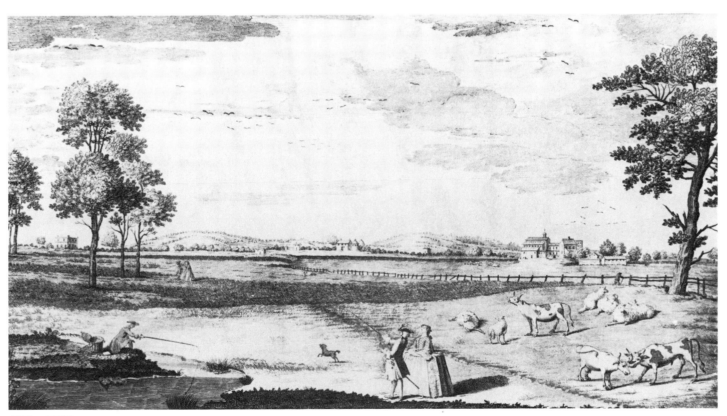

417:c.1760

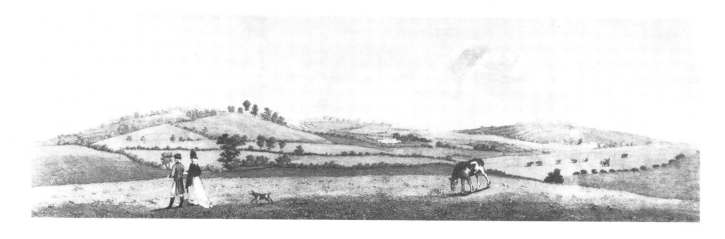

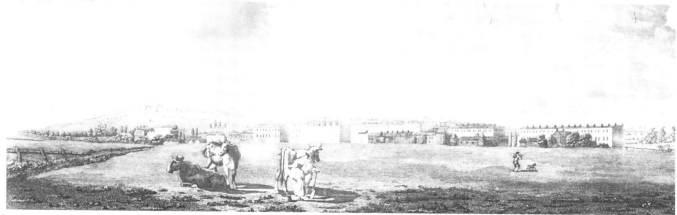

418–19:1794

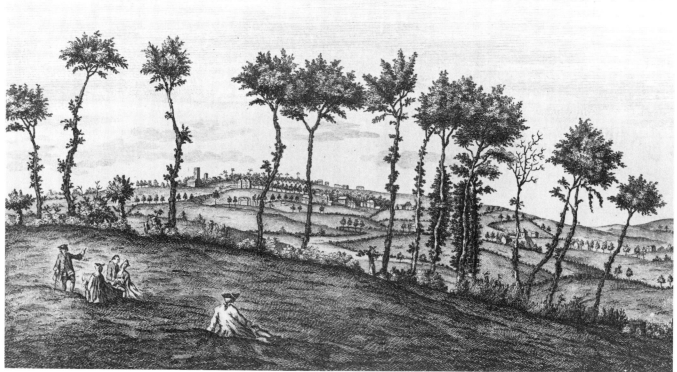

420:1775

421:1877

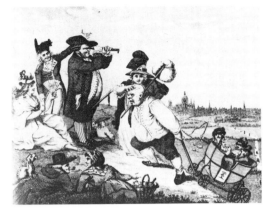

422:1791

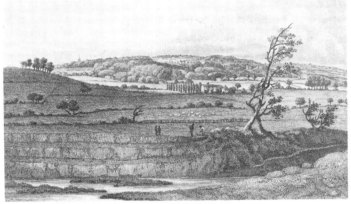

423:1814

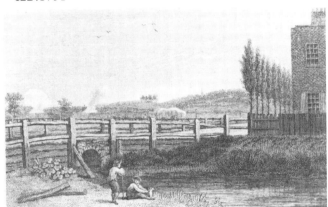

424:1791

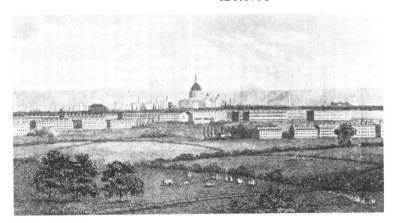

425:c.1810

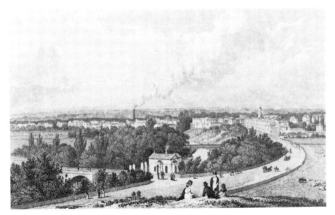

426:1825

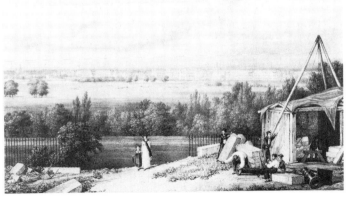

427:c.1830

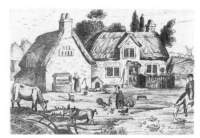

428:c.1790

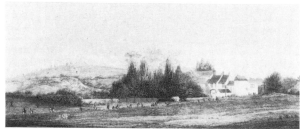

429:c.1790

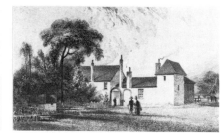

430:c.1810

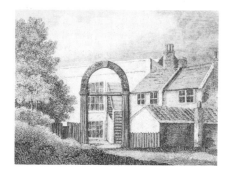

431:c.1810

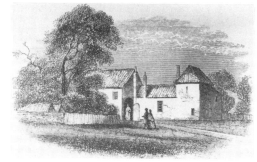

432:1869

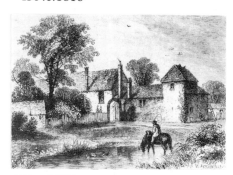

433:c.1877

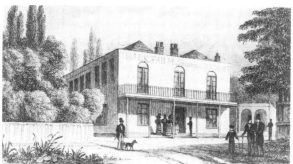

434:1834

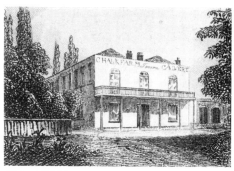

435:c.1840

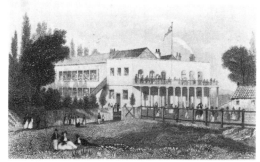

436:1838

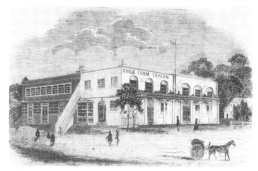

437:1847

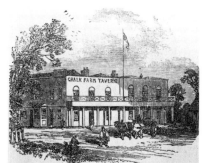

438:1853

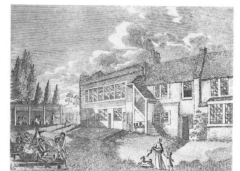

439:c.1820

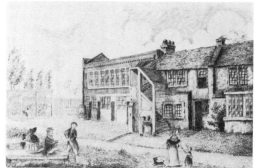

440:1842

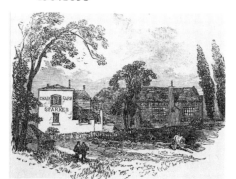

441:1853

442:1854

443:1824

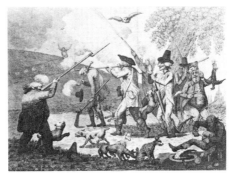

444:1790

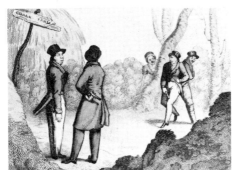

445:1826

446:1843

447:1832

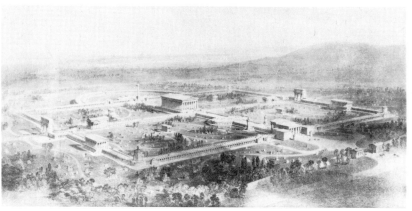

448:c.1830

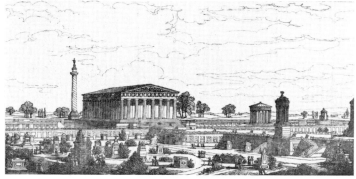

449:1830

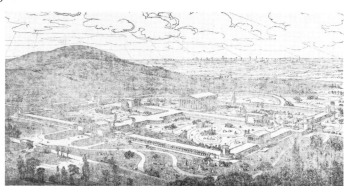

450:1830

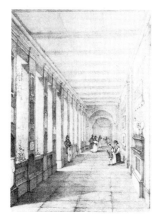

451:c.1830

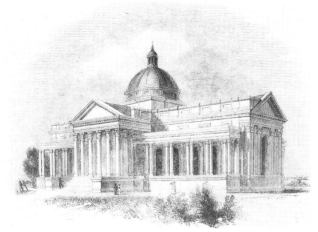

452:c.1854

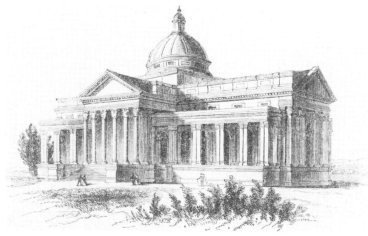

453:c.1844                    454:c.1844

455:c.1848

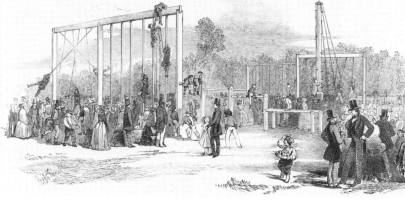

456:1848

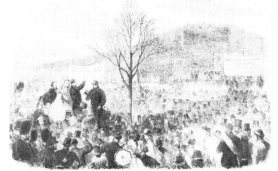

457:1856

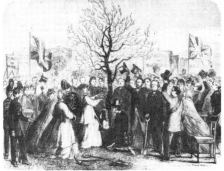

458:1856

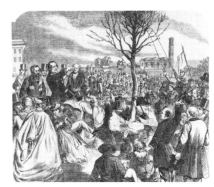

459:1856

460:1864

461:1864

462:1864

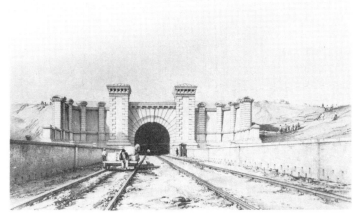

463:1839

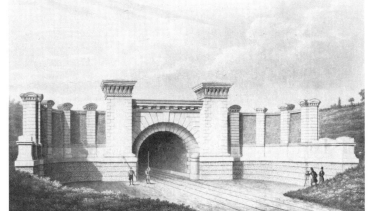

464:1837

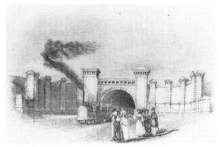

465:1838

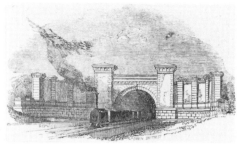

466:c.1839

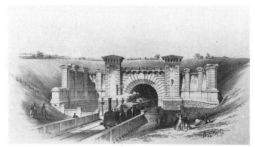

467:c.1840

468:c.1850

469:1839

470:1876

471:1883

472:c.1870

473:c.1894

474:1890

475:1852

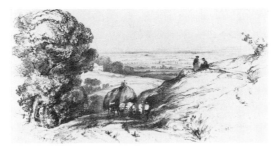

476:1852

477:1854

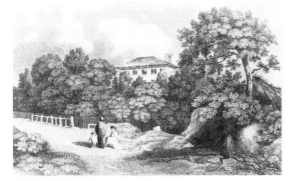

478:1813

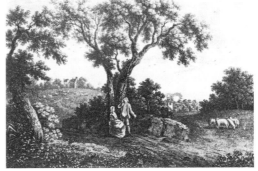

479:1784

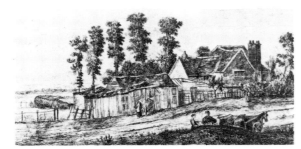

480:1799

481:1799

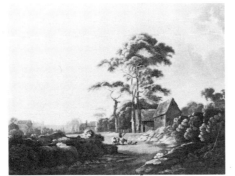

482:c.1870

483:c.1860

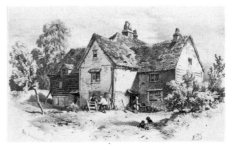

484:c.1860

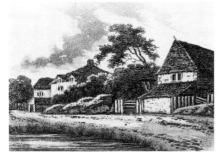

485:1800

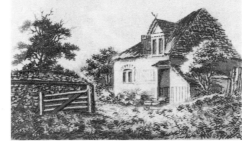

486:c.1800

487:1828

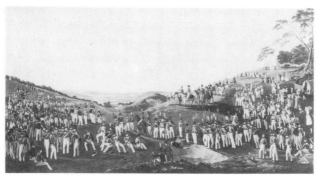

488:1831

489:1867

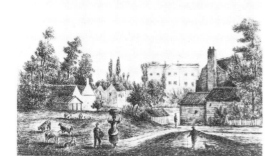

490:c.1840

491:c.1840

492:c.1880

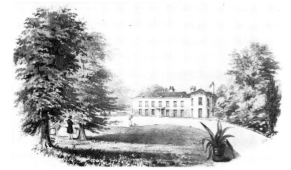

493:c.1835

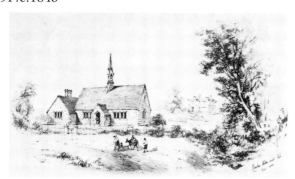

494:1844

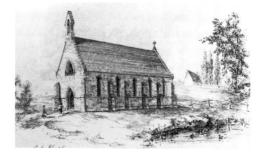

495:1844

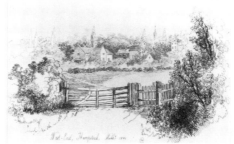

496:1841

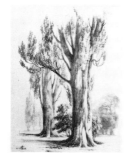

497:1848

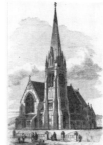

498:1872

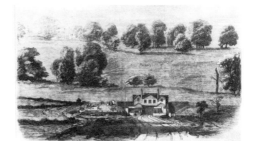

499:1860

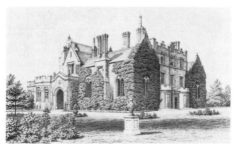

500:c.1850

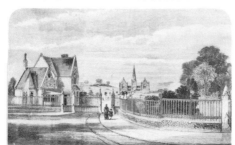

501:1876

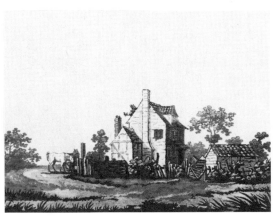

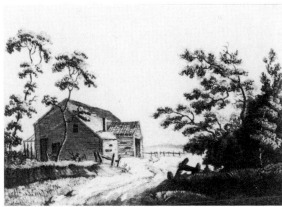

502:1877          503:1782                    504:c.1800

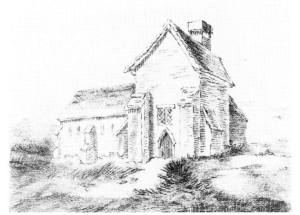

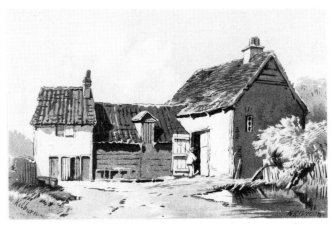

505:1848                      506:c.1888

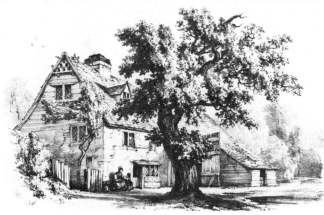

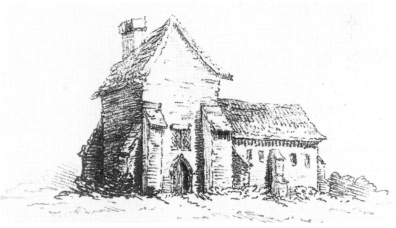

507:1798                    508:c.1812

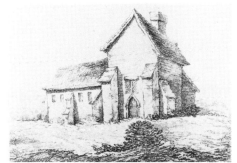

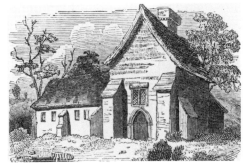

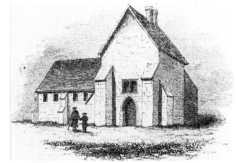

509:1813          510:1834                    511:1869

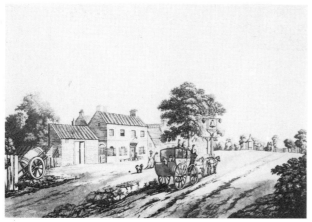

512:1789

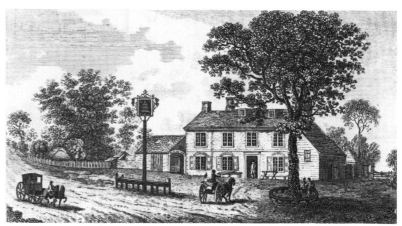

513:1797

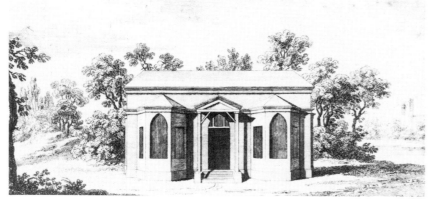

514:c.1750

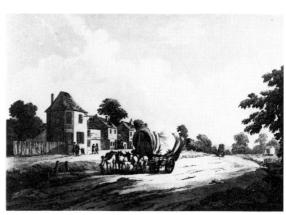

515:1789

516:1857

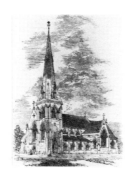

517:1856

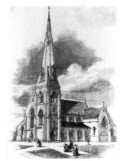

518:c.1856

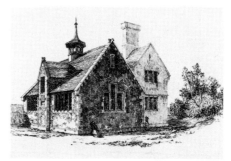

519:c.1840

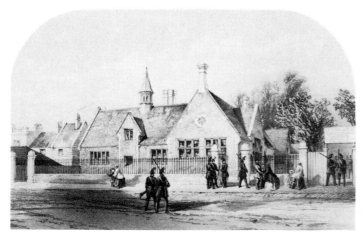

520:1860

521:1850

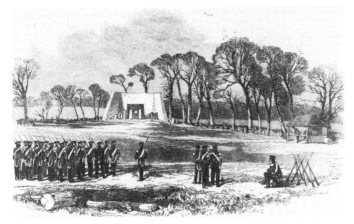

522:1855

523:1855

524:1830

525:1831

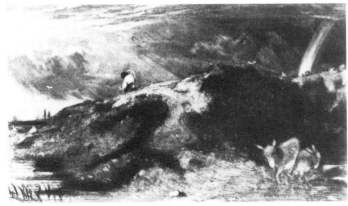

526:1831

527:1845

528:1855

529:1845

530:1874

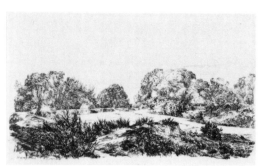

531:c.1874

532:1874

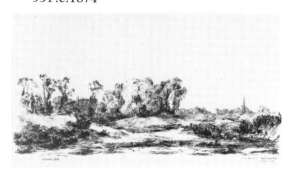

533:1874

534:c.1874

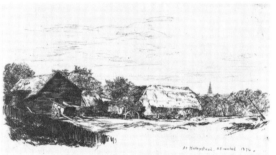

535:1874

536:c.1874

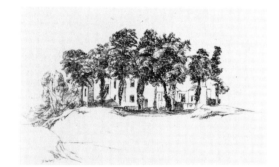

537:c.1874

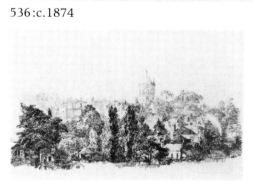

538:1874

539:1874

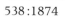

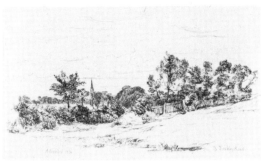

540:1874

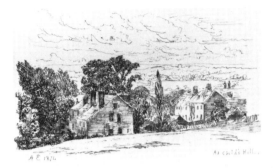

541:1874

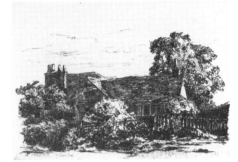

542:c.1874

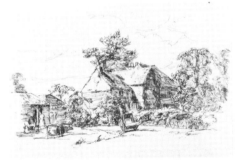

543:c.1874

544:1874

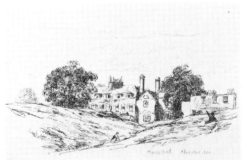

545:1874

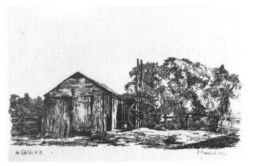

546:c.1874

547:c.1874

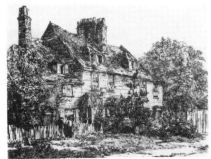

548:1879

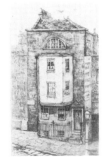

549:1890

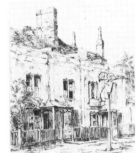

550:1876

*Prints numbered above 550 appear only in the Catalogue (see p. 260).*

# CATALOGUE

## JONATHAN DITCHBURN

IDENTIFYING PRINTS

Most collectors of topographical prints are more interested in the subject of the print than in the process involved, but perhaps it may be of interest to give here the details by which different types of print can be identified. There are three distinct categories of plates from which prints can be made.

a. *Intaglio printing*. Intaglio means to cut in, in Italian, and it refers – as the name implies – to those plates in which lines, dots or patterns are cut or otherwise formed in the smooth surface of a metal plate. Before printing, the plate is dabbed with ink. The surface is wiped clean, but the wiping pad passes over every indentation leaving it filled with ink. When a damp sheet of paper is placed on the plate and the two are passed together between a pair of rollers, the paper is pressed into the grooves and picks out the ink. If an intaglio print is looked at through a strong glass, the ink can often be seen standing up from the paper in little ridges. And every intaglio print, if untrimmed, has a rectangular plate mark, outside all the printed details, which is the indentation left by the edges of the copper plate being pressed into the paper. Such plate marks are exclusively the characteristic of intaglio prints. The intaglio processes are engraving, etching, dry point, mezzotint and aquatint.

b. *Surface or planographic printing*. These are prints made from a flat surface, on which the ink sticks to some parts through the attraction of grease to grease and runs off others because of the antipathy between grease and water. The principle was first discovered with a stone surface, and although other materials have since been used, the general term for such processes is still lithography.

c. *Relief printing*. This was the method of the earliest prints of all, woodcuts. The entire surface of a block is cut away except for those areas which are to print black. Ink can then be applied to the flat raised surface which remains, and it is this area alone which will print when the paper is lightly pressed on to it. Because the principle is exactly the same as the printing of type, a wood block can be placed amongst the type and printed with it in one operation. Until the mid-nineteenth century almost every illustration printed integrally with a page of text came from a wood block. In our own century such improvements have been made in printing text by lithography that it is now more convenient to combine text and illustration on a lithographic plate, which is the process used for the vast majority of modern illustrated books.

The following are the definitions which we have used for the prints in this book, with some suggestions on how to identify them – though it should be stressed that the more subtle differences between types of print can only be seen through a fairly strong magnifying glass.

*Copper-engravings*. Two methods were used to make the lines in the prints which we have classified as copper-engravings. One was the process known as engraving, first used for this purpose in about 1440, which involves the use of a sharp gouge, known as a graver or burin, to cut grooves of variable depth and width in the surface of the copper plate. It is these grooves which will hold the printer's ink until it is virtually blotted from the plate by dampened paper pressed against it with considerable force. Engraving is a purely manual craft, limited by the craftsman's dexterity in guiding his tool through the metal.

The other method was etching, which followed about seventy years later than engraving and

which uses acid to make the grooves in the copper. The plate is coated with wax, impenetrable by acid, and the artist draws his design with a sharp needle, cutting through the wax but not necessarily into the metal. The plate is then submerged in acid, which will eat away the copper only where the needle has removed the protective layer of wax. The plate is removed from the acid to 'stop out' with protective varnish those lines which are intended to print light. The longer a line is exposed, the deeper the acid will bite, and the darker it will print.

The two processes, engraving and etching, have nearly always been used together in the making of topographical copper-engravings. The etching needle moves through wax almost as freely as a sharp pencil on the surface of paper. This makes etching suitable for ruling in straight lines, for example in showing architecture, and enables it to achieve more random and intricate patterns of curves, as in the squiggles conventional among printmakers for the leaves of trees. By contrast, the burin provides harder lines, with a much cleaner edge, which are capable of varying in width as the burin is pressed more or less deeply into the copper. Engraved lines are therefore suitable for giving emphasis in foreground figures, and for effectively sculpting the curves of a face, an arm or a dress.

Although some topographical prints are purely engraved, and a few purely etched, a majority of the plates began with what is called an outline etching (mainly trees and buildings) before the more emphatic details and the human figures were engraved. Such prints have been conventionally called line-engravings (being composed purely of lines, as opposed to the half-tone effects of mezzotint or aquatint). We have called them copper-engravings so as both to link and to contrast them with the later steel-engravings, which use precisely the same techniques but in the harder metal.

*Steel-engravings.* During the 1820s steel began to replace copper as the medium for making intaglio prints. The original purpose was to meet a larger demand, for a copper plate is so soft that impressions from it will deteriorate slightly after the first fifty and noticeably after a few hundred; steel, far harder, can sustain an almost indefinite run. But the new material also made possible a much finer line, and this – most easily seen in the sky – is the easiest way of distinguishing a steel-engraving from one on copper. It will also tend to have a greyer and less warm tone. In a good steel-engraving (and the brilliance of the best of them has only recently begun to be appreciated) the lines in lightly shaded areas are so delicate that they merge to the eye into a shimmering pale grey half-tone. In the 1850s it was discovered to be more convenient to engrave a copper plate (a softer material, easier to work) and then to electroplate it with a harder surface akin to steel before printing. These plates too we have called steel-engravings.

*Etchings.* Although the majority of topographical engravings contain etched lines (as described above under *Copper-engravings*) we have reserved the description 'etching' for what are sometimes also called artist's etchings. The longer phrase, with its implied contrast to the work of a craftsman, perfectly captures the quality of such prints. At many different periods (Rembrandt, Goya, Whistler) artists have used the free movement of the etching needle to express themselves through the medium of prints – a very different matter from sending a drawing to a craftsman, who will copy it on to the plate in a combination of etching and engraving. An artist's etching displays the informal quality of its origins. It has the merits and sometimes the defects of a sketch, with quick and often rather scratchy lines varying from very faint in parts to violently emphatic in others. In such a print the more methodical lines of the engraver's burin would be out of place (with their hint of the railway track, tending to run parallel, never attempting too sharp a bend) nor would the artist-etcher be likely to have the technical skill needed to add them. To classify therefore as an etching in this Catalogue, a print must be not only entirely etched but etched by the artist himself. A few such prints from the early nineteenth century by the great caricaturists (Rowlandson, George Cruikshank etc.) may find their way into the Catalogue if they include topographical details of interest. But very few artists in this country etched purely topographical subjects until Whistler led a revival of interest in etching in the second half of the nineteenth century.

It was also, incidentally, the artists who found it hardest to cope with the reversal involved in printmaking. (The view on the plate is a mirror image, reversed left to right, of the view that will

be printed.) Artists enthusiastically sketching in the countryside on the wax ground of the plate often either overlooked or were indifferent to the fact that the print would be a reversal of the familiar scene they had sketched. One of them expressed a fashionable disdain for topography: 'In etching directly from nature . . . your drawing comes in reverse in the printing, so that there can be no local resemblance. If anybody in the neighbourhood asks for a proof . . . he will not recognise the place.' (Philip Hamerton, *Etching and Etchers*, third edition, 1880). The same outdoor etcher was pleased also to have fallen out of his boat without harming his sketch. The other frequent cause of a reversed view was a publisher cribbing an earlier print and his copyist tracing the image without reversal on to the new plate. However, a few reversed engravings in the late eighteenth century were intentional. These were prints sold for use in optical machines and designed to give the viewer the illusion of seeing a distant scene in perspective. A mirror in the machine reversed the print, and for this reason the words of the title above such an engraving are also printed backwards.

*Soft-ground etchings.* The name derives from the wax, softer than for a normal etching, which is used to protect the copper plate. The artist lays a sheet of paper over this soft ground, and draws on that with a lead pencil. When the paper is raised, it lifts some of the wax and exposes the copper in a broad and soft-edged line. Such a line, when etched and printed, looks much like the mark of a crayon. This quality made the technique popular in about 1800. But after 1820 the informal look of a crayon drawing was much more easily achieved by lithography and soft-ground etching was then rarely used. A soft-ground etching is easily confused with a lithograph, but the distinction of before or after 1820 is a rough and ready guide-line. And if a soft-ground etching is not trimmed it will have a plate mark, being an intaglio process.

*Dry point.* This is the use of the sharp point of the etching needle directly on the copper, scoring the surface and leaving a groove with a delicate burr of copper on either side. It is chiefly the burr which holds the ink, printing a strong and almost furry line – but only for a few impressions, since the burr is rapidly worn down by the printing and the wiping of the plate. Occasionally an entire print is dry-point. More often the dry-point lines are added to give final emphasis to parts of an etching (and surely, a fact not often acknowledged, because the artist has wanted to make minor improvements without the bother of laying a new ground and returning the plate to the acid).

*Mezzotints.* This was a type of intaglio plate developed in the mid-seventeenth century (Prince Rupert of the Rhine in his spare moments was one of the earliest mezzotint engravers). The entire surface of the copper plate is roughened with a special tool, a tooth-edged crescent which is rocked back and forth in numerous directions until the metal is pitted all over with tiny holes, giving it the quality of a very fine metallic mesh with a slightly raised burr. If inked in this state it prints an even velvety black, and the dark parts of a mezzotint retain this quality. The image is then created by smoothing parts of the plate to differing degrees. If fully smoothed, so that none of the tiny ink-retaining pits survive, that part of the plate will print pure white. Intermediate degrees of burnishing will result in tones all the way from dark to very light grey. In the lightest tones the black dots of ink will often resolve themselves into faint parallel lines, revealing that the rocker was used with slightly more force when crossing the plate in that direction and that those particular marks of its teeth have longest survived the burnishing. Mezzotint was the first half-tone printing process and was very well suited to portraits. It was rarely used for landscape, giving too sombre an appearance.

*Aquatints.* Although less sensitive a half-tone process than mezzotint, aquatint was far more appropriate to the demands of landscape. It is essentially a form of etching, but one that is capable of making a pattern of marks so delicate and so random that they appear to the eye like a half-tone or the wash of a watercolour (the precise effect which aquatint was attempting to reproduce in topographical prints). In the normal etching process the solid wax of the ground protects the copper completely except where the needle exposes it completely. As a result an etched plate can only print lines or dots, and shading can only be achieved by a closer arrangement of such lines or dots. The revolutionary development in the aquatint process was the use of a coating which gave the copper only partial protection. Instead of solid wax, it

was covered with a layer of powdered resin which was melted on to the plate. Each grain of resin protected the copper beneath it from the action of the acid, but there were inevitably gaps between the grains through which the acid could work its way. The printed result is a pattern of white specks (each one a tiny patch of the plate protected by a grain or grains of resin) set among a network of meandering lines where the acid has found its way through. The fineness of the specks varies according to the fineness of the powdered resin; and the depth of tone depends on how long the acid is allowed to bite. The earliest series of British views in aquatint was published in 1775 (Paul Sandby's *XII Views in Aquatinta from drawings taken on the spot in South-Wales*) but aquatints remained comparatively rare in topography until the 1790s. From then they developed into a flood, until they began in the 1820s to be replaced by lithographs. Aquatints can easily be recognised by the characteristic mottled or reticular pattern of the aquatint ground. Seen through a glass this is composed of white dots, enclosed by the meandering lines of the ink, in contrast to the black dots, each deriving from a single little pit in the copper, which make up the texture of a mezzotint. Also the half-tone areas in a topographical aquatint will almost invariably have clearly defined edges, whereas the differing tones of a mezzotint can merge imperceptibly into one another. Pure aquatints are rare. The majority use etched lines for the sharp details of buildings, or lines etched in soft ground to give a less harsh outline to figures. But the term aquatint is conventionally used for any print which includes patches of the mottled aquatint ground.

*Lithographs.* Lithography was the most startling new development in printmaking since the beginning of engraving three and a half centuries earlier. It was discovered in the late 1790s in Germany. It worked on a basis which is simple in principle but so hard to imagine in practice that it seems to verge on magic, and it had the great advantage that an artist could make a drawing on stone almost as freely and as easily as he would draw on a sheet of paper. He no longer needed the skill of a craftsman to guide an engraving tool through metal: he no longer needed to master the chemical process involved in etching or aquatint. Lithography leaves unaltered the flat printing surface, working only on the principle that

grease and water are incompatible. The artist draws his picture on a slab of smooth stone, using a greasy chalk. The stone is then moistened with water, which wets those parts of the surface on which the artist has not drawn, but which runs off his greasy lines, leaving them unchanged. The next stage repeats the process, but in reverse. The printer's greasy ink is rolled on to the stone. It is repelled by the water on the untouched parts of the stone, but clings to the lines of the drawing. These will therefore be transferred to the paper, in printing, exactly as the artist drew them on the stone (apart from being reversed into a mirror image). A lithograph is most frequently recognisable by the absence of hard lines (as well as by the lack of a plate mark). The lines of an intaglio print, deriving from grooves in metal, have sharp edges, much like the lines of pen and ink. Lithography is capable of imitating this fineness of line, but the average lithograph, however delicate, remains more true to the texture of the stone and has the quality of a drawing in chalk.

*Tinted lithographs.* Lithography was the process which was to triumph over all others in the field of colour printing. A first step was the addition of a background colour, to add more depth and interest to the black ink of the image itself. This colour, usually fawn but sometimes pale grey or blue, was in the nature of a general tint and was printed from a separate stone. In topographical prints the tint was often used to dramatic effect for clouds, by leaving swirling patches of white paper to show through as highlights. In this Catalogue tinted lithograph is used exclusively for those lithographs using just one tint.

*Chromolithographs.* Soon lithographers began using more than one colour to enliven their prints, on the way towards fully coloured chromolithographs. It is hard to draw any absolute line between lithographs printed in several colours which nevertheless look tinted (because the colour is used in broad and flat washes) and others which are undeniably chromolithographs, with colour being printed in very precise areas to emphasise detail in exactly the manner of someone colouring a print by hand. To avoid confusion, the term chromolithograph is used in this Catalogue for any lithograph printed in more than one colour plus black.

To distinguish a hand-coloured lithograph from a

printed chromolithograph, it is necessary to look for the characteristic signs of a watercolourist's brush strokes – the precise curving edge of the stroke, the sudden variations of tone where the paint has dried unevenly, the building up of pigment at the edge of strokes, the accidental slipping over the margin. By contrast the printer's ink of a chromolithograph has a much more even look, and where the colouring is deliberately blotchy it appears to have been dabbed on with a pad rather than applied with a brush. Since each colour has been printed from a separate stone, each ink will appear in its own pure colour in at least some part of the print (though the overlapping areas can make a nightmare of counting up the number of colours or stones used). The effect is totally different from a modern colour print (described below under *Process prints*), which uses tiny dots of the three primaries and black to provide an infinitely variable range of colour.

*Wood-engravings.* Relief-printing from wood blocks was the earliest form of printmaking, used in China from the ninth century and in Europe from at least the early fifteenth. Such woodcuts used the plank edge of the wood (with the grain), which was easy to carve but was not capable of lines anything like as fine as the intaglio copper-engravings which for most purposes gradually replaced them. But relief-printing made a dramatic comeback in the late eighteenth century, in response to the wish to print decorative vignettes within a page of text. Like letterpress, a wood block holds the ink on its raised surface. It can therefore be set amongst the type in the printer's forme to produce a decorated page from one impression. A much finer line than any in the old woodcuts was now achieved by using hard wood (particularly box) cut across the grain. Such blocks could be carved with conventional engraver's tools – and so prints taken from them became known as wood-engravings. They had a highly successful century of use, roughly corresponding with the nineteenth century, and appeared widely on pages of books, catalogues and magazines (particularly such as the *Illustrated London News*).

When looking at a good wood-engraving it is often almost impossible to believe that it is not the black lines which have been cut by the engraver's tool, but the white spaces between them which have been cut away – yet such is

invariably the case. Any print is almost certainly a wood-engraving if it appears before the 1860s on a page of text but without a plate mark – as opposed to the separate copper-engraved or lithographed prints which are bound as 'plates' into earlier and more expensive books, or the occasional copper-engraving which appears with its own plate mark on a page of text which has gone through separate impressions in two different kinds of press. Certain characteristics of a wood-engraving rapidly become recognisable. The black areas, such as windows of houses or shadows under trees, are the easiest places in which to identify the tell-tale white lines where the engraver has only scooped out a few narrow grooves of wood and therefore the lines of his engraving tool are for once visible. In wood-engravings of the second half of the nineteenth century there is often a characteristic pattern of rectangular dots, particularly in the sky. If one contrives to refocus the mind and the eye, they stand revealed for what they are – the series of points left by a close grid of white lines engraved on black. By that period wood-engravers were often giving their views the rectangular shape which had been conventional in other types of print. Earlier wood-engravings, intended to provide variety among the regular lines of text, were more often left as vignettes.

*Colour-printed wood-engravings.* The oldest form of colour printing was from wood blocks, an early example being the chiaroscuro woodcuts of the sixteenth century which used flat tints and strong white highlights in exactly the manner of tinted lithographs three centuries later. The most brilliant of all schools of colour printing, that of Japan, used wood blocks, and in early nineteenth-century Europe wood seemed the most likely material for the colour printer. A print was made from a succession of blocks, each applying a separate colour, just as a chromolithograph would use a succession of stones. But it was to be chromolithography, the later arrival, which would eventually carry the day.

*Baxter-prints.* In the 1840s George Baxter was the most successful colour-printer in Britain. His technique was closest to that of colour-printed wood-engravings, but he himself saw the use of wood blocks as replacing the lengthy hand-colouring of copper or steel engravings, and he began each of his prints with an intaglio impression. The type of plate he used for this was

most often a steel aquatint, printing a neutral colour and giving both areas of tone and a very rough outline of the subject. On top of this image he would then print his colours from wood, using on occasion as many as thirty different blocks. Topography was not one of his main subjects, and the problem of identifying his prints is usually eased by the prominent mention on the mount of George Baxter, Inventor and Patentee.

*Nelson-prints.* In the late 1850s various publishers, most notably Thomas Nelson and Sons, used a mixed method for producing cheap colour prints. The design or view was engraved on a steel plate and was printed on paper so as to be transferred, while the ink was still wet, from the paper to a lithographic stone. In this way production was greatly speeded up because it only required another impression from the steel plate, transferred in the same way, to create a second printing surface on another stone. Any number of presses could thereby be working simultaneously to reproduce the same single engraved image. The resulting lithographs, for such they were, were then coloured from two or more wood blocks. Nelson almost invariably used horizontal lines of pale blue from one wood block for the sky, and vertical lines of fawn from another block for the buildings, trees and ground. No term exists for prints made by this quite complex method, so we have called them Nelson-prints. At a later date Nelson found acceptable ways of printing his colours, like the view itself, from stone rather than wood. These later prints are therefore conventional tinted lithographs – or, when several colours are involved, chromolithographs – and are described as such in the Catalogue.

*Process prints.* In the second half of the nineteenth century there began the gradual takeover of printing techniques by the camera. Instead of the image being created on the plate, stone or block by a craftsman's hand, it would be transferred – as it is in all modern commercial printing – by the action of light through a lens on plates coated with a variety of light-sensitive substances. Processes have been invented to achieve this for all three methods of printing – intaglio, planographic and relief – and the results of all such methods are now known by the general name of process prints. Any image stands clearly revealed as a process print if through a glass it shows a regular pattern of little dots or

squares – the result of the screen which is the process printer's way of producing a half-tone, achieved more artistically in earlier centuries by mezzotint or aquatint. For a colour print the camera and its filters break the image down into the primary colours, so that the dots on the white paper are yellow, magenta (red), cyan (blue) and black, until they merge to the eye into the infinitely variable colours of the original subject. Certain nineteenth-century photographic printing processes did manage to do without a screen – by using the texture of gelatine (Collotype) or by projecting the image on to a light-sensitised aquatint ground (Heliogravure) – and these are often hard to distinguish from the older prints which they imitate, unless the publisher boasts of his up-to-date technique and so reveals the secret. Once identified as process prints, they fall outside the scope of this catalogue – unless, on a very rare occasion, the topographical content of a process print is of sufficient interest to make of it an exception.

ARRANGEMENT OF THE CATALOGUE

*Sequence of prints.* The prints follow the sequence established in the Gallery, where they are placed in whatever grouping makes the most of their topographical content. Only those prints appearing in the Gallery acquire a full number of their own. Minor variants, not worth separate reproduction in the Gallery, appear therefore in the Catalogue as sub-headings to a main entry.

*Structure of each entry.* The easiest way of explaining the often complex details of the system is to give here the component parts of an entry. A main entry consists of some or all of the following:

Title of print, verbatim. We reproduce the exact spelling and punctuation of the engraved letters, and this is so frequently exotic that we decided against the recurrent use of 'sic'. As the modernist American composer Charles Ives once had to emphasise to his copyist, 'the wrong notes are the right ones'. Any abbreviation by us of part of a very long title will appear in round brackets. Where the print itself has no title, our own description of the content of the view appears in square brackets. In transcribing the titles of prints we have not used capitals except for the first letters of words. There is therefore no distin-

ction between words appearing on prints wholly in capitals and those merely beginning with a capital.

Names of artists etc. appearing immediately below picture area (usually to left or right), also verbatim. Diagonal strokes are used to give the placing of the names. Those before a diagonal stroke are on the left of the print, between strokes in the centre, after a stroke on the right.

Publishers, their addresses, date of publication. We follow the spelling of the letters on the plate but omit unnecessary words (for example 'as the Act directs'). Where no date appears on the print, a year is added by us in square brackets following the three conventional degrees of uncertainty. [1820] means that the year of publication is firmly established from other sources, such as the title-page of a book. [c. 1820] means that evidence exists to establish publication not far from that year, as when the publisher was only at that address for a short period. [c. 1820?] means that the period is our own best guess, based on no stronger evidence than artistic style, costume, topographical content, printing technique or working years of the artists and publishers concerned. If the print has been traced to its original publication in a book, the date will appear after the title of the book (see 'source of print' below) using the same conventions.

Markings on the print, such as Plate number.

Type of print (the types are listed and described above).

Dimensions in millimetres, height before width, and relating only to the image area. In catalogues of prints it has been conventional to give the dimensions of the plate (on any untrimmed intaglio print this is the indented rectangle clearly visible outside the engraved area). But many topographical prints have been trimmed or are sold framed, with the mount coming well inside the plate mark and concealing it. It therefore seemed more useful to give the measurement of the view itself (i.e. the area actually worked on by the artist), excluding the letters and even discounting any decorative borders. Measurements of vignetted views are of course only approximate, but

it is also worth adding that even on a normal rectangular view a small variation in size does not necessarily mean that the print is from a different plate. This is particularly true with engravings, etchings and aquatints. In these intaglio processes the paper has to be damp when it passes through the press. Each sheet is then hung up to dry, and they will shrink to a differing extent. This can account for a variation of up to 3% in the final size of the image.

Source of print. If the print has been traced to publication in a book, the source given will be that book; an abbreviated version of author and title will lead to the book's entry in the first of the three bibliographies, where full details are given together with a list of other local prints appearing in the same volume. (Prints were often published on their own before being reissued with a text, but the earlier date on the print itself will usually reveal that fact.) Where the print has not been traced to a book, the source given is a collection in which a copy of the print may be found. A list of the collections and the abbreviations used is given immediately before the first Catalogue entry.

A print's main entry may be followed by two different types of sub-entry:

Sub-entries numbered a,b,c,d etc. These are other prints published from the same plate but not sufficiently different from the original impression to warrant separate reproduction in the Gallery. The sub-entry will specify only those details which have been added, altered or removed. If for example a date appears on the original impression and the sub-entry neither gives a revised date nor lists an erasure, then the date has remained unchanged. The same holds for title, artists, publishers and their addresses. Any changes within the image itself are described. If these changes are so great that the print is reproduced in the Gallery alongside the original impression (thus acquiring a Catalogue number of its own), a sub-entry in the correct place will give a cross-reference to the separate main entry. In the rare cases where detailed work has already been done by others on different states of a plate, we give the general outlines of the previous research with a reference to the work

in question, rather than repeating every smallest detail.

Sub-entries numbered i, ii, iii etc. These are new prints, copied from the original entry but not sufficiently different to merit separate reproduction in the Gallery. Since they are printed entirely from new plates, each is dealt with on the same principles as a main entry. Details are then given of how the copyist has altered the original view. Other prints published from the same plate as one of these copies are treated in the same way as other states of a main entry (see above) and are numbered ia, ib etc.

The final entries in the Catalogue are of prints which have not been reproduced in the Gallery but which readers might expect to find included here. There are two likely reasons for their omission from the Gallery. Some, although proclaiming otherwise in their titles, fall outside our geographical limits. Others show nothing of any possible interest, although perhaps claiming to in their title, or else are tiny views (decorating a larger print, such as a map) which will never be found on their own as prints. Full bibliographical details are given for these prints, just as for those in the main part of the Catalogue, and their titles, artists and publishers are indexed.

*Scope.* Within our geographical limits (defined in the introduction to the Gallery) we have tried to include every print up to 1860 and any of special artistic or topographical interest from then to the present day.

---

*Abbreviations used for collections.* Where a print was published on its own, or has not been traced by us to a book, the source given is a print room or library where a copy of the print can be found. The local public library is invariably given as the source if a copy in good condition was in the collection there at the time of this publication. Otherwise one other source is given. The following are the abbreviations used:

SCL   Swiss Cottage Library (Local History), 88 Avenue Road, NW3.

ML    Marylebone Library (Archives & Local History Department), Marylebone Road, NW1.

SJDH  Saint John's Downshire Hill.

StJ   Saint John's Parish Church.

BLK   British Library, King's Topographical Collection (Map Room).

BM    British Museum: Department of Prints and Drawings.

GLC   Greater London Council, County Hall: Collection of Maps and Prints.

GuP   (City of London) Guildhall Print Room.

MuL   Museum of London: Department of Paintings, Prints and Drawings.

V&A   Victoria and Albert Museum: Department of Prints, Drawings, Paintings and Photographs.

P     Private Collection

THE PRINTS

1 [The Hollow Elm of Hampstead].
W. Hollor Delin. et sculp. 1653/ (within
image area, below). Copper-engr.,
160 × 190 (BM). Hind 71, i: 'Before flock
of birds about the tree: the turret only
contains five people (including one whose
head alone is seen)'. Parthey 979.

a *Printed by E. Cotes for M.S., at the Blue
Bible in Green Arbour, and are to be given
or sold on the Hollow Tree at Hampsted,
July 1, 1653 (at foot of broadside).* (BL).
Centrepiece illustration of a broadside
'The Dimension of the Hollow Tree of
Hampsted.' Surrounding the engraving
are verses celebrating the delights of the
Elm including 'The Welcome. Verses on
the Door':
    'Civil people, you welcome be,
    That come to view this Hollow Tree.
    Debaucht Drunkard, Ranting Whore,
    Come no such within this Dore:
    Wanton Boyes and ranting Rigs,
    Cut no Bowes, break no Sprigs.'
Hind 71, ii: 'Flock of birds added about
the tree: the turret now contains six
people. Descriptive lettering added in the
margin with eight reference numbers to
the print, in three columns.'

b A Curious Hollow Tree on Langley Park
near Windsor 1653 from a very rare Print
by Hollar.
*J. Manson, No. 6 Pall Mall, 1796.* Copper-
engr., 160 × 190 (SCL). Mistakenly titled
in identical fashion to Vertue, *Wenceslaus
Hollar*, 1759, class iii no. 70. Both this
publisher and Vertue may have been
misled by the MS inscription on the proof
copy (no. 1) in the BM into believing the
Hollow Elm was located near Windsor.
Another Hollar bibliographer Gustav
Parthey demonstrates a geographical
vagueness by calling it 'The Hollow Tree
at Hampsted near Windsor'.

2 Hunter's Oak.
/Etched by Nicholls from a rare Print of
Hollars/. *J. Wheble, Warwick Square, 1
Jan. 1809.* Etching, 110 × 90 (SCL).
Derived from no. 1.

3 The Hollow Elme of Hampstead from a
scarce Print by Hollar.
W. Hollar delin. 1653 (faintly within
image area, below)/J. Quilley sculp.
*White, Cochrane & Co., 1 May, 1813.*
Copper-engr., 115 × 135 (Park, *Topography
of Hampstead*, 1814, opp. p. 34, Pl. iii).
Derived from no. 1.

4 [The Hollow Elm of Hampstead].
W. Hollar Delin. et Sculp. 1653/(within
image area, below). [c. 1870?]. Etching,
165 × 195 (SCL). A reversed copy of no. 1.

5 [The Hollow Elm of Hampstead].
[c. 1835?]. Lith., 85 × 125 (BM). MS
inscription on verso of copy seen 'Only
ten copies printed off separately by J.C.
Landon, Esq. to give to J.H. Fennell for
lending him the plate to copy. These
reprints were some of the first specimens
ever done in zincography.' The term
zincography draws a rather fine and
unnecessary distinction between
lithographs printed from stone and those
printed from zinc. Derived from no. 1.

6 A Prospect of the Long Room at
Hampstead from the Heath.
Chatelain Delin/W. H. Toms Sculp. *W. H.
Toms, Engraver in Union Court, near
Hatton Garden, Holborn, 25th March 1745.*
Top right: 1. Copper-engr., 160 × 260
(BM).

a A View of ye Long Room at Hampsted
from the Heath (& in French).
Chatelain Delin. et sculp/. *Heny Overton,
at the White Horse without Newgate &
Robt Sayer, at the Golden Buck opposite
Fetter Lane, Fleet Street, 1752.* Top right:
4. (SCL).

b *C. Dicey & Co., in Aldermary Church
Yard, 1752.* (SCL).

i The Old Well Walk, Hampstead, About
1750.
WP/(within image area, below). Wood-
engr., 145 × 210 (Walford, *Old & New
London*, [1873–78], v, p. 463). Clearly a
derivative although with both the
foreground figures and Wells building in
the background altered.

7 Long Room At The Wells. (From a Print by Chatelaine, in the possession of J. E. Gardner, Esq.)
/O. Jewitt Sc. (within image area, below). Wood-engr., 50 × 95 (Howitt, *Northern Heights of London*, 1869, p. 274). As the title acknowledges this is a copy of no. 6.

8 Made. Duval Dancing a Minuet at the Hampstead Assembly.
W. Heath Del/. *Jones & Co., Feby 16, 1822.* Bottom left: page 277. Aquatint, 100 × 185 ([Burney], *Evelina*, 1822, opp. p. 277).

9 A Prospect of Hampstead from the Corner of Mrs. Holford's Garden, opposite the Well Walk.
Chatelain Delin/W. H. Toms Sculp. *W. H. Toms, Engraver in Union Court near Hatton Garden, Holborn, March 25th 1745.* Top right: 2. Copper-engr., 165 × 255 (SCL).

a Date within imprint different. *Feb. 11th 1744/5 W. H.* (BM).

b A View of Hampsted, from ye corner of Mrs. Holfords Garden (& in French). Chatelain Delin. et sculp/. *Heny Overton, at the White Horse without Newgate & Robt Sayer, at the Golden Buck, opposite Fetter Lane, Fleet Street, 1752.* Top right: 3. (GuP).

c *C. Dicey and Co. in Aldermary Church Yard, 1752.* (SCL).

10 A View of Hampsted from the Heath near the Chapel (& in French).
Chatelain Delin. et Sculp/. *Henry Overton, at the White Horse without Newgate & Robt Sayer, at the Golden Buck, opposite Fetter Lane, Fleet Street, 1752.* Top right: 6. Copper-engr., 160 × 260 (GuP).

a *C. Dicey and Co. in Aldermary Church Yard, 1752.* (GuP).

11 [Mr Thomas Osborne's Duck Hunting 1754].
Etching 150 × 600 (BM). MS inscription on copy seen 'Went to an entertainment they call Duckhunting 10th of September 1754. recd. this October the 5, 1754' (bottom left of fan). Schreiber 124 (reverse); Cust 40. A fan. Shows guests dancing under a marquee in front of the house. A handbill

entitled 'A Day at Hampstead with Osborne the Bookseller' attributes these fans to Gravelot.

12 [Mr Thomas Osborne's Duck Hunting 1754].
Etching 150 × 600 (BM). MS inscription on copy seen 'a View of Osborn house & gardens' (bottom right of fan). Schreiber 123 (obverse); Cust 40. A fan. Shows in the centre of the print the duckhunt; the pond is beyond in the 'parck' with the deer. In the foreground, on the right, guests eat within marquees.

13 Well Walk Hampstead (bottom right corner of image area).
S. Sharpe 1878/ (within image area, below). Etching, 120 × 160 (BM).

14 The Gate.
T. R. Way '06/ (within wall). 150 copies only, printed by Thos Way, Gough Square, &c/. Chromolith., 215 × 145 (SCL). Christmas card illustration of 1908 showing the entrance to Burgh House.

15 Burgh House, Hampstead.
T. R. Way/ (faintly, within image area, below). 150 copies only, printed by Thos Way, Gough Square, &c/. Chromolith., 215 × 145 (SCL). Christmas card illustration for Dr and Mrs Williamson in 1906.

16 The Beautys of Hampstead.
Set by Mr. Wichello/G. Bickham junr sc. Top right: 15. Copper-engr., 90 × 180 (Bickham, *Musical Entertainer*, [1737–39], ii, Pl. 15).

17 View of a Skittle Ground at Hampstead (above the image).
[*Woodward del/Cruikshanks Sculp. Allen & West, 15 Paternoster Row, Aug. 1, 1796*]. Top: Plate IV/Page 14. Immediately above oval:/Compartment 1st/. Copper-engr., 95 × 135. (Woodward, *Eccentric Excursions*, 1796, p. 14, Pl. IV top). *B.M. Satires*, no. 8933.

18 The Excursition of Mr. Lovelace, Clarissa, &c. to Hampstead.
Richter delin/Charter Sculpt. *Alexr Hogg, Novr 16, 1793.* Top: Mr Hogg's New Novelist's Magazine. Copper-engr., 160 × 100 (*New Novelists Mag.*, 1793).

19 [View of a Skittle Ground at Hampstead]. Woodward del/Cruikshanks sculp. *Allen & West, 15 Paternoster Row, 1 Aug. 1796.* Top: Compartment 2. Copper-engr., 95 × 135 (Woodward, *Eccentric Excursions*, 1796, p. 14, Pl. IV bottom). *B.M. Satires*, no. 8933.

20 View of the Old Church at Hampsted. /Goldar sculpt. *I. Sewell, Cornhill, 1785.* Top right: European Mag. Copper-engr., 95 × 170 (*European Mag.*, Nov. 1785, opp. p. 329).

21 The Old Church At Hampstead. /Engraved by Charles Heath from an original picture in oil in the possession of the late M. Richardson/. *White, Cochrane & Co., Fleet Street, Jany 1814.* Copper-engr., 115 × 190 (Park, *Topography of Hampstead*, 1814, opp. p. 222, Pl. VII). Clearly this and no. 20 derive from the same oil painting.

22 The Old Church. From Park's 'History of Hampstead'. Wood-engr., 60 × 95. (Howitt, *Northern Heights of London*, 1869, p. 3).

   a Hampstead Old Church. (From Park's 'History of Hampstead'.) /O. Jewitt Sc. (within image area, below). (Howitt, *Northern Heights of London*, 1869, p. 141).

23 Hampstede on the Hill neare London . . . (above the image). /JE 1640 (within image area, below). Etching, 195 × 305 (SCL). MS inscription on copy seen 'a fabrication of about 1870'.

24 The South East View of Hampstead Church. Chatelain del/J. Roberts sculp. *Robt Sayer Printseller in Fleet Street, Octr. the 13, 1750.* Top right: 31. Copper-engr., 70 × 115 (SCL).

   a Without publisher's name. *Octr. the 13, 1750.* (Chatelain, *Fifty Original Views*, [1750], unnumbered).

25 Hampstead Church. /Drawn & Etch'd by J. Storer/. *Vernor & Hood, Poultry, J. Storer & J. Greig, Chapel Str., Pentonville, 1 June, 1805.* Copper-engr., 155 × × 10 (*Select Views of London*, 1804–5, ii, unnumbered, right).

26 Hampstead, Middx. *S. Woodburn, 112 St Martins Lane, 28 March, 1807.* Top right: 8. Copper-engr., 130 × 180 (*Ecclesiastical Topography*, 1807 [-10], ii, Pl. 8).

   a *J. Edington, 64 Gracechurch Street.* (SCL).

27 Hampstead (bottom centre of image area). J. Quilley sculp/. Copper-engr., 100 × 120 (Park, *Topography of Hampstead*, 1814, bottom left corner of map). Essentially the central details of no. 25.

28 View from Hampstead Church Yard. Looking towards St. John's Wood. Drawn from Nature & on Stone by T. M. Baynes/ Printed by C. Hullmandel. *D. Walther, Brydges Stt, Covent Garden, Aug. 10, 1822.* Lith., 165 × 240 (Baynes, *Twenty Views in London*, 1823, Pl. 5).

29 Hampstead Church. [Drawn by T. H. Shepherd/Engraved by J. Shury]. Steel-engr., 60 × 50 (Partington, *National History and Views of London*, 1834, i, opp. p. 203, top left).

30 [St. Johns Church, Hampstead. 1843]. Lith., 290 × 350 (SCL)

31 St. Johns Church, Hampstead, Middlesex (with dedication below to the Rev. Thomas Ainger by R. Martin). *Lithographed and Published by R. Martin, 26 Long Acre, Jany 1st 1843.* Tinted lith., 280 × 345 (SCL).

32 Hampstead Parish Church – 1868. Lith., 125 × 200 (SCL).

33 The Parish Church, Hampstead. F. W. /(within image area, below). [c. 1886?]. Wood-engr., 175 × 150 (SCL).

34 The Parish Church. Hampstead. /HC (monogram of H. Hovell Crickmore within the image, below). *Catty & Dobson, London.* [c. 1890?]. Etching, 105 × 70 (SCL).

35 The Parish Church, Hampstead (with dedication below to Revd Thos Ainger, M.A. by C. J. Greenwood).

C. J. Greenwood Del & Lith/. [c. 1857?].
Tinted lith., 255 × 360 (StJ).

36 [Hampstead Church Interior.]
[c. 1857?]. Lith., 325 × 260 (StJ).

37 Interior of Hampstead Church.
Drawn by J. E. Kelly/Engd by G. B. Smith.
*C. Wheaton, Library, Hampstead.*
[c. 1860?] Steel-engr., 100 × 130 (SCL).

a No artist statement, new imprint.
*Hewetson's Library, Hampstead.* (SCL).

38 Church Street. Hampstead Middlesex.
Copper-engr., 60 × 95 (*Marshall's Select Views*, [1825–8], ii, after p. 118).

39 Church Street, Hampstead, Middlesex.
Steel-engr., 65 × 105 (Dugdale, *Curiosities of Great Britain*, [1838–43], vi, unnumbered).

40 [Church Row].
/Albert Hardy (within image area, below).
[c. 1880?]. Etching, 150 × 200 (SCL).

41 The Old Church Hampstead (bottom right of image area).
EMB [Esther M. Bakewell]/ (within image area, below). *Catty & Dobson, London.*
[c. 1890?]. Etching, 140 × 215 (SCL). See note to no. 138.

42 [Church Row].
/S. Sharpe 1878 (within image area, below). Etching, 75 × 110 (SCL).

43 [Church Row].
T. R. W. [T. R. Way] 98/ (within image area, below). Bottom right: Plate 1. Lith., 135 × 185 (Way & Wheatley, *Reliques of old London North*, 1898, opp. p. 22, Pl. 1).

44 Church Row.
/T. R. Way (within image area, below).
Top: Hampstead. Chromolith., 75 × 130 (Way, *Hampstead*, 1908, Pl. 2).

45 Church Row, Hampstead, In 1750.
W. H. Sc/WP (both within image area, below). Wood-engr., 140 × 210 (Walford, *Old & New London*, [1873–78], v, p. 475).

46 Old Houses In Church Row.
WP/indecipherable artist's monogram based on R or QL (both within image area, below). Wood-engr., 145 × 105 (Walford, *Old & New London*, [1873–78], v, p. 474).

47 Church Row, Looking East, Hampstead.
Etching, 190 × 145 (*Old Hampstead*, [c. 1900?], unnumbered).

48 Oriel House, From an Upper Window, 27, Church Row.
W. H. Thompson delt/A. Evershed fec. aq.-f. Etching, 175 × 100 (Baines, *Records of Hampstead*, 1890, frontis).

49 Rosslyn House. (From a Photograph taken expressly for this work.)
/O. Jewitt del. & Sc/ (within image area, below). Wood-engr., 75 × 90 (Howitt, *Northern Heights of London*, 1869, p. 191).

50 Shepherd's Well, Hampstead.
Wood-engr., 90 × 110 (Hone, *Table Book*, 1827, i, column 382; *Every-Day Book*, 1830, iii, column 382).

i Shepherd's Well In 1820.
Wood-engr., 105 × 140 (Walford, *Old & New London*, [1873–78], v, p. 493).

51 Shepherd's Well, Hampstead.
Wood-engr., 75 × 110 (*Pictorial World*, 24 Oct. 1874).

52 House built and Inhabited by Sir Henry Vane, At Hampstead.
W. Davison del/J. Smith Sc. *White & Cochrane, Fleet Street, Nov. 1813.* Copper-engr., 100 × 165 (Park, *Topography of Hampstead*, 1814, Pl. ix, opp. p. 269).

a Publisher removed and markings added. Top right: Gent. Mag. May, 1828. Pl. II. p. 401. (*Gent Mag.*, May 1828, opp. p. 401).

i Vane House, In 1800.
Greenaway/WP (both within image area). Wood-engr., 105 × 145 (Walford, *Old & New London*, [1873–78], v, p. 480). Alterations to the foreground and building in this version.

53 Sir Harry Vanes House. (From Park's 'Hampstead'.)
/O. Jewitt del. & Sc. Wood-engr., 75 × 90 (Howitt, *Northern Heights of London*, 1869, p. 179). Copied from no. 52.

54 Chicken House, Hampstead.
/Malcolm del. et s. *J. P. Malcolm, No. 10 Middlesex St, Somers Town, May 31st 1797.* Copper-engr., 120 × 130 (Malcolm,

*Views Round London*, 1800, for Vol. ii, p. 536).

i The Chicken-House. (From an Old Print in Mr Gardner's Collection.) /O. Jewitt sc. (within image area, below). Wood-engr., 55 × 80 (Howitt, *Northern Heights of London*, 1869, p. 162).

55 Near Downshire Hill. (Hampstead.) G. Childs (within image area, below)/Printed by Graf & Soret. *Charles Tilt, 86 Fleet Street*. Top right: 10. Lith., 155 × 240 (Childs, *Child's Advanced Drawing Book*, [c. 1840], Pl. 10).

56 Near Downshire Hill, (Hampstead.) /G. Childs (within image area, below) Printed by Graf & Soret. *Charles Tilt, No. 86 Fleet St.* Top right: 12. Lith., 170 × 250 (Childs, *Child's Advanced Drawing Book*, [c. 1840], Pl. 12).

57 Scene Near The Vale Of Health. Printed by Graf & Soret/G. Childs (latter within image area, below). *Charles Tilt, No. 86 Fleet Street.* Top right: 21. Lith., 170 × 245 (Childs, *Child's Advanced Drawing Book*, [c. 1840], Pl. 21).

58 Near The Vale Of Health. /G. Childs (within image area, below). Printed by Graf & Soret. Top right: 23. Lith., 175 × 245 (Childs, *Child's Advanced Drawing Book*, [c. 1840], Pl. 23). None of the examined copies of this print provided the imprint of *Charles Tilt, 86 Fleet St*, common to all the views in this series.

59 On The Heath, Near The Vale Of Health. Printed by Graf & Soret/G. Childs (latter within image area, below). *Charles Tilt, 86 Fleet St.* Top right 2. Lith., 170 × 255 (Childs, *Child's Advanced Drawing Book*, [c. 1840], Pl. 2).

60 Back of some Old Houses in Grove Place, Hampstead. Etching, 150 × 200 (*Old Hampstead*, [c. 1900?], unnumbered).

61 Old Houses in Streatley Place, Hampstead. Etching, 200 × 145 (*Old Hampstead*, [c. 1900?], unnumbered).

62 New End, Hampstead. Etching, 205 × 180 (*Old Hampstead*,

[c. 1900?], unnumbered). A view from opposite New End House (corner of which is on extreme left) looking towards Christ Church and 16 New End, formerly the Dispensary and Soup Kitchen (building on extreme right).

63 Work. /H. F. Davey (within image area, below). /(Painted by Ford Madox Brown. Engraved by H. F. Davey.)/[c. 1872?]. Wood-engr., 160 × 220 (SCL). Oil painting at City of Manchester Art Galleries.

64 Cherry Tree House, Heath Street, Hampstead. Etching, 185 × 175, (*Old Hampstead*, [c. 1900?], unnumbered).

65 Holly-Bush Hill, Hampstead. GC [G. Childs] (within image area, below)/ Printed by Graf & Soret. *Charles Tilt, 86 Fleet Street*. Top right: 6. Lith., 165 × 250 (Childs, *Child's Advanced Drawing Book*, [c. 1840], Pl. 6).

66 Holly Hill. T. R. Way/ (within image area, below). Top: Hampstead. Chromolith., 125 × 75 (Way, *Hampstead*, 1908, Pl. 4).

67 View of the Constitutional Club, Hampstead. Etching, 135 × 215 (*Old Hampstead*, [c. 1900?], unnumbered).

68 Fountain North Esqr. Hampstead. /Malcolm del. et s. *J. P. Malcolm, No. 2 Evesham Buildings, Sommers Town, Dec. 1, 1796*. Top left: Vol. ii. Copper-engr., 135 × 195 (Malcolm, *Views Round London*, 1800, for Vol. ii, p. 536).

a Admiral Bartons Hampstead. (SCL). Recent research indicates that Admiral Barton never resided at the Grove. Malcolm may have realised his error and adjusted the title in favour of that found at the main entry.

69 House At Hampstead. J. Constable R.A./H. R. Robertson. *Art Union of London, 112 Strand, 1891*. Etching, 330 × 275 (SCL). *Camden History Review*, 1, p. 22: 'One of Constable's three paintings of the house in Admiral's Walk (then called "The Grove"), this was

exhibited at the Royal Academy in 1832 under the title ''A Romantic House in Hampstead''. The picture is now in the Tate Gallery.'

i The Romantic House.
John Constable R.A. pinx/J. Park sc. *Fçois Liénard Imp, Paris*. Etching, 245 × 205 (P).

70 [''Night.'' The Grove, Frognal (in pencil below on copy inspected)].
/S. Sharpe 1880. Etching, 105 × 155 (SCL).

71 The Old Clock House, 1780.
Wood-engr., 105 × 145 (Walford, *Old & New London*, [1873–78], v, p. 468).

72 [Fenton House].
/T. R. Way 98/ (detail in fencing within image, below). Bottom right: Plate 2. Lith., 140 × 190 (Way & Wheatley, *Reliques of Old London North*, 1898, Pl. 2, after p. 25).

73 [Hampstead?].
/Artist's monogram based on the letters EVW. [c. 1910?]. Etching, 130 × 190 (SCL). A mysterious view so far unlocated and not proved to be of Hampstead.

74 A Meadow Scene at Hampstead, Middlesex.
/Painted by W. Robson & Engraved by W. Birch Enamel Painter/. *W. Birch, Hampstead Heath, Feby 1, 1790*. Copper-engr. 90 × 125 (Birch, *Délices de la Grande Bretagne*, 1791, unnumbered).

75 [View of Hampstead Church from Frognal with London in the distance].
T. Stowers delt/S. Alken fecit. *S. Alken, 2 Francis Street, Bedford Square, Oct. 22, 1796*. Aquatint, 160 × 225 (Stowers, *Six Views in Hampstead*, [1796], unnumbered).

76 [Clock House Pond and Alms House].
T. Stowers delt/S. Alken fecit. *S. Alken, 2 Francis Street, Bedford Square, Oct. 22, 1796*. Aquatint, 165 × 225 (Stowers, *Six Views in Hampstead*, [1796], unnumbered).

77 Alms House Hampstead.
*J. P. Malcolm, Somers Town, 25* [month omitted?], *1797*. Copper-eng., 100 × 125 (Malcolm, *Views Round London*, 1800, unnumbered).

78 The Poor House At Hampstead.
Drawn by W. Alexander 1801/Engraved by Charles Heath. *White, Cochrane & Co., Fleet Street, Jany 1814*. Copper-engr., 125 × 175 (Park, *Topography of Hampstead*, 1814, Pl. x, opp. p. 286).

79 The Old Workhouse. (From Park's 'Hampstead.')
/O. Jewitt Sc/. Wood-engr., 55 × 90 (Howitt, *Northern Heights of London*, 1869, p. 140). Copied from no. 78.

80 Old Building at Hampstead.
[c. 1805?]. Copper-engr., 25 × 50 (BM). From an unidentified almanac.

81 Frognall Priory, Hampstead W. Thompson, Esqr.
Copper-engr., 60 × 95 (*Marshall's Select Views*, [1825–8], ii, after p. 118).

82 Frognall Priory Hampstead.
[Drawn by T. H. Shepherd/Engraved by J. Shury]. Steel-engr., 60 × 100 (Partington, *National History and Views of London*, 1834, ii, opp. p. 70 middle).

83 Frognal Priory.
Wood-engr., 105 × 145 (Walford, *Old & New London*, [1873–78], v, p. 498).

84 ''Corner-Memory Thompson's'' House At Hampstead.
Wood-engr., 70 × 135 (*Illus. London News*, 25 Mar. 1843, p. 207).

85 Gauntlet Court.
Wood-engr., 110 × 190 (*Reynold's Miscellany*, 5 Dec. 1863, p. 377).

86 Frognal Priory. (From an Original Drawing in the possession of J. E. Gardner, Esq.)
/O. Jewitt (within image area, below). Wood-engr., 60 × 95 (Howitt, *Northern Heights of London*, 1869, p. 154).

87 Frognal Grove Hampstead, the Mansion of Edward Montague Esqr.
/M. C. Prestell sculp. *Messrs Boy[d]ell's, Cheapside*. [c. 1790?]. Aquatint, 230 × 315 (SCL).

88 [Dr. White's Frognal Grove Hampstead].
[c. 1840?] Lith., 180 × 255 (P).

89 Hampstead Church.
[c. 1842?]. Lith., 75 × 125 (SCL).

90 Branch Hill Hampstead.
Drawn by W. Westall A.R.A./Engraved by E. Finden. *Charles Tilt, 86 Fleet Street 1829*. Steel-engr., 95 × 145 (Moule, *Great Britain Illustrated*, 1830, opp. p. 54 bottom).

91 Branch Hill Hampstead.
/G. Childs (within image area, below) Printed by Graf & Soret. *Charles Tilt, 86 Fleet Street*. Top right: 20. Lith., 170 × 245 (Childs, *Child's Advanced Drawing Book*, [c. 1840], Pl. 20).

92 Road Leading To Holly-Bush Hill From The Heath.
G. Childs (within image area)/ Printed by Graf & Soret. *Charles Tilt, No. 86 Fleet Street*. Top right: 1. Lith., 190 × 240 (Childs, *Child's Advanced Drawing Book*, [c. 1840], Pl. 1).

93 The End of the Grove and part of Hampstead Heath.
T. H. [T. Hastings] 1825/. Bottom right: 14. Etching, 80 × 95 (Hastings, *Etchings Hampstead Heath*, [1822–26], Pl. 14, bottom).

94 Branch Hill Lodge.
/T. Way Lith., London. Lith., 190 × 185 (SCL). From the auction catalogue issued for the sale of the property, 20 June 1899.

95 Branch Hill Lodge.
/T. Way Lith., London. Lith., 160 × 210 (SCL). From the auction catalogue issued for the sale of the property, 20 June 1899.

96 'Branch Hill Lodge', Hampstead Heath (above the image).
T. Way, Lith., London/. Lith., 165 × 150 (SCL). Auction catalogue cover for the sale of the property, 20 June 1899.

97 North End. Hampstead. On the Road to Hendon.
Drawn from Nature & on Stone by T. M. Baynes/ Printed by C. Hullmandel. *D. Walther, Brydges Stt, Covent Garden, 10 Aug. 1822*. Lith., 160 × 235 (Baynes, *Twenty Views in London*, 1823, Pl. 1). This view was included as a design theme for a dish in a Staffordshire blue series called *Metropolitan Scenery*. The dish is reproduced in *Staffordshire Blue* by W. L. Little as illustration 83.

98 North End Left Of The Road.
G. Childs (within image area, below)/Printed by Graf & Soret. *Charles Tilt, No. 86 Fleet Street*. Top right: 17. Lith., 160 × 245 (Childs, *Child's Advanced Drawing Book*, [c. 1840], Pl. 17).

99 [The Gibbet Elms, North End].
T. Stowers delt/S. Alken fecit. *S. Alken, 2 Francis Street, Bedford Square, 22 Oct. 1796*. Aquatint 160 × 225 (Stowers, *Six Views in Hampstead*, [1796], unnumbered).

100 Road Leading To North End.
/G. Childs (within image area, below) Printed by Graf & Soret. *Charles Tilt, 86 Fleet Street*. Top right: 19. Lith., 150 × 250 (Childs, *Child's Advanced Drawing Book*, [c. 1840], P. 19).

101 Elms North End, Hampstead (bottom left of image).
/Geo. Barnard del. (within image area, below). Top right: 16. Lith., 225 × 305 (Barnard, *Elementary Studies of Trees*, 1844, first series, Pl. 16).

102 Hampstead (bottom left of image area).
Monk May 98/ (within image area, below). Etching, 255 × 180 (Monk, *Hampstead Etchings*, 1900, unnumbered).

103 The Old 'Bull & Bush' (bottom right of image area).
EVW/ (artist's monogram, within image area, below). [c. 1910?]. Etching, 145 × 225 (GuP).

104 The Old Bull and Bush. Hampstead.
HF [H. Fancourt] delt 1870/. Etching, 165 × 235 (SCL).

105 North End Hampstead.
HC/ (monogram of H. Hovell Crickmore within the image area, below). *Catty & Dobson, London*. [c. 1890?]. Etching, 70 × 105 (SCL).

106 North end Hampstead (bottom right of image).
Paul Gauci/ (within image area, below). *Published and Printed by P. Gauci, 9 North Crescent, Bedford Square, Jany 1859*. Bottom: Paul Gauci's Pencil Sketches,

No. 9 in his new style of Chalk Transfer. Lith., 235 × 350 (SCL). From the same series as nos. 108, 148 & 185.

107 North End. (High Road.)
/G. Childs (within image area, below) Printed by Graf & Soret. *Charles Tilt, No. 86 Fleet Street.* Top right: 9. Lith., 165 × 255 (Childs, *Child's Advanced Drawing Book*, [c. 1840], Pl. 9).

108 Hampstead.
Paul Gauci/. *Published & Printed by P. Gauci, 9 North Crescent, Bedford Square, Jany 1859.* Bottom: Paul Gauci's Pencil Sketches, No. 7 in his new style of Chalk Transfer. Lith., 210 × 300 (GLC). From the same series as nos. 106, 148 & 185.

109 On Hampstead Heath (bottom right of image).
J. Skinner Prout (within image)/J. Graf Printer to her Majesty. *Ackermann & Co., 96 Strand.* Top right: 11. Lith., 145 × 250 (SCL).

110 Tea Gardens. – From a drawing by Robert W. Macbeth.
Wood-engr., 85 × 120 (*Harper's New Monthly Mag.*, July 1883, p. 178).

111 Old Cottages, at Northend – near Hampstead/1868/.
/J. S. Whitty (within image area, below). Top: No. 1. – Specimens of Pen Etching. Lith., 100 × 185 (BM).

112 [Cottages at North End].
Albert Hardy/(within image area, below). [c. 1880?]. Etching, 150 × 200 (BM).

113 At Hampstead.
/A. Evershed 1879. Etching, 145 × 190 (*Etcher*, Jan. 1881, Part xix, Pl. 3).

114 [North End Cottages].
[c. 1880?]. Etching, 225 × 295 (SCL).

115 Cottages, North End Place.
/Philip Pimlott 1905 (within image area, below). Etching, 155 × 215 (SCL).

116 North End Hampstead.
[c. 1840?]. Lith., 200 × 310 (SCL).

117 Heath Farm Hampstead (bottom left of image area).
[c. 1880?]. Wood-engr., 65 × 110 (SCL).

118 North-End House. (From a Photograph taken expressly for this work).
/O. Jewitt del. (within image area, below). Wood-engr., 70 × 95 (Howitt, *Northern Heights of London*, 1869, p. 83).

119 North End Place, Hampstead.
/Philip Pimlott 1905/ (within image area, below). Etching, 150 × 215 (SCL).

120 North End Place, Hampstead.
/Philip Pimlott 1905 (within image area, below). Etching, 155 × 210 (SCL).

121 The Hall, North End Place.
/Philip Pimlott (within image area, below). [c. 1905]. Etching, 155 × 215 (SCL).

122 Library, North End Place.
/Philip Pimlott/ (within image area, below). [c. 1905]. Etching, 155 × 215 (SCL).

123 North End. The Heath.
G. Childs (within image area, below)/Printed by Graf & Soret. *Charles Tilt, No. 86 Fleet Street.* Top right: 4. Lith., 170 × 245 (Childs, *Child's Advanced Drawing Book*, [c. 1840], Pl. 4).

124 The Heath Near North End.
Printed by Graf & Soret/G. Childs (latter within image area, below). *Charles Tilt, No. 86 Fleet Street.* Top right: 11. Lith., 170 × 255 (Childs, *Child's Advanced Drawing Book*, [c. 1840], Pl. 11).

125 Near Northend On The Heath.
/G. Childs (within image area, below) Printed by Graf & Soret. *Charles Tilt, No. 86 Fleet Street.* Top right: 15. Lith., 140 × 250 (Childs, *Child's Advanced Drawing Book*, [c. 1840], Pl. 15).

126 Northend – From The Heath.
Printed by Graf & Soret/G. Childs (latter within image area, below). *Charles Tilt, No. 86 Fleet Street.* Top right: 5. Lith., 170 × 250 (Childs, *Child's Advanced Drawing Book*, [c. 1840], Pl. 5).

127 At North End.
G. Childs/ (within image area, below). *Charles Tilt, No. 86 Fleet Street.* Top right: 18. Lith., 170 × 245 (Childs, *Child's Advanced Drawing Book*, [c. 1840], Pl. 18).

128 [North End].
Printed by Graf & Soret/ G. Childs.

*Ackermann & Co., 96 Strand.* Top right: 20. Lith., 140 × 225 (SCL).

129 At North End. Left Of The Road.
/G. Childs, Printed by Graf & Soret. Top right: 13. Lith., 160 × 235 (Childs, *Child's Advanced Drawing Book*, [c. 1840], Pl. 13).

130 [Golders Hill House].
Lith., 120 × 220 (SCL). From the auction catalogue issued for the sale of the property 10 May 1838.

131 Golders Green, Near Hendon, Middlesex.
/Painted by J. Russell R.A. & engraved by W. Birch Enamel Painter/. *Wm. Birch, Hampstead Heath, & sold by T. Thornton, Southampton Street, Covent Garden, Augt 11, 1789.* Copper-engr., 95 × 125 (Birch, *Délices de la Grande Bretagne*, 1791, unnumbered).

132 The Garden, Golders Hill.
T. R. Way/(within image area, below). Top: Hampstead. Chromolith, 125 × 75 (Way, *Hampstead*, 1908, Pl. 6).

133 At North End Hampstead.
/Painted & Etched by T. H. [T. Hastings] 1822. Bottom Left: 1. Etching, 110 × 95 (Hastings, *Etchings Hampstead Heath*, [c. 1822–26], Pl. 1 top).

134 Harrow On The Hill, From Hampstead Heath.
[c. 1820?]. Copper-engr., 60 × 95 (SCL).

135 Harrow, from Hampstead Heath.
[c. 1820?]. Copper-engr., 25 × 50 (SCL).

136 On Hampstead Heath with Harrow Hill in the Distance, near North End.
T. H. [T. Hastings] 1825/. Bottom right: 11. Etching, 105 × 145 (Hastings, *Etchings Hampstead Heath*, [1822–26], Pl. 11, bottom).

137 Northend. Harrow In The Distance.
/G. Childs (within image area, below). *Charles Tilt, No. 86 Fleet Street.* Top right: 14. Lith., 170 × 230 (Childs, *Child's Advanced Drawing Book*, [c. 1840], Pl. 14).

138 The Firs Hampstead (bottom right corner of image).
EMB [Esther M. Bakewell]/(within image

area, below). *Catty & Dobson, London* (bottom left of image). [c. 1890?]. Etching 130 × 215 (SCL). From the wrapper to a series of four Hampstead views by E. M. Bakewell. Wrapper title of copy seen cropped, probably, [Four Views] of Hampstead. The other views listed are; the Spaniards (no. 168), the Old Church (no. 41) and Holly Hill (no. 323).

139 Fir Trees North end Hampstead.
E. H. [Edward Hassell] 1837/ (barely visible, within image area, below) From Nature by Edward Hassell/. *Pigot & Co., Fleet Street.* Lith., 270 × 210 (SCL).

i Fir Trees, North-End, Hampstead. From Nature & on Zinc by Edward Hassell/ Printed by C. Chabot 7 Thavies Inn, Holborn/. *Pigot & Co., Fleet Street.* [c. 1845?]. Tinted lith., 275 × 220 (SCL).

140 The Firs Hampstead Heath (bottom centre of image area).
HC/ (monogram of H. Hovell Crickmore within the image area, below). *Catty & Dobson, London* (bottom left of image area). [c. 1890?]. Etching, 110 × 75 (SCL).

141 Firs Near North End. Sketches On Hampstead Heath.
RCH/ (within image area, below). Wood-engr., 135 × 235 (*Illus. London News*, 23 Sept. 1871, p. 272, bottom).

142 The Frontage To Hampstead Heath.
T. Way, Lith., London/ (at foot of cover). Top: Golder's Hill, Hampstead Heath. Lith., 175 × 235 (SCL). From the auction catalogue issued for the sale of the Golders Hill estate, 28 June 1898.

143 Hampstead (bottom right of image area). [Leg of Mutton Pond].
/Monk 1898 (name bisects the date, within the image area, below). Etching, 180 × 255 (Monk, *Hampstead Etchings*, 1900, unnumbered).

144 Hampstead Was My Passy
[George Du Maurier]. Line block, 90 × 120 (Du Maurier, *Peter Ibbetson*, 1892 [1891], i, p. 127).

145 View From The Fir Trees Hampstead Heath. Looking towards Harrow.

Drawn from Nature & on Stone by T. M. Baynes/ Printed by C. Hullmandel. *D. Walther, Brydges Stt, Covent Garden, Augt 10, 1822.* Lith., 155 × 235 (Baynes, *Twenty Views in London*, 1823, Pl. 2).

146    Hampstead Heath.
Wood-engr., 95 × 145 (*Illus. London News*, 25 May 1844, p. 322 [i.e. 332]).

147    Spaniards, Hampstead.
/Geo. Barnard Delt. *G. Rowney & Co., 51 Rathbone Place.* Tinted Lith., 280 × 405 (*Selection of Studies*, 1850–51, Part 1, unnumbered).

148    Hampstead.
/Paul Gauci. *P. Gauci, 9 North Crescent, Bedford Sq., Jany 1859.* Bottom: Paul Gauci's Pencil Sketches, No. 12 in his new style of Chalk Transfer. Lith., 230 × 325 (SCL). From the same series as nos. 106, 108 & 185.

149    A Summer Day At Hampstead (above the image).
[P. J. Skelton] Swain Sc/ (within image area, below). Wood-engr., 105 × 125 (*Once a Week*, 6 Aug. 1864, p. 169).

150    [Near the Spaniards].
RSC [Richard Samuel Chattock] 1877/ (within image area, below). Etching, 180 × 255 (*Etcher*, Aug. 1881, Part ii, Pl. 4).

151    [The Firs near the Spaniards, Harrow in the distance].
/Albert Hardy (within image area, below). [c. 1880?]. Etching, 150 × 200 (SCL).

152    [The Firs near the Spaniards, Harrow in the distance.
Signature in pencil on copy inspected: S. Sharp. c. 1880?]. Etching, 65 × 100 (SCL).

153    The Firs Avenue. Hampstead.
/HC (monogram of H. Hovell Crickmore within the image area, below). *Catty & Dobson, London.* [c. 1890?]. Etching, 75 × 110 (SCL).

154    [The Firs Spaniards].
Monk/. Etching, 290 × 245 (Monk, *Hampstead Etchings*, 1900, unnumbered).

155    The Firs, Spaniard's Road.
/T. R. Way (within image area, below).

Top: Hampstead. Chromolith, 130 × 75 (Way, *Hampstead*, 1908, Pl. 5).

156    On Hampstead Heath – North.
Painted and etched by T. Hastings – 1823/. Bottom right: 7. Etching, 105 × 150 (Hastings, *Etchings Hampstead Heath*, [1822–26], Pl. 7).

157    Near the Spaniards. Hampstead Heath.
T. Hastings 1824/. Bottom right: 3. Etching, 75 × 125 (Hastings, *Etchings Hampstead Heath*, [1822–26], Pl. 3, top).

158    Heath Scene Near The Spaniard.
Printed by Graf & Soret/G. Childs. *Charles Tilt, No. 86 Fleet Street.* Top right: 7. Lith., 165 × 240 (Childs, *Child's Advanced Drawing Book*, [c. 1840], Pl. 7).

159    Lord Erskine's House, Near 'The Spaniards'. (From a Photograph taken expressly for this work.)
Wood-engr., 70 × 75 (Howitt, *Northern Heights of London*, 1869, p. 56).

160    The entrance to Lord Chancellor Erskine's Garden, at Hampstead.
Copper-engr., 30 × 60 (*Polite Repository*, 1808). Barratt, *Annals of Hampstead*, 1912, ii, p. 101: 'View of Ken Wood, as formerly seen through the tunnel (now filled up) under the Spaniards road. . . . This tunnel led from Erskine House.'

161    The South View of the Spaniards near Hampstead.
Chatelain del/J. Roberts scu. *Octr the 13, 1750.* Copper-engr., 70 × 115 (Chatelain, *Fifty Original Views*, [1750], unnumbered).

a  Plate number added and date abridged to: *1750.* Top right: 32. (SCL).

i  The Spaniards, 1745.
Wood-engr., 55 × 65 (Chambers, *Book of Days*, [1862–64], ii, p. 71).

162    South View Of 'The Spaniards'. (From a Print by Chatelaine, in the King's Library, British Museum.)
/O. Jewitt Del Et Sc. Wood-engr., 65 × 95 (Howitt, *Northern Heights of London*, 1869, p. 92). Copied from no. 161.

163    The Spaniards Tavern, Hampstead. Middlesex.
Steel-engr., 75 × 115 (Dugdale, *Curiosities*

*of Great Britain,* [1838–43], i, unnumbered).

a With additional plate markings. Bottom: Drawn & Engraved for Dugdales England & Wales Delineated. (Dugdale, *Curiosities of Great Britain,* [1838–43], ix, unnumbered).

164 The Spaniards Tavern, Hampstead. Wood-engr., 80 × 95 (Timbs, *Clubs & Club Life in London,* [1872], opp. p. 528). Copied from no. 163.

165 The Old Taverns. Wood-engr., 100 × 120 (*Illus. London News,* 23 Sept. 1871, p. 272, top left).

166 'The Spaniards', Hampstead Heath. R. P. Leitch/ (within image area, below). Wood-engr., 105 × 145 (Walford, *Old & New London,* [1873–78], v, p. 445).

167 Hampstead (bottom right of image area). /Monk 1899 (name bisects the date, within the image area, below). Etching, 185 × 260 (Monk, *Hampstead Etchings,* 1900, unnumbered).

168 The Spaniards Hampstead (bottom right of image area). E.M.B. [Esther M. Bakewell]/ (within image area, below). *Catty & Dobson, London* (bottom left of image area). [1890?]. Etching, 140 × 215 (SCL). See note to no. 138.

169 The Spaniards Inn. S. Sharpe 1878 (within image area, below). Etching, 120 × 80 (SCL).

170 "'He's not much used to ladies' society, and it makes him bashful. If you'll order the waiter to deliver him anything short, he won't drink it off at once, won't he? only try him'''. /T.O. [Thomas Onwhyn] del/. *E. Grattan, 51 Paternoster Row, Octr 26, 1837.* Etching, 120 × 110 (Weller, *Illustrations to the Pickwick Club,* 1837, Part vi, unnumbered).

a Artist removed and new imprint: *J. Newman, 48 Watling St.* (*Thirty Two Plates of Pickwick,* [1847], Part v, unnumbered).

b With plate number at bottom: 17. (BM).

171 The Spaniards. [H. Fancourt? c. 1870?]. Etching, 85 × 125 (BM).

172 Vale of Health Pond Hampstead with a distant View of London. T. Hastings int et fecit/1831. Etching, 115 × 185 (SCL).

173 On Hampstead Heath. 1825. T. Hastings 1825/ (detail within rock in bottom corner of image area). Etching, 100 × 150 (SCL).

174 Hampstead Heath. Painted by R. Corbould/Engraved by J. Landseer. [c. 1810?]. Copper-engr., 65 × 100 (SCL).

175 Philip Godsal's Esqr. Hampstead. [c. 1820?]. Copper-engr., 25 × 50 (SCL). From an unidentified almanac.

176 [View of London from the Vale of Health]. T. Stowers delt/S. Alken fecit. *S. Alken, 2 Francis Street, Bedford Square, Oct. 22, 1796.* Aquatint, 165 × 225 (Stowers, *Six Views in Hampstead,* [1796], unnumbered).

177 A View on Hampstead Heath, looking towards London. From an original Drawing by F. J. Sarjent/Engraved by F. Jukes. *F. Jukes, No. 10 Howland Street, Novr 30th 1804.* Aquatint, 385 × 570 (BM).

a Different imprint: *Jukes & Sarjent, 57 Upper John Strt, Fitzroy Square.* [c. 1810]. (SCL).

b Different imprint: *B. Strange, 137 Strand, April 1829.* (SCL).

i A View on Hampstead Heath, looking towards London. From an original Drawing by F. J. Sarjent/Engraved by F. Jukes. *F. Jukes, No. 10 Howland Street, Novr 30th 1804.* Aquatint, 135 × 200 (SCL).

178 Vale of Health – Hampstead, Looking from the Road. [c. 1850?]. Steel-engr., 75 × 125 (SCL).

179 The Vale of Health – Hampstead. G. Shepherd/S. Lacey. Bottom left: Printed by E. Brain. Copper-engr., 60 × 95 (*Pledge of Friendship,* 1827, opp. p. 217).

a  Printer's statement removed.
(*Marshall's Select Views*, [1825–28], iii,
after p. 94).

180  Leigh Hunt's Cottage At Hampstead.
Wood-engr., 90 × 110 (*Art Journal*,
1 Oct. 1865. p. 319).

181  Hunt Cottage, Vale of Health, Hampstead.
Etching, 160 × 215 (*Old Hampstead*,
[c. 1900?], unnumbered).

182  Vale of Health, Hampstead.
Drawn from Nature & on Stone by J.
Powell/. [c. 1825]. Lith, 75 × 100 (SCL).

183  Vale of Health – Hampstead.
J. & F. Harwood, 26 Fenchurch Street/.
[c. 1850]. Steel-engr., 80 × 135 (SCL).

184  Hampstead Heath.
Drawn by C. Stanfield A.R.A./Engraved
by E. Finden. *John Murray, Albemarle
Street, 1834*. Steel-engr., 70 × 95 (Crabbe,
*Life and Poems of George Crabbe*, 1834,
viii, engraved title page).

185  Vale of health, Hampstead.
Paul Gauci/. *P. Gauci, 9 North Crescent,
Bedford Square, Jany 1859*. Bottom: Paul
Gauci's Pencil Sketches, No. 11 in his new
style of Chalk Transfer. Lith., 255 × 325
(GLC). From the same series as nos. 106,
108 & 148.

186  Near The Vale of Health.
[George Childs]/Printed by Graf & Soret.
*Charles Tilt, No. 86 Fleet St*. Top right:
8. Lith., 165 × 245 (Childs, *Child's
Advanced Drawing Book*, [c. 1840], Pl. 8).

187  An Autumn Study (bottom right of image
area).
S. Sharpe 1878/ (within image area,
below). Etching, 175 × 240 (SCL). A view
from the Vale of Health pond towards
Christ Church.

188  The Lake in The Vale of Health.
[c. 1880?]. Wood-engr., 90 × 135 (SCL).

189  (Suburban Hotel, Hampstead Heath.)
[c. 1863]. Wood-engr., 110 × 180 (BM).

190  The Suburban Hotel Company Limited.
A Sketch of Their First Hotel Recently
Erected In The Vale of Health In The

Centre Of Hampstead Heath (above the
image).
/F. Waller Lith., 18 Hatton Garden/.
[c. 1864]. Lith., 255 × 405 (SCL).

191  A Prospect of Hampstead from the Foot
way next the Great Road at the Top of
Pond Street.
Chatelain Delin/W. H. Toms Sculp. *W. H.
Toms, Engraver in Union Court near Hatton
Garden, Holborn, March 25th 1745*. Top
right: 5. Copper-engr., 165 × 260 (BM).

a  A View of Hampsted from the foot way
next the Great Road Pond Street (& in
French).
Chatelain Delin. et Sculp/. *Heny Overton, at
the White Horse without Newgate & Robt
Sayer, at the Golden Buck opposite Fetter
Lane, Fleet Street, 1752*. Top centre: Vues
divers des Villages près de Londres. Top
right: 1. Copper-engr., 165 × 260 (GuP).

b  Different imprint: *C. Dicey & Co. in
Aldermary Church Yard, 1752*. (SCL).

i  A View of Hampstead from the footway
next the Great Road Pond Street (& in
French).
*Robert Sayer Map & Printseller, near
Serjeants Inn, Fleet Street*. Top right: 11.
Copper-engr., 150 × 260 (SCL).

192  A View of Hampstead from ye foot way
next the Great Road, Pond Street.
Top right: V. 1. P. 29. Copper-engr.,
115 × 190 (*New Display of Beauties of
England*, 1773, i, opp. p. 29). Copied from
no. 191.

a  Different markings. Top: Vol. 2/Pa. 78.
(*New Display of Beauties*, 1787, ii, opp.
p. 78).

193  View Of Hampstead in Middlesex taken
from the footway in Pond Street.
[*Alexr Hogg, at the Kings Arms, No. 46
Paternoster Row*]. Copper-engr., 125 × 170
(Walpoole, *New British Traveller*, [1784],
after p. 286, top). Copied from no. 191.

194  A Prospect of part of Hampstead from the
Top of Pond Street looking down to the
Bottom.
Chatelain Delin/W. H. Toms Sculp. *W. H.
Toms Engraver, in Union Court near Hatton*

*Garden, Holborn.* [1745]. Copper-engr., 165 × 260 (SCL).

a View of Hampsted from the Top of Pond Street (& in French).
Chatelain Delin. et Sculp/. *Heny Overton, at the White Horse without Newgate & Robt Sayer, at the Golden Buck opposite Fetter Lane, Fleetstreet.* [1752]. Top right: 2. (SCL).

b Different imprint: *C. Dicey & Co., in Aldermary Church Yard, 1752.* (SCL).

195 Pond Street, Hampstead, In 1750.
WP/ (within image area, below). Wood-engr., 145 × 205 (Walford, *Old & New London,* [1873–78], v, p. 499). Copied from no. 194 with alterations especially to the figures in the foreground.

196 View at Hampstead, near the New Medicinal Springs.
/F. Chesham sc. 1803. Copper-engr., 75 × 115 (Goodwin, *Account of the Saline Waters,* 1804, frontis).

197 Pond Street – Hampstead.
Copper-engr., 60 × 95 (*Marshall's Select Views,* [1825–28], iii, after p. 94).

198 From The Fields Near Pond Street.
G. Childs (within image area)/Printed by Graf & Soret. *Charles Tilt, No. 86 Fleet Street.* Top right: 22. Lith., 165 × 245 (Childs, *Child's Advanced Drawing Book,* [c. 1840], Pl. 22).

199 Water-Carrier At Hampstead.
Wood-engr., 115 × 75 (*Illus. London News,* 23 March 1850, p. 200).

200 The Sluice House At Hampstead.
W. C. Kemp/(within image area, below). Wood-engr., 85 × 100 (*Kemp's West London Sketcher,* 1 July 1889, p. 191).

201 Entrance To The Heath From Pond Street.
G. Childs (within image area, below)/Printed by Graf & Soret. *Charles Tilt, 86 Fleet Street.* Top right: 3. Lith., 165 × 245 (Childs, *Child's Advanced Drawing Book,* [c. 1840], Pl. 3).

202 Near Pond Street, Hampstead.
T. Hastings/1828. Etching, 75 × 90 (SCL).

203 A Prospect of Hampstead from the Pond at the bottom of the Heath looking towards Pond Street.
Chatelain Delin/W. H. Toms Sculp. *W. H. Toms Engraver in Union Court, near Hatton Garden, Holborn, 25 March 1745.* Top right: 4. Copper-engr., 160 × 255 (BM).

a A View of Hampsted from the Pond (& in French).
Chatelain Delin et Sculp/. *Heny Overton at the White Horse without Newgate, & Robt Sayer, at the Golden Buck opposite Fetter Lane, Fleet Street, 1752.* Top right: 5. (SCL).

b Different imprint: *C. Dicey & Co., in Aldermary Church Yard, 1752.* (SCL).

204 Hampstead.
J. & F. Harwood, 26 Fenchurch Street/Jany 24th 1842. Bottom right: No. 108. Steel-engr., 100 × 160 (SCL).

a Date removed. (*Cruchley's Illustrated London,* [c. 1854], in random sequence).

205 Saint John's Chapel, Downshire Hill, Hampstead.
/Dedicated by Permission to the Revd John Ayre, M.A. by his most obed Servt J. C. Deeley, Artist/. *Published for the Artist by D. Smith Bookseller & Stationer, High St, Hampstead.* [c. 1835?]. Lith., 205 × 260 (SCL).

206 Keats Seat, Old Well Walk.
Wood-engr., 145 × 105 (Walford, *Old & New London,* [1873–78], v, p. 469).

a Keat's Seat, Well Walk, Hampstead. Below the image: From 'Old and New London', by permission of the Publishers, Messrs Cassell, Petter & Galpin. (*Proposed Destruction of the Well Walk,* 1879, p. 17).

b Same title as a. Above the print appears the full title of the pamphlet. Below: The proceeds of the sale of this pamphlet will be given as a contribution towards . . . (*Proposed Destruction,* 1879, cover illustration). This state is easily identifiable since it was printed on blue paper.

207 Well Walk. (From a Photograph taken expressly for this work.)
/O. Jewitt (within image area, below). Wood-engr., 85 × 75 (Howitt, *Northern Heights of London,* 1869, p. 54).

208　Jack Straw's Castle Hampstead Heath.
[Drawn by T. H. Shepherd/Engraved by J.
Shury]. Steel-engr., 55 × 100 (Partington,
*National History and Views of London*,
1834, ii, opp. p. 180, middle).

209　R. Ware, Jack Straws Castle Hotel &
Tavern, Hampstead Heath.
[c. 1840?]. Wood-engr., 40 × 80 (SCL).

210　The Old Taverns.
Wood-engr., 95 × 110 (*Illus. London News*,
23 Sept. 1871, p. 272, top right).

211　Jack Straw's Castle.
WP/ (within image area, below). Wood-
engr., 105 × 145 (Walford, *Old & New
London*, [1873–78], v, p. 450).

212　Hampstead (bottom left of image area).
[Jack Straws Castle].
Monk May 1st 1898 /(name bisects the
date, within the image area, below).
Etching, 180 × 250 (Monk, *Hampstead
Etchings*, [c. 1900], unnumbered).

213　[Jack Straw's Castle].
/T. R. Way 98/ (within image area, below).
Bottom right: Plate 3. Lith., 165 × 165
(Way & Wheatley, *Reliques of Old London
North*, 1898, Pl. 3, opp. p. 30).

214　''Jack Straws Castle''.
Artist's monogram made up of the letters
EVW/. [c. 1910?]. Etching, 140 × 220 (P).

215　Near Jack Straw's Castle, Hampstead
Heath.
/Drawn & etch'd by J. T. Smith, Engraver
of the antiquities of London, and its
environs/. *N. Smith, Rembrandt's Head, Gt
Mays Buildings, St Martins Lane & I. T.
Smith, No. 40 Frith Street, Soho, June 1797.*
Etching, 150 × 160 (Smith, *Remarks on
Rural Scenery*, 1797, unnumbered).

216　Near Jack Straw's Castle.
/G. Childs (within image area,
below)/Printed by Graf & Soret. *Charles
Tilt, No. 86 Fleet Street.* Top right: 24.
Lith., 170 × 250 (Childs, *Child's Advanced
Drawing Book*, [c. 1840], Pl. 24).

217　[Top of North End Way?].
Monogram of G. England. [c. 1880?].
Etching, 165 × 225 (SCL).

218　Thos Gattaker's Esqr. (left) Hampstead
Heath, Middx (right).
[c. 1800]. Top right: 4. Copper-engr.,
125 × 175 (SCL).

　　a　No plate number (SCL).

219　Seat of Jas. Kesteven Esq. Hampstead.
J. Landseer del & sc/. [c. 1810?]. Copper-
engr., 25 × 50 (BM).

220　Sr. Frans Wills, (left) Hampstead Heath,
Middx (right).
[c. 1800]. Top right: 3. Copper-engr.,
125 × 175 (SCL).

　　a　No plate number (P).

221　Whitestone Pond & Spaniard's Road.
/T. R. Way (within image area, below).
Top: Hampstead. Chromolith., 75 × 125
(Way, *Hampstead*, 1908, Pl. 3). Shows
Heath House and on the right the railings
overlooking the Vale of Health.

222　View On Hampstead Heath.
Drawn by W. Westall A.R.A./E. Finden
sculp. *Charles Tilt, 86 Fleet Street, 1829.*
Steel-engr., 85 × 145 (Moule, *Great Britain
Illustrated*, 1830, opp. p. 50, bottom).

　　a　With different imprint: *No. 357 J. & F.
Harwood, London.* [c. 1840]. (SCL).

223　View on Hampstead Heath.
J. Harwood, 26 Fenchurch Street/No. 357.
[c. 1850]. Steel-engr., 95 × 150 (SCL).
Copied from no. 222 with minor
alterations. In this version a seated man
has replaced the bonneted lady.

224　Hampstead Heath From Castle Inn.
/Engraved by J. Hewetson. *J. Hewetson,
Hampstead, 1867.* Steel-engr., 70 × 95
(SCL).

225　Belmore House & Alsops Cottage
Hampstead Heath as in 1819.
T. Hastings/. Bottom right: 21. Etching,
75 × 95 (Hastings, *Etchings Hampstead
Heath*, [1822–26], Pl. 21, top).

226　Alsop's Cottage looking over the Vale of
Health Hampstead Heath, sketched in
1819.
T. Hastings 1825/. Etching, 100 × 150
(Hastings, *Etchings Hampstead Heath*,
[1822–26], Pl. 19[?], bottom).

227 The Residence Of George Steevens, F.R.S. Hampstead Heath.
I. T. Smith del/Cha. J. Smith sculp. *John Murray, London, 1836*. Steel-engr., 70 × 90 (*Johnsoniana*, 1836, opp. p. 173).

228 Upper Flask Tavern, Hampstead Heath.
/Bonner Sc. (within image area, below). Wood-engr., 60 × 85 (Smith, *Historical & Literary Curiosities*, 1840, part viii, p. 88).

229 The "Upper Flask", About 1800.
WRP/ (within image area, below). Wood-engr., 105 × 145 (Walford, *Old & New London*, [1873–78], v, p. 456).

230 The Upper Flask. (From a Photograph taken expressly for this work.)
/O. Jewitt sc (within image area, below). Wood-engr., 65 × 85 (Howitt, *Northern Heights of London*, 1869, p. 123).

231 On Hampstead Heath near Rackstraw's Castle, & the Horse Pond.
T. Hastings 1826/. Bottom right: 18. Etching, 155 × 100 (Hastings, *Etchings Hampstead Heath*, [1822–26], Pl. 18).

232 On Hampstead Heath (bottom left of image area).
/Etched by T. Hastings 1824 (within image area, above). Top left: 4. Etching, 80 × 130 (Hastings, *Etchings Hampstead Heath*, [1822–26], Pl. 4, bottom).

233 The Upper Terrace Avenue. Hampstead Heath.
George Stanfield Pinx./Paul Gauci Litho. [c. 1850]. Tinted lith., 235 × 355 (SCL).

i King's Bench Avenue. (From a Lithograph in the possession of Miss Meteyard.)
/O. Jewitt. Wood-engr., 65 × 85 (Howitt, *Northern Heights of London*, 1869, p. 136).

234 Hampstead, Middlesex. "Ut Umbra sic Vita".
Painted by John Constable R.A./Engraved by David Lucas. *John Constable, 35 Charlotte St, Fitzroy Square, 1831*. Top: Vignette. Mezzotint, 90 × 155 (GuP). Wedmore 22; Shirley 3. Wedmore: 'First Published State. The word "Heath" in the title is omitted. Scarce.'

a Artist statement unaltered, but with new full title: Hampstead Heath,

Middlesex. "Ut Umbra Sic Vita". *John Constable, 35 Charlotte Stt, Fitzroy Square, 1831*. Top: Vignette. To Mr. Constable's English Landscape. (Constable, *English Landscape Scenery*, 1830–32, Part v, unnumbered).

235 A Heath.
Painted by John Constable R.A./Engraved by David Lucas. *Mr Constable, 35 Charlotte St, Fitzroy Square, 1831*. Mezzotint, 140 × 190 (Constable, *English Landscape Scenery*, 1830–32, Part iii, unnumbered). Original painting dated 1828, at V & A. Wedmore 8; Shirley 23.

a No imprint. Top right: 22. (Constable, *English Landscape Scenery*, Bohn, 1855, Pl. 22).

i [Hampstead Heath.
By Luke Taylor after J. Constable. c. 1900?]. Etching, 200 × 245 (V&A). Central details from no. 235, but with alterations. Probably a Royal College of Art exercise.

236 A Heath Scene.
John Constable R.A./. [c. 1831]. Etching, 225 × 395 (SCL).

237 Hampstead Heath.
John Constable R.A./David Lucas. Top right: 13. Mezzotint, 140 × 180 (Constable, *English Landscape Scenery*, Bohn, 1855, Pl. 13). Wedmore 39; Shirley 51.

238 Noon.
Painted by John Constable R.A./Engraved by David Lucas. *Mr Constable, 35 Charlotte St, Fitzroy Square, 1830*. Mezzotint, 140 × 220 (Constable, *English Landscape Scenery*, 1830–32, Part ii, unnumbered). Wedmore 4; Shirley 16. According to A. Hyatt Mayor in *Prints & People* 'Lucas submitted as many as 13 trial proofs for Constable to correct with black lead and white paint until the plate finally captured the sparkle of raindrops in a sunny breeze.'

a No imprint. Top right: 36. (Constable, *English Landscape Scenery*, Bohn, 1855, Pl. 36).

b No imprint or plate number (P).

239 Hampstead Heath, Harrow in the Distance.
John Constable R.A./David Lucas. *The engraver, 27 Westbourne Street, Pimlico, 1845.* Mezzotint, 140 × 180 (SCL).

a No imprint. Top right: 10. (Constable, *English Landscape Scenery*, Bohn, 1855, Pl. 10).

b No imprint or plate number (P).

240 [View from Pond below Judge's Walk with Harrow in the distance.]
T. Stowers delt/S. Alken fecit. *S. Alken, 2 Francis Street, Bedford Square, Oct. 22, 1796.* Aquatint, 165 × 225 (Stowers, *Six Views in Hampstead*, [1796], unnumbered).

241 Hampstead Heath.
Drawn by C. Marshall/Engraved by D. Lucas. *S. Hollyer, 7 Compton Str. East, & H. Gibbs, 23 Gt Newport Str., 1832.* Bottom left: (Plate 3). Mezzotint, 130 × 190 (SCL).

242 Hampstead Heath In 1840. From a Drawing by Constable.
WP/ (within image area, below). Wood-engr., 140 × 210 (Walford, *Old & New London*, [1873–78], v, p. 451). A copy of no. 241.

243 On Hampstead Heath. West.
/T. H. [T. Hastings] 1823. Bottom left: 2. Etching, 65 × 120 (Hastings, *Etchings Hampstead Heath*, [1822–26], Pl. 2, bottom).

244 On Hampstead Heath. West.
T.Hˢ. [T. Hastings] 1825/. Bottom right: 12. Etching, 60 × 90 (Hastings, *Etchings Hampstead Heath*, [1822–26], Pl. 12, top).

245 Pond near the Terrace, Hampstead Heath.
T. Hastings 1824/. Bottom left: 5. Etching, 70 × 125 (Hastings, *Etchings Hampstead Heath*, [1822–26], Pl. 5, top).

246 The Upper Pond.
Wood-engr., 80 × 150 (*Illus. London News*, 23 Sept. 1871, p. 272, middle).

247 The Pond Hampstead Heath.
*Catty & Dobson, London.* [c. 1890?]. Etching, 75 × 105 (SCL). Almost concealed by the trees is the Old Court House.

248 A View From The Flagstaff.
F. Anderson/ (within image area).
[c. 1870?]. Wood-engr., 85 × 150 (SCL). From an unknown newspaper source. Width probably cropped on copy examined.

249 View Towards Harrow, From The Flagstaff.
T. R. Way/ (within image area, below). Top: Hampstead. Chromolith., 75 × 125 (Way, *Hampstead*, 1908, Pl. 1).

250 Hampstead Heath.
Wood-engr., 130 × 205 (*Leisure Hour*, 11 Sept. 1856, p. 585).

251 Hampstead (bottom left of image area). [The Ride Hampstead Heath].
Monk 1898 May/ (name bisects the date, within image area, below). Etching, 175 × 255 (Monk, *Hampstead Etchings*, 1900, unnumbered).

252 From The Heath Near The Spaniard.
[G. Childs]/Printed by Graf & Soret. *Charles Tilt, 86 Fleet Street.* Top right: 16. Lith., 170 × 250 (Childs, *Child's Advanced Drawing Book*, [c. 1840], Pl. 16).

253 [London: From Hampstead Heath.
*The Proprietors, Hodgson & Co., 10 Newgate Street.* c. 1830]. Lith., 140 × 190 (SCL). Mounted below the print examined is the label characteristic of this series of 'polygraphs' which provides the title and publisher.

254 [London from Hampstead Heath?].
Peint et Lithogré par F. Nash/ Imp. Lith. de F. Noël. *Giraldon Bovinet, Passage Vivienne No. 26, Paris & 54 Frith Street, Soho Square.* [c. 1830?]. Lith., 140 × 205 (SCL).

255 London from Hampstead Heath.
[c. 1810?]. Copper-engr., 25 × 50 (SCL). An almanac illustration for the month of February, but exact year unknown.

256 The Heath, Hampstead.
Wood-engr., 100 × 110 (*Pictorial World*, 9 Sept. 1876, p. 28).

257 London, From The Hampstead Fields (1734). From Mr. W. J. Callcott's Scene In 'The Knights Of The Round Table', Performed At The Haymarket Theatre.

[*Musical Bouquet Office, 192 High Holborn, & J. Allen 20 Warwick Lane, Paternoster Row.* c. 1860?]. Top: Musical Bouquet. Wood-engr., 130 × 180 (SCL). Music sheet illustration.

258  Hampstead (bottom right of image area). [London from Hampstead] /Monk (within image area, below). Etching, 105 × 260 (Monk, *Hampstead Etchings*, 1900, unnumbered).

259  A View of Hampstead Heath (above the image). J. Lens delin/J. Couse Sculp. *C. Dicey & Co., in Aldermary Church Yard*. [c. 1760?]. Bottom right: No. 136. Copper-engr., 200 × 320 (SCL).

260  View Near Hampstead Heath. Drawn & Etched by T. Webb/. [c. 1820?]. Etching, 185 × 290 (SCL).

261  Hampstead Heath – Middx. Drawn by I. Hassell/Aquatd D. Havell. *I. Hassell, 1 May 1818*. Aquatint, 60 × 85 (Hassell, *Picturesque Rides and Walks*, 1817–18, ii, opp. p. 250).

262  Hampstead Heath. [c. 1842]. Lith., 95 × 135 (SCL).

263  The Fleet. – Sketched Near Hampstead. E. Evans Sc/ (within image area, below). Wood-engr., 180 × 110 (*Illus. London News*, 21 Jan. 1854, p. 49).

264  [Hampstead Heath. John Mallows Youngman]. Etching, 250 × 200 (*English Etchings*, 1881–91, Part 66, p. 36).

265  On Hampstead Heath looking towards Islington. T. Hastings/ (within foreground rock in image). /T. H. 1825. Bottom left: 10. Etching, 70 × 110 (Hastings, *Etchings Hampstead Heath*, [1822–26], Pl. 10, top).

266  Near Squires Mount Hampstead Heath 1826. /Painted & Etched by T. Hastings. Bottom left: 20. Etching, 75 × 95 (Hastings, *Etchings Hampstead Heath*, [1822–26], Pl. 20, top).

267  On Hampstead Heath near the Well Walk. T. Hastings 1826/. Bottom right: 16. Etching, 105 × 145 (Hastings, *Etchings Hampstead Heath*, [1822–26], Pl. 16, out of sequence).

268  Near Pond Street, Hampstead Heath. T. Hastings/1828. Etching, 75 × 140 (SCL).

269  Between Well Walk & Pond St. Hampstead. T. H$^s$ [T. Hastings] 1825/. Bottom right: 8. Etching, 75 × 90 (Hastings, *Etchings Hampstead Heath*, [1822–26], Pl. 8, top).

270  Near the Well Walk Hampstead. T. Hastings/1828. Etching, 75 × 95 (SCL).

271  The Viaduct, Hampstead Heath. [c. 1890?]. Wood-engr., 115 × 145 (SCL).

272  Water lilies (bottom right corner of image). S. Sharpe 1878/ (within image area, below). Etching, 175 × 240 (SCL).

273  [Meeting of Asses on Hampstead Heath]. Lith., 120 × 165 (BM). Caption below the print reads: ' '"A chiel's amang you takin' notes" – R.A. said the present meeting was a special meeting – called by many respectable asses for the purpose of securing for asses a locality for the cultivation of assinery near the metropolis for ever. The meeting had nothing to do with the question of the health and enjoyment of the public but the object it had in view, was, that Hampstead Heath should be secured to asses as it always had been. See Kentish Mercury Aug. 30th 1853.'

274  Suburban Puzzles. No. 1. The Hampstead Heath Puzzle. To find Out Where To Ride Safely, – The So-Called 'Ride' Having Been Strewn, With What Americans Would Call 'Small Rocks'. /Courbould July 1883 (within image area, below). Wood-engr., 110 × 165 (*Punch*, 28 July 1883, p. 45).

275  The Londoner's Holiday – Hampstead Heath. E. Buckman/ (within image area, below). Wood-engr., 300 × 500 (*Graphic*, 9 Sept. 1871, p. 252–53).

276  Summer Days. – No. 4. (left edge). Hampstead Heath (right edge). Swain Sc/Mc (both within image area).

Wood-engr., 165 × 225 (*Town Talk*, 4 July 1859, p. 121).

277   Hampstead Heath (above the image).
/T. Packer (within image area, below).
[c. 1865]. Chromolith., 295 × 215 (SCL).
Music sheet cover 'Comic Quadrille, On Popular Airs, by Burckhardt.'

278   The Start.
Painted by Henning/Lith. J. W. Giles.
[c. 1850]. Lith., 275 × 380 (SCL).

279   Hampstead Is The Place To Ruralise (above the image).
/R. J. Hamerton (within image area, below). *H. D'Alcorn, 8 Rathbone Place, Oxford St. W.* [c. 1863]. Chromolith., 280 × 230 (SCL). Music sheet cover to song of that title by Watkin Williams.

280   A Midnight Pic-Nic.
Steel-engr., 95 × 180 (Mayhew, *Paved with Gold*, 1857–58, Part v, opp. p. 146).

281   ''Phil'' tries a new walk in Life.
Steel-engr., 95 × 165 (Mayhew, *Paved with Gold*, 1857–58, Part iv, opp. p. 128).

282   Hampstead Heath.
N. E. Green Del. Et Lith/Day & Son, Lithrs To The Queen. *J. Barnard, 339 Oxford St, 1854.* Tinted lith., 305 × 445 (SCL).

283   Hampstead Heath.
Engraved by/Butterworth and Heath.
Wood-engr., 120 × 180 (*Art Journal*, 1 April 1859, p. 105).

284   Hampstead-Heath.
S. Read/M. Jackson Sc. (both within image area, below). Wood-engr., 235 × 345 (*Illus. London News*, 26 July 1856, p. 107).

285   Hampstead: Building The Bonfire On The Heath.
Wood-engr., 120 × 80 (*Illus. London News*, 4 April 1863, p. 393).

286   The Triumphal Arch. Erected on Hampstead Heath in honor of their Majesties' visit on the 23rd July 1835. (Below is a dedication to the Committee by Wm. Thwaites).
/W. T. [Wm. Thwaits] Fecit 1835/ (within image area, below). Copper-engr.,

225 × 200 (SCL). According to Barratt, *Annals of Hampstead*, 1912, ii, p. 263 the arch was situated at the entrance to the Heath opposite Whitestone Pond.

287   Field-Day And Sham Fight Of Volunteers On Hampstead Heath.
/Smyth (within image area, below). Wood-engr., 160 × 235 (*Illus. London News*, 11 Aug. 1860, p. 131).

288   Inspection Of The East Middlesex Militia, Well-Walk, Hampstead.
/E. Evans Sc. (within image area, below). Wood-engr., 165 × 235 (*Illus. London News*, 20 Jan. 1855, p. 49).

289   Richard Wilson's favorite Oak which formerly stood on Hampstead Heath.
T. H. [T. Hastings] 1825/. Bottom right: 15. Etching, 145 × 100 (Hastings, *Etchings Hampstead Heath*, [1822–26], Pl. 15).

290   Wilson's Oak near Hampstead.
J. Powell fecit/. *J. Dickinson, No. 114 New Bond Street; for J. Powell, No. 14 Allsop's Buildings, New Road, Marylebone, March 27th 1821.* Lith., 185 × 140 (Powell, *Progressive Lessons in Drawing*, [1821], unnumbered).

291   From Hampstead Heath.
T. Hastings – 1821/. Soft ground etching, 285 × 215 (SCL).

292   Willow near Hampstead.
/Harriot Gouldsmith. *R. Ackermann, 101 Strand, 1823.* Soft ground etching, 260 × 185 (P). One of three unnumbered Hampstead prints from a collection of six studies of trees by Harriet Gouldsmith which were published by R. Ackermann. The other Hampstead prints are nos. 293–4. The remaining plates in the series are: Weeping Willow, Lopped Elm and Oak in Hyde Park.

a   No imprint (SCL).

293   Fir near Hampstead.
/Harriot Gouldsmith. *R. Ackermann, 101 Strand, April 1823.* Soft ground etching, 260 × 185 (P). See note to no. 292.

a   No imprint (SCL).

294 Ash. near Hampstead.
/Harriot Gouldsmith. *R. Ackermann, 101 Strand, 1823.* Soft ground etching, 260 × 180 (P). See note to no. 292.

a No imprint (SCL).

295 Spanish Chestnut.
/G. C. [G. Childs] (within image area, below). Drawn & Lith. G. Childs, 12 Amwall St, Pentonville/J. Graf, Printer to her Majesty. *Robert Tyas, 50 Cheapside, March 1st 1839.* Top right: 14. Lith., 320 × 225 (Childs, *Woodland Sketches*, 1839, Pl. 14, opp. p. 27). Uncertain that this view is of Hampstead.

296 [Hampstead Heath?].
/Russells Tint From Nature. [c. 1870?]. Etching, 210 × 300 (SCL). Technically a most interesting print, made from an intaglio plate with a variable ground very similar in effect to aquatint. However, the ground is so regular that it implies the photomechanical transference of a chalk drawing to the plate with the use of a screen. Russell's process does not feature in Wakeman, *Victorian Book Illustration*, where the various attempts at photomechanical plate-making are described (pp. 119–45).

297 [Hampstead Heath].
[c. 1800?]. Aquatint, 195 × 235 (SCL).

298 The Heath.
R. Paterson Sc/artist's monogram based on the letter H (all within image area, below). [c. 1880?]. Etching, 175 × 150 (SCL).

299 [Hampstead Heath.
H.B. Ker. 1812]. Etching, 115 × 185 (SCL). MS inscription on verso of print examined provided title, artist and date.

300 On Hampstead Heath (near Highgate Road).
/J. S. Whitty (within image area, below). [c. 1868]. Lith., 110 × 195 (P). Ikin, *Hampstead Heath*, 1978, p. 15: 'The trees on the left mark the old boundary of the Elms Estate. Through them can be seen Christ Church spire. Those in the distance are in the garden of Heath House by Jack Straw's Castle. The track in the left foreground is the old road from Spaniards Inn to Vale of Health, now overgrown.'

301 Near Hampstead.
Dillon Delint/M. Jones Fecit. *John Harris, Sweetings Alley, Cornhill, 1st Jany 1782.* Top right: No. 4. Aquatint, 170 × 220 (*Four Views in Middlesex*, 1782, Pl. 4).

302 [Cottage and Pond Scene].
T. Stowers delt/S. Alken fecit. *S. Alken, 2 Francis Street, Bedford Square, Oct. 22, 1796.* Aquatint, 165 × 225 (Stowers, *Six Views in Hampstead*, [1796], unnumbered).

303 A View At North End.
/Aquatinta by F. Jukes. *J. Walker, No. 148 Strand, Jany 1st 1783.* Top right: No. 14. Aquatint, 160 × 200 (SCL).

a Later imprint: *T. Simpson, St Pauls Church Yard & John P. Thompson, Gt Newport Stt, July 1, 1794.* (GuP).

304 Cottage near Hampstead.
[c. 1790?]. Aquatint, 160 × 215 (BM).

305 At Hampstead.
[c. 1800?]. Aquatint, 55 × 75 (SCL).

306 Hampstead, Middlesex.
/Drawn & Engrav'd by J. Greig/. *Vernor & Hood, Poultry; J. Storer & J. Greig, Chapel Street, Pentonville, June 1st. 1805.* Copper-engr., 135 × 195 (*Select Views of London*, 1804–5, ii, unnumbered).

a Artist statement removed. *J. Robins & Co., Albion Press, Ivy Lane.* Top right: Plate 43. (Dugdale, *New British Traveller*, 1819, iii, opp. p. 489, Pl. 43).

307 From a Picture in the possession of E. Magrath, Esq.
Painted by W. Collins R.A./Engraved by H. Cullen. [c. 1852]. Steel-engr., 150 × 215 (SCL). MS inscription on impression examined suggests that this is a private plate and reads 'Hampstead Heath 12 July 1852'.

308 Hampstead (bottom right of image area).
/Studies From Nature, By J. Petitfourt. No. 2/. [c. 1860?]. Lith., 190 × 390 (SCL).

309 At Hampstead.
N. E. Green/. [c. 1850?]. Lith., 130 × 220 (SCL).

310 [Hampstead (in pencil on copy inspected].
1881 (possibly visible within image area,
bottom left). Etching, 140 × 215 (SCL).

311 [Little Nell and Her Grandfather Resting].
/Landells Sc/ (within image area, below)
Wood-engr., 90 × 115 (Dickens, *Master
Humphrey's Clock*, 1840 [1841], i, p. 172;
*Old Curiosity Shop*, 1841, p. 172).

312 Christ Church, Hampstead.
Rock & Co., London, No. 2231/2 Nov.
1860. Steel-engr., 60 × 100 (SCL).

313 Christ Church, Hampstead.
Wood-engr., 115 × 150 (*Illus. London
News*, 14 Jan. 1860, p. 36).

314 Christ Church, Hampstead.
/A. Berry Sc. (within image area, below).
[c. 1885?]. Wood-engr., 140 × 105 (SCL).

315 Christ Church Steps Hampstead.
Etching, 175 × 130 (*Old Hampstead*,
[c. 1900?], unnumbered).

316 Proposed Alterations And Additions To St
Johns Parish Church, Hampstead.
/C. F. Kell Lith., 8 Castle St, Holborn,
E. C./. [c. 1874]. Lith., 195 × 180 (SCL).
The published plan and perspective view
circulated by The Trustees which resulted
in the campaign to preserve the
eighteenth-century tower.

317 Unitarian Chapel, Hampstead.
J. Johnson Archt, 9 John St, Adelphi/J. R.
Jobbins. [c. 1862]. Lith., transferred from
steel, 85 × 155 (SCL).

318 Rosslyn-Hill Chapel, Pilgrim-Lane,
Hampstead (above the image).
Wood-engr., 85 × 75 (*Illus. London News*,
14 June 1862, p. 616). The building had
recently been completed.

319 [Rosslyn Hill Chapel].
Wood-engr., 65 × 85 (Sadler & Martineau,
*Sermons Delivered*, 1862, title page).

320 Parochial National Schools Hampstead.
/Day & Son, Lithrs to the Queen W. G. &
E. Habershon Architects, 38 Bloomsbury
Square. [c. 1855]. Lith., 190 × 280 (SCL).

321 Proposed Dispensary And Soup Kitchen,
New End, Hampstead (above the image).
/R. Hesketh Archt/. Lith., 125 × 140 (SCL).
Published appeal plan of 25 March 1852.

322 New Fire Brigade Station, Hampstead. –
Mr. G. Vulliamy, Architect.
B.W/A.D. 1874 (details on building
immediately above first floor windows).
Wood-engr., 180 × 115 (SCL).

323 Holly Hill Hampstead (bottom right of
image area).
EMB [Esther M. Bakewell]/ (within image
area). *Catty & Dobson* (within image area,
bottom right). [c. 1890?]. Etching,
215 × 140 (SCL). See note to no. 138.

324 [Hollybush Hill].
/S. Sharpe 1881 (within image area,
below). Etching, 160 × 120 (SCL).

325 [Flask Walk].
/1901 Monk (name bisects the date within
the image area, below). Etching, 245 × 170
(SCL).

326 C. Franklin, Wine and Spirit Merchant,
Bird-In-Hand, High Street Hampstead,
(Between Hamilton And Woodward's
Coach Offices).
[c. 1835]. Wood-engr., 75 × 115 (SCL). A
billhead of the 1830s with the first three
digits of the year provided (i.e., 183–) on
the copy examined.

327 Joseph Lane, M.P.S., 29 High Street
Hampstead.
Anderson/ (within image area, below).
[c. 1860?]. Wood-engr., 125 × 80 (SCL).

328 Hampstead Brewery Estabd. 1720. Harris
& Co. Wine Merchants Brewers & Bottlers
High St. Hampstead.
Lith., 115 × 65 (SCL). Trade card, with the
date 23 April 1872.

329 The Soldiers' Infant Home, Roslyn-Park,
Hampstead.
Wood-engr., 120 × 155 (*Illus. London
News*, 26 Jan. 1855, p. 97).

330 The Soldiers' Daughters' Home,
Hampstead.
Wood-engr., 235 × 345 (*Illus. London
News*, 19 June 1858, p. 600). Made up of
three wood blocks. It is possible to detect
the two white joint lines running up the
image.

331 Soldiers' Daughters' Home, Hampstead.
[c. 1858]. Wood-engr., 90 × 155 (SCL). The

page heading 'Fine Arts Catalogue Advertiser' appears over the image of the copy in the BM collection.

332 The Soldiers' Daughters' School And Home, Hampstead. – William Munt, Esq., 25, Bloomsbury-Square, Architect. /O. Jewitt Sc. [c. 1858]. Wood-engr., 165 × 235 (SCL).

333 Soldiers' Daughters Home and School, Hampstead (along left of image). R.H./W.E. Hodgkin Sc. (both within image area, below). [c. 1858]. Wood-engr., 85 × 150 (SCL).

334 The Sailors' Daughters' Home At Hampstead, Opened By Prince Arthur Yesterday Week. Wood-engr., 100 × 155 (*Illus. London News*, 24 July 1869, p. 96).

335 School And Home, At Hampstead, For The Orphan Daughters Of Sailors In The Royal Navy. [c. 1869]. Wood-engr., 170 × 230 (SCL).

336 (New Building Of The Sailors' Daughters' Home, Hampstead.). [c. 1869]. Wood-engr., 110 × 185 (P).

337 [The Sailors' Daughters' Home at Hampstead]. [c. 1870?]. Wood-engr., 65 × 100 (SCL).

338 "The Logs", Hampstead. – Mr. J. S. Nightingale, Architect. B. Sly Del/W. E. Hodgkin (both within image area, below). Wood-engr., 170 × 270 (*Builder*, 28 Nov. 1868, p. 877).

339 The North London Consumption Hospital At Hampstead. F.W./H.I.P. (both within image area, below). [c. 1880]. Wood-engr., 90 × 115 (SCL).

340 North London Hospital For Consumption, Hampstead, – Messrs Roger Smith, Son & Gale, Architects. A. Howard delt (within image area)/ Photo-Litho., Sprague & Co., 4 & 5 East Harding Street, Fetter Lane. E. C. [c. 1880]. Photo-lith., 180 × 285 (SCL).

341 Bellsize House (on ribbon in sky). [c. 1721]. Copper-engr., 160 × 200 (SCL).

The date suggested by Wroth in *London Pleasure Gardens*, 1896, for this illustration advertising Belsize House. Wroth also lists a view by J. Maurer of Belsize House which I have been unable to trace.

342 Bellsize House (on ribbon in sky). 2404. – Belsize House. Wood-engr., 70 × 95 (*Old England*, 1845, ii, p. 324, Illus. 2404). Derived from no. 341.

343 Bellsize House (on ribbon in sky). Old Belsize House, Hampstead – From A Print Of The Time. Wood-engr., 125 × 155 (*Illus. London News*, 9 Sept. 1854, p. 239). The newspaper's report of the demolition of old Belsize House was illustrated by this copy of the eighteenth-century view (no. 341).

344 Old Belsize House. (From a Print in the possession of J. E. Gardner, Esq.) /O. Jewitt (bottom right of image area). Wood-engr., 75 × 90 (Howitt, *Northern Heights of London*, 1869, p. 10). An undisguised copy of no. 341.

345 Bellsize House. Hampstead 1750. [c. 1860?] Etching, 160 × 240 (SCL).

346 Bellsize House. From an Old Print. Wood-engr., 80 × 120 (*Builder*, 11 Dec. 1875, p. 1104). Copy of no. 345.

347 Belsize House, Hampstead. Wood-engr., 95 × 160 (*Pictorial Times*, 12 April 1845, p. 236).

348 Haverstock Hill. Drawn by R. Freebairn/Engraved by John Peltro. *John Sharpe, Piccadilly, Jany 1, 1805*. Bottom centre: Vol. 1. Page 85. Copper-engr., 45 × 85 (SCL).

349 The Cottage formerly Sir Richd. Steele's, Haverstock Hill. Copper-engr., 95 × 120 (Park, *Topography of Hampstead*, 1818, opp. p. 309).

a Title unaltered, plate markings added. Top right: Gent. Mag. Jan 1824 Pl. II. p. 17. (*Gent. Mag.*, Jan. 1824, opp. p. 17).

350 Haverstock Hill. Misty Morning. /G. Harley del/. *Rowney & Forster, 51*

*Rathbone Place, Septr 7, 1818.* Aquatint, 155 × 215 (BM).

i Sir Richard Steele's House, Haverstock Hill.
/WP (within image area, below). Wood-engr., 145 × 210 (Walford, *Old & New London*, [1873–78], v, p. 295).

351   Sir Richard Steele's Cottage At Haverstock Hill.
Wood-engr., 65 × 95 (*Monthly Mag.*, 1 Jan. 1824, p. 481).

a Sir Richard Steele's Cottage at Haverstock Hill (above the image). (SCL). Below the image appears a brief history of the building.

352   (Sir Richard Steele's Cottage, at Haverstock Hill.)
Wood-engr., 60 × 75 (*Mirror*, 15 July 1837, p. 40). The accompanying article suggests that this view is from a drawing by Samuel Ireland. A copy of no. 351.

353   Formerly The Residence Of Sir Richard Steel, Haverstock Hill, Hampstead Middlesex.
*J. Tallis, London.* Steel-engr., 85 × 130 (Dugdale, *Curiosities of Great Britain*, [1838–43], x, unnumbered).

354   Sir Richard Steele's Cottage, Haverstock Hill, where many of the Papers for the Spectator were written.
Rock & Co., London/. [c. 1848?]. Steel-engr., 60 × 90 (SCL).

355   Steele's Cottage, Hampstead Heath. (From a Print in Mr. Gardner's Collection.)
/O. Jewitt Sc. (within image area, below). Wood-engr., 50 × 85 (Howitt, *Northern Heights of London*, 1869, p. 214). Copied from no. 354.

356   Sr. R. Steele's Cottage, & Primrose Hill.
[c. 1820?]. Copper-engr., 25 × 50 (SCL). From an unidentified almanac.

357   Cottage, Haverstock Hill, near Hampstead, the Residence of Sir Richard Steele.
/From a Drawing taken 1804. *Chas John Smith Engraver, London, 1836.* Lith., 90 × 135 (Smith, *Historical & Literary Curiosities*, 1840, part ii, Pl. 24). A view of the rear of the house.

358   (The Country Residence Of Sir Richard Steele).
/E. Whimper Sc. (within image area, below). [c. 1850]. Wood-engr., 100 × 110 (SCL).

359   Steele's Cottage Haverstock Hill.
W. B. Rye/1853. Bottom right: Pl. 42. Vol. 5. Etching, 105 × 155 (Antiquarian Etching Club, *Publications*, 1854, v, Pl. 42).

a No markings. (Rye, *Etchings*, [1857], unnumbered).

i Sir Richard Steele's House At Haverstock Hill.
/Kemp. Wood-engr., 100 × 150 (*Kemp's West London Sketcher*, 16 July 1889, p. 173).

360   Sir Richard Steele's House, Haverstock Hill.
Wood-engr., 60 × 95 (*Illls. London News*, 24 July 1858, p. 74).

a Steele's House, Haverstock Hill. (*Illus. Penny Almanack for 1860*).

361   Steele's Cottage
J. Brown/Landells. [c. 1855?]. Wood-engr., 65 × 105 (SCL))

362   Sir Richard Steele's Cottage On Haverstock-Hill, Now In Course Of Demolition.
Wood-engr., 125 × 150 (*Illus. Times*, 18 May 1867, p. 308).

363   Sir Richard Steeee's Cottage, Haverstock-Hill, In Course Of Demolition.
Wood-engr., 170 × 235 (*Illus. London News*, 11 May 1867, p. 456). Bottom right of image indecipherable monogram of the engraver.

364   Sir Richd. Steele's Cottage, Hampstead Road.
John Constable R.A./David Lucas. The engraver, 27 Westbourne Street, Pimlico, 1845. Mezzotint, 135 × 185 (SCL). *Camden History Review*, i, p. 23: 'The original picture, exhibited at the Royal Academy in 1832, has been lost but Constable painted . . . [a] . . . small replica, probably intended for David Lucas to use when preparing his mezzotint. This painting is

now in the Mellon Collection'. Wedmore 25; Shirley 48.

a No imprint. Top right: 30. (Constable, *English Landscape Scenery*, Bohn 1855, Pl. 30).

b No imprint or plate number (GLC).

365 Steels Cottage Haverstock Hill.
Drawn by W. Westall A.R.A./Engraved by E. Finden. [*Charles Tilt, 86 Fleet Street, 1829*]. Steel-engr., 85 × 145 (Moule, *Great Britain Illustrated*, 1830, opp. p. 71, top).

a Different imprint. *No. 358 - J & F. Harwood, London.* [c. 1840]. (SCL).

366 Steele's Cottage, Haverstock Hill.
J. Harwood, 26 Fenchurch Street/No. 358. [c. 1850]. Steel-engr., 100 × 150 (SCL). A copy of no. 365 with alterations to the figures and buildings on the right.

367 The Hampstead Host.
Copper-engr., 85 × 130 (SCL). According to Barratt, *Annals of Hampstead, 1912,* vol. ii, p. 70 from the *Wits Magazine*, 1806.

368 Steele's Road, N. W. Post Office, Telegraph And Money Order Office And Savings Bank (above the image). Norman Neame, Teas Coffees & Colonial Produce. 81, Haverstock Hill, Steele's Road, London, N.W.
C. Robinson & Co. London/. [c. 1860?]. Lith., transferred from steel, 155 × 160 (SCL).

369 A View of Hampstead Road near Tom King's House.
/J. B. Chatelain Fecit. *May 2d. 1750.* Copper-engr., 105 × 160 (SCL).

370 A View of Hampstead Road near Tomkins's House.
/Chas White Sct. Top right: No. 6. Copper-engr., 100 × 155 (*Six Views of the Thames*, 1794, Pl. 6). A copy of no. 369 with a carriage included in the left foreground instead of the single figure.

371 View From "Moll King's House", Hampstead, in 1760.
/WP (within image area, below). Wood-engr., 140 × 210 (Walford, *Old & New London*, [1873–78], v, p. 487).

Thematically derived from no. 369 but with a number of alterations.

372 Cottage, near Pancras.
*John P. Thompson, Gt Newport Street.* [c. 1790]. Aquatint, 140 × 185 (SCL).

373 Haverstock Park.
F. Sexton/L'Enfant Lith., 12 Rathbone Pl. *Williams & Co., 141 Strand.* [c. 1855]. Top: Modern Cottages & Villa Architecture No. 10. Lith., 150 × 305 (SCL).

374 Majr. Cartwrights, Haverstock Hill.
[c. 1810?]. Copper-engr., 25 × 50 (BM). From an unidentified almanac.

375 A Representation of the March of the Guards towards Scotland, in the Year 1745. To His Majesty the King of Prussia, an Encourager of Arts and Sciences! Painted by Willm Hogarth/Engrav'd by Luke Sullivan. *Dec. 30, 1750.* Copper-engr., 410 × 540 (BM). A more detailed account of the complicated sequence of states and copies of this engraving will be contained in the *Images* volume which will cover the Tottenham Court Road. Details of the many states are provided in *B. M. Satires*, nos. 2639–2654 and Paulson, *Hogarth's Gaphic Works*, 1965, no. 237. The painting of this subject was given to the Foundling Hospital.

376 The Horrible Murder Of Mr. De La Rue At West Hampstead (above the image). Wood-engr., 145 × 325 (*Lloyds Penny Sunday Times*, 16 March 1845).

377 New Church On The Challcotts Estate, Haverstock Hill, Hampstead.
E. T. Dolby lith/H. E. Kendall Junr F.S.A. and W. Webbe Archts/Day & Son Lithrs to the Queen. [c. 1848]. Lith., 135 × 195 (P).

378 Saint Saviour's New Church Chalcots Estate, Haverstock Hill, Hampstead Rd.
W. L. Walton Lith/Day & Son, Lithrs to the Queen. *H. E. Kendall Junr Archt F.S.A., 33 Brunswick-Square.* Tinted lith., 435 × 615 (GuP). *Lady's Newspaper*, 20 May 1848, p. 398: 'The large lithograph is for sale, and is a private undertaking: it forms a splendid picture, and the surplus

profits from the sale thereof are to be given to the funds of the permanent church. Price 10s 6d. plain, and 21s. coloured.' Kendall exhibited a drawing of the subject at the Royal Academy in 1848.

i St. Saviour's Church, Haverstock-Hill. Wood-engr., 130 × 180 (*Lady's Newspaper*, 20 May 1848, p. 398). According to the article below: 'the annexed woodcut is a just representation taken from a large lithograph . . . by W. L. Walton, after a design the joint production of H. E. Kendal [sic], jun. F.S.A., and William Webbe, Esq., architects.'

379  St Saviour's.
Within the image area below are two indecipherable artists' monograms.
[c. 1856?]. Wood-engr., 115 × 100 (SCL).

380  New Church Of St. Saviour, Haverstock-Hill, Consecrated On Monday Last. – The Chancel.
Wood-engr., 150 × 115 (*Illus. London New*, 12 July 1856, p. 36).

381  St. Stephen, the Martyr, Avenue Road, Portland Town.
G. Hawkins lith/S. W. Daukes & J. R. Hamilton Archrs/Day & Haghe Lithrs to the Queen. [c. 1869]. Tinted lith., 350 × 470 (GLC).

382  St. Paul's Church, Hampstead.
/S.S. Teulon Architect/Day & Son Lithrs to The Queen [c. 1859]. Tinted lith., 215 × 175 (SCL).

383  St. Stephen's, Hampstead.
S. S. Teulon Archt/Day & Son Limited Lith. [c. 1869]. Tinted lith., 300 × 240 (SCL).

384  St. Stephen's Church, Hampstead. - Mr S. S. Teulon, Architect.
Wood-engr., 260 × 175 (*Builder*, 4 Sept. 1869, p. 707).

385  St. Stephen's Church. Hampstead.
Wood-engr., 150 × 90 (*Church Builder*, July 1872, p. 245). Central details taken from no. 383.

386  Church of S. Stephen, Hampstead. S. S. Teulon Architect, 1869.
Wood-engr., 175 × 125 (SCL). Copied from no. 383.

387  St. Stephens, Hampstead.
Sheather & Co., London/. [c. 1870?]. Lith., transferred from steel, 175 × 180 (SCL). Copied from no. 383.

388  St. Stephen's Church.
[c. 1880?]. Wood-engr., 55 × 55 (SCL).

389  New Convent, School, And Orphanage, Bartrams, South Hampstead. – Mr. C. G. Wray, Architect.
/Walmsley (within image area, below). [c. 1888]. Wood-engr., 170 × 270 (SCL).

390  Haverstock Hill Chapel.
F. Bedford lith/Barry & Brown Architects, Liverpool/Day & Son Lithrs to the Queen. [c. 1848]. Tinted lith., 205 × 275 (SCL).

391  Haverstock Chapel, Haverstock Hill.
[c. 1848]. Lith., 85 × 155 (SCL).

392  The New Congregational Chapel, Haverstock Hill, Hampstead Road (above the image).
/Barry & Brown Architects/(within image area, below). [c. 1848]. Wood-engr., 100 × 150 (SCL). Copied from no. 390.

393  Orphan Working School The New Building about to be erected at Haverstock Hill.
Alfred Ainger Architect/Day & Haghe, Lithrs to the Queen. [c. 1846]. Lith., 150 × 225 (SCL).

a Orphan Working School, Haverstock Hill. Instituted 1758. Removing from the City Road.
(*Orphanhood*, [c. 1847], after p. xxi).

i The Orphan Working School, Haverstock Hill.
Possibly an indecipherable signature in the bottom right hand corner of the image. Wood-engr., 115 × 180 (*Lady's Newspaper*, 8 May 1847, p. 438).

ii The New Asylum Of The Orphan Working School, Haverstock Hill.
Wood-engr., 115 × 225 (*Illus. Historic Times*, 1 Feb. 1850, p. 80). Figures slightly altered.

394  Elevation Of The New Building Now Being Erected At Haverstock Hill, Hampstead Road. Removing From The City Road.

Wood-engr., 85 × 130 (*Brief Notices of the Orphan Working School*, 1846, frontis). A copy of no. 393.

395 [Orphan Working School].
Tinted lith., 35 × 75 (*Orphanhood* [c. 1847], title page). A copy of no. 393 but with no figures entering the building.

396 The Orphan Working School, Haverstock Hill.
/H. Adlard. Steel-engr., 55 × 135 (*London Almanack For 1848*).

397 The Orphan Working School, Haverstock Hill, Instituted 1758 (above the image) Removed From The City Road, 1847.
/Ashley Glyphography/ (within image area, below). Glyphograph, 85 × 125 (*Orphan Working School*, 1848, cover illus). A glyphograph was printed in exactly the same way as a wood-engraving, but the block was created by a different process in metal.

a Title reduced to: The Orphan Working School. (SCL).

398 Orphan Working School, London.
[c. 1850]. Wood-engr., 70 × 80 (SCL).

399 The Orphan Working School. Haverstock Hill, Hampstead.
Steel-engr., 95 × 125 (Gaspey, *Tallis's Illustrated London*, [1851–52], ii, opp. p. 264).

400 The Orphan Working School, Maitland Park, Haverstock Hill.
Wood-engr., 110 × 155 (*Illus. News of the World*, 6 March 1858, p. 77).

401 Orphan Working School, (above the image) Maitland Park, Haverstock Hill, Near Hampstead.
/John Ashdown Architect, 42 Charing Cross, S. W./G. A. Ferrier Sc. (both within image area, below). *Yates And Alexander Printers, Symonds Inn, And 7,8,9, Church Passage, Chancery Lane*. [c. 1860]. Wood-engr., 100 × 185 (SCL).

a Altered title and artist statement. No imprint: The Orphan Working School, Haverstock Hill.
/John Ashdown Archt, 42 Charing Cross, S. W./G. A. Ferrier Sc. (SCL).

402 Orphan Working School, Haverstock-Hill.
L. H. Michill/(faint indecipherable signature within image area, below).
Wood-engr., 135 × 235 (*Illus. London News*, 16 Nov. 1861, p. 490).

403 The Orphan Working School, Maitland Park, Haverstock Hill, N.W.
[c. 1865?]. Wood-engr., 55 × 90 (SCL).

404 Annual Examination Of Children At The Orphan Working School, Haverstock-Hill.
[c. 1866]. Wood-engr., 160 × 240 (SCL). From an unknown newspaper article.

405 The Children At Dinner In The Orphan Working School, Haverstock Hill.
HJ/H. Harral (within the image area, below) Wood-engr., 225 × 225 (*Graphic*, 9 July 1870, p. 45).

406 Tailors' Asylum, Haverstock Hill.
Wood-engr., 90 × 155 (*Illus. London News*, 19 Aug. 1843, p. 117). The building had been recently completed.

407 Tailors' Almshouses.
Wood-engr., 65 × 140 (*Pictorial Times*, 25 Nov. 1843, p. 212).

408 The Asylum, Haverstock Hill.
WSW Del/Mary Byfield Sc. (both within image area, below). [c. 1845]. Wood-engr., 100 × 195 (SCL).

a The Journeymen Tailors' Asylum.
WSW Del/Mary Byfield Sc, (both within image area, below) [c. 1850]. (SCL). The dogs in the foreground on the left have been removed.

b Benevolent Institution For Aged And Infirm Tailors, Haverstock Hill.
(*Illus. Historic Times*, 25 Jan. 1850, p. 61).

409 The Tailors' Benevolent Institution.
Wood-engr., 75 × 130 (*Penny Illustrated News*, 16 Feb. 1850, p. 129).

410 Schools Of The London Society, For Teaching The Blind To Read Avenue Road, R. P.
E. Dolby lith/H. E. Kendall Junr Archt/Day & Son lithrs to the Queen.
[c. 1848]. Lith., 120 × 190 (SCL).

411 London Society for Teaching the Blind, (above the image). Upper Avenue Road,

Hampstead, (Opposite the Swiss Cottage Station.)
[c. 1870]. Wood-engr., 55 × 95 (SCL).

412 New College, London.
/John T. Emmett, Archt/. Steel-engr., 100 × 155 (*New College London: Introductory Lectures*, 1851, frontis).

413 New College, London. – Mr. J. T. Emmett, Architect.
B. Sly/Laing Sc. (both within image area, below). Wood-engr., 165 × 265 (*Builder*, 13 Dec. 1851, p. 787).

414 The Swiss Cottage – Frank Redmond's.
[c. 1844]. Wood-engr., 90 × 150 (BM).

i The Swiss Cottage, Finchley Road. (House of Meetings for Germans in London.)
Wood-engr., 60 × 90 (Timbs, *Clubs and Club Life in London*, [1872], opp. p. 432, top).

415 The Swiss Cottage, Hampstead.
Wood-engr., 90 × 155 (*Pictorial Times*, 12 April 1845, p. 236).

416 [Panoramic Views of the Hills of Harrow, Primrose Hill and Hampstead].
Two aquatint plates, 100mm high, average width 450mm (Morris, *Panoramic View*, [1831]). Below the views are geographic locations which read from left to right on each plate as follows:
Harrow – Little Primrose Hill – Primrose Hill – Hampstead.

417 A View of Highgate and Hampstead, taken from Mary-le-bone-fields.
Chatelain Delint/J. Hulett Sculpt. *I. Ryall & R. Withy, at Hogarths Head in Fleet Street*. [c. 1760]. Copper-engr., 240 × 415 (MuL).

418– [Primrose Hill].
419 Horwood Delint/Spear Sculpt Star Alley, Fenchurch Street (foot of map below).
*Feby 17, 1794*. Copper-engr., 150 × 500 (P). Appears on some impressions of sheets A1 and B1 of the first edition (1792–1799) of Richard Horwood's Plan of the Cities of London, Westminster and the Borough of Southwark. Howgego no. 200.

420 View of Hampstead from Primrose Hill.
/Royce sc. Top: Engraved for Harrison's History of London. Copper-engr., 155 × 275 (Harrison, *New History of London*, 1775, opp. p. 664).

421 Primrose Hill In 1780.
/WP (within image area, below). Wood-engr., 105 × 145 (Walford, *Old & New London*, [1873–78], v, p. 288).

422 Pastimes Of Primrose Hill.
Drawn by Cruikshanks/Etchd by Barlow. *W. Locke, Septr 1st 1791*. Top: Attic Miscellany. Copper-engr., 155 × 195 (*Attic Miscellany*, 1789–92, ii, no. xxiv, opp. p. 409). Krumbhaar 877.

i View From Hampstead Hill.
Copper-engr., 155 × 110 (SCL). Central details of original version only.

ii Pastimes Of Primrose Hill.
Isaac Cruikshank/September, 1791. Wood-engr., 110 × 135 (Cruikshank, *Cruikshankian Momus*, 1892, opp. p. 12).

423 Distant View Of Hampstead. from the Banks of the Regents Canal.
G. Shepherd del/W. Angus sculp. *White, Cochrane & Co., Feb. 7, 1814*. Copper-engr., 115 × 195 (Park, *Topography of Hampstead*, 1814, frontis).

a Printed on silk. (SCL).

424 Hampstead & Primrose Hills, from the Duke of Bedfords Road.
Courbould del/Angus sculp. *Bellamy & Robarts, March 1, 1791*. Top: General Magazine & Impartial Review. Copper-engr., 95 × 160 (*General Magazine*, 1791, opp. p. 26).

a No artist statement and different imprint. *Alexr Hogg, No. 16 Paternoster Row, Feb. 13, 1796*. (BM).

425 Part Of London From Primrose Hill.
[c. 1810?]. Copper-engr., 60 × 115 (SCL).

a London, from Primrose Hill.
(W., *Visit to London*, 1813, frontis).

426 Regent's Park &c. From Primrose Hill.
Drawn by W. Westall A.R.A./Engraved by Chas. Heath. *Hurst, Robinson & Co., 1825*. Steel-engr., 75 × 120 (Heath, *Views of London*, [1825], unnumbered).

427 London View Of Regent's Park.
/Drawn by W. Westall A.R.A./. [c. 1830?]
Lith., 230 × 335 (ML).

428 Chalk Farm (above image).
[c. 1790?]. Copper-engr., 140 × 200 (SCL).
Rather a fanciful view.

429 [Old Chalk Farm].
[c. 1790?]. Copper-engr., 100 × 230 (SCL).

430 South View Of Old Chalk Farm, Allowed
By Tradition To Have Been A Country
Residence Of Ben Jonson.
[c. 1810?]. Etching, 105 × 165 (SCL).

431 Chalk Farm Tea Garden (faintly visible
over gateway, in centre of image).
[c. 1810?]. Copper-engr., 95 × 125 (GuP).

432 Old Chalk Farm. (From a Print in Mr.
Gardner's Collection.)
/O. Jewitt sc. (within image area below).
Wood-engr., 60 × 90 (Howitt, *Northern
Heights of London*, 1869, p. 227).

433 Old Chalk Farm In 1730.
J. Green [or Greenaway] (within image
area, below). Wood-engr., 105 × 145
(Walford, *Old & New London*, [1873–78],
v, p. 289).

434 Chalk Farm.
[Drawn by T. H. Shepherd/Engraved by J.
Shury]. Steel-engr., 55 × 100 (Partington,
*National History and Views of London*,
1834, ii, opp. p. 181, middle).

435 [Chalk Farm Tavern].
[c. 1840?]. Copper-engr., 25 × 35 (P).

436 Chalk Farm, Primrose Hill, Middlesex.
Steel-engr., 75 × 120 (Dugdale, *Curiosities
of Great Britain*, [1838–43], i,
unnumbered).

a Bottom centre: Drawn & Engraved for
Dugdales England & Wales Delineated.
(Dugdale, *Curiosities of Great Britain*,
[1838–43], ix, unnumbered).

437 Chalk Farm.
Top: Metropolitan Sketches. – No. vii.
Wood-engr., 105 × 160 (*Sporting Mag.*, 17
April 1847, p. 129).

438 Chalk Farm Tavern.
Wood-engr., 65 × 75 (*Illus. London News*,
3 Dec. 1853, p. 472).

439 Chalk Farm Tea Garden.
*Sold by D. Ash, 27 Fetter Lane, Fleet Street.*
[1820?]. Copper-engr., 135 × 170 (P).

a Different imprint: *D. Ash, 9 Red Lion
Ct, Watling St.* (GuP).

b Same title but lacks any imprint. (SCL).
For some reason the plate has been cut
back, reducing the height of the image
from 135mm to 105mm. There is a choice
of three likely reasons for the alteration to
the plate. Possibly the plate had become
damaged and the affected area was
eliminated. Alternatively a subsequent
publisher may have chosen to remove an
element of the print he considered dull.
Most likely it was reduced so that it could
be included in a periodical which for some
reason was unable to include the whole of
the original version.

440 Chalk Farm Tea Gardens MDXXX.
J.P.[?] 1842/. Etching, 80 × 115 (SCL). A
copy of no. 439.

441 Chalk Farm Tavern. – Back View.
Wood-engr., 60 × 75 (*Illus. London News*,
3 Dec. 1853, p. 472).

442 April 24. Sunday Afternoon Primrose
Tavern Chalk Farm.
/Percy Cruikshank delt (within image
area, below). /Percy Cruikshank del/.
Lith., 210 × 570 (Cruikshank, *Sunday
Scenes in London*, 1854, frontis).

443 The Trial Of Nerves (above the image).
/Design'd & Etch'd by D. T. Egerton/.
*Thos McLean, 26 Haymarket, 1824.* Top
right: Pl. 6. Aquatint, 160 × 225 (Egerton,
*Fashionable Bores*, 1824, Pl. 6). Caption
below the print reads: 'He who aspires to
become a man of Fashion must make up
his mind now and then to "exchange
cards", in fact these things under proper
management are highly desirable as they
insure you notoriety, but when you are
compelled to stand fire against one who
will not admit blank cartridge system &
who has arrived at the enviable distinction
of having "kill'd his man", the pleasure of
taking the field is apt to degenerate into a
nervous Bore as you consider yourself
mark'd for crow's meat, and in pacing

your ground you are only marching to your grave.

> And thus the native hue of resolution
> Is sicklied o're with the pale cast of thought.'

Recorded as a variant issue by Tooley, *English Books with Coloured Plates*, 1979, no. 204. I have not seen the version which was published by W. Sams.

444 Metropolitical Gunnery. Vide the Cockneid. [Drawn by Collings/Etchd by Barlow. *Bentley & Co., Oct. 1, 1790.* Top: Attic Miscellany. Copper-engr., 160 × 215 (*Attic Miscellany*, 1790, ii, frontis). *B.M. Satires*, no. 7756. Illustration to verses entitled 'The Cockneid'.

445 No Joke.
*At Artist's Depoy, 21 Charlotte St, Fit . . . [Fitzroy], . . . 1826.* Top right: Busbys Humorous Etchings N 56 [or 36?]. Copper-engr., 95 × 130 (BM). In the top left corner is a sign 'Chalk Farm' and inscribed on the plate below the anxious duellist on the right is 'Busby'.

446 By permission of the Patentees, this Engraving of The First Carriage, The "Ariel", is respectfully inscribed to the Directors of The Aeriel Transit Company, By Their Obedient Servants – Ackermann & Co.
*Ackermann & Co., 96 Strand, March 28th 1843.* Aquatint, 300 × 425 (GuP). A view towards St Paul's and on the right Regent's Park indicating that it is taken from Primrose Hill, or thereabouts. Sadly, in spite of the printmaker's optimistic representation of an apparently successful flight, the 'Ariel' never became airborne.

447 View of The Botanical & Ornamental Garden, to be formed on Primrose Hill. Designed by Wm. Bd. Clarke Archt, 9 Chapel Street, Bedford Row. Printed by C. Hullmandel/. *Priestly & Weale, High Holborn, 1st June 1832.* Lith., 240 × 340 (SCL). A copy of the Proposal for the Establishment of a Botanical and Ornamental Garden is in 'Public Gardens' scrapbook at the City of London Guildhall Library. Never built.

448 View of the Proposed Grand National Cemetery Intended for the Prevention of the Danger and Inconvenience of burying the Dead within the Metropolis; Proposed to be erected by a Capital of 400,000L. in 16,000 shares at 75L. each Designed By Francis Goodwin Esqe. Architect. Drawn on Stone by T. Allom/Printed by Engelmann, Graf, Coindet & Co. [c. 1830]. Lith., 310 × 620 (GuP). Never built.

449 [Proposed National Cemetery]. Wood-engr., 105 × 215 (*Literary Gazette*, 10 April 1830, p. 243). Never built.

450 [Proposed National Cemetery]. Wood-engr., 110 × 215 (*Literary Gazette*, 12 June 1830, p. 387). Never built.

451 Interior View Of The Cloister Surrounding the Centre Region of Tombs, In which will be erected The Parthenon, And several other Greek and Roman Temples. /Printed by Engelmann, G. [Graf], C. [Coindet] & Co. [c. 1830]. Lith., 220 × 155 (GuP). Never built.

452 Proposed Royal Champs Elysees (above the image).
Designed And Proposed By W. H. Twentyman Esq/ Lith. Waterlow & Sons, London. [c. 1854]. Lith., 105 × 170 (MuL). Bottom right illustration to a map indicating the location for the project. A scheme to link Regent's Park and Hampstead by a boulevard which included a Pagoda on Primrose Hill as a vantage point fom which the public could admire the view and presumably the architect's creation. Never built.

453 Proposed Casino for Primrose Hill. [c. 1844]. Wood-engr., 110 × 145 (SCL). Never built.

454 Proposed Casino On Primrose Hill. [c. 1844]. Wood-engr., 90 × 145 (SCL). Never built.

455 Gymnas(s)t(r)icks (above the image) Professor Voelkickups school (for the instruction of Gentlemen of all ages in the arts of Running, Tumbling Leaping, Scrambling, Crawling, Creeping, Climbing, Punching, Poking, and Hobby-horsemanship.

/Drawn & Etched by Wm Taylor. *W. T. Taylor, 11* [?] *Church Street, St Saviors Boro.* [c. 1848]. Etching, 170 × 210 (ML).

456 Gymnasium, Primrose-Hill.
Wood-engr., 220 × 110 (*Illus. London News*, 29 April 1848, p. 283).

457 The Peace Commemoration – The Fireworks On Primrose-Hill: The Grand Finale, And Shower Of 10,000 Rockets.
/W. Thomas, Sc (within image area, below). Wood-engr., 345 × 505 (*Illus. London News*, 7 June 1856, pp. 640–41).

458 The Display Of Fireworks At Primrose Hill, On The Day Of The Peace Rejoicing.
[1856]. Wood-engr., 230 × 335 (SCL). From an unknown newspaper source.

459 (The Fireworks On Primrose Hill.)
/W. H. Aske (within image area, below). Wood-engr., 210 × 125 (*London Journal*, 14 June 1856, p. 201).

460 The Shak[e]speare Commemoration In London: Planting An Oak On Primrose Hill.
Wood-engr., 235 × 345 (*Illus. London News*, 30 April 1864, p. 413).

461 The Shak[e]speare Tercentenary: Planting The Shakespeare Oak On Primrose-Hill.
Wood-engr., 175 × 235 (*Illus. Times*, 30 April 1864, p. 273).

462 Working-Men's Celebration Of The Tercentenary Of Shakespeare's Birth: Planting An Oak On Primrose Hill In Honour Of The Poet.
[c. 1864]. Wood-engr., 200 × 230 (SCL). From an unknown newspaper source.

463 Primrose Hill Tunnel (bottom left corner of image area).
J. C. Bourne del. et. lithog (within image area, below) /Printed by C. Hullmandel/. *The proprietor J. C. Bourne, 19 Lambs Conduit Street, and Ackermann & Co, Strand, 1839.* Tinted lith., 170 × 260 (Bourne & Britton, *London & Birmingham Railway*, 1839, unnumbered). Watercolour in Elton Collection at Ironbridge Gorge Museum.

464 London And Birmingham Railway. London Entrance to the Primrose Hill Tunnel, now in progress of erection, Sept. 1837. Designed by W. H. Buddon – Robert Stephenson Esqr. Engineer. James Hennell del/C. Rosenberg Sc. Bottom right: Printed by Gad & Keningale, Top right: Plate 1. Aquatint, 255 × 415 (Simms, *Public Works of Great Britain*, 1838, Pl. 1 frontis).

a Names of printers removed. (SC).

b Different artist statement.
W. H. Budden del/C. Rosenberg Sc. *John Weale, Architectural Library, 59 High Holborn.* (GuP).

465 (Southern Entrance to the Primrose-Hill Tunnel.)
Wood-engr., 100 × 150 (*Penny Mag.*, 31 August 1838, p. 332).

a 2461. – Primrose Hill Tunnel.
(*Old England*, 1845, ii, opp. p. 340, Illus. 2461).

b Eingang des Tunnels durch den primroser hugel.
(*Pfennig-Magazin*, 9 Feb. 1839, p. 45).

466 Entrance To The Primrose Hill Tunnel
/Orrin Smith Sc/ (within image area, below). Wood-engr., 50 × 80 (*Hand-Book for Travellers*, [1889?], opp. p. 22. Roscoe, *London and Birmingham Railway*, [1839], p. 17).

467 Chalk Farm Tunnel. (Birmingham Railway).
E. Dolby delt/Clerk & Co. Lith., 202 High Holborn. [c. 1840]. Lith., 245 × 380 (SCL).

a Different title and lithographic statement. Primrose Hill Tunnel.
/Lithographed by Clerk & Co., 202 High Holborn/. (SCL)

468 Primrose Hill Tunnel, London & North-Western Railway. Drawn & Engraved for the British Gazetteer.
J.F. Burrell delt/A. Ashley exct. *H. G. Collins, 22 Paternoster Row.*[c. 1850]. Steel-engr., 135 × 200 (SCL). This print was not found in the Bodleian Library's copy of Benjamin Clarke, *British Gazetteer*, 1852 [1849–52], 4 vols.

469  Chalk Farm Bridge, Birmingham Railway.
/J. Fussell. *Simpkin, Marshall & Co. & the
Proprietors, 1 Cloudesley Terrace, Islington.*
Steel-engr., 95 × 150 (Trotter, *Select
Illustrated Topography*, 1839, opp. p. 146).

a Artist and imprint removed.
(Fearnside, *Holmes's Great Metropolis*,
[1851], opp. p. 72).

470  [Boys' Home Regent's Park Road].
[c. 1876]. Wood-engr., 100 × 150 (SCL).
Illustration to a report on the home dated
28 February 1876.

471  [Boys' Home in Regent's Park Road].
Wood-engr., 90 × 145 (*Budget*, 28 Feb.
1883, cover illus).

472  Room In The Boys' Home, Regent's Park
Road. In Memory Of Seymour Sydney
Hyde Sixth Earl of Harrington, Born at
Ashburnham House . . .
[c. 1870]. Chromolith., 295 × 250 (SCL).

473  [A Woodwork Class].
Wood-engr., 110 × 165 (*Story of the Boys'
Home*, [c 1894?], p. 5).

474  Primrose Hill In The Snow.
Wood-engr., 125 × 175 (*Budget*, 28 Feb.
1890, p. 24).

475  From Telegraph Hill Hampstead (bottom
right of image area).
T. C. Dibdin 1852/M. & N. Hanhart Imp/.
*T. C. Dibdin, 25 Polygon, Somers Town.*
Top right: Pl. 23. Lith., 140 × 240
(Dibdin, *Dibdin's Progressive Drawing
Book*, 1852, Pl. 23).

476  From Telegraph Hill. Hampstead (bottom
left of image area).
/T. C. Dibdin 1852 (within image area).
/M. & N. Hanhart impt/. *T. C. Dibdin, 25
Polygon, Somers Town.* Top right: Pl. 24.
Lith., 130 × 240 (Dibdin, *Dibdin's
Progressive Drawing Book*, 1852, Pl. 24).

a From Telegraph Hill Hampstead (bottom
left of image area).
/T. C. Dibdin 1852 (within image area,
below). *Thomas Nelson & Sons, London.*
Top right: Pl. 23. (SCL).

477  Harrow, from the fields near Hampstead.
/T. C. Dibdin 1854 (within image area,

below). Bottom right: Wanderings in the
Woods. Pl. 7. Lith., 240 × 370 (SCL).

478  Child's Hill House, Hampstead,
Middlesex. (The Seat of Thos. Platt, Esqr).
Engraved by C. Pote, from a drawing by
J. P. Neale/for the Beauties of England &
Wales. *John Harris, St. Pauls Church Yard,
Jan. 1, 1813.* Copper-engr., 90 × 140
(Britton & Brayley, *Beauties of England*,
1801–18, x, Part iv, opp. p. 201. Brayley
& others, *London and Middlesex*, 1810–16,
iv, opp. p. 201).

479  The Happy Shepherd with a View of
Childs Hill Middlesex.
/John Peltro sculp. *R. Sayer & J. Bennett,
Map Chart & Printsellers, No. 53 Fleet
Street, October 1st 1784.* Along right
margin: 52. Copper-engr., 140 × 200 (SCL).

a With different plate number. Top right:
3. (SCL).

480  North End – from Hampstead Heath –
near London.
J. Rathbone pinxt/F. Jukes fecit. *F. Jukes,
Howland Street, June 20, 1799.* Aquatint,
240 × 300 (SCL).

481  View At Childshill, Hendon.
*J. Hassell, No. 23 Bishopsgate Street,
1 March 1799.* Aquatint, 80 × 115 (SCL).

482  At Childs Hill Hampstead.
[Written below on copy inspected: Etched
by Mr. Fancourt. c. 1870]. Etching,
130 × 260 (SCL).

483  Nr. Hampstead.
/N. E. Green. *G. Rowney & Co., 51
Rathbone Place.* [c. 1860?]. Lith., 180 × 290
(GLC).

484  At Hampstead.
/N.E.G. [Nathaniel Everett Green].
*G. Rowney & Co., 51 Rathbone Place.*
[c. 1860?]. Top right: Pl. 13. Tinted lith.,
205 × 305 (GuP).

485  View at Childs Hill near Hampstead.
/Drawn and Aquatinta by J. Hassell/
(above the image). *S. W. Fores, No. 50,
Piccadilly, Jany 1, 1800.* Aquatint,
100 × 145 (SCL).

486  Cottage at Childs Hill, Middlesex.
[c. 1800]. Aquatint, 75 × 115 (SCL).

487 Hampstead.
/GB (artist's monogram within image area, below). *J. Dickinson, 114 New Bond Street, 1828.* Top right: 16. Lith., 110 × 205 (SCL).

488 This Print representing The Honourable Artillery Company assembled for Ball practice, at Childs Hill, Hampstead is . . . dedicated to . . . His Royal Highness Prince Augustus Frederick Duke of Sussex . . . By . . . George Forster.
Painted by G. Forster/Engraved by R. Havell Junr. 77 Oxford Street. *G. Forster, 6 Grays Inn Terrace, Jany 1st 1831.* Aquatint., 330 × 585 (P). Listed in the *Index to British Military Costume Prints,* 1972, no. 323 with a companion print published by George Forster in April 1829 depicting a review of the Honourable Artillery Company.

489 View from Hampstead Heath (West).
*J. Hewetson, Hampstead, 1867.* Etching, 85 × 75 (SCL).

490 Cock & Hoop Hampstead.
/HF [H. Fancourt] delt. [c. 1840?]. Etching, 135 × 200 (SCL).

491 West End Hampstead.
/HF [H. Fancourt] delt. [c. 1840?]. Etching, 130 × 235 (SCL).

492 View Near Hampstead, Middlesex. From A Painting By J. Constable, R.A.
Constable P./L. Marvy d./Piaud S. (all within image area, below). [c. 1880?]. Wood-engr., 175 × 135 (SCL).

493 [Treherne House].
/Indecipherable artist's monogram (within image area, below) [c. 1835?]. Lith., 135 × 220 (SCL).

494 West-End Schools.
/Charles Miles Archt lith. Decr 1844. Tinted lith., 140 × 220 (SCL). The house on the right is Cholmley Lodge.

495 Proposed Chapel, West End, Hampstead (bottom centre of image area).
Charles Miles Archt 1844/ (within image area, below). Etching, 120 × 205 (SCL).

496 West-End, Hampstead. Middx 1841.
/CM. Etching, 75 × 130 (SCL).

497 Poplar, West End, Hampstead.
/George Barnard delt 1848. Top right: Pl. 2. Lith., 320 × 225 (Barnard, *Second Series of Elementary Studies,* 1849, Pl. 2).

498 Trinity Church, Finchley Road.
Wood-engr., 175 × 115 (*Illus. London News,* 5 Oct. 1872, p. 336).

499 Finchley-Road Station, Hampstead Junction Railway.
Wood-engr., 145 × 235 (*Illus. London News,* 14 Jan. 1860, p. 36).

500 Oaklands Hall.
Martin & Hood Lith., 8 Gt. Newport St, W.C./. [c. 1850]. Tinted lith., 200 × 305 (P).

501 The Hampstead Cemetery. – Mr. Charles Bell, Architect.
Artist's monogram based on J/ (within image area, below). Wood-engr., 170 × 265 (*Builder,* 25 Nov. 1876, p. 1147).

502 Hampstead, From The Kilburn Road.
/SP (within image area, below). Wood-engr., 210 × 145 (Walford, *Old & New London* [1873–78], v, opp. p. 243).

503 Near Kilburn.
Dillon Delint/M. Jones Fecit. *John Harris, Sweetings Alley, Cornhill, Jany 1st 1782.* Top right: 2. Aquatint, 165 × 220 (*Four Views in Middlesex,* 1782, Pl. 2).

504 Barn, near Kilburn.
*John P. Thompson, Gt Newport Street.* [c. 1800]. Aquatint, 135 × 185 (SCL).

505 Oak Kilburn.
GC [G. Childs] 1848/ (within image area, below). Lith., 160 × 250 (SCL).

506 Kilburn (bottom left corner of image area).
/N. E. Green (within image area, below). *G. Rowney & Co., 51 & 52 Rathbone Place.* Top right: 9. Aquatint, 130 × 200 (Green, *N. E. Green's Sepia Drawing Lessons,* [1888], No. 3, Pl. 9). Also included within this drawing book are incomplete versions recording the growth of the image to this final version. These are listed below.

i Kilburn (bottom left corner of image area).
/N. E. Green (within image area, below). Top right: 7. (Green, *N. E. Green's Sepia*

*Drawing Lessons*, [1888], No. 3, Pl. 7). The earliest stage in the development of the image showing the outline of the picture.

ii Kilburn (bottom left corner of image area).
/N. E. Green (within image area, below). Top right: 8. (Green, *N. E. Green's Sepia Drawing Lessons*, [1888], No. 3, Pl. 8). The middle stage in the development of the image.

507 South West prospect of Kilburn Abbey, as it appeared in the Year 1722 from a Copy of the Original Drawing in the possession of James Hormsby Esqr.
*J. Seago Printseller, High Street, St. Giles, Septr 2d 1798.* Soft ground etching, 100 × 145 (BM).

i The Priory, Kilburn, 1750.
WP/Greenaway (both within image area, below) Wood-engr., 105 × 140 (Walford *Old & New London*, [1873–78], v, p. 247).

508 [Kilburn Priory].
[c. 1812?]. Etching, 50 × 100 (SCL). MS inscription on copy inspected states that this was an experimental plate by I. Quilley and his first attempt at etching.

509 Remains of Kilburn Priory As It Appeared in 1722.
/I. Quilley sculp. *White, Cochrane & Co., May 1813.* Soft ground etching, 105 × 145 (Park, *Topography of Hampstead*, 1814, opp. p. 202, Pl. vi).

510 Kilburn, Or Kilbourn, Priory; Middlesex (above the image).
Wood-engr., 70 × 100 (*Graphic & Historical Illustrator*, 1834, p. 336).

511 Old Kilburn Priory. (From an old Drawing in Mr. Gardner's Collection.)
/O. Jewitt (within image area, below). Wood-engr., 50 × 70 (Howitt, *Northern Heights of London*, 1869, p. 39).

512 View at Kilborn on the Edgeware Road.
*J. Cary, Engraver, Map & Print seller, No. 188 Strand, Jany 12, 1789.* Aquatint, 310 × 425 (SCL). For companion print see no. 515.

513 Kilbourn Wells, Middlesex.
Copper-engr., 90 × 160 (*Universal Mag.*, Oct. 1797, opp. p. 225).

a Different imprint: *I. I. Stockdale, 41 Pall Mall, 6th of Jan. 1818.* (GuP).

514 The Long Room (above the image).
/F. Vivares Scul. (within image area).
[c. 1750?]. Copper-engr., 95 × 195 (BLK). Mentioned by Wroth, *London Pleasure Gardens*, 1896, p. 196: 'An engraved handbill, describing the waters, at the top of which is a print of the Long Room, by F. Vivares'.

515 The Red Lion at Kilborn.
Rathbone delt/C. A. Prestal sculpt. *J. Cary Engraver, Map & Print-seller, No. 188 Strand, Jany 12, 1789.* Aquatint, 310 × 425 (BM). For companion print see no. 512.

516 The St. John's Foundation School, Kilburn.
Wood-engr., 100 × 150 (*Illus. London News*, 9 May 1857, p. 435).

517 New Church Of St. Mary, Kilburn.
Wood-engr., 110 × 180 (*Illus. London News*, 19 July 1856, p. 58).

518 S. Mary's Church, District Of Kilburn, Hampstead.
F. & H. Francis Arct/. [c. 1856]. Wood-engr., 180 × 140 (SCL).

519 Proposed National Schools, Kilburn.
C. Miles Archt Etched/. [c. 1840]. Etching, 90 × 160 (SCL).

520 Victoria Rifle Ground And Kilburn Schools, London.
Restored 1860, Ewan Christian Archt Whitehall Place/ Kell Bros Lithrs, Castle St, Holborn. *Published In Aid Of The Building Fund Of The Kilburn Schools, By The Secretary Charles Saunderson, Stanmore Lodge, Kilburn.* Lith., 185 × 280 (SCL).

521 Rifle Practice At Kilburn-Gate On Tuesday Last.
Wood-engr., 155 × 230 (*Illus. Historic Times*, 28 June 1850, p. 401).

a Slightly different title: Rifle Practice At Kilburn - Pits On Tuesday Last. (P).

522 The Guards Practising At The Victoria Rifle-Ground, Kilburn.
/E. Evans Sc. Wood-engr., 150 × 235 (*Illus. London News*, 3 Feb. 1855, p. 117).

523 The Victoria Rifle Corps At Kilburn.
Wood-engr., 145 × 235 (*Illus. London News*, 17 Feb. 1855, p. 160).

THE MEZZOTINTS OF DAVID LUCAS

For greater convenience all the mezzotints by David Lucas after John Constable have been reproduced as a group. All have already been reproduced with other prints of the same subject. Consequently the full entry will be found under the original number, with only a cross-reference here.

524 Noon.
See no. 238.

525 A Heath.
See no. 235.

526 Hampstead, Middlesex. "Ut Umbra sic Vita".
See no. 234.

527 Hampstead Heath, Harrow in the Distance.
See no. 239.

528 Hampstead Heath.
See no. 237.

529 Sir Richd. Steele's Cottage, Hampstead Road.
See no. 364.

THE WORK OF ARTHUR EVERSHED.

For greater convenience, and because they are topographically so vague, all the views by Arthur Evershed have been reproduced as a group at the end of the Gallery. The only ones reproduced earlier (nos. 548 & 549) are cross-referenced here.

530 Hampstead.
/AE [A. Evershed] 1874. Etching, 55 × 115 (SCL).

531 Hampstead (bottom left of image area).
A. Evershed/ (within image area, below). [c. 1874]. Etching, 85 × 190 (SCL).

532 Hampstead Heath.
/A. Evershed July 1874. Etching, 155 × 295 (SCL).

533 Hampstead May 8 1874 From Nature.
/Arthur Evershed. Etching, 65 × 215 (BM). A reversed view.

534 West Heath, Hampstead.
/A. Evershed. [c. 1874]. Etching, 75 × 205 (SCL).

535 At Hampstead.
/A. Evershed 1874. Etching, 85 × 170 (SCL).

536 Hampstead Heath
/A. Evershed. [c. 1874]. Etching, 105 × 190 (SCL).

537 [Trees at Upper Terrace.
Arthur Evershed c. 1874]. Etching, 75 × 125 (BM). An incomplete print.

538 St Stephen's, Hampstead (bottom right of image area).
A. Evershed 1874/ (within image area, below). Etching, 175 × 250 (SCL).

539 At Hampstead.
/A. Evershed July 1874. Etching, 80 × 230 (SCL).

540 By Finchley Road.
A. Evershed 1874/. Etching, 120 × 210 (SCL).

541 At Child's Hill (bottom left of image area).
AE 1874/ (within image area, below). [Signature on copy inspected: A. Evershed. MS title: 'After Rain']. Etching, 80 × 120 (SCL).

542 at Child's Hill (bottom left of image area).
A. Evershed/ (within image area, below). [c. 1874]. Etching, 100 × 160 (BM).

543 [Farm at Childs Hill.
Signature in pencil below on copy inspected: A. Evershed. c. 1874]. Etching, 95 × 125 (SCL).

544 At Childs Hill.
A. Evershed 1874. Etching, 85 × 220 (BM).

545 Hampstead.
/A. Evershed 1874. Etching, 65 × 115 (SCL).

546 [At Hampstead Coombe Edge.
Signature in pencil on copy inspected: A. Evershed. c. 1874]. Etching, 60 × 130 (SCL). Incomplete.

547  [Near Jack Straw's Castle, Hampstead Heath.
Signature in pencil on copy inspected: A. Evershed not direct from Nature.
c. 1874?]. Etching, 120 × 180 (SCL).

548  At Hampstead.
See no. 113.

549  Oriel House, From an Upper Window, 27, Church Row.
See no. 48.

550  [Hampstead?].
/A. Evershed 1876. Etching, 110 × 90 (SCL).

PRINTS NOT REPRODUCED.

There remain some prints which might be thought to qualify for inclusion in *Images of Hampstead* which are not reproduced in the Gallery. The reasons for their exclusion are that they are elevations or ground plans (our survey is limited to views), or that they have so little topographical content that they are not worth reproducing, or that they are prints made by the traditional methods after 1860 often as copies of earlier views. Although not considered worthy of reproduction, we have thought it useful to include them in the Catalogue.

551  Melting Moments (above the title).
*Laurie & Whittle, 53 Fleet Street, 3d Octr 1795.* Bottom left: 162. Copper-engr., 175 × 230 (SCL). This print repeats the theme of the fickle wife receiving *billets doux* from a series of gallants on Primrose Hill or other leisure resorts.

552  Hampstead Old Church.
Pickett del. et sc./ *R. Martin Book & Printseller, Great Queen Street, Lincolns Inn Fields.* [c. 1800?]. Aquatint, 135 × 190 (SCL). In fact Hornsey church and not Hampstead.

553  View of London from Primrose Hill.
*W. Darton Junr, Augst 9th 1813.* Copper-engr., 80 × 125 (BM).

554  Near Finchley.
[c. 1815]. Etching, 105 × 175 (P).

555  The Estuary of the Thames from Hampstead.
/Malcolm del. et sculp. Copper-engr., 115 × 175 (Park, *Topography of Hampstead*, 1818, opp. p. 3).

a  Minor title variant. The Estuary of the Thames from Highgate. (SCL).

556  On Hampstead Heath.
Painted and Etched by T.H. [Hastings] 1823/. Bottom right: 6. Etching, 75 × 155 (Hastings, *Etchings Hampstead Heath*, [1822–26], Pl. 6, bottom). The view shows Highgate ponds.

557  Between Highgate and Hampstead.
/T. Hastings 1825. Etching, 155 × 105 (Hastings, *Etchings Hampstead Heath*, [1822–26], Pl. 17).

558  London going out of Town – or – The March of Bricks & Mortar!
/Designed Etched & Published by George Cruikshank November 1st 1829/. Top right: 10. Etching, 155 × 265 (Cruikshank, *Scraps & Sketches*, [1828–32], Pl. 10). Print satirising the spread of London. Sir Thomas Maryon Wilson had introduced his bill for the enclosure of the Heath in 1829. *B.M. Satires* no. 15977. Also two proofs in B.M. collection, one with pencil drawings of the marching houses. *B.M. Satires* 15977 A and B.

559  Between Highgate and Hampstead near Kentish Town.
By T. Hastings/Etched 1831. Etching, 90 × 140 (SCL).

560  View Taken From Under The Hampstead Road Bridge.
T. T. Bury delt/C. Hunt sculpt. *Ackermann & Co., 96 Strand, September 18th 1837.* Top: London And Birmingham Railroad/Plate 2. Aquatint, 210 × 265 (Bury, *Six views of the London & Birmingham Railway*, 1837, Pl. 2). Shows a part of the line near Euston.

561  Primrose Hill Tunnel.
Wood-engr., 50 × 65 (*Osborne's London & Birmingham Railway Guide*, [1840], p. 81).

562  St John's Chapel, Hampstead, Middlesex (with dedication to the Revd John Ayre

M.A. Minister).
/Lithographed & Published by R. Martin, 26 Long Acre, Jany 1st 1843/. Lith., 290 × 345 (P).

563 (Cedar in the grounds of the late T. N. Longman at Hampstead).
Wood-engr., 125 × 110 (*Penny Mag.*, 11 March 1843, p. 93).

564 Scene Of The Recent Murder At Hampstead.
Withy Sc. Wood-engr., 85 × 150 (*Pictorial Times*, 1 March 1845, p. 132). The murder referred to was that of Delarue.

565 Fancy Sale At The Orphan Working School.
Wood-engr., 140 × 180 (*Lady's Newspaper*, 8 May 1847, p. 439).

566 The Primrose Hill Tunnel.
Top: The North-Western Railroad. Wood-engr., 65 × 95 (*Visitor*, 1849, p. 41).

567 The Meteor Of Monday Night (Feb. 11), As Seen Near Hampstead.
Wood-engr., 100 × 230 (*Illus. London News*, 16 Feb. 1850, p. 120).

568 Hampstead-Heath.
Wood-engr., 145 × 225 (*Lady's Newspaper*, 2 April 1853, p. 205).

569 Soldiers Daughters' Home – Hampstead supported By Voluntary Contributions for the Maintenance Clothing and Education of the Daughters of Soldiers Orphans or not, Instituted 8th May 1855.
W. Munt, 25 Bloomsbury Square, Hony Architect/. Lith., 170 × 275 (GLC). The only copy of this print located was in such poor condition that it was impossible to tell whether the artist statement was handwritten or printed or whether it was a chromolith. or a tinted lith.

570 St Monday, Or The Peoples Holiday – No. 4 – Hampstead Heath.
Swain Sc/Mc (both within image area, below). Wood-engr., 150 × 225 (*Illus. Times*, 19 July 1856).

571 (Soldiers' Daughters' School And Home, Hampstead.)

W. H. Aske sc/EB (both within image area, below). Wood-engr., 110 × 185 (*London Journal*, 6 Feb. 1858, p. 365).

572 (Sir Gilbert Confounds Winch By A Display Of Unusual Firmness And Determination.)
Wood-engr., 110 × 180 (*London Journal*, 6 Aug. 1859, p. 61). Illustration to a story 'Violet Davenant, or the Red Hand' by Bayle St John. The meeting at night took place on Primrose Hill.

573 Hampstead Heath.
Rock & Co., London, No. 2230/ 2 Nov. 1860. Steel-engr., 65 × 95 (SCL). In fact shows Highgate not Hampstead.

574 Hampstead Ponds.
/N. E. G. [Nathaniel Everett Green].
*G. Rowney & Co., 51 Rathbone Place* [c. 1860]. Lith., 205 × 310 (SCL). The subject of this print is Highgate.

575 (New Building Of The Sailors' Daughters' Home, Hampstead.)
Wood-engr., 110 × 185 (*London Journal*, 1 Aug. 1869 p. 61).

576 "Joe's Birthday" Or Did You Ever Go To Hampstead In A Van? (above the image).
/Alfred Concanen delt/ J. Bath, 40 St Marlborough Street, W. [c. 1870?].
Chromolith., 250 × 250 (P). Music sheet cover. Among the five scenes depicted is a glimpse of Jack Straws Castle within the central image.

577 The Aged Pilgrims' Home, Hampstead. – Mr F. Boreham, Architect.
Wood-engr., 160 × 265 (*Builder*, 12 Nov. 1870, p. 907). Hornsey Rise, in fact, not Hampstead.

578 Belsize Lane Leading To Belsize Farm.
[c. 1870?]. Top: Established 1848. Lith., transferred from steel, 60 × 70 (SCL). Trade card of W. Thomas cow-keeper and dairyman, Belsize Farm.

579 North London Hospital for Consumption at Hampstead.
Maclure & Macdonald Lith., London/ T. Roger Smith F.R.I.A. Archt. [c. 1880]. Chromolith., 155 × 225 (SCL).

580 Hampstead Heath In The Olden Time.
G. Doré/ (within image area, below).
Wood-engr., 85 × 175 (SCL).

    a No title. (Doré & Jerrold, *London a Pilgrimage*, [1872], p. 1).

581 [Hampstead Heath].
G. Doré/Gauchard Brunier (within image area below). Wood-engr., 195 × 245 (Doré & Jerrold, *London a Pilgrimage*, [1872], opp. p. 162).

582 Hampstead Heath On A Holiday.
Artist's monogram based on 'B' 72/Swain sc. (both within image area, below).
Wood-engr., 295 × 485 (*Illus. London News* 25 May 1872, pp. 504–5).

583 The 'Bell Inn', Kilburn, 1750.
WP/ (within image area). Wood-engr., 110 × 145 (Walford, *Old & New London*, [1873–78], v, p. 246).

584 The Vale Of Health.
W. H. Boot/ (within image area). Wood-engr., 105 × 140 (Walford, *Old & New London*, [1873–78], v, p. 438).

585 Rosslyn House.
WP/ (within image area). Wood-engr., 105 × 140 (Walford, *Old & New London*, [1873–78], v, p. 481).

586 Belsize House In 1800.
WP/ (within image area). Wood-engr., 110 × 145 (Walford, *Old & New London*, [1873–78], v, p. 492).

587 [St Stephens Church, Rosslyn Hill].
S. Sharpe 1878/ (bottom left corner of image). Etching, 80 × 115 (SCL).

588 Hampstead Heath From The Gravel Pits.
[c. 1875?]. Wood-engr., 105 × 180 (BM).
From an unidentified newspaper.

589 Gibbet Elm.
E. F. Brewtnall 1881/Wigand Sc (both within image area, below). Wood-engr., 80 × 120 (*Harper's New Monthly Mag.*, July 1883, p. 166).

590 Old Gate, Hampstead. From a drawing by Robert W. Macbeth.
R [or P?]/ (within image area, below).
Wood-engr., 130 × 100 (*Harper's New Monthly Mag.*, July 1883, p. 168).

591 At The Pond.
E. F. Brewtnall 1881/C. P. Williams Sc. (within image area, below). Wood-engr., 75 × 120 (*Harper's New Monthly Mag.*, July 1883, p. 169).

592 The Vale Of Health. – From a drawing by Robert W. Macbeth.
/R [or P?] (within image area, below).
Wood-engr., 80 × 120 (*Harper's New Monthly Mag.*, July 1883, p. 170).

593 'A Gay Parasol'.
E. F. Brewtnall '81/C. P. Williams (within image area, below). Wood-engr., 70 × 90 (*Harper's New Monthly Mag.*, July 1883, p. 171).

594 On The Heath. – From a drawing by Robert W. Macbeth.
F. Wolf sc/R [or P?] (latter within image area, below). Wood-engr., 140 × 105 (*Harper's New Monthly Mag.*, July 1883, p. 173).

595 Gordon Rioters At "The Spaniards".
E. F. Brewtnall 1881/A. Whitney sc (former within image area, below, latter within border, below). Wood-engr., 75 × 120 (*Harper's New Monthly Mag.*, July 1883, p. 175).

596 Hogarth's Mulberry. – From a drawing by Robert W. Macbeth.
/E. Sharp (within image area, below).
Wood-engr., 80 × 120 (*Harper's New Monthly Mag.*, July 1883, p. 176).

597 A Girl Of The North End. – From a drawing by Robert W. Macbeth.
R [or P?]/S (within image area, below).
Wood-engr., 135 × 105 (*Harper's New Monthly Mag.*, July 1883, p. 177).

598 Court Near Church Row. – From a drawing by Robert W. Macbeth.
R [or P?]/S (both within image area, below). Wood-engr., 75 × 120 (*Harper's New Monthly Mag.*, July 1883, p. 181).

599 In Jack Straw's Castle.
E. F. Brewtnall '81/ (within image area, below). Wood-engr., 65 × 80 (*Harper's New Monthly Mag.*, July 1883, p. 182).

600 The Paddock Hampstead.
HC/ (monogram of H. Hovell Crickmore).

*Catty & Dobson, London*. [c. 1890?].
Etching, 75 × 105 (SCL).

601 [The Tailors' Shop].
Wood-engr., 115 × 90 (*Story of the Boys'
Home*, [c. 1894?], p. 4). One of the older
skilled boys is shown stitching beside the
master tailor. Both are sitting cross-legged
'after the manner of tailors'.

602 Stacking Wood.
Line block, 150 × 220 (*Story of the Boys'
Home*, [c. 1894?], opp. p. 7). Planks of
wood, obtained from Sweden, are stacked
in the yard before being converted into
marketable bundles of firewood by the
boys of the Regent's Park Road Boys'
Home.

603 [Interior of the Chapel].
Line block, 155 × 205 (*Story of the Boys'
Home*, [c. 1894?], opp. p. 9).

604 Central Portion Of The Premises, As Seen
From The Entrance Gates.
Line block, 150 × 210 (*Story of the Boys'
Home*, [c. 1894?], opp. p. 10).

605 Hampstead Heath.
Charles Louis Kratké after John Constable.
*Boussod, Valadon & Co., 21 April 1890*.
Etching. (Print not seen but included in
the lists published by the Printsellers'
Association.)

# BIBLIOGRAPHIES

The first of the three bibliographies lists those books in which we have established that prints of Hampstead were published (as opposed to reproduced). At the end of each entry the catalogue numbers are given of the prints which that book contains, though only the extra prints are listed for any later edition of a title.

The second bibliography gives the full details of any work of reference mentioned in abbreviated form in the Catalogue. The third lists those works on which the Narrative section of the book is largely based.

The place of publication is London unless otherwise specified. Publishers are given only where the author is not known, in which cases the publisher's name may help in finding the book in library catalogues.

## A. SOURCES OF PRINTS

Antiquarian Etching Club. *The Publications of the Antiquarian Etching Club.* 1849–54. 5 vols in 4. (359)

*Art Journal.* 1849–1912. (180, 283)

*Attic Miscellany; and Characteristic Mirror of Men and Things.* 1789–92. (422, 444)

Baines, F. E. *Records of the Manor, Parish, and Borough of Hampstead in the County of London, to December 31st, 1889.* 1890. (48)

Barnard, George. *Elementary Studies of Trees.* 1844. 6 Parts. (101)

Barnard, George. *Second Series of Elementary Studies of Trees.* 1849. (497)

Baynes, Thomas Mann. *Twenty Views in the Environs of London.* 1823. (28, 97, 145)

Bickham, George (Junior). *Bickham's Musical Entertainer.* [1737–9]. (16)

Birch, William. *Délices de la Grande Bretagne.* 1791. (74, 131)

Bourne, John Cooke & Britton, John. *Drawings of the London and Birmingham Railway.* 1839. (463)

Brayley, Edward Wedlake and others. *London and Middlesex; or, an Historical, Commercial, and Descriptive Survey of the Metropolis of Great-Britain.* 1810–16. 5 vols. Constitutes vol. 10 of *Beauties of England and Wales.* (478)

*Brief Notices of the Orphan Working School, now in the City Road, about to be removed to Haverstock Hill, Hampstead Road. Its Origin, History, Future Prospects, etc.* 1846. (394)

Britton, John and Brayley, Edward Wedlake. *The Beauties of England and Wales.* 1801–18. 18 vols. in 25. Vol. 10 deals with London and Middlesex. Hampstead is covered in part iv which was written by J. Norris Brewer. (478)

*The Budget of the Boys' Home, Regent's Park Road, London.* [c.1883–90]. I have seen only two copies of this newsletter of the Boys' Home. They appeared on 28 Feb. 1883 and 28 Feb. 1890. (471, 474)

*Builder* (an illustrated weekly magazine). 1843, etc. (338, 346, 384, 413, 501, 577)

[Burney, Frances (afterwards D'Arblay)]. *Evelina: or Female Life in London; being the History of a Young Lady's Introduction to London.* 1822. (8)

Bury, T. T. *Six Coloured Views of the London and Birmingham Railway, from drawings made on the Line with the Sanction of the Company.* 1837. (560)

Chambers, Robert. *The Book of Days; a Miscellany of Popular Antiquities.* London & Edinburgh, 1863, 1864 [1862–64]. 2 vols. (161i)

Chatelain, John Baptist Claude. *Fifty Small Original, and Elegant Views of the Most Splendid Churches, Villages, Rural Prospects and Masterly Pieces of Architecture, Adjacent to London.* [1750]. (24a, 161)

Childs, George. *Child's Advanced Drawing Book.* [c.1840]. The title of the drawing book appeared only on the front cover of the publisher's cloth binding, which survived intact on the Abbey copy (Abbey, *Scenery*, 235). There is no way of knowing whether the misplaced apostrophe was a pun or an error. (55–9, 65, 91–2, 98, 100, 107, 123–7, 129, 137, 158, 186, 198, 201, 216, 252)

Childs, George. *Woodland Sketches; a series of Characteristic Portraits of Trees, adapted for Studies for Artists and Amateurs.* 1839. (295)

*Church Builder* (a quarterly). 1862–1916. (385)

Constable, John. *Various Subjects of Landscape, Characteristic of English Scenery.* 1830 [–1832]. 5 Parts. (234a, 235, 238)

Constable, John. *English Landscape Scenery; a series of Forty Mezzotinto Engravings on Steel by D. Lucas, from Pictures painted by J. Constable.* 1855. (235a, 237, 238a, 239a)

Crabbe, George. *The Poetical Works of the Rev. George Crabbe; with his Letters and Journals and his Life, by his Son.* 1834. 8 vols. (184)

*Cruchley's Illustrated London.* G. F. Cruchley, [1841–54]. A selection of the London plates from however many series J. Harwood had by then published. (204a)

Cruikshank, George. *Scraps and Sketches.* [1828–32]. (558)

Cruikshank, Isaac. *The Cruikshankian Momus . . . Pictorial Broadsides and humorous song-headings. Fifty-two comic designs to popular ballads by the three Cruikshanks, the elder Isaac, Robert, and the great George.* 1892. (422ii)

Cruikshank, Percy. *Sunday Scenes in London and its Suburbs.* 1854. (442)

Dibdin, Thomas Colman. *Dibdin's Progressive Drawing Book for 1852.* 1852. 6 Parts. (475–76)

Dickens, Charles. *Master Humphrey's Clock.* 1840. 3 vols. This includes two novels, *The Old Curiosity Shop* and *Barnaby Rudge.* (311)

Dickens, Charles. *The Old Curiosity Shop.* With illustrations by George Cattermole and Hablot K. Browne. 1841. A reissue of the original edition from *Master Humphrey's Clock.* Although there is a new title page, the original title is used at the top of the text pages. (311)

Doré, Gustave and Jerrold, Blanchard. *London: a Pilgrimage.* [1872]. (580–81)

Dugdale, James. *The New British Traveller; or, Modern Panorama of England and Wales.* 1819. 4 vols. (306a)

Dugdale, Thomas. *Curiosities of Great Britain: England and Wales Delineated, Historic, Entertaining and Commercial.* [c. 1838–43]. 11 vols. (39, 163, 353, 436)

Du Maurier, George. *Peter Ibbetson.* 1892 [1891]. 2 vols. (144)

*Ecclesiastical Topography, a Collection of One Hundred Views of Churches, in the Environs of London.* [Edited by S. Woodburn]. 1807 [–10]. 2 vols. Although the date of the title-page to each volume is 1807 some of the plates in vol. 2 are dated 1809, whilst the preface is dated 1810. (26)

Egerton, D. T. *Fashionable Bores or Coolers in High Life.* 1824. Some of the plates in this series are unnumbered. (443)

*English Etchings* (a quarterly publication of original etchings by English artists). 1881–91. Originally a monthly issue but with no. 61 it became a quarterly. (264)

*Etcher* (a magazine of the etched work of artists). 1879–83. (113, 150)

*European Magazine.* 1782–1826. (20)

Fearnside, William Gray and Harrel, Thomas. *Holmes's Great Metropolis: or, Views and History of London in the Nineteenth Century.* [1851]. (469a)

*Four Views in Middlesex.* John Harris, 1782. A set of four numbered aquatints, sewn as issued, each with the letters 'Dillon Delint/M. Jones Fecit'. The series title appears at the top of Plate 1 'Near Paddington'. The remaining print in the series, apart from the two of Hampstead, is Plate 3 'Near Pancras'. (301, 503)

Gaspey, William. *Tallis's Illustrated London; in Commemoration of the Great Exhibition of all*

*Nations*. London and New York, [1851–2]. 2 vols. A reissue of the engravings in Bicknell's *Illustrated London*. (399)

*General Magazine and Impartial Review*. 1787–92. (424)

*Gentleman's Magazine*. 1731–1922. (52a, 349a)

Goodwin, Thomas. *An Account of the Neutral Saline Waters Recently Discovered at Hampstead*. 1804. (196)

*Graphic*. 1869–1923. (275, 405)

*The Graphic and Historical Illustrator: an original miscellany of literary, antiquarian and topographical information*. Edited by E. W. Brayley. 1834. (510)

Green, Nathaniel Everett. *N. E. Green's Sepia Drawing Lessons*. [c.1888?]. Fawn wrappers. In six numbers, price one shilling each. 'Each number contains One subject In Three Stages.' (506)

*A Hand-Book for Travellers along the London and Birmingham Railway*. R. Groombridge, London and Wrightson & Webb, Birmingham, [c.1839]. (466)

*Harper's New Monthly Magazine*. 1881, etc. (110, 589–99)

Harrison, Walter. *A New and Universal History, Description and Survey of the Cities of London and Westminster, the Borough of Southwark, and their adjacent parts*. 1775. (420)

Hassell, John. *Picturesque Rides and Walks, with Excursions by Water, thirty miles round the British Metropolis*. 1817–18. 2 vols. (261)

Hastings, Thomas. *Etchings. Subjects from Hampstead Heath and its Vicinity*. [1822–26]. A series of twenty-one etchings which includes a few prints outside the boundaries of this volume. (93, 133, 136, 156–7, 225–6, 231–2, 234–5, 265–7, 269, 289, 556–7)

Heath, Charles (artist). *Views of London: a Series of Picturesque Views of London and its Environs*. [1825]. (426)

Hone, William. *The Every-Day Book and Table Book*. 1830. 3 vols. (50)

Hone, William. *The Table Book*. 1827–28. 2 vols. (50)

Howitt, William. *The Northern Heights of London or Historical Associations of Hampstead, Highgate, Muswell Hill, Hornsey, and Islington*. 1869. (7, 22, 49, 53, 54i, 79, 86, 118, 159, 162, 206, 230, 233i, 344, 355, 432, 511)

*illustrated Historic Times*. 1849–50. (393ii, 408b, 521)

*Illustrated London News*. 1842, etc. (84, 141, 146, 165, 199, 210, 246, 263, 284–5, 287–8, 313, 318, 329–30, 334, 343, 360, 363, 380, 402, 406, 441, 456–7, 460, 498–9, 516–17, 522–3, 567, 582)

*Illustrated News of the World*. 1858–63. (400)

*Illustrated Penny Almanack*. [c.1850]. (360a)

*Illustrated Times Weekly Newspaper*. 1852–72. (362, 461, 570)

*Johnsoniana: or, Supplement to Boswell*. John Murray, 1836. (227)

*Kemp's West London Sketcher and 'Theleme'*. 1888–9. (200, 359i)

*Lady's Newspaper and Pictorial Times*. 1847–63. (378i, 393i, 565, 568)

*Leisure Hour*. 1852–1905. (250)

*Literary Gazette and Journal of the Belles Lettres*. 1817–58. (449–50)

*Lloyds Penny Sunday Times and Peoples' Police Gazette*. 1840–45. (376)

*London Almanac(k)*. 1848. (396)

*London Journal*. 1845–1912. (459, 571–72, 575)

Malcolm, James Peller. *Views Within Twelve Miles Round London*. 1800. A volume of engravings which, as the title-page goes on to explain, are specifically of subjects described by Lysons in his *Environs of London*, and so this is offered as an 'Appendage to that Work'. This was a period when 'grangerising' was becoming increasingly popular – a fashion and a word which derived from James Granger, who in 1769 had published a *Biographical History of England* with pages left blank for the addition of engraved portraits. Malcolm offers his customers views with which they can grangerise their copies of Lysons, and he identifies his prints by the pages they relate to in that work. (54, 68, 77)

*Marshall's Select Views in Great Britain.*
W. Marshall, [1825–8]. 3 vols. (38, 81, 179a, 197)

Mayhew, Augustus. *Paved with Gold or the Romance and Reality of the London Streets.* Illustrations by H. K. Browne. 1857–58. 13 Parts. (280–81)

*Mirror of Literature, Amusement, and Instruction.* 1823–47. (352)

Monk, William. *Hampstead Etchings.* [c. 1900]. (102, 143, 154, 167, 212, 251, 258)

*Monthly Magazine.* 1796–1835. (351)

Morris, Richard. *Panoramic View Round the Regent's Park from Drawings taken on the Spot, by Richard Morris, Author of Essays on Landscape Gardening.* [1831]. (416)

Moule, Thomas. *Great Britain Illustrated: a Series of original Views from Drawings by William Westall, A.R.A.* 1830. According to Holloway the Hampstead prints were reissued in 1832 and 1834 with the title *The Landscape Album.* (90, 222, 365)

New College, London. *The Introductory Lectures Delivered at the Opening of the College.* 1851. (412)

*A New Display of the Beauties of England.*
R. Goadby,
    1773. 2 vols. (192)
    1787. 2 vols. (192a)

*New Novelists Magazine.* [c.1790]. (18)

*Old England: a Pictorial Museum of Regal, Ecclesiastical, Baronial, Municipal, and Popular Antiquities.* C. Knight and Co., 1845 [1846]. 2 vols. (342, 465a)

*Old Hampstead: an Interesting Series of Nine Etchings of 18th Century Houses situate at Hampstead.* [c.1900?]. I have not seen a complete copy of this set, merely the top wrapper with the title (SCL). The etchings are rather stark and simplistic derivatives of some drawings by Patrick Lewis Forbes (c.1898). I have been unable to identify one of the nine. (47, 60–2, 64, 67, 181, 315)

*Once a Week: an illustrated miscellany.* 1859–80. (149)

*The Orphan Working School, Removed from the City Road to Haverstock Hill, Hampstead, Instituted in the Year 1758, for the Maintenance,*

*Instruction and Employment of Orphans and other Necessitous Children.* Richard Barrett, 1848. (397)

*Orphanhood. Free Will Offerings to the Fatherless.* James Nisbet, Fisher, Son & Jackson, Thomas Ward & Co., Charles Gilpin, etc., [1847]. (393a, 395)

*Osborne's London & Birmingham, Railway Guide.* E. C. W. Osborne, Birmingham, and Simkin, Marshall & Co. and Darton & Clark, London, [1840]. (561)

Park, John James. *The Topography and Natural History of Hampstead, in the County of Middlesex.*
    1814. (3, 21, 27, 52, 78, 423, 509)
    1818. (349, 555)

Partington, Charles Frederick (ed.). *National History and Views of London and its Environs.* 1834. 2 vols. (29, 82, 208, 434)

*Penny Illustrated News.* 1849–50. (409)

*Penny Magazine.* 1832–45. (465, 563)

*Das Pfennig-Magazin.* Leipzig, 1834–58. The German equivalent of the *Penny Magazine.* Issued by a German society similar to the Society for the Diffusion of Useful Knowledge which was founded by Lord Brougham and others in the 1830s in Britain. (465a)

*Pictorial Times.* 1843–7. (347, 407, 415, 564)

*Pictorial World.* 1874–92. (51, 256)

*The Pledge of Friendship.* 1826–8. 3 vols. (179)

*The Polite Repository, or Pocket Companion: Containing an Almanack, etc.* W. Peacock, [c.1786?–1808?]. The dates are those of the earliest and latest copies which I have been able to trace. (160)

Powell, J. *Progressive Lessons in Drawing.* [1821]. (290)

*Proposed Destruction of the Well Walk, Hampstead.* 1879. (207a)

*Punch.* 1841, etc. (274)

*Reynold's Miscellany.* 1847–69. (85)

Roscoe, Thomas. *The London and Birmingham Railway, with the Home and Country Scenes on each side of the line.* [1839]. (466)

Rye, William Brenchley. *Etchings.* [1837]. (359)

Sadler, Rev. T. and Martineau, Rev. J. *Sermons Delivered at Hampstead at the Closing of the Old Chapel, and the Opening of the New, Sunday, June 1st, and Thursday, June 5th 1862.* 1862. (319)

*A Selection of Studies from the Portfolios of Various Artists.* George Rowney & Co., 1850–51. 3 Parts [?]. The only version I have seen is at the V&A which has three parts. Part i contains plates by George Barnard; Part ii by H. Brittain Willis; Part iii by J. Syer. (147)

*Select Views of London and Its Environs.* Vernor & Hood, 1804–5. 2 vols. Neither plates nor pages are numbered. (25, 306)

Simms, Frederick Walter. *Public Works of Great Britain.* 1838. (464)

*Six Views of the River Thames etc.* Laurie & Whittle, 1794. (370)

Smith, Charles John. *Historical and Literary Curiosities, Consisting of Fac-Similes of Original Documents.* 1840. (228, 357)

Smith, John Thomas. *Remarks on Rural Scenery.* 1797. (215)

*Sporting Magazine.* [c.1847]. (437)

*The Story of the Boys' Home.* Boys' Home, [1894]. An appeal pamphlet which outlined the history and scope of the Regent's Park Road Boys' Home. (473, 601–4)

Stowers, T. *Six Views in the Vicinity of Hampstead.* [1796]. According to Abbey (*Scenery,* no. 206) this set was issued in blue wrappers with no title-page but with this title on the front wrapper. (75–6, 99, 176, 240, 302)

*Thirty Two Plates to Illustrate the Cheap Edition of Pickwick.* J. Newman, [1847]. 8 Parts. (170a)

Timbs, John. *Clubs and Club Life in London.* [1872]. (164, 414i)

*Town Talk.* 1858–9. (276)

Trotter, William Edward. *Select Illustrated Topography of Thirty Miles round London.* 1839. (469)

*Universal Magazine.* 1747–1815. (513)

*Visitor or Monthly Instructor.* 1836–51. (566)

W., S. *A Visit to London, containing a Description of the Principal Curiosities in the British Metropolis.* 1813. (425a)

Walford, Edward. *Old and New London.* London, Paris & New York, [1873–8]. 6 vols. (6i, 45–6, 50i, 71, 83, 166, 195, 206, 211, 229, 242, 350i, 371, 421, 433, 502, 507i, 583–6)

Walpoole, George Augustus. *The New British Traveller.* [c.1784]. (193)

Way, Thomas Robert. *Hampstead: six Lithographs.* 1908. (44, 66, 132, 155, 221, 249)

Way, Thomas Robert & Wheatley, Henry Benjamin. *Reliques of old London Suburbs North of the Thames.* 1898. (43, 72, 213)

Weller, Samuel [pseud. i.e. Thomas Onwhyn]. *Illustrations to the Pickwick Club.* 1837. 8 Parts. Originally (according to the wrappers of parts i–vi) to be completed in ten parts, but by part vii this has been revised to eight only. (170)

Woodward, George Moutard. *Eccentric Excursions.* 1796. (17, 19)

## B. WORKS OF REFERENCE

Abbey, J. R. *Scenery of Great Britain and Ireland in Aquatint and Lithography 1770–1860.* 1952. Reprinted 1972.

Barratt, Thomas J. *The Annals of Hampstead.* 1912. 3 vols. Reprinted 1972.

*British Museum. Catalogue of Political and Personal Satires Preserved in the Department of Prints and Drawings in the British Museum.* Vols. V–XI. 1935–54.

Cust, Lionel. *Catalogue of the Collection of Fans and Fan Leaves Presented to the Trustees of the British Museum by Lady Charlotte Schreiber.* 1893. 2 vols.

Holloway, Merlyn. *Steel Engravings in Nineteenth Century British Topographical Books.* 1977.

Howgego, James. *Printed Maps of London circa 1553–1850.* Folkestone, 1978.

Ikin, C. W. *Hampstead Heath: How the Heath was saved for the Public.* 1978.

*Index to British Military Costume Prints.* Army Museums Ogilby Trust, 1972.

Krumbhaar, E. B. *Isaac Cruikshank: a catalogue raisonné.* 1966.

Mayor, A. Hyatt. *Prints & People: a social history of printed pictures.* Princeton, New Jersey, 1980.

Nevill, Ralph. *British Military Prints.* 1909.

Parthey, Gustav. *Wenzel Hollar, Beschreibendes Verzeichnis seiner Kupferstiche.* Berlin, 1853.

Paulson, R. *Hogarth's Graphic Works.* 1965. 2 vols.

Ray, Gordon N. *The Illustrator and the Book in England from 1790–1914.* 1976.

Schreiber, Lady Charlotte. *Fans and Fan Leaves: English.* 1888.

Shirley, Andrew. *The Published Mezzotints of David Lucas after John Constable.* 1930.

Tooley, R. V. *English Books with Coloured Plates 1790–1860.* Revised edition, 1979.

Vertue, George. *A Description of the Works of the Ingenious Delineator and Engraver Wenceslaus Hollar, disposed into Classes of Different Sorts; with some Account of his Life.* 1759.

Wakeman, Geoffrey. *Victorian Book Illustration: the technical revolution.* Newton Abbot, 1973.

An invaluable unpublished source of information is a three-page typescript, Newton, E. E. *Description of the Plates in 'G. Childs Views in Hampstead'.* This describes the contents of the plates in *Child's Advanced Drawing Book.* It is in the Guildhall Library, City of London.

## C. SOURCES FOR NARRATIVE

Publishers are given when they are local publishers of recent publications. The following abbreviations have been used. CH: Carlisle House Press. CHS: Camden History Society. HH: High Hill Press.

Baines, Frederic Ebenezer. *Records of the Manor, Parish and Borough of Hampstead.* 1890.

Barratt, Thomas. *The Annals of Hampstead.* 1912.

Bentwich, Helen. *The Vale of Health.* HH, 1974.

*Camden History Review.* CHS, 1973 etc.

Cook, Olive. *Constable's Hampstead.* CH, 1976.

Cooper, Anthony (ed.). *Primrose Hill to Euston Road.* CHS, 1982.

Glanville, Philippa. *London in Maps.* 1972.

*Hampstead Annual.* 1897–1906.

*Hampstead and Highgate Express.* 1860, etc.

Howitt, William. *Northern Heights.* 1869.

Ikin, Christopher. *Hampstead Heath.* 1971.

Kennedy, J. *The Manor and Parish Church of Hampstead.* 1906.

Maxwell, Anna. *Hampstead.* 1898.

Norrie, Mavis and Ian. *The Book of Hampstead.* HH, 1960. Revised ed., 1968.

Norrie, Ian and Bohm, Dorothy. *Hampstead, London Hill Town.* 1981.

Park, John James. *The Topography and Natural History of Hampstead.* 1814.

Pevsner, Nikolaus. *London except the Cities of London and Westminster.* Harmondsworth, 1952.

Potter, George William. *Hampstead Wells.* 1904. CH reprint, 1978.

Potter, George William. *Random Recollections.* 1907.

Preston, Joseph Harold. *The Story of Hampstead.* 1948.

Rees, Gareth. *Early Railway Prints.* 1980.

Russell, Ronald. *Guide to British Topographical Prints.* 1979.

Scott, Don. *The Nature of Hampstead Heath.* HH, 1979.

Thompson, F. M. L. *Hampstead: the Building of a Borough.* 1974.

*Transactions of the Hampstead Antiquarian and Historical Society.* 1899, etc.

Wade, Christopher (ed.). *The Streets of Hampstead.* HH, 1972.

Wade, Christopher (ed.). *More Streets of Hampstead.* HH, 1973.

Wade, Christopher (ed.). *The Streets of West Hampstead.* HH, 1975.

White, Caroline. *Sweet Hampstead.* 1901.

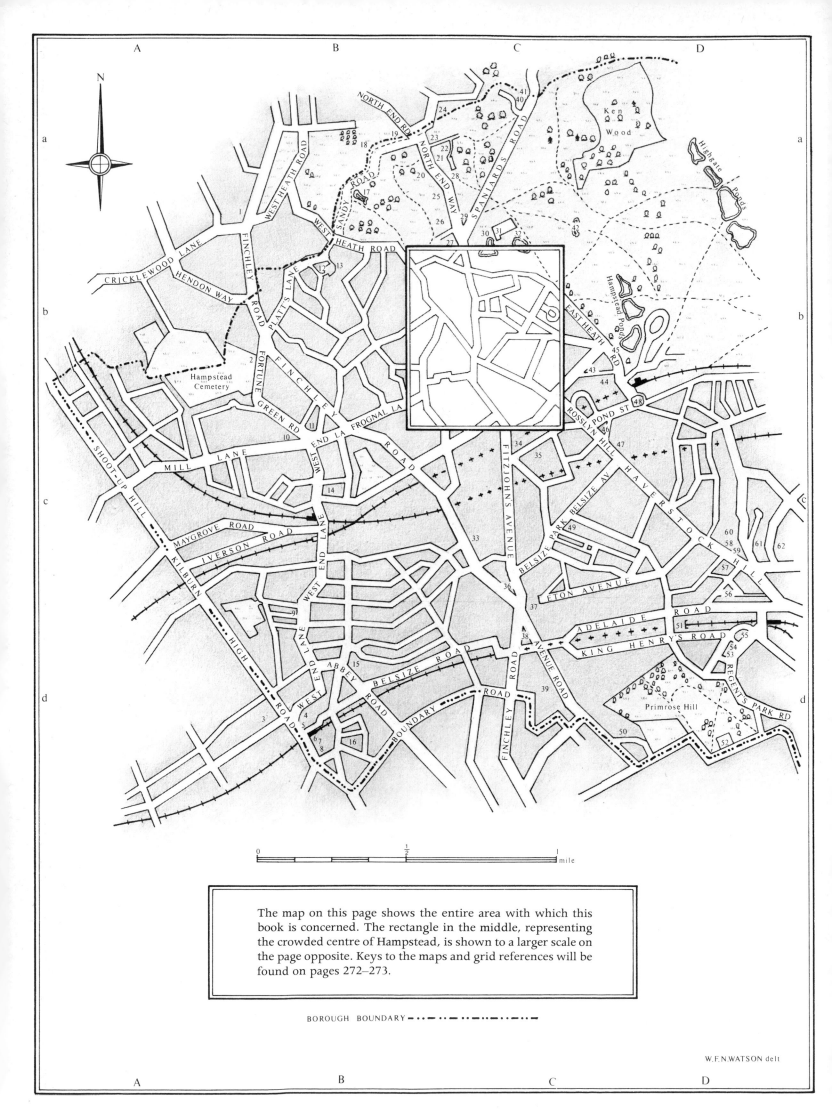

The map on this page shows the entire area with which this book is concerned. The rectangle in the middle, representing the crowded centre of Hampstead, is shown to a larger scale on the page opposite. Keys to the maps and grid references will be found on pages 272–273.

BOROUGH BOUNDARY ▪▬▪▬▪▬▪▬▪▬▪▬▪▬▪▬▪▬

W.F.N.WATSON delt

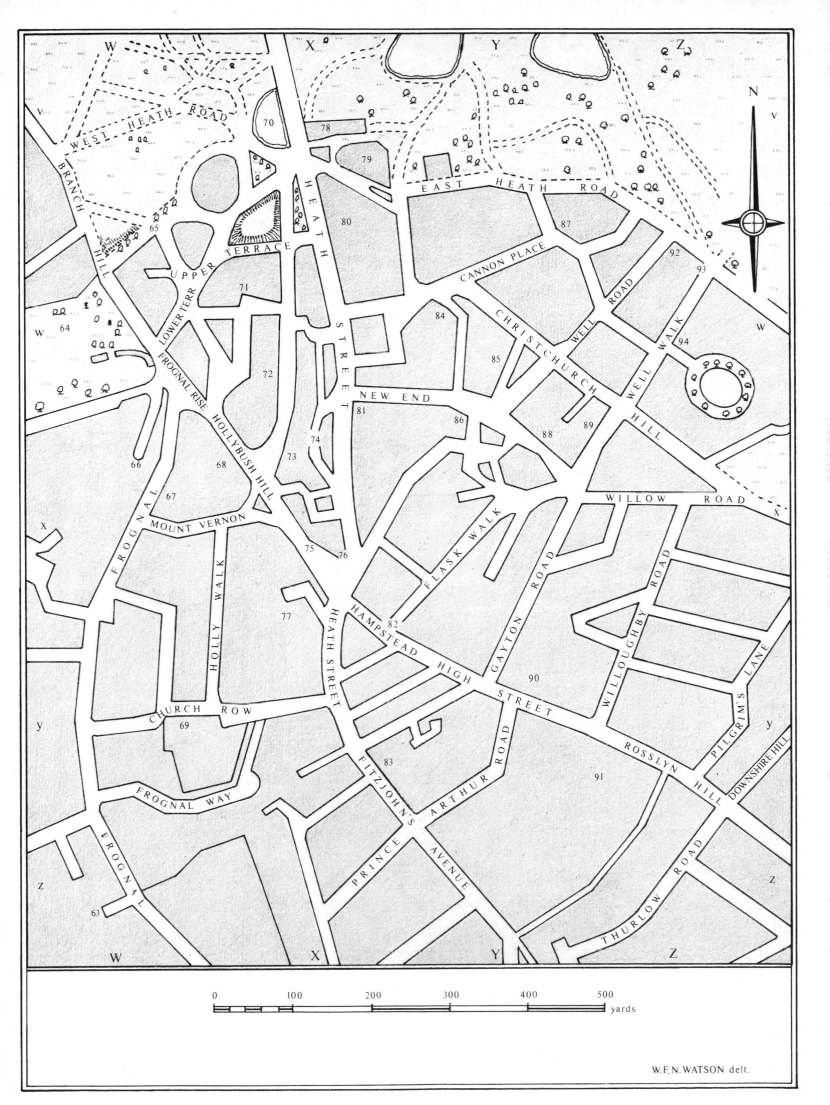

# KEYS TO MAP

*The first key, arranged numerically, identifies each of the numbers on the maps. The second arranges in alphabetical order the various names of buildings and streets appearing in the captions of prints, together with the number locating each on the map. The numbering moves from left to right but as a further guidance a grid reference is given in brackets, A – D relating to the map of the entire area and W – Z to the enlarged inner area.*

NUMERICAL KEY

1 Childs Hill Kiln (Bb)
2 Hampstead Cemetery (Bb)
3 Victoria Rifles Drill Ground (Bd)
4 Proposed National School, Kilburn (Bd)
5 Kilburn Wells (Bd)
6 Bell, Kilburn (Bd)
7 Kilburn Priory (approximate site of) (Bd)
8 Red Lion, Kilburn (Bd)
9 Oaklands Hall (Bd)
10 Emmanuel School (Bc)
11 Cock and Hoop (Bc)
12 Childs Hill House (Bb)
13 Telegraph Hill (Bb)
14 Treherne House (Bc)
15 St Mary's, Kilburn (Bd)
16 St John's Foundation School, Kilburn (Bd)
17 Leg of Mutton Pond (Bb)
18 Golders Hill Park (Ba)
19 Golders Hill House (Ba)
20 Gibbet Elms (Ca)
21 North End House (Ca)
22 Hope Cottage (Ca)
23 Bull and Bush (Ca)
24 Wyldes Farm (Ca)
25 Hill House (Cb)
26 Heathlands (Cb)
27 Jack Straw's Castle (Cb)
28 Wildwood Avenue (Ca)
29 Heath House (Cb)
30 Vale of Health (Cb)
31 Vale Lodge (Cb)
32 Suburban Hotel (Cb)
33 Holy Trinity Church, Finchley Road (Cc)
34 Shepherd's Well (Cc)
35 Rosslyn House (Cc)
36 New College (Cd)
37 School for the Blind (Cd)
38 The Swiss Cottage (Cd)
39 St Paul's, Hampstead (Cd)
40 Erskine House (Ca)
41 Spaniards Inn (Ca)
42 Viaduct (Cb)
43 St John's Downshire Hill (Cb)
44 Wentworth Place (Cb)
45 Engine House (Db)
46 St Stephen's, Rosslyn Hill (Cc)
47 Bartrams Convent (Dc)
48 South End Green (Dc)
49 Belsize House (Cc)
50 St Stephen's, Avenue Road (Dd)
51 Primrose Hill Tunnel (Dd)
52 Open Air Gymnasium, Primrose Hill (Dd)
53 Primrose Tavern (Dd)
54 Chalk Farm Tavern (Dd)
55 The Boys' Home, Regent's Park Road (Dd)
56 St Saviour's, Eton Road (Dd)
57 Steele's Cottage (Dc)
58 Load of Hay (Dc)
59 Tom King's House or Moll King's (approximate site of) (Dc)
60 Orphan Working School (Dc)
61 Haverstock Hill Chapel (Dc)
62 Tailors' Asylum (Dc)
63 Frognal Priory (Wz)
64 Branch Hill Lodge (Ww)
65 Judges Walk (Wv)
66 Frognal Grove (Wx)
67 The Workhouse, Frognal (Wx)
68 Mount Vernon Hospital (Xx)
69 St John's, Church Row (Wy)
70 Whitestone Pond (Xv)
71 Admiral's House (Xw)
72 Fenton House (Xw)
73 Romney's House (Xx)
74 Location depicted in 'Work' by Ford Madox Brown (Xx)
75 Holly Hill (Xx)
76 Fire Station (Xx)
77 Hampstead, Parochial School (Xx)
78 Gangmoor (Xv)
79 Bellmoor (Xv)
80 Upper Flask (Xv)
81 Cherry Tree House (Xw)
82 Flask Walk (Xx)
83 Sailors' Orphan Girls' Home (Xy)
84 Christ Church (Yw)
85 Grove Place (Yw)
86 New End Dispensary (Yw)
87 Squire's Mount (Yv)
88 Burgh House (Yx)
89 Long Room, second (Yw)
90 Hampstead Brewery (Yy)
91 Vane House; Royal Soldiers' Daughters' Home (Yy)

92 Foley House (Zw)
93 Keats' Seat (Zw)
94 Long Room, first (Zw)

SUBJECT KEY

Admiral Barton's 71 (Xw)
Admiral's House 71 (Xw)
Alms House, Frognal 67 (Wx)
Avenue 28 (Ca)

Barton, Admiral 71 (Xw)
Bartrams Convent 47 (Dc)
Bell, Kilburn 6 (Bd)
Bellmoor 79 (Xv)
Belsize House 49 (Cc)
Boys' Home, Regent's Park
Road 55 (Dd)
Branch Hill Lodge 64 (Ww)
Bull and Bush 23 (Ca)
Burgh House 88 (Yx)

Chalk Farm Tavern 54 (Dd)
Cherry Tree House 81 (Xw)
Childs Hill House 12 (Bb)
Childs Hill Kiln 1 (Bb)
Christ Church 84 (Yw)
Clock House 72 (Xw)
Cock and Hoop 11 (Bc)
Constitutional Club 73 (Xx)
Corner-Memory
Thompson's 63 (Wz)

Emmanuel School 10 (Bc)
Engine House 45 (Db)
Erskine House 40 (Ca)

Fenton House 72 (Xw)
Fire Station 76 (Xx)
Flask Walk 82 (Xx)
Foley House 92 (Zw)
Fortune Green Cemetery 2 (Bb)
Frognal Grove 66 (Wx)
Frognal Priory 63 (Wz)

Gangmoor 78 (Xv)
Gattaker, Thomas 25 (Cb)
Gibbet Elms 20 (Ca)
Golders Hill House 19 (Ba)
Golders Hill Park 18 (Ba)
Great Room 94 (Zw)
Grove Place 85 (Yw)

Hampstead Brewery 90 (Yy)
Hampstead Cemetery 2 (Bb)

Hampstead Parochial School 77
(Xx)
Haverstock Hill Chapel 61 (Dc)
Heath Farm 24 (Ca)
Heath House 29 (Cb)
Heathlands 26 (Cb)
Hill House 25 (Cb)
Holly Hill 75 (Xx)
Holy Trinity Church, Finchley
Road 33 (Cc)
Hope Cottage 22 (Ca)

Jack Straw's Castle 27 (Cb)
Judges Walk 65 (Wv)

Keats House 44 (Cb)
Keats' Seat 93 (Zw)
Kilburn Priory (approximate
site of) 7 (Bd)
Kilburn Wells 5 (Bd)
King, Moll or Tom
(approximate site of house)
59 (Dc)

Leg of Mutton Pond 17 (Bb)
Load of Hay 58 (Dc)
Long Room, first 94 (Zw)
Long Room, second 89 (Yw)

Medical Research Institute 68
(Xx)
Monro House 83 (Xy)
Montagu Grove 66 (Wx)
Mount Vernon Hospital 68
(Xx)

New College 36 (Cd)
New End Dispensary 86 (Yw)
North, Fountain 71 (Xw)
North End Avenue 28 (Ca)
North End Cottages 22 (Ca)
North End House 21 (Ca)
North End Place 21 (Ca)

Oaklands Hall 9 (Bd)
Open Air Gymnasium 52 (Dd)
Orphan Working School 60
(Dc)

Pitt House 21 (Ca)
Poor House 67 (Wx)
Primrose Hill Tunnel 51 (Dd)
Primrose Tavern 53 (Dd)
Proposed National School,
Kilburn 4 (Bd)

Red Lion, Kilburn 8 (Bd)

Romney's House 73 (Xx)
Rosslyn House 35 (Cc)
Royal Soldiers' Daughters'
Home 91 (Yy)

Sailors' Orphan Girls' Home 83
(Xy)
St John's Church Row 69 (Wy)
St John's Downshire Hill 43
(Cb)
St John's Foundation School,
Kilburn 16 (Bd)
St John's Parochial Schools 77
(Xx)
St Mary's, Kilburn 15 (Bd)
St Paul's, Hampstead 39 (Cd)
St Saviour's, Eton Road 56 (Dd)
St Stephen's, Avenue Road 50
(Dd)
St Stephen's, Rosslyn Hill 46
(Cc)
School for the Blind 37 (Cd)
Shepherd's Well 34 (Cc)
Sluice House 45 (Db)
South End Green 48 (Dc)
Spaniards Inn 41 (Ca)
Squire's Mount 87 (Yv)
Steele's Cottage 57 (Dc)
Steevens, George 80 (Xv)
Suburban Hotel 32 (Cb)
Swiss Cottage 38 (Cd)

Tailors' Asylum 62 (Dc)
Telegraph Hill 13 (Bb)
Treherne House 14 (Bc)

Upper Flask 80 (Xv)

Vale Lodge 31 (Cb)
Vale of Health 30 (Cb)
Vane House 91 (Yy)
Viaduct 42 (Cb)
Victoria Rifles' Drill Ground 3
(Bd)

Weatherall House 89 (Yw)
Wentworth Place 44 (Cb)
West End School 10 (Bc)
Whitestone Pond 70 (Xv)
Wildwood Avenue 28 (Ca)
Willes, Sir Francis 26 (Cb)
'Work'—location of scene by
Ford Madox Brown 74 (Xx)
Workhouse, Frognal 67 (Wx)
Wyldes Farm 24 (Ca)

# INDEX TO NARRATIVE

*Entries relate to page numbers, the pages in question being pp. 11–155.*

# INDEX TO CATALOGUE
## TITLES

*The numbers relate to the numbering of the prints in the catalogue, not to pages of the book. No distinction is made between a main entry and its subheadings in either the a, b, c or the i, ii, iii sequences. Thus a title appearing on print no. 364a or 364,i will be indexed merely as 364.*

*The main use of this index will be as the most rapid way of tracing a particular print in the Gallery or Catalogue, so the prints are listed not under key words but under the first word in the title, excluding only 'the' and 'a'. Punctuation is as on the print. To find all the prints on a given subject, the quickest way is not through this index but through the list on page 157.*

# INDEX TO CATALOGUE
## ARTISTS, ENGRAVERS AND PUBLISHERS

*The numbers relate to the numbering of the prints in the Catalogue, not to pages of the book. No distinction is made between a main entry and its subheadings in either the a, b, c or the i, ii, iii sequences. Thus a name appearing on print no. 364a or 364,i will be indexed merely as 364.*